Death in Contemporary Popular Culture

With intense and violent portrayals of death becoming ever more common on television and in cinema and the growth of death-centric movies, series, texts, songs, and video clips attracting a wide and enthusiastic global reception, we might well ask whether death has ceased to be a taboo. What makes thanatic themes so desirable in popular culture? Do representations of the macabre and gore perpetuate or sublimate violent desires? Has contemporary popular culture removed our unease with death? Can social media help us cope with our mortality, or can music and art present death as an aesthetic phenomenon? This volume adopts an interdisciplinary approach to the discussion of the social, cultural, aesthetic, and theoretical aspects of the ways in which popular culture understands, represents, and manages death, bringing together contributions from around the world focused on television, cinema, popular literature, social media and the internet, art, music, and advertising.

Adriana Teodorescu is Associate Lecturer in the Faculty of Sociology at Babeş-Bolyai University, Cluj-Napoca, Romania. She is the editor of *Death within the Text: Social, Philosophical and Aesthetic Approaches to Literature, Death Representations in Literature. Forms and Theories* and co-editor of *Dying and Death in 18th–21st Century Europe* and *Dying and Death in 18th–21st Century Europe: Volume 2.*

Michael Hviid Jacobsen is Professor of Sociology at Aalborg University, Denmark. He is the editor of *The Poetics of Crime* and *Postmortal Society* and co-editor of *The Sociology of Zygmunt Bauman, Encountering the Everyday, The Transformation of Modernity, Utopia: Social Theory and the Future, Liquid Criminology, Emotions and Crime: Towards a Criminology of the Emotions, Exploring Grief: Towards a Sociology of Sorrow,* and *Imaginative Methodologies: The Poetic Imagination in the Social Sciences.*

The Cultural Politics of Media and Popular Culture

Series Editor: C. Richard King
Columbia College Chicago, USA

Dedicated to a renewed engagement with culture, this series fosters critical, contextual analyses and cross-disciplinary examinations of popular culture as a site of cultural politics. It welcomes theoretically grounded and critically engaged accounts of the politics of contemporary popular culture and the popular dimensions of cultural politics. Without being aligned to a specific theoretical or methodological approach, *The Cultural Politics of Media and Culture* publishes monographs and edited collections that promote dialogues on central subjects, such as representation, identity, power, consumption, citizenship, desire, and difference.

Offering approachable and insightful analyses that complicate race, class, gender, sexuality, (dis)ability, and nation across various sites of production and consumption, including film, television, music, advertising, sport, fashion, food, youth, subcultures, and new media, *The Cultural Politics of Media and Popular Culture* welcomes work that explores the importance of text, context and subtext as these relate to the ways in which popular cultures work alongside hegemony.

Also available in the series:

Crazy Funny
Popular Black Satire and The Method of Madness
Lisa A. Guerrero

Death in Contemporary Popular Culture
Edited by Adriana Teodorescu and Michael Hviid Jacobsen

Afro-Surrealism
The African Diaspora's Surrealist Fiction
Rochelle Spencer

For more information about this series, please visit: www.routledge.com/The-Cultural-Politics-of-Media-and-Popular-Culture/book-series/ASHSER-1395

Death in Contemporary Popular Culture

Edited by Adriana Teodorescu
and Michael Hviid Jacobsen

 Routledge
Taylor & Francis Group

LONDON AND NEW YORK

First published 2020
by Routledge
2 Park Square, Milton Park, Abingdon, Oxon OX14 4RN

and by Routledge
52 Vanderbilt Avenue, New York, NY 10017

Routledge is an imprint of the Taylor & Francis Group, an informa business

First issued in paperback 2021

British Library Cataloguing-in-Publication Data
A catalogue record for this book is available from the British Library

Library of Congress Cataloging-in-Publication Data
A catalog record for this book has been requested

ISBN: 978-0-367-18585-5 (hbk)
ISBN: 978-1-03-208444-2 (pbk)
ISBN: 978-0-429-19702-4 (ebk)

Typeset in Garamond
by Apex CoVantage, LLC

Contents

Contributors

Martin Bartelmus is a scientific assistant at the department for German studies and general literary studies, RWTH Aachen, Germany. His research interests include killing, kill-ability, animated aesthetics, animal studies, French theory, poetics of knowledge, German media theory, materiality, and ecology in arts, film, and literature.

Denise Blake is a senior lecturer working in the Joint Centre for Disaster Research and the School of Psychology at Massey University, Wellington, New Zealand. She has a wide range of research interests that attend to issues of social justice, including identity, welfare, health and disaster preparedness, response, and recovery.

Glenys Caswell is Senior Research Fellow in the School of Health Sciences at the University of Nottingham, United Kingdom. Her research interests are centred on the social management of death and dying, and she has a particular focus on the notion of dying alone and the ways in which such deaths transgress social norms.

Florina Codreanu is Assistant Professor at the Department of Modern Languages and Communication, Technical University of Cluj-Napoca, Romania. Besides the didactics of modern languages, her research interests include cultural studies, history of art, and contemporary imagery.

Cristina Douglas is a postgraduate researcher in social anthropology at the University of Aberdeen, United Kingdom. Her research interests include cultural and social practices related to death and dying, end-of-life and palliative care, aging studies, dementia care, human-non-human relationships, animal-assisted therapy, and qualitative research methodologies.

Michael Hviid Jacobsen is Professor of Sociology at the Department of Sociology and Social Work, Aalborg University, Denmark. His research interests include death and dying, palliative care, grief, deviance, the sociology of emotions, criminology, utopia, social theory, and creative and qualitative research methodologies.

David Johnston is Professor of Disaster Management and director of the Joint Centre for Disaster Research in the School of Psychology at Massey University, Wellington, New Zealand. His research focuses on human responses to volcano, tsunami, earthquake and weather warnings; crisis decision-making; and the role of public education and participation in building community resilience and recovery.

Devaleena Kundu is Assistant Professor of English at the School of Business Studies and Social Sciences, Christ (Deemed to Be University), Bangalore, India. Her research interests include death representations in literature, cultures of mourning, symbolic immortality, cultures of the Undead, serial killing and the psychology of violence, and Indian mythologies.

Ruth McManus is Associate Professor in Sociology at the University of Canterbury, Christchurch, New Zealand. Her research interests involve the social aspects of death and dying. Current projects include disaster memorialization and new technologies for body disposal.

E. Moore Quinn is Professor of Anthropology at the Department of Sociology and Anthropology, College of Charleston, South Carolina, United States. Her research addresses the social life of language, especially as experienced in Ireland and Irish America; the linguistic aspects of commemorating *An Gorta Mór* (the Great Irish Famine); and the myriad ways that ideological perspectives affect responses to life and death.

Ruth Penfold-Mounce is Senior Lecturer in Criminology at the University of York, United Kingdom. Her research interests focus on celebrity and popular culture, crime, and death. She is one of the founders of the Death and Culture Network based at the University of York.

Panagiotis Pentaris is Senior Lecturer of Social Work at the School of Human Sciences, University of Greenwich, England, United Kingdom. He is a thanatologist whose research interests include thanatology, death and dying, end-of-life care, death and childhood, death and technology, the sociology of religion, religion and social work, religion and death, qualitative methodologies, and social theory.

Nicklas Runge studies psychology at Aarhus University, Denmark. His research interests include the psychology of death and dying, death in literature, and the culture of death and immortality.

Adriana Teodorescu is Associate Lecturer in the Department of Sociology, Babeș-Bolyai University, Cluj-Napoca, Romania. Her research interests include death studies, sociology of ageing and old age, gender and cultural studies, and comparative literature.

Preface and acknowledgements

This book is the concrete outcome of a chance collaboration between the two editors. This was not a book we initially sketched or planned together, but circumstances meant that we ended up completing the book and tying everything together in a collaborative manner. Sometimes good things do indeed emerge from coincidences.

This is a book about death – but it is not about death *as such*, death *proper*, or death *in itself*, but rather about the ways in which death is being depicted, described, circumscribed, mediated, presented, analysed, framed, transformed, transfigured, and encountered through popular cultural lenses. To slightly paraphrase the title of a well-known song by Wet Wet Wet from 1995 (the title track from the box-office success *Four Weddings and a Funeral* – if anything an iconic piece of contemporary popular culture), we claim that 'death is all around'. Death is part and parcel of social life – it always has been, it always will be – it is there, mostly taking place surrounded by secrecy behind the scenes, but nevertheless still deeply woven into the very fabric of social life. Today, death is mostly invisible to us – in contemporary society, it is hidden from sight, and our immediate contact with the dying or dead is severely limited. However, what we do no longer experience directly abounds in our vicarious experiences and encounters with death through popular culture. Never before has death loomed as large in the popular cultural imagination as in contemporary society, not least because popular culture is today an expansive, invasive, and diversified industry reaching into every nook and cranny of individual and collective consciousness. In this way, death and dying – through movies, poetry, literature, paintings, photographs, television, social media, music, and many other forms of popular cultural expression – re-enter our lives and shape how we think and feel about real, actual, and authentic death. In this book, we will look into how popular culture nowadays plays a significant role in shaping, mediating, and negotiating our meetings with human mortality.

At the end of the day, most books are born out of collective and collaborative efforts. This is indeed very much the case with this book. This volume would never have materialized were it not for the many insightful contributions provided by our good colleagues from around the world. Thank you for

incisive and important analyses, interpretations, and perspectives on the intricate relationship between death and popular culture. Moreover, we would also like to express our gratitude to our two editors at Routledge, Neil Jordan and Alice Salt, for helping us sail the ship through smooth waters. We hope this volume will inspire studies of death in contemporary society in general and, more specifically, stir interest in exploring how popular culture and death relate to each other in this particular time and age.

Michael Hviid Jacobsen and Adriana Teodorescu
Aalborg and Cluj-Napoca, autumn 2019

Introduction

Death as a topic in contemporary popular culture

Adriana Teodorescu and Michael Hviid Jacobsen

The proliferation of death in contemporary popular culture

Lana Del Rey asserts we are all 'born to die' in a song that reached the number one position in more than ten countries in 2012. 'There's a certain safety in death', exclaims Jaime Lannister in one of the most widely acclaimed television shows of this decade, *Game of Thrones*, while another character from the same fantasy series, Syrio Forel, observes that 'there is only one God, and His name is Death. And there is only one thing we say to Death: "Not today"'. Lana's, Jamie's, and Syrio's utterances – while apparently oscillating between philosophical wisdom and common sense – are evocative of the now-formulaic trend in Western entertainment history: on one hand, intense and violent portrayals of death and dying that have undoubtedly made death a truly remarkable and striking expression of our times and, on the other, neo-romantic representations of a death which does not cease to intrigue, seduce, and obsess. The increasingly overwhelming number of death-centric movies of all genres (e.g., *The Lovely Bones*, 2009; *Transcendence*, 2014, *Edge of Tomorrow*, 2014; *SelfLess*, 2015; *Get Out*, 2017, *Coco*, 2017), television series (e.g., *River*, 2015; *The Frankenstein Chronicles*, 2015; *The Coroner*, 2015; *The Alienist*, 2018; *After Life*, 2019), comic books (e.g. *Death Note*, 2003–2006; *The Walking Dead*, 2003–2019), news and songs (Wang and Kopf 2018; see also Durkin 2003), and video clips and video games (e.g., *Last of Us*; *Grand Theft Auto*), among many other forms of entertainment, attract an enthusiastic global reception so that, indeed, death seems safe, a truly lucky card. Likewise, it would seem safe for any observer of this phenomenon to state that death is used by popular culture in order to gain fame and profits and that stereotypes, truisms, exaggerations, and deformed and superficial visions of reality often find a comfortable place in various manifestations of popular culture so that morbid, voyeuristic curiosity (Foltyn 2008:153–173), the narcissist's need for self-eternalization (Aceti 2015:319–333), and the aestheticization and commodification of conventional thanatic symbols such as skulls (Kearl 2015/2020) are stimulated.

Despite a persistent tradition of seeing popular culture in a negative or unsettling light (Scruton 2012) – and more recent concerns in relation to the

somehow paradoxical transformation of the 'popular' culture, which seems no longer to be the expression of collective, shared experiences, into a rather synthetical culture due to the growing influence of corporations that orchestrate people's social interests and cultural tastes (Taylor 2009, 2010) – simply equating popular culture with the entertainment industry could be too narrow and inaccurate, especially if we think, for example, of forms that are not mass produced, such as folklore, or which finds in mass culture a means to challenge traditional art-making conventions, like pop art. In addition, if it is true that popular culture may function as a strategic mechanism through which consumerism is instilled into people's habits, being, at the same time, the result of this process, it is also true that creativity and genuine expressions are not just made possible, but are even encouraged, feeling at home in blogs, on social media and in the productions of the game industry. So if popular culture involves the risk of promoting vicarious and trivialized experiences of mortality and unrealistic images of death, it also offers possibilities to explore meanings of death and to discover resources for an authentic understanding of the dying. Online cemeteries or social networks can ease the pain of losing someone dear and facilitate grief (Walter 2015:215–232); blogs can empower people to share their experiences of dying or their thoughts related to death (e.g., *The Order of Good Death* or *Mastering the Art of Living while Dying*); social media can be used by various professional organizations and communities to familiarize people with death, dying, and bereavement and change their reluctance towards these subjects (e.g. *Dying Matters* and *Death Café* on Facebook); dead celebrities, continue to exert agency and their connections with the living through television (Penfold-Mounce 2018); and the increasingly popular art of photography can help translating feelings into aesthetic expressions able to expose social problems (e.g., Rachel Cox: *Photos of My Dying Grandma's Last Days*, 2010; Angelo Merendino: *The Battle We Didn't Choose*, 2013).

And there is more to this story. During the last few years, death has become more than ever an all-pervasive topic within the Western popular culture, in the sense not only that there are tons of death-related representations in movies, pop songs, and video games, but also that there is a palpable fascination with death to be observed in the rise of different types of books, many of them becoming bestsellers, that seem to be determined to popularize various aspects of death: medical, forensic, transhumanist and social aspects, such as Mary Roach's volumes *Spook: Science Tackles the Afterlife* (2006) and *Stiff: The Curious Lives of Human Cadavers* (2012); Dick Teresi's *The Undead: Organ Harvesting, The Ice-Water Test, Beating-Heart Cadavers, How Medicine Is Blurring the Line Between Life and Death* (2012); Laurent Alexandre and Jean-Michel Besnier's book *Les robots font-ils l'amour? Le transhumanisme en 12 questions* (2016); researches on near-death experiences and life after death (mediumship, reincarnation, etc.), such as Sam Parnia's books *What Happens When We Die?* (2007) and *Erasing Death: The Science That Is Rewriting the Boundaries Between Life and Death* (2014); Pim van Lommel's *Consciousness*

Beyond Life: The Science of the Near-Death Experience (2010); Chris Carter's *Science and the Near-Death Experience: How Consciousness Survives Death* (2012); Gary Schwartz's *The Afterlife Experiments: Breakthrough Scientific Evidence of Life After Death* (2014); and Leslie Kean's *Surviving Death: A Journalist Investigates Evidence for an Afterlife* (2017), to mention but a few examples.

Although there is much debate about whether literature is part of popular culture (Barry 1995:69–94) or in sharp contrast to it, one has to admit that there are 'popular' literary writings which arouse the interest of the many and which, even though some of them are not completely immersed in popular culture, enter into various aesthetical and thematic dialogues with its concerns and obsessions. The relatively fresh tradition of the popular novels dealing with death and mortality in a quasi-scientific or philosophical manner – established by books such as Jose Saramago's *Death at Intervals* (2005) that imagines and criticizes a world without death – vigorously goes on with, for example, Drew Magary's (2011) anti-anti-ageing novel *The Postmortal* and Frédéric Beigbeder's transhumanist novel *Une vie sans fin* (2018). Of course, one must add to these a plethora of young adult fantasy and romance books with vampires, the Undead, and zombies, such as the renowned novel series *Twilight* by Stephenie Meyers (2005–2008). Moreover, there are popular literary books that attack the very notion used and abused in those popular culture manifestations that emulate psychology or philosophical thinking or have the ambition of offering slices of popular wisdom (e.g., Fauen 2012; Hayasaki 2013; Goranson et al. 2017; Horin 2015): namely, the notion of a meaningful death and a necessary mortality, such as Julian Barnes's *Nothing to be Frightened Of* (2008) or Antonio Tabucchi's *Tristano Dies: A Life* (2015) as there are books that brilliantly succeed in debunking shallow common ideas of grief and bereavement, like Don DeLillo's *Body Artist* (2001), Joan Didion's *The Year of Magical Thinking* (2005), and Patrick Ness' *A Monster Calls* (2015).

The presence of the topic of death not only in visual popular culture, but also within the written popular culture is perhaps an indicator of the fact that death in popular culture is much more than an accidental, adorning, or banal element, that we are witnessing a self-reflective consciousness of popular culture, an impulse (and an invitation as well) to meditate on what death means and on its preoccupation with it.

'Pop-death' matters

This introduction might render visible the huge extent to which death permeates contemporary popular culture. Regardless, it is perhaps still deficient in giving answers to all the questions that this situation could entail. In fact, what makes thanatic themes so desirable in popular culture, and why do they matter? Can we discuss the social and personal benefits of representing and consuming death in popular culture? In what proportion do movies, fiction, and other kinds of popular artistic products participate in constructing death

as a social and cultural reality? Are all the popular culture discourses of death equal from an aesthetic point of view? Is it possible for death to function as an aesthetic asset even when it is strongly indebted to social norms? What about collective attitudes towards death, dying, and immortality; are they influenced by mass media and new media or the other way around? How do myths and stereotypes get along in popular culture and in its various ways of visually or narratively organizing death? Does popular culture encourage the ideologization of death, or, on the contrary, are we witnessing a process of death democratization?

There is no simple, straightforward, or definite answer to all these aspects due to the fact that death has been so profoundly incorporated into popular culture. Nonetheless, it is evident that 'pop-death' matters. And it matters for at least two reasons. First of all, because, beyond any discussion of good or bad, popular culture is both unavoidable and continuously fluctuating. People can certainly select and prefer different parts or channels of popular culture – and this seems valid especially when referring to the entertainment industry. They can be aware of and try to control the influence of popular culture on their lives, but they cannot entirely evade it. Of course, realizing that there is an inevitable impact of popular culture on our life can be helpful, part of a Socratic 'know thyself' rule, as popular culture can 'teach us something about ourselves as we map new meaning onto our own experience based on what we see; it also "teaches" us a lot about "others" in often unconscious ways' (Tisdell and Thompson 2005). Otherwise, as sagaciously observed by Damion Damaske, all these choices are limited, and the will to belong or not to popular culture is not the same as the capacity to freely operate on our cultural reality. Therefore, whilst not watching television and not enjoying movies, music, and videogames, even not being invited to parties, 'you are still embroiled in pop-culture. . . . you stay at home, staring at a blank wall 24/7, then maybe you're not a part of pop-culture. But the moment you eat something, you're bombarded by cereal mascots, fast food slogans, etc. It is just a part of modern life' (Damaske 2011).

Moreover, popular culture fluctuates not only geographically, so that the plural notion popular *cultures* is actually more suitable, but also in the sense that there is no fixed and homogeneous historical meaning for it, being always composed of multiple cultural layers. Through this lens, even the distinction between 'high culture' and 'popular culture' is a matter of convention and a source of conceptual difficulty. If high culture is characterized by a process of selection based on values and principles, this does not mean that any such selection is absent from the intricate process through which popular culture becomes *popular* culture. Often popular culture's selection is continued by high culture's selection – think only of jazz and pop art that appeared as popular phenomena and are now taught in music conservatories and academia – or the other way around: think about books (at times described as 'world literature') that are adapted into films that thus become popular or of ideas from quantum physics disseminated by lots of Hollywood movies. Another

way of saying this is that high culture itself does not come out of nothing but, as Raymond Williams (1974) explained in a classical essay, 'relates, explicitly or implicitly, to wider elements of the society'. In other words, high culture contains particles of popular culture and vice versa. Coming back to the distinction between the two mentioned earlier, there can thus be no clear contrast between them.

Secondly, 'pop-death' matters because of the other main element besides 'popular', which is 'death'. While there are voices that advocate for the positive role of popular culture, sometimes producing an effect of unbalanced interpretation (Johnson 2006), popular culture's manifestations of the topic of death are too often deemed irrelevant or shallow for a sociology of death and dying so that death representations within pop culture are investigated mostly in their capacity to expose people to a death that was previously shaped according to consumerist standards, prepared for offering an enjoyable experience, and encouraging a morbid sensibility. Thereby, there are too few books addressing the topic of death in popular culture. Moreover, many works (articles included) that actually do this tend to focus rather on the thanatic aspects of popular culture (e.g., skulls, skeletons, the Undead/zombies), which are greatly indebted to market-driven strategies, while ignoring others pertaining to the same popular culture, such as artistic productions or aspects that could be candidates for an artistic status such as animations and popular and non-technological mediated manifestations (e.g. contemporary folklore) or the other way around.

However, according to already-established classical philosophical and sociological perspectives, human culture – and not in an elitist sense – is itself deeply shaped by death (Scheler 1952) while, at the same time, it is engaged in an endeavour to continuously construct and deconstruct death (Simmel 1988; Jacobsen 2013). Among other reasons, this happens because, paraphrasing Thomas W. Laquer (2015:1), the living need the dead much more than the dead need the living. This existential, genuine, ontological vein is frequently denied or neglected in regard to popular culture. Instead, themes like deadly violence, encountered for example in slasher movies, or superheroes' power to defy death and minimalize its consequences are privileged (see Durkin 2003; Koslofsky 2019), with a tendency to approach them in order to reveal their potential to be imitated and to counterfeit presumably authentic perceptions and attitudes towards death and dying.

On the contrary, we believe that popular culture should be considered the realm 'where deep cultural trends are crystallised and given clear expression' (Kearl 2017:222). A novel approach to pop-death is needed, an approach that should start both from assuming the complexity of popular culture and from the urgency to understand its ways of making sense of death, going beyond commonsensical and predictable interpretations, by recognizing – from Tony Walter's (2018) suggestion – that perhaps scholars should differentiate between death, dying, and the dead and stop situating them under the same conceptual umbrella. Practically, the idea of a homogenous system of

concepts and a monolithic imaginary of death in popular culture (and maybe not exclusively there) should thus be deconstructed, while the many differences, nuances, and variations should be seized and emphasized, thereby trying to identify where they emanate from – the specific approaches, channels, genres, layers of popular culture – and what their possible social impact is. This way, one could explain, for example, the difference between the role and functions of death in an animated movie like *Lion King* (1994) and a Quentin Tarantino movie, between collective grief as made possible by the pop commemorations of dead celebrities and personal grief as expressed through social media, and the similarities and differences between recent television series that focus on corpses (such as *Frankenstein Chronicles*) and Mary Roach's book on cadavers. Resisting the impulse to apriorically consider pop-death as leading to knowledge and empowerment in relation to death in general or as participating in distorting people's strategies for coping with dying, the inherent ambivalence of pop-death, repeatedly denied, should become a premise for all humanistic and social sciences studies. Furthermore, bringing forth academic discussions about the role of popular culture in both shaping death and being simultaneously shaped by it is very much needed.

About this book

Being aware of the growing importance of approaching popular culture from an academic perspective and steering clear of giving in to either positive or negative biases related to the possibility of popular culture making sense of death, this *Death in Contemporary Popular Culture* volume seeks to explore the numerous diverse ways in which death is tackled by popular culture and to provide, from an interdisciplinary perspective, answers to the critical question: why do the representations of death in popular culture matter? It argues, from a cultural and a sociological perspective, that popular culture, with its great openness and flexibility in terms of content production, is used to negotiate different meanings regarding the eternal problem of death, which lies both in individuals (Heidegger 1927/1962) and in society (Kastenbaum 2007). Also, the collective volume is interested in discussing whether the substantial presence of death in contemporary popular culture might be a symptom of the fact that death is no longer (if it was ever) a taboo as suggested in so many prominent pieces of writing throughout the past century (Gorer 1955; Becker 1973; Ariès 1974) and that perhaps we are no longer (if we were ever) living in a society where, as Jean Baudrillard complained in 1976, 'the dead cease to exist' (Baudrillard 1993). At the same time, while the book is also interested in establishing why popular culture appears to privilege 'spectacular death' (Jacobsen 2016) over other, subtler forms of death representations, the book's chapters, authored by acclaimed international scholars with strong and diverse backgrounds in the social sciences and humanities, suggest that it is quite difficult and perhaps not so efficient to draw a firm line between what is negative and what is positive regarding the many depictions and descriptions of death in popular culture.

The book aims at expanding the methodological, theoretical, and analytical approaches to the study of death in general and in popular culture in particular, and it thus debates the many different and changing facets of death in popular culture, paying attention to the diversity of both death forms (from grief and bereavement to absolute or symbolic immortality) and death meanings (slippery, but always in danger of being monopolized or ideologized) and the often conflictual, paradoxical social features of popular culture – able to reproduce and produce collective attitudes, to function aesthetically and to over-aestheticize, to quench the need for mythical structures either by appealing to tradition or inventing new ones. A truly innovative aspect of this book consists in its capacity to offer various complementary perspectives on why the interest in death has grown significantly in Western societies in recent years and why popular culture has to be carefully studied as a trigger of this interest as well as a reflection of our social constructions of death. It offers new and provocative insights into research on the sociology, anthropology and philosophy of death and dying, but the book could also be of great importance for the research on cultural studies, mass media and new media, and also comparative literature and literary critique.

Considering that an interdisciplinary approach is key to exploring the mechanisms and the social logic of death in popular culture, this book tackles social, cultural, aesthetical, theoretical, and anthropological aspects of the ways in which popular culture understands, represents, interprets, and manages death, gathering contributions on its most prominent fields: television, social media and the internet, pop art, folklore, popular fiction, and advertising. The volume comprises 12 chapters authored by scholars from different countries – Britain, the United States, Denmark, New Zealand, Germany, India, and Romania – organised into three sections: (1) *Collective attitudes towards and responses to death and mortality* (four contributions), (2) *Aesthetical aspects and mythical structures* (four contributions), and (3) *Death as a significant narrative device* (four contributions). The rationale behind this organization of chapters is to focus not on different and seemingly independent fields of popular culture (movies, advertising, etc.), which would have been too predictable and ineffective, but on the very prominent dimensions of popular culture (the collective dimension, the aesthetical and mythical dimension, and the narrative dimension), where death is largely represented, encapsulated, anticipated, reconstructed.

The book's first section, *Collective attitudes towards and responses to death and mortality*, comprises contributions that share the goal of exploring the dynamics of meanings associated with death and mortality in different communities, societies, and contexts, paying attention to their distinctive pop-cultural features: what influences these meanings, how are they evolving, and how are they interpreted by societies and individuals? In Chapter 1, *Michael Hviid Jacobsen* discusses classical and contemporary scholarly attitudes towards perhaps two of the most salient concepts from the academic field of death studies – namely 'death denial' and 'death revival' – in strict connection with the latest transformations of Western contemporary societies that have

impacted on the collective mechanisms of understanding death (e.g., the new mediated visibility of death or its commodification). He offers both a theoretical and an applied contribution, proposing a new concept – 'spectacular death' – that can account for how death is increasingly mass produced. The chapter functions as an alternative introduction to this volume, examining the most prevalent trends in interpreting death in culture and popular culture alike, proposing the different theses of 'trivialization', 'tivoization' and 're-domestication' of death and the surprising difficulties in theorizing this subject. Chapter 2 by *Glenys Caswell* investigates the changes experienced in contemporaneity by the powerful and traditional collective belief – with strong cultural roots – according to which no one should die alone, uncovering the ideological nature that it acquires within British popular culture. The author discusses scenes from a British soap opera and recent texts from the news media contrasting accompanied deaths (seen as good) and deaths happening when the person is alone (seen as bad), insisting on the power of popular culture to shape people's knowledge and attitudes, especially about topics of which the public has rather poor personal experience, such as death, and to impose unrealistic standards of dying. The chapter identifies the risks of ideologizing dying alone in perpetuating perspectives on death that lack subtlety and do not encourage personal agency. In Chapter 3, *Ruth Penfold-Mounce* brings to the forefront the very interesting concept of 'thanatological imagination', derived from C. Wright Mills's concept of 'sociological imagination', and reveals how it can be used in explaining celebrity deaths in a consumerist society and their posthumous careers, which constitute a new beginning for those becoming 'productive deads' – persons who work and make money after their death. The author discusses thoroughly how the thanatological imagination produces a critical engagement with mortality amongst those who are not thanatologists in the academic sense of the word and how it creates a morbid space within popular culture, a space where lyrical approaches to death can be exerted. Chapter 4 by *Ruth McManus, Denise Blake,* and *David Johnston* argues that, through collective memorialization, individuals and communities can respond to their need to find meaning when confronted with death and successfully cope with it, generating both tangible (museum displays, monuments, and publications) and more intangible forms of remembrance. The authors present two New Zealand maritime disasters (1909 and 1968), carefully observing the role played by the media then and now in drawing connections between memorialization and prevention. They argue that the narratives of disaster resilience conveyed by mass media are not always – particularly when based on heroic death – a catalyst for good risk management and disaster prevention.

The book's second section, *Aesthetical aspects and mythical structures*, is constituted by chapters engaged in an endeavour to clarify the means by which death finds in popular culture a proper field for developing aesthetic(al) traits while also investigating some social, ethical, and theoretical consequences of thanatic aestheticization. At the same time, there is an interest in the

mythological elements of popular culture, in conjunction or not with the aesthetical dimension, and the possibility of their structuring thanatic images and even succeeding in mythologizing death itself and to determine attitudes towards dying. In Chapter 5, *Cristina Douglas* reveals how the myth of a terrestrial paradise is adjusted to a secular world, absorbed in the model of bio-medicalized death, and employed by Western popular culture in order to offer the illusion of the immortality of the body or of an experiential immortality (extreme longevity). The chapter brings to light the connections between popular perceptions and representations of death, illness, and nature as sources of healing in contemporary and traditional popular culture and elements such as (neo-)colonial practices and anti-ageing commercial trends from modernity and postmodernity. A lot of sources are discussed, from advertising for naturist remedies to popular books, biblical texts, and medieval cartography. Starting from the observation that 'death as spectacle' is a recurrent motif in a popular culture that otherwise tends to relegate the dead and the dying to hospitals and hospices and then applying theories of the 'aesthetic distancing' effect, *Devaleena Kundu*, in Chapter 6, inquires into the possibilities of the aestheticized death reshaping contemporary popular narratives of the corpses that emerge as objects of desire, and she seeks to establish clearer boundaries between representations of the macabre and gore that advance a 'new sense of beauty' and voyeurism. Recent television shows such as *Six Feet Under*, *Hannibal*, and *The Fall* are analyzed against the background of popular culture. Chapter 7 by *Florina Codreanu* focuses on the ways in which pop art, through famous artists such as Andy Warhol and Banksy, addresses aspects of popular culture taken for granted – in advertising, mass media, capitalism, and democracy – by using images of death (anonymous death, celebrity death, capital punishment, suicide) and suggestions of immortality in their artistic work. The chapter emphasizes the double connection between pop art and popular culture: pop art criticizes popular culture while finding artistic inspiration in it and tacking the real, *popular* world back into art. In Chapter 8, *Martin Bartelmus* argues that within the logic of Quentin Tarantino's movies lies a cultural theory of killing that accounts not only for the narrative, but also for the aesthetic functioning of the killings represented in his cinematographic productions. The chapter reveals how the persistent taboo of 'thou shalt not kill' is constantly transgressed ethically and aesthetically through the use of prominent cultural representations: of laughter (correlated with morality), of law (correlated with power), and of sexual desire. By doing this, the chapter engages in a process of deconstructing the meaning of killing in general, as it is understood by and represented in contemporary popular culture, so that it becomes visible that there might be only cultural born killers.

The last section of the book, *Death as a significant narrative device*, comprises chapters that centre on the manners in which popular culture employs death as a significant narrative device. Both visual and textual narratives are examined, either as thanatic narratives *per se* or as stories where the meaning of death is always continuously negotiated while at the same time being a source

of narrativity, a story generator. In Chapter 9, *E. Moore Quinn* discusses the structures and features of the narratives of noble 'rebel' deaths, ever present in Irish popular music, and the ways in which these were and continue to be disseminated within the public cultural sphere via processes such as heroic and mythical transformation of those who fought and died for Ireland. The chapter considers both the historical and contemporary roles played by these narratives, as complex products of popular culture, in maintaining social ties and a sense of resistance based on praising the dead for their brave deeds and for the ways in which they had approached death – such as dying for a cause and having obtained imagined immortality. Chapter 10 by *Panagiotis Pentaris* addresses a sensitive topic: what and how do children get to know about death by watching animated films? The chapter considers the contemporary contradiction between, on the one hand, the recent cultural precept of protecting children not only from death, grief, and loss, but also from being exposed to them in media, and, on the other, the frequent exposure to death due to its constitutive narrative role in 18 animated films extremely popular in contemporary Western societies, such as *Lion King, Finding Nemo*, and *Coco*. Several types of death are found and discussed in relation to their narrative functioning and cultural meanings – permanent death, reversible death, traumatic or sudden death, conventional death, etc. The chapter also discusses the reasons that animated films are a consistent and challenging part of popular culture and differentiates between their capacity to present death – linked rather to the narrative potential of death – and their capacity to actually explore it. Chapter 11 by *Michael Hviid Jacobsen* and *Nicklas Runge* considers the 'elective affinities' between fiction and sociological commentary, both by theorizing the connection between the two, with all the implications for scholars wanting to go beyond traditional research methodologies, and by analyzing the representations and ideas of death and dying in Don DeLillo's novel *White Noise*, through sociological and death-studies lenses. The chapter shows how the novel succeeds in capturing the ambivalence of the contemporary culture of death and in illustrating the alienation towards death and towards life itself as well. The anxiety generated by the lack of social and personal strategies in the face of death, the commodification and mediatization of death, and the quest for immortality are all approached with a keen eye for sociological detail and with the aim of better understanding, by analyzing the literary narratives of death, the most significant death narratives in contemporary popular culture. In the book's final chapter, *Adriana Teodorescu* examines death and immortality narratives present in the discourse on Twitter of the Islamic State militants and the ways in which they try to interpolate the moral, social, and political values of Western culture. Much attention is paid to the narrative and aesthetic strategies of constructing death used by the Islamic State group with the purpose of reaching a Western audience familiar with the representations of death nurtured by Western popular culture.

All in all, this book brings together a variety of perspectives on how the topics of death and dying are understood, mediated, transmitted, portrayed,

proliferated, distorted, and made meaningful within many different popular cultural contexts and how, in contemporary society, popular culture perhaps means more in our encounters with and comprehension of death than ever before in human history.

References

Aceti, Lanfranco (2015): 'Eternally Present and Eternally Absent: The Cultural Politics of a Thanatophobic Internet and Its Visual Representations of Artificial Existences'. *Mortality*, 20 (4):319–333.

Ariès, Philippe (1974): *Western Attitudes Toward Death from the Middle Ages to the Present*. Baltimore: Johns Hopkins University Press.

Barry, Jonathan (1995): 'Literacy and Literature in Popular Culture: Reading and Writing in Historical Perspective'. In Tim Harris (ed.): *Popular Culture in England, c. 1500–1850*. London: Palgrave.

Baudrillard, Jean (1976/1993): *Symbolic Exchange and Death*. London: Sage Publications.

Becker, Ernest (1973): *The Denial of Death*. New York: Free Press.

Damaske, Damion (2011): 'Why Popular Culture is Actually . . . Cultured'. *Daily Nexus*, University of California, Santa Barbara, October 20.

Durkin, Keith F. (2003): 'Death, Dying and the Dead in Popular Culture'. In Clifton D. Bryant (ed.): *Handbook of Death and Dying: Volume1: The Presence of Death*. Newbury Park, CA: Sage Publications, pp. 43–49.

Fauen, Eva (2012): '10 Terrifying Downsides to Immortality'. *Listverse*, December 12.

Foltyn, Jacque Lynn (2008): 'Dead Famous and Dead Sexy: Popular Culture, Forensics and the Rise of the Corpse'. *Mortality*, 13 (2):153–173.

Goranson, Amelia, Ryan S. Ritter, Adam Waytz, Michael I. Norton and Kurt Gray (2017): 'Dying Is Unexpectedly Positive'. *Psychological Science*, 28 (7):988–999.

Gorer, Geoffrey (1955): 'The Pornography of Death'. *Encounter*, October 16, 49–52.

Hayasaki, Erika (2013): 'Death Is Having a Moment'. *The Atlantic*, October 25. Available online at: www.theatlantic.com/health/archive/2013/10/death-is-having-a-moment/280777/.

Heidegger, Martin (1927/1962): *Being and Time*. Oxford: Blackwell.

Horin, Adela (2015): 'Why Talking About Death Is Good for You'. *Adela Horin Blog*, February 8. Available online at: http://adelehorin.com.au/2015/08/02/why-talking-about-death-is-good-for-you/.

Jacobsen, Michael Hviid (ed.) (2013): *Deconstructing Death: Changing Cultures of Death, Dying, Bereavement and Care in the Nordic Countries*. Odense: University Press of Southern Denmark.

Jacobsen, Michael Hviid (2016): '"Spectacular Death": Proposing a New Fifth Phase to Philippe Ariès's Admirable History of Death'. *Humanities*, 5 (19):1–20.

Johnson, Steven (2006): *Everything Bad is Good for You: How Today's Popular Culture is Actually Making Us Smarter*. New York: Riverhead Books.

Kastenbaum, Robert (2007): *Death, Society and Human Experience*. London: Pearson Education.

Kearl, Michael C. (2017): "The Proliferation of Postselves in American Civic and Popular Cultures". In Michael Hviid Jacobsen (ed.): *Postmortal Society: Towards a Sociology of Immortality*. London: Routledge, pp. 216–233.

Koslofsky, Jonah (2019): '*Logan, Avengers Endgame* and the Death of Superheroes'. *The Spool*, May 14.

Laquer, Thomas W. (2015): *The Work of the Dead: A Cultural History of Mortal Remains*. Princeton: Princeton University Press.

Magary, Drew (2011). *The Postmortal*. London: Penguin Books.

Penfold-Mounce, Ruth (2018): *Death, the Dead and Popular Culture*. Bingley: Emerald Publishing.

Scheler, Max (1952): *Mort et survie*. Paris: Aubier.

Scruton, Roger (2012): 'High Culture is Being Corrupted by a Culture of Fakes'. *The Guardian*, December 19. Available online at: www.theguardian.com/commentisfree/2012/dec/19/high-culture-fake.

Simmel, Georg (1988): *La tragédie de la culture et culture et autres essais*. Paris: Rivages-Poche.

Taylor, Jim (2009): 'Popular Culture: We Are What We Consume – Is Popular Culture Really Popular?'. *Psychology Today*, December 8. Available online at: www.psychologytoday.com/us/blog/the-power-prime/200912/popular-culture-we-are-what-we-consume.

Taylor, Jim (2010): 'Parenting: Take the Offensive Against Popular Culture – Can You Protect Your Kids from Popular Culture?'. *Psychology Today*, October 14. Available online at: www.psychologytoday.com/us/blog/the-power-prime/201010/parenting-take-the-offensive-against-popular-culture.

Tisdell, Elizabeth J. and Patricia M. Thompson (2005): 'The Role of Pop Culture and Entertainment Media in Adult Education Practice'. *Adult Education Research Conference*. Available online at: http://newprairiepress.org/aerc/2005/papers/6.

Walter, Tony (2015): 'Communication Media and the Dead: From the Stone Age to Facebook'. *Mortality*, 20 (3):215–232.

Walter, Tony (2018): 'The Pervasive Dead'. *Mortality*, DOI: 10.1080/13576275.2017.1415317.

Wang, Amy X. and Dan Kopf (2018): 'Pop Music Has Become Obsessed with Death'. *Quartzy*, January 26.

Williams, Raymond (1974): 'On High and Popular Culture'. *The New Republic*, November 22.

Part 1

Collective attitudes towards and responses to death and mortality

1 Thoughts for the times on the death taboo

Trivialization, tivolization, and re-domestication in the age of spectacular death

Michael Hviid Jacobsen

Introduction

For decades, it has been fashionable among social researchers, psychologists, historians, and others with an interest in thanatology to declare death a taboo. The existence of this taboo, it is often suggested, fundamentally mirrors modern society's and modern man's [sic] inability to deal adequately and openly with the fact of the finality of life. Today, however, it seems as if death has, at last, been liberated from the heavy shackles of its previous taboo, denial, and repression. Many studies thus point out that death – alongside sexuality – has now finally come out of the closet in which it was kept and is no longer confined to a shadowy existence. This chapter critically discusses such claims by examining a variety of examples from contemporary culture. Simultaneously, the chapter questions the claim that death was in fact ever a taboo. First, the chapter revisits and recapitulates the arguments of the so-called 'death taboo thesis'. Following this, the chapter turns its attention to the notion of so-called 'spectacular death' and some of its defining features, such as the new mediated visibility of death, the commercialization of death, the re-ritualization of death, the palliative care revolution, and death as academic specialization. Finally, the chapter discusses whether the taboo on death has in fact been lifted or whether it has rather been replaced by a trivialization, tivolization, or re-domestication of death in contemporary society. The purpose of this opening chapter is thus to frame or to set the broader historical, social, and cultural scene for the subsequent chapters more specifically concerned with death in contemporary popular culture.

When one is researching death and dying and in that capacity is thus invited to circulate and proliferate one's knowledge and ideas by participating in debates in the media, publishing research-based outputs, giving public lectures, and interacting and communicating with people who have an academic or private interest in the topic, it happens quite often that one is confronted with the tricky yet almost unavoidable question: is death taboo? From my own personal experience, journalists often seem particularly keen to ask this question as if the clarification of that particular question would lead to

media headlines or breaking news. British sociologist Tony Walter (2014) has reported the same frequently occurring kind of experience with inquisitive journalists keen to boil our culture of death down to 'taboo' or 'not taboo'. At the end of the day, however, we all know that the answer to the question of death as taboo would hardly reach the front pages of the newspapers or the top stories in the news. Social science knowledge in general, and perhaps particularly knowledge about a rather obscure and morbid topic like death, is not and never will be a hot potato. The reason for the suggested trickiness of the question about death as taboo primarily relates to the expectation of the asking person (journalist or not) that a definitive 'yes' or 'no' will eventually be spelled out. The dissatisfaction with any hesitant, ambivalent, or inconclusive answer is sometimes hinted at or even openly expressed and is often accompanied by an ill-concealed suspicion that one does not really know what one is talking about despite being designated a 'death expert'. It seems as if a direct question about the presence or non-presence of a death taboo – or other matters relating to our attitudes towards death and dying – should be readily answered. From my experience, however, this is not the case. Death is indeed difficult to communicate meaningfully about, especially in sensation-seeking media settings allowing only for quick one-liners or either-or answers. A telling story of this fact was once reported by death scholar Michael A. Simpson, who took part in a televised debate about the topic of death in the mid-1970s with the presence of a sociologist, a priest, and a surgeon. He recalled this following incident:

> I turned to the Sociologist first: You've spent the last five years in research on our national attitudes to death, could you tell us some of your findings?' 'We're scared of it', he said. There was an awkward pause. 'Are there any differences between men and women, or young and old?' I tried. 'No', he said, 'we're all scared of it'. He sat back looking profoundly satisfied. The next pause was more awkward and fast becoming ugly. He made one final comment. 'I think it all starts when we're three, and stand at the toilet watching everything disappear down the drain'.
>
> Simpson 1978–1979:94

Surely also other scholars working with death and dying who are asked to provide the public with their findings, and perhaps particularly those with a social science background who are asked about either hard facts or professional interpretations, will find at least something recognizable in this description: the fact that just because one intensively studies an exotic topic such as death as an object of scientific and intellectual curiosity, one cannot always provide hardcore data or clear-cut answers or reveal the deepest of secrets or the most insightful understandings of that which is studied. The human experience of death is simply too complex and too difficult to boil down to all-clarifying and definitive one-liners.

Thus, the reason it is extremely difficult to obtain an adequate answer to such an otherwise-relevant question about the existence of a death taboo

from a death researcher has to do with the deep-seated complexity of such a question. It almost unavoidably opens up a torrent of related questions such as "Has death always/ever been a taboo? How is it a taboo? Why is it a taboo? Should death be a taboo? and What can we do to break the taboo on death?" It is thus my contention that the discussion about death as taboo is almost as impossible to decide definitively as it is to authoritatively determine if something tastes good or bad, if men are smarter than women, or if life was better in the old days. It is, after all, a matter of perspective, contention, and personal judgement (depending on who you ask in which social and cultural context and with not least depending on what one means by the concept of 'taboo' on death in the first place).

In our society, it seems as if the notion of 'taboo' is being used and abused for anything exotic that we not only don't want to avoid but also seem to revel in, almost as if the taboo is nowadays synonymous with = the strange, the deviant, the dangerous, and the immensely interesting. Scanning media stories using the notion of 'taboo' in recent article headings, one will, for instance, come across how today it is seemingly taboo to allow hair to grow on intimate parts of the body, how one's personal income is taboo, how loneliness among young people is taboo, how sexual fantasies are taboo, how men who cry are taboo, and so on. It is obvious that the concept of taboo is far reaching and covers quite a broad range of phenomena and experiences related to these. This obviously makes it even more difficult to answer the question of 'death as taboo' in any qualified and meaningful manner.

In this chapter, we will venture into a delineation and discussion of the status of death in our 'postmodern', 'late-modern', 'liquid-modern', 'second-modern', or 'hypermodern' society. (The sociological epithets invented to capture the present phase of social development are as many as they are abstract.) The chapter does not aspire to provide any in-depth or comprehensive account of death or on the taboo on death, but rather to provide a commentary on some of the social and cultural changes that seem to accompany the way we talk about and understand death and dying in contemporary society.

Death as modern taboo

Reading through a lot of the published research on our attitudes towards death and dying in modern Western society from the early 20th century onwards, one is almost immediately convinced that death for quite some time has remained a taboo topic. One will find ample illustrations and proclamations that death is hidden, forbidden, suppressed, sequestered, and moved to the margins of society. Death is also medicalized, institutionalized, and professionalized. Death is not something we talk about, witness directly, or want to spend our living hours contemplating or planning. We want, as French historian Philippe Ariès (1974a:106) would have it, to live happy lives and as if we were ultimately immortal. For all practical intents and purposes, it seems

that death is tabooed. But what does it actually mean that death is taboo? The concept of 'taboo' has a long history, dating back to the voyages of Captain James Cook and his acquaintance with Polynesian culture on the island of Tonga in 1777. Relying on his observations, the notion of taboo (in Tongan, *tapu*) has been used to describe those forbidden objects, places, or topics that, for example due to their sacredness, dangerousness or uncleanliness, were regarded off-limits for ordinary people, being primarily the domain of chieftains, witch doctors, shamans, priests, or other initiated groups. Taboo thus spells out prohibition, restriction, and isolation – tabooed topics are no-go areas (see Steiner 1967).

Within academic circles, the notion of 'taboo' was first embraced and used by psychoanalysts and anthropologists trying to understand different cultural and/or sexual practices that were deemed dangerous or forbidden. For example, Sigmund Freud was one of the first specifically and systematically to investigate the notion of taboo. In his book *Totem and Taboo* (1913), Freud concerned himself with cultural taboos in relation to religion, totemism, animism, and incest and the continued impact of primitive societies on modern society. In the later essay 'Thoughts for the Times on War and Death' (1915), published during the early months of World War I, Freud elaborated more specifically on taboo in regard to death in modern society. His view was that death in general – and not least the horror associated with the mass death of war – was an incomprehensible phenomenon to people because individuals maintain some sort of unconscious sense of immortality, thus not believing in either the reality or the inevitability of their own deaths. Also, elsewhere in Freud's writings, the topic of death taboo appears either directly or indirectly in relation to notions of 'castration anxiety', 'death instinct', and the 'uncanny'. In the wake of the writings of Freud and other early psychologists and psychoanalysts, it became increasingly commonplace throughout the 20th century to uncritically declare death a modern taboo (Feifel 1959; Farberow 1963; Gifford 1971).

Psychologists and anthropologists, however, were not the only ones concerned with our changing attitude towards death in modern society. Before the rise of the academic niche or sub-discipline known as 'Death Studies', the aforementioned Philippe Ariès was one of the first key intellectual figures to draw attention to the study of death as a topic in its own right, deserving of in-depth empirical study. (Obviously, we must not forget classical sociological works such as Émile Durkheim's famous study of suicide from 1897, Robert Hertz's *Death and the Right Hand* from 1907, and other of the more psychologically informed pieces of work to which we return later). In several formidable pieces of historical work published from the early 1970s to the mid-1980s, Ariès showed with a great sense of systematic overview as well as of incredible detail how our so-called 'death mentality' had changed in the Western world from the Middle Ages to the present modern society (Ariès 1974a, 1981a, 1985). Ariès – although not systematically employing the specific notion of 'death taboo' – is today perhaps still the most quoted scholar in

'Death Studies', despite the fact that his work has also been heavily criticized for, for example, being excessively normative, relying on a unilinear model of change, making sweeping generalizations, and at times lacking substantial empirical foundation. His general thesis was that our cultural understanding and handling of death and dying (and also of immortality) does not stand still but changes – however slowly – over time. In his work, Ariès outlined four so-called 'death mentalities' or 'death phases' that gradually over a thousand years gave way to one another: 'tamed death' (covering the high Middle Ages and late Middle Ages), 'death of the self/death of one's own' (approximately covering the Renaissance and Enlightenment periods of European history), 'death of the other/thy death' (the 19th century or the 'Victorian Age'), and 'forbidden death' (the 20th century). It was his contention – which is relevant to this chapter – that our death mentality at the threshold of the 20th century began to change quite drastically from that of earlier times. Even though he already saw a 'turning of the tide' between the phases of 'death of the self/death of one's own' and its familiarity with death and the increasing alienation associated with the phases of 'death of the other/thy death', it was nevertheless particularly during the 20th century's 'forbidden death' that our discomfort with and distance towards death and dying decidedly began to set in. Death, previously a tamed and natural occurrence in communal and everyday life, had now become something alien, incomprehensible, and 'wild'. In Ariès's own aptly chosen words:

> In a world of change the traditional attitude toward death appears inert and static. The old attitude in which death was both familiar and near, evoking no great fear or awe, offers too marked a contrast to ours, where death is so frightful that we dare not utter its name. This is why I have called this household sort of death 'tamed death'. I do not mean that death had once been wild and that it has ceased to be so. I mean, on the contrary, that today it has become wild.
>
> Ariès 1974a:13–14

As mentioned, although Ariès's work was indeed ground-breaking with its deep insight, sweeping scope, and general appeal, he was neither the first nor the last to declare death a problem for modern society, and many others – well before Ariès – had also prominently proclaimed 'the dying of death', 'the decline of mourning', and the 'passing of the world of the dead' as a trademark of this development in modern death mentality from the late 19th to the early 20th century (see, e.g., Jacobs 1899; Jackson 1977; Wolfram 1966).

An important feature of Ariès's analysis of the transformation of death mentality from traditional to modern society was his insistence that death had increasingly become a medical specialty rather than a clerical or religious concern and how death, previously handled by the family and local community members, now became a task performed by professionals in hermetically closed hospital settings. Ariès claimed that the handling of the hospitalized

death – now more technical than ritual – in many ways deprived the dying of the autonomy and dignity previously associated with the traditional death bed scene:

> Death in the hospital is no longer the occasion of a ritual ceremony, over which the dying person presides amidst his assembled relatives and friends. Death is a technical phenomenon obtained by the cessation of care. . . . Death has been dissected, cut to bits by a series of little steps, which finally makes it impossible to know which step was the real death.
>
> Ariès 1974a:88

Even before Ariès wrote about it, this view of the dying being deprived of their deaths described from a historical perspective was substantiated by the two American sociologists Barney G. Glaser and Anselm L. Strauss (1965), who through extensive qualitative work discovered how different 'awareness contexts' (and especially those that in one way or another kept the dying person in the dark about his or her imminent death) characterized modern hospitalized dying. According to their studies (leading up to the later development of the 'grounded theory methodology') – which were conducted well before notions of the 'happy death movement', 'dying with dignity', 'patient-centred nursing', 'palliative care', or similar humanistic notions became popular – many patients would end up dying in 'closed', 'suspicious', or 'mutual pretence' awareness contexts, leaving them little if any room to prepare for or reconcile themselves with death. A few years later, another American sociologist, David Sudnow (1967), also came up with the conclusion based on intensive field-work that the dying were often treated by healthcare personnel as 'socially dead' whilst physically alive. The ancient art of dying had been transformed into a charade of concealing death to those who perhaps needed the most to be in the know. Moreover, besides making it easier for professionals to 'police' death and dying by transferring them to medically controlled settings (Prior 1989), this development also meant that the very discourse on death became permeated by a medio-legal terminology that largely made references to other types of understanding irrelevant to treatment and care. In such a context, death is defined as 'failure' (Ariès 1981b:113), and it thus reveals the very 'scandal of reason' (Bauman 1992b:15).

It was also in the middle of the 20th century that the famous 'death as pornography' thesis was proposed by English anthropologist and writer Geoffrey Gorer. It was his claim that death had become shrouded in prudery and that death was now such an unspeakable topic that it made sense to suggest that death had replaced sex as the most persistent taboo of modern Western society (Gorer 1955). Gorer also claimed that the media served as an outlet for the cultural banishment and repression of death by insisting that 'while natural death became more and more smothered in prudery, violent death has played an ever growing part in the fantasies offered to mass audiences' (Gorer 1955:51). Later, many other theories also proclaimed that modern man [sic]

found it increasingly difficult to live with and recognize the prospect of death. For example, within the so-called 'terror management theory' (TMT), it has been proposed – following the seminal work of cultural anthropologist Ernest Becker (1973/1997) – that human beings are biologically predisposed to seek to avoid death/annihilation and that they thus 'strive to transcend death by adhering to *cultural worldviews* that provide them with hopes for symbolic and sometimes literal immortality' (Lifshin, Helm, and Greenberg 2017:79). It was Becker's own contention – to be taken up and tested in numerous studies and experiments by TMT – that society/culture is a symbolic contraption intended to keep the awareness of and experience with death at bay and that humans act on their survival instincts in order to maintain their sense of immortal reality. Becker also pointed out how the so-called traditional 'hero-systems' of religion and mythology no longer provide meaning vis-à-vis death and that modern society thus instead relies on reason and science-based explanations that, however, are found not to be comforting. In general, theories building on psychoanalytic ideas have tended to regard death as a problem particularly to modern rational-oriented civilization, because death seems to escape our cognitive capacities and thus necessarily is suppressed and denied with a whole range of detrimental social and human consequences in its wake (see Feifel 1959; Sobo 1999; Zilboorg 1943). Psychiatrists such as Elisabeth Kübler-Ross (1969) and philosophers such as Jacques Choron (1972) have also supported the view that death is denied and tabooed in modern Western society, making it difficult for individuals in general and perhaps professionals in particular to create meaning or make sense whenever confronted with their own inescapable mortality or the death of others. (For a critique of some of these denial theories, see Killilea 1980–1981.)

More recently, besides their contributions to general social theory, a number of prominent sociologists have also written specifically about the changing role of death in contemporary society. For instance, key social thinkers such as Norbert Elias (1985/2001), Anthony Giddens (1991), and Zygmunt Bauman (1992a) have all, each in their own way, claimed that death – and especially our first-hand experiences with death – have become increasingly problematic in modern society, because death is now seen as an annoyingly stubborn reminder of the unassailable illusion of human control over nature, of the defeat of modern medicine and technology, and of the ultimate futility of human life (which, according to Elias, in turn makes us abandon the dying to lonely deaths). Moreover, in a post-traditional world in which identity is increasingly chosen and life trajectories are planned, death threatens our biographical life projects and the reflexive re-ordering of self-identity as well as proving all our hopeful investments in bodily immortality – anti-ageing crèmes, fitness exercises, healthy diets, and cosmetic surgeries – in vain. Instead of fighting 'death as such' – the great unknown and unknowable – we thus instead ceaselessly try to fight and win all the battles against the many different 'causes of death', as Bauman (1992b:5–7) so convincingly has suggested. Consequently, people are lured into believing that if they only stop

smoking, if they refrain from eating unhealthy and fatty food, if they exercise enough, and if they look after their bodies, then they will be able to defeat most of the causes of death and ultimately postpone death and thus outlive all the self-blameable others who drank more alcohol than advised by the chief medical officers, who relaxed on the sofa rather than running that extra mile or going on that treadmill, or who chose, despite multiple warnings, to eat that juicy steak instead of the tofu alternative. However, since no battle against death is winnable in the long run, and since there is for all practical intents and purposes no available cure or prophylaxis for 'death itself', death can only be sequestrated and moved to the margins of society, where the expert system of modern medicine has made death part of an endless treatment regime (see Mellor and Shilling 1993). As Jane Littlewood (1992) has shown, due to this modern medicalization of death and dying, death and death-related rituals have been gradually removed from communal life, which previously – in the times before 'forbidden death' – provided death with some sort of cultural and individual meaning.

As should be obvious from the foregoing selective and thus by no means exhaustive review of literature, during the latter part of the 20th century, within the social sciences and humanities, scholars virtually stumbled over each other in order to declare the taboo on or denial of death in modern society. Due to the apparent enormity of the 'evidence' provided supporting the taboo and denial theses, today it has almost become a truism and a trivial thing to state that death is taboo. Four decades ago, this situation had already made French historian Michelle Vovelle, who also wrote incisively of death, muse that 'the taboo on death is the latest fashion and everyone believes he has invented it' (Vovelle 1980:90). Almost at the same time – at the heights of the 'death taboo thesis' – in a bibliography of literature on death, dying, and grief, Michael A. Simpson sarcastically remarked that '[d]eath is a very badly kept secret; such an unmentionable topic that there are over 650 books now in print asserting that we are ignoring the subject' (Simpson quoted in Walter 1991:294). And please keep in mind that this observation was made almost 40 years ago and that the heaps of literature on death, dying, and taboo have grown significantly since then.

In the wake of these many proclamations and declarations of death taboo and death denial, several scholars have discussed the viability and validity of the taboo or denial theses (see, e.g., Kellehear 1984; Robert and Tradii 2017; Tradii and Robert 2017; Zimmerman and Rodin 2004). Most of these scholars end up concluding that death does not, at least any longer, really qualify as a tabooed and denied topic and that there are many signs around that we have left denial and taboo behind. A really important and much-needed critical sociological contribution to this discussion about the death taboo was advanced by Tony Walter (1991) quite some time ago. In his view, 'if it came to a vote, the tabooists would probably win handsomely' (Walter 1991:293). He thus went a long way to show how the seemingly self-explanatory notion of 'death taboo' needed to be rearranged and deconstructed if we are to

understand what is meant – or what *can* be meant – when we claim that death is taboo in contemporary society. Walter differentiated between six types of taboo on death (depending on the range and character of the proposed taboo) that each in its way challenges and problematizes the common-sense view that death *is* and *continues to be* taboo.

As this admittedly non-systematic review of some of the most important pieces of research literature on death and dying from the past century has shown, it seems almost indisputable and is generally agreed among many authoritative voices in academic writings on death that death is, or at least over the past century has developed into, a taboo topic. In the following, we shall try to provide some ideas and examples that may challenge this view.

The reversal and partial re-reversal of death

Death does not stand still. Obviously, death as a biological fact of life always and universally remains the same (the brutal yet incontrovertible fact that we must all and will all die – indiscriminate of ethnic background, gender, age, social class, weight, and other collective or individual traits), but the ways we as individuals and societies understand, deal with, and ascribe meaning to death differ and change quite considerably across history and culture. We may say that death continuously finds itself in a process of a meaningful construction and deconstruction (Jacobsen 2013). It does indeed seem as if our conception of and approach to death has changed since the times of Gorer, Feifel, Kübler-Ross, Choron, Ariès, and others writing during and about the period of 'forbidden death'. Obviously, our conception of or approach to death does not change overnight. As Ariès (1974a:1) insisted, death mentalities necessarily need to be studied diachronically (over the long term) and not only synchronically as isolated snapshots are what count if we are to appreciate historical continuities and changes; hence his rich and detailed historical evidence drawn from across many centuries.

In his work, Ariès also specifically suggested that our attitude towards death had been profoundly reversed during the extended period from the Middle Ages to modern society – from 'tamed death' to 'forbidden death'. According to him, this reversal process – described as 'unprecedented' and 'bewildering' (Ariès 1974b:538) – was particularly evident in three overall tendencies (we need to remember that he wrote about this in the early 1970s): (1) the dying is deprived/dispossessed of his/her death, (2) the denial of mourning, and (3) the invention of new funerary rites (particularly in the United States). Regarding the first reversal point, Ariès spoke of the silence and secrecy surrounding modern death as compared to the traditional death in which the dying could – and was expected to – prepare for death, often described as an elaborate deathbed scene in which the dying communicated with those present. But nowadays, 'nothing remains of the sense that everyone has or should have of his impending death, or of the public solemnity surrounding the moment of death. What used to be appreciated is now hidden; what used to be solemn is

now avoided' (Ariès 1974b:540). Regarding the second reversal point, Ariès noted that traditional and elaborate mourning rituals have been dismantled and how public expressions of grief have been made inappropriate and embarrassing: 'society forbids the living to appear moved by the deaths of others, it does not allow them either to weep for the deceased or to seem to miss them' (Ariès 1974b:545). Finally, regarding the third reversal point, Ariès observed how the – at that time – newly invented American ways of orchestrating the funeral ceremony seemed more commercial than ritual, leaving the participants with the impression that the embalmed body (no longer laid out in the home but now in the funeral parlour) was not really dead but merely sleeping. In this way, real physical death is symbolically denied through an elaborate 'series of complicated and sumptuous rites' that all contribute to 'the denial of the absolute finality of death and the repugnance of physical destruction without ritual and solemnity' (Ariès 1974b:556). In addition to this more romanticized practice, and especially in many Northern-European countries, the success of the cremation movement throughout the 20th century has meant that the more elaborate and extensive mortuary rituals associated with the conventional burial ceremony have been gradually replaced with less time-consuming, ritually more minimalistic, and seemingly less frightening ways of disposing of the dead body (see also Laqueur 2015).

Today, or at least over the decades since the mid-1970s when Ariès declared death forbidden, something new is happening and has been for quite some time within the realm of death. Paradoxically, modern 'forbidden death', which – as mentioned – marked a reversal of 'tamed death', is perhaps itself now slowly being re-reversed (Jacobsen 2016). Consequently, we may start to talk about a 'partial re-reversal' of death mentality from 'forbidden death', as Ariès would have it, to something new. This 'something new' is perhaps best understood as a hybrid between 'forbidden death' and a 'revived death' with its combined 'late-modern' and 'postmodern' tendencies (Walter 1994). Hence the notion of 'partial' re-reversal – as death does not really seem to be entirely revived yet. It does makes one speculate, as Michel Foucault (1978) did about the changing status of sexuality in modern society, if death – just as sex – was in fact ever repressed and tabooed and then supposedly liberated in the so-called 'sexual revolution' of the late 1960s or if death – just as sexuality – is continuously being circumscribed by and interwoven in the discourses (religious, secular, everyday) that in different ways try to make death meaningful and manageable.

Elsewhere I have argued that we may perhaps denote this apparently new phase of death mentality 'spectacular death' (Jacobsen 2016), as death today seems to be a spectacle that we witness at a safe distance without ever getting really close to or becoming familiar with it. In this way, we still – as in the days of 'forbidden death' – have some sort of externalized relationship to death and do not allow it to become a natural and expectable occurrence in life. There are many different – at times mutually supportive, at other times opposed – social motors behind the gradual appearance of 'spectacular death'

that each in their way have transformed death from a forbidden and hidden topic to something that is today more openly discussed and publicly displayed and commemorated as well as politically and professionally debated. Some of the most significant social motors driving 'spectacular death' forward have been (1) *the new mediated/mediatized visibility of death*, (2) *the commercialization of death*, (3) *the re-ritualization of death*, (4) *the palliative care revolution*, and finally (5) *death as a topic of academic attention and specialization*. This is neither the time nor the place to go into great detail on each of these – in and by themselves significant and quite comprehensive – developments (see instead Jacobsen 2016), but we will illustrate some of them later in the chapter, and their impact on the realm of death is readily observable to most. Even though there are indeed some aspects of 'spectacular death' that link it to the more traditional forms of dying and grieving as outlined by Ariès, it is highly unlikely that 'tame death' can be revived. As Seamus O'Mahony rightly contended in his book *The Way We Die Now*: 'In Europe, the process of secularization has advanced so far that we will never see a return to Philippe Ariès's "tame death"' (O'Mahony 2016:60). So the 'partial re-reversal' thesis proposed here proposes that, while we have not returned (and probably cannot return) to any medieval 'taming of death', as Ariès outlined, we have within the past few decades started to reconsider and renegotiate our relationship with death – for better and for worse.

The trivialization of death

One can vividly imagine that in the days when Geoffrey Gorer spoke of the 'pornography of death' and Philippe Ariès wrote of 'forbidden death', any untoward mentioning of death, dying, or incurable disease would have been regarded as a social offence: it had to be whispered, kept as far away from children as possible, and only be made if it was entirely impossible to avoid the issue altogether. Death, it seems, was not a suitable topic of polite conversation. Since I was not alive at that time (being born in the early 1970s), I am unable to say if this was actually the case, and even though the historical testimonies of our not-so-distant ancestors are indeed reported in numerous pieces of published research from that period (e.g. that of Gorer and Ariès), and not least can be found in the diaries and fiction of that time, any kind of more detailed and representative data informing us about how death was actually talked about, understood, and socially and culturally sanctioned is in fact pretty hard to come by.

One way of trying to detect a reason why death was apparently not talked about and was also socially marginalized and sequestrated – as indicated by the taboo thesis – could be to suggest that death throughout the latter part of the 20th century became increasingly trivialized. Two long, drawn-out world wars with millions of human casualties undoubtedly affected the interest in talking about or dealing with death – it was simply too overwhelming. Moreover, all the talk about death as taboo may, in itself, have killed off any residual

inclination to engage with the topic. If we thus continue along the previously mentioned parallel drawn between sexuality and death as suggested by Gorer (and many others), we may claim that the topic of death underwent the same kind of exhaustion of energy as Volkmar Sigusch (1998) described within the realm of sexuality in the 1990s in the aftermath of the AIDS epidemics. Whereas the 'sexual revolution' of the 1960s and 1970s, through a positive discourse, had sought to liberate sexuality and pornography from their shackles of normative and legislative constraint by playing on their association with pleasure, freedom, happiness, and sexual self-realization, the 'neo-sexual revolution' of the 1980s and 1990s instead, through a negative discourse, equated sex with deadly disease, prohibitive moralization ('safe sex'), as well as harassment and abuse agendas. Moreover, in the age of 'hypersexuality' (Kammeyer 2008) with the almost-instantaneous availability of sexual material (through videos, internet tubes, and so on) to everyone everywhere, sex and porn as part of the spreading culture of consumption became increasingly banalized and trivialized. Perhaps this tendency also pertains to death? After decades of denial and taboo, we gradually began to take an interest in and to talk about death again, but perhaps we did not really have anything interesting to say? Perhaps the taboo was simply transformed into the trivial?

We can particularly witness this proposed trivialization of death through the thoroughly standardized, ritualized, repetitious, and routinized ways of depicting and reporting about death and dying in the media and on social media. Stories about celebrity deaths, terrorist attacks, spectacular murder cases, natural disasters, famines, accidents, and other tragedies resulting in the loss of life use almost the same template or script: shock, surprise, finding the guilty culprit, talking to survivors or the bereaved, attending public mourning ceremonies, inquisitively covering court cases, making a movie about the event, annually re-remembering the tragedy with new stories and new testimonies, and so on. Death is also trivialized by the 'empathetic' politicians on primetime television expressing their 'deepest sympathy' with the bereaved relatives of victims of terrorism or accidents or by the reporting journalists from the hotspots around the world who, in staged postures and with the right facial folds, inform us about unimaginable horrors, human casualties, unmatched heroism, and the like. The consequence of these seemingly staged and rehearsed displays of compassion and concern is that actual death is increasingly trivialized, depersonalized and made into a media spectacle. As recently proposed by Anthony Elliott:

> Perhaps it is not so much that death is unmentionable today, but rather that there is a never-ending discourse on trivialized death. Death is 'on show' everywhere – it is the spectacle of our information age – and yet it functions as spectacle only to the extent that the proper distance is maintained. This is the distance of generalization, of repetition, and of objectivity, all of which are crucial to the trivialization of death.
>
> Elliott 2018:117

In a similar vein, Stjepan G. Meštrović, in his book *Postemotional Society*, claimed that 'death has been made ordinary, pedestrian, the stuff of everyday experience devoid of the rituals and collective effervescence that used to keep it sacred' (Meštrović 1997:128). If death and dying today are regarded as such pedestrian and trivialized topics – something we have become so accustomed to or too tired of discussing in any serious or genuinely interested kind of way – then the strength of the death taboo is perhaps not as tenacious as otherwise suggested. Perhaps we have simply talked the topic of death to death?

The tivolization of death

The aforementioned suggestion that we are now witnessing a new phase of death mentality in the West – extending and/or substituting Ariès's notion of 'forbidden death' – which could be called 'spectacular death' (Jacobsen 2016), has perhaps not yet persuaded a larger academic audience (for a recent exception, see Stone 2018). However, the success or shelf-life of any labels or descriptive terms is notoriously unpredictable. Within sociology, some notions and concepts seem to stick and attract the attention of colleagues in a wide range of incisive analyses of society. For example, just think of George Ritzer's (1993) famous thesis of 'McDonaldization' – insisting that many parts of modern social life imitate organizing features from fast-food restaurants – which was coined a quarter of a century ago and which has since been used in numerous studies. Later, the notion of 'Disneyization' was proposed by Alan Bryman (2004), who relied on but also extended the idea of McDonaldization and used it to show how many activities of contemporary life draw on the principles from the famous theme park. In the context of studying death and dying in contemporary society, McDonaldization and Disneyization are also useful concepts, and Ritzer actually utilized the notion of McDonaldization specifically to describe changes in the American funeral industry. However, one might also suggest a new terminology to capture some central features of our contemporary death culture – that of 'tivolization'. But what is meant by the notion of 'tivolization' here? Tivolization – a notion used more in Danish (the home of the Tivoli Gardens in Copenhagen) than in English language contexts – means that the otherwise inconspicuous normality of certain events or themes is transformed or even exaggerated into a playful, carnivalesque, commercialized, entertainment-based, self-propelling, unserious, and often rather superficial kind of spectacle. In the following, we shall briefly review four selected aspects of tivolization (not all that different from the five aforementioned dimensions of 'spectacular death') that each in its way point out that death today is indeed a hot topic.

First, what could be simply called *the new visibility of death*, testifying to the fact that death is no longer silenced or hidden from sight (although perhaps 'actual death' is more so than ever before). As Benjamin Noys noted, 'in modern culture death is not simply invisible or taboo but bound up with new structures that expose us to death' (Noys 2005:3). There are, for

example, the Bodyworld exhibitions of dead plastinated bodies touring the world and attracting huge audiences. Death is also used as a sellable provocation in advertising strategies such as the use of skulls in clothing brands and the fashion industry (Kearl 2015); death is frequently alluded to or directly depicted in art exhibitions and decadent art (just think of Damian Hirst's *For the Love of God* diamond-plated cranium); fictitious death is being constantly watched, played, and executed in movies and computer games; death is part and parcel of contemporary popular culture (McIlwain 2005); funeral companies advertise their services in commercial breaks on television; death is ceaselessly talked about by commentators, celebrities, politicians, and everybody else on the news, on talk shows, and so on (see also Macho and Marek 2007). As observed by Tony Walter: 'Death sells newspapers, books, movies, by the bucket load; far from marginal, it is integral to the capitalist economy of western media' (Walter 2017:12). Another less indirect way of getting close to death is through what is called 'dark tourism', where tourists, adventurers, and other daredevils pay generously in order to visit the gory places of actual death (murder sites, the locations of terrorist attacks, or war zones) or engage in neck-breaking activities just in order to experience death vicariously and voluntarily without risking actual death. It seems as if our incessant curiosity and boredom draws us to the dark corners of life and becomes some kind of existential 'edgework' (Lyng 1990) in a period of history in which we live more prosperously and securely than ever before. It appears that the inventiveness when it comes to using death for commercial or entertainment purposes is limitless. When death becomes such a tivolicized spectacle, we tend to forget that it is real – something that really happens to real people. The spectacle of death is often observed at a safe distance from actual events or for the purpose of satisfying one's insatiable appetite for excitement and entertainment. Watching Western journalists being decapitated by terrorists on television, dead bodies of children from refugee boats washed up on the beaches of holiday resorts, the brutal murder videos of two Scandinavian back-packer tourists in Morocco recently distributed and shared on YouTube, or similar extremely violent images makes us think that these events perhaps did not really take place but were staged and performed merely in order to entertain or provoke. Just as Jean Baudrillard (1995) once mused that 'the Gulf war did not take place', so we seem to think that these horrendous spectacles of actual human death are not really real. We are seduced into believing that what we witness or hear about through the media representation of death, war, and suffering (with their recycling of empathy-imitating one-liners, clinical military jargon, or cosy sofa talk about death and old age anxiety with celebrities) is just a simulacrum that did not really happen to real people. One consequence of the incessant and morbid fascination with spectacular death in the media is that we tend to become desensitized to the suffering of others because people stop thinking about death as an actual – and most often to most people – very unspectacular and normal thing that does not produce headlines or widespread memorialization.

Second, *the new memorialization and ritualization of death and grief* show our still-deep-seated need for rituals, ceremonies, and celebrations whenever death strikes. Erika Doss (2010) captured this need by the memorable notion of 'memorial mania' – that we erect physical memorials or engage in memorializing activities in order to make sense of often traumatic events in our individual or collective lives. For example, sports matches are often initiated with a minute of silence or applause to mark the death of long-since-retired players or people who died in events that had no relation whatsoever to the game in question. Similarly, players wear black armbands in order to show their respect for the deceased and bereaved. More mundanely, so-called 'spontaneous memorialization', which was previously a relatively rare phenomenon, has now become custom whenever someone dies in public and especially if the circumstances of death were regarded as violent or tragic (fatal traffic accidents, homicide, or terrorist attacks) or if the person in question was a celebrity or public person (as in the cases of Princess Diana, Michael Jackson, Prince, and David Bowie). There are many common features across these 'roadside memorials' or 'spontaneous shrines', such as an inclusive community of mourners, a motley collection and bricolage of religious and secular items deemed personally significant for the mourners (flowers, candles, handwritten notes, memorabilia, etc.), the public expression of moral or political statements by mourners angered by the circumstances of death, and the site of death (not of burial) being made into the site of collective and individual memory (see, e.g., Haney, Leimer, and Lowery 1997). In general, the recent civic and commercial ingenuity when it comes to drawing attention to death through different forms of memorialization and ritualization and increasing awareness is quite breath-taking: 'death cafés', 'memorial walks', 'death awareness weeks', 'dining with death' events, supplying 'angel kits' for the bereaved, and so on (see, e.g., Fong 2017). Death is now something that we apparently must have an open debate about, and we are invited to participate in such conversations through the depiction of death and dying in many popular movies and novels. Just think of box-office successes such as *Meet Joe Black* or *The Bucket List* or bestselling books such as *Death at Intervals* by José Saramago or *Being Mortal* by Atul Gawande, now available as 'airport literature'. In addition to this, many autobiographical accounts of experiences with death, dying, and grief, written by ordinary people or public figures, have become highly publicized and continue to attract a large reading audience.

Third, *the new carnival of grief* can also be seen as a sign of tivolization. Not only has death become spectacular, so also has its loyal companion of grief in a manner that is historically quite unprecedented. As compared to the silenced and suppressed grief at the time of Gorer or Ariès, there are nowadays so many experts on grief around (psychologists, doctors, sociologists, psychiatrists, spiritual advisers, etc.), so many (often opposing) theories, research findings, and treatment options available, that the sheer polyphony of perspectives is destined to create widespread confusion. Today, grief has become a topic of intense professional interest, and there is an ongoing trench war

going on about the right to define and to intervene in processes of grief. In recent years, we have witnessed the increasing monopolization of the realm of grief, particularly by the medical and psychiatric professions, with the soon-to-be-implemented ICD diagnosis of 'complicated' or 'prolonged' grief (see, e.g., Jacobsen and Petersen 2018, 2019). It is quite possible that, within a few years, we will also see the invention of the more general treatment-requiring category of 'grief disorder', adding to the plethora of problematic instances of the otherwise normal human emotion of grief.

Fourth, *the new professionalization and specialization of death*: whereas death on the doorstep to modernity was professionalized as part of an advancing medical regime (which gradually took over the leading role of religion in dealing with death and dying), today, the aforementioned 'palliative care revolution' means that there are now new strong players on the pitch. Palliative medicine, palliative care practice, and the hospice movement have fundamentally altered the way we view, understand, handle, and relate to death and dying. These fields have contributed to the development of a much more holistic approach to death but also to new types of specialization. Today, dying is a process recognized as starting (and often diagnosed) much earlier than was the case just a century ago and involving many different professional groups such as doctors, nurses, priests, music therapists, psychologists, social workers, dieticians, physiotherapists, volunteers, funeral directors, etc. In this way, treatment and care is now a bigger part of death than ever before in human history. This expanding professionalization and specialization tendency also extends to other fields of research and practice related to the care or study of death and dying. For example, within the humanities and social sciences, death throughout the past three decades or so has turned from a marginalized topic most social researchers did not take seriously, regarded with some suspicion, and did not think could serve as a career-promoting move (Walter 1992), whereas today, the topic of death is simultaneously much more integrated and proliferated and within many disciplines constitutes a research frontier rather than occupying an obscure niche (as the aforementioned preoccupation with grief is evidence of). The tivolicized dimension of this new professionalization and specialization tendency is detectable in the way that death, dying, dignity, humanism, care, and the like have *perhaps* now become the property of a new type of 'death regime' with its own institutions, methods, and vocabulary that is in the process of replacing or at least putting pressure on the older 'vanguards of death' such as religion and medicine.

The re-domestication of death

Towards the end of his magnum opus, *The Hour of Our Death*, and years before the aforementioned professionalization and specialization development really took off, Philippe Ariès critically commented on what he saw as a new attempt to 'humanize death':

A small elite of anthropologists, psychologists and sociologists has . . . (proposed) not so much to 'evacuate' death as to humanize it. . . . They propose to reconcile death with happiness. Death must simply become the discreet but dignified exit of a peaceful person from a helpful society that is not torn, not even overly upset by the idea of a biological transition without significance, without pain or suffering, and ultimately without fear.

Ariès 1981a:614

The proposed trivialization and tivolization theses of death therefore cannot stand alone as explanations of where we may be standing or heading now. After all, most social phenomena are, at least, two edged. So besides trivialization and tivolization, we also need to consider that we do in fact find a genuine interest in re-domesticating and/or re-enchanting the death that was – at least if we are to take historical, sociological, and psychological studies seriously – tabooed during the 20th century. Instead of viewing the many new attempts at confronting ourselves with death and dying as shallow or merely entertainment driven, one may also suggest that they rather seek to re-appropriate the death that we were deprived of with the coming of modern society.

After their review of Norbert Elias's (1985/2001) thesis on 'the loneliness of the dying', suggesting that the widespread fear and horror of death in modern society was accompanied by a rapid decline in death rituals previously so prevalent, Liz Stanley and Sue Wise commented:

However, years on it is clear many new mourning practices, including both the 'privy' and the very public, have come into being subsequently. There are new practices of dying and death for those themselves experiencing dying, including living wills, assisted deaths and message banks. There are also domestic ceremonies occurring within the formal public structures of funerals, ritualized activities around the disposal of someone's ashes, the creation of public mourning practices which are both domestic and public (e.g. roadside shrines), and new forms of public commemorations of very private aspects of death (e.g. memorial websites).

Stanley and Wise 2011:954

The authors thus propose that these are all signs of a so-called 'domestication' of death that attempts to make it less alien and more attuned to the actual needs of bereaved individuals and communities (e.g., by taking post-mortem photographs). There is little doubt that these many new and different initiatives are regarded as personally meaningful to those who invent them and participate in them. Moreover, they also seem to fill a void left by the dismantling of many time-honoured traditions and conventional rituals at the threshold of modern society.

These new ritualization and memorialization practices inform and extend to many different corners of how we culturally think about and handle death

and dying in contemporary society. Perhaps, however, they are not that new after all. For instance, within the realm of palliative and spiritual care, Carlo Leget (2007, 2017) has written about the need for retrieving parts of the forgotten medieval *ars moriendi* in our contemporary care for the dying as a sign that we are once again seeking out ways to achieve a 'good death'. According to Leget, spiritual and existential issues need to be re-integrated in end-of-life decisions and situations, perhaps particularly in an increasingly secularized, individualized, and multiform society that often has nothing but medical or institutional solutions to offer those about to die.

Without specifically mentioning our relationship to death, Max Weber once famously declared the 'disenchantment of the world' as an outcome of the rationalization and bureaucratization processes in the Western world he described. To him, these processes resulted in a loss of personal and cultural meaning that was instead substituted by instrumental rationality. Perhaps we are now seeing some signs of opposition to this process with the declared inauguration of a 're-enchantment' of death that goes beyond the aforementioned trivialization and tivolization. For example, Raymond L. M. Lee (2007, 2008) has described how a kind of New Age–inspired 'spiritual individualism' relying on a view of death as transition, afterlife imagery and insights from near-death experiences challenge many conventional (e.g., medical) knowledge claims in our understanding of death and dying, which, in his view, seemingly suggests 'that if there had been a taboo [on death], it is certainly no longer in effect now' (Lee 2008:756). This counter-culture to death taboo and death denial thus insists that it is only by embracing death, by allowing it to be a recognized and conscious part of our transcendental lives, that we may feel empowered instead of fearful and that we may eventually come to live peacefully with the prospect of our own inescapable mortality.

Discussion and conclusion

As this chapter has tried to indicate and illustrate, death is seemingly no longer what it used to be, at least if we look at death from a historical, cultural, and social perspective. The chapter has toyed with the notion of 'death as taboo' so prominent in a lot of social scientific research conducted and published particularly since the early and mid-20th century. While the chapter does not deny that death *to some extent* can be regarded as a taboo (perhaps even as a 'universal taboo' in Tony Walter's terms), it no longer seems as frozen or fixed in its taboo as was perhaps the case just a quarter of a century ago. Does this mean, then, that death has now been thoroughly and definitively de-tabooed?

First of all, determining the presence or measuring the relative strength of a taboo is indeed a most difficult task, as researchers dealing with taboos in general and death taboos in particular will probably appreciate. At the end of the day, the discomfort associated with death today is perhaps not all that different from what people felt half a century ago during the age of

'forbidden death' (or in medieval times), but the way we discursively talk about death, the way we through the media portray and discuss topics associated with death previously deemed inappropriate (such as euthanasia, suicide, or private grief), and the way we individually and collectively – privately and publicly – commemorate, mourn, and celebrate the dead seem to suggest that something indeed changed at the threshold of the new millennium. On the other hand, however, a culture celebrating youth and devaluing old age seems to gain strength, medical advancements aimed at curing diseases and postponing death are constantly made, technologies allowing your avatar or virtual identity to outlive your physical body have been invented, and so on. Postmortality is far from a dead idea (Jacobsen 2017). So perhaps we are caught in the 'emotional ambivalence' Sigmund Freud (1913) spoke of in relation to taboos: that the death taboo somehow seems to persist even though that which generated it in the first place no longer exists.

Secondly, the so-called 'revival thesis' (supported by now with some pieces of evidence by many scholars) seems to suggest two things. First, that death at some point disappeared or submerged in society (presumably sometime during the early or mid-20th century). This is what seems to be suggested by Gorer, Ariès, and quite a few others. Second, that death is now apparently re-emerging or is being reinstalled (perhaps even resuscitated) in contemporary society as some sort of 'return of the repressed' after decades of taboo and denial (see, e.g., Berridge 2002; Walter 1994). As mentioned, determining whether and to what extent death is revived is difficult – just as it is difficult to decide if death was ever actually a taboo. As Tony Walter has teasingly suggested: 'it is a mistake therefore to say that "modern society cannot cope with death"; it deals with it very nicely thank-you, with its elevation of youth, education and progress' (Walter 1991:306). Contemporary society thus does not taboo or deny death – if, by this, we mean that death and dying are totally absent from our social and individual experiences – but it rather deals with it in a roundabout or obscure way in which death is dealt with indirectly, as something that is not really real or as something that can in fact be prevented if enough energy and ingenuity is invested in it: youth-celebrating culture, anti-ageing, healthcare, fitness, cosmetic and plastic surgery, life-enhancing treatment, functional foods, beauty ideals, etc. – in such a world, one makes a mockery of death, but a mockery that is quite possibly deeply rooted in a diehard fear of death that makes death absolutely alien to everything we otherwise know and experience. In such a time and age, call it the age of 'spectacular death' or otherwise, however, death is perhaps even more powerful than when it was seemingly denied and tabooed, and its semi-presence makes it a staunch enemy. As Zygmunt Bauman once suggested:

> The impact of death is at its most powerful (and creative) when death does not appear under its own name; in areas and times which are not explicitly dedicated to it; precisely where we manage to live as if death was not or did not matter, when we do not remember about mortality

and are not put off or vexed by the thoughts of the ultimate futility of life.

Bauman 1992a:7

Thirdly, with the increased exposure through the media and social media to topics and experiences of death and dying; with the use of death paraphernalia for commercial purposes; with the invention of new ways of publicly memorializing and mourning the dead; with the rise, consolidation, and expansion of the hospice movement and palliative care as areas of specialization; and with 'Death Studies' as a viable academic career path – which are all characteristic features of 'spectacular death' – the danger lurks, as the chapter has proposed, that death becomes irrelevant: at best trivialized, at worst tivolicized. As we saw, however, there may also be signs of a more genuine and deep-seated desire to re-domesticate death by making it more familiar and by embracing the existential and spiritual dimensions of dying and in this way reconciling oneself with the fact that death and loss are inevitable parts of life.

Trying to conclude on the inconclusive in contemporary society – call it 'late-modern', 'liquid-modern', 'second-modern', 'radicalized modern', 'hypermodern' or otherwise (such academic labels never really change the reality to which they refer) – death is still a conundrum, just as much as it was it to the villagers in the Middle Ages, to the Renaissance men and women or to our grandfathers and grandmothers living in so-called 'modern society'. Death, to us all, is the ultimate existential brick wall. In our society, we have decided that since no meaning – metaphysical, religious, or scientific – can apparently account for or explain death away, we will have to learn to live with it as best we can: in a way that mirrors our thoroughly mediatized, entertainment-driven, health-obsessed, youth-centered, and emotionally troubled society in general. We started out by posing the tricky question: is death taboo? Based on the ideas proposed in this chapter, the answer seems simultaneously to be a 'no' and a 'yes'. If by taboo one means the fact that nobody ever speaks of death, that death is shrouded in mystery and ignorance, and that death is surrounded by distance and evasion, then the answer must be a 'no'. Today, death, it seems, is all over the place, not least in the media. If, by taboo, one thinks instead of a situation in which the way we communicate about and interact in connection to actual death (as it happens to actual people in our lives) is less than relaxed and somewhat strained, then the answer must be a 'yes'. In all honesty, we do not seem to have a very relaxed attitude towards death and dying, and perhaps this is quite understandable, since death is the main certainty of life we would wish could be made optional. Finally, one might also add a more normative question: should death be taboo? Here, again, the answer may be simultaneously a 'no' and a 'yes': 'no' if we think a situation in which death is trivialized and tivolicized is preferable to utter silence, avoidance, or serious conversation; 'yes' if we think death is so difficult to deal with and so terrifying a human prospect – for ourselves and those whom we know and love – that we need

to tread carefully with the required solemnity, sensitivity, and profundity of such a tricky topic. This is perhaps easier said than done. As Kate Berridge, by quoting Geoffrey Gorer, thus rightly contended: 'If we dislike the modern pornography of death, then we must give back to death – natural death – its parade and publicity, re-admit grief and mourning. The challenge, however, is how to civilise death without trivialising it' (Berridge 2002:266). It seems as if this challenge still lies ahead of us.

References

Ariès, Philippe (1974a): *Western Attitudes Toward Death from the Middle Ages to the Present.* Baltimore: Johns Hopkins University Press.

Ariès, Philippe (1974b): 'The Reversal of Death: Changes in Attitudes Toward Death in Western Societies'. *American Quarterly,* 26 (5):536–560.

Ariès, Philippe (1981a): *The Hour of Our Death.* London: Allen Lane.

Ariès, Philippe (1981b): 'Invisible Death'. *The Wilson Quarterly,* 5 (1):105–115.

Ariès, Philippe (1985): *Images of Man and Death.* Cambridge: Harvard University Press.

Baudrillard, Jean (1995): *The Gulf War Did Not Take Place.* Bloomington: Indiana University Press.

Bauman, Zygmunt (1992a): *Mortality, Immortality and Other Life Strategies.* Cambridge: Polity Press.

Bauman, Zygmunt (1992b): 'Survival as a Social Construct'. *Theory, Culture & Society,* 9 (1):1–36.

Becker, Ernest (1973/1997): *The Denial of Death.* New York: Free Press.

Berridge, Kate (2002): *Vigor Mortis: The End of the Death Taboo.* London: Profile Books.

Bryman, Alan (2004): *The Disneyization of Society.* London: Sage Publications.

Choron, Jacques (1972): *Death and Modern Man.* New York: Collier.

Doss, Erika (2010): *Memorial Mania: Public Feeling in America.* Chicago: University of Chicago Press.

Elias, Norbert (1985/2001): *The Loneliness of the Dying.* London: Continuum.

Elliott, Anthony (2018): 'The Death of Celebrity: Global Grief, Manufactured Mourning'. In Anthony Elliott (ed.): *The Routledge Handbook of Celebrity Studies.* London: Routledge, pp. 109–123.

Farberow, Norman L. (1963): *Taboo Topics.* New York: Atherton Press.

Feifel, Herman (ed.) (1959): *The Meaning of Death.* New York: McGraw-Hill.

Fong, Jack (2017): *The Death Café Movement: Exploring the Horizons of Mortality.* London: Palgrave/Macmillan.

Foucault, Michel (1978): *The History of Sexuality, Volume 1: An Introduction.* London: Allen Lane.

Freud, Sigmund (1913): *Totem and Taboo.* Boston: Beacon Press.

Freud, Sigmund (1915/1955): 'Thoughts for the Times on War and Death'. In James Strachey (ed.): *The Standard Edition of the Complete Psychological Works of Sigmund Freud* (Volume 14). London: Hogarth Press, pp. 275–300.

Giddens, Anthony (1991): *Modernity and Self-Identity: Self and Society in the Late Modern Age.* Stanford, CA: Stanford University Press.

Gifford, Sanford (1971): 'Some Psychoanalytic Theories about Death: A Selective Historical Review'. *Annals of the New York Academy of Sciences,* 164:638–668.

Glaser, Barney G. and Anselm L. Strauss (1965): *Awareness of Dying.* Chicago: Aldine.

Gorer, Geoffrey (1955): 'The Pornography of Death'. *Encounter*, October, pp. 49–52.

Haney, Allen, Christina Leimer and Juliann Lowery (1997): 'Spontaneous Memorialization: Violent Death and Emerging Mourning Ritual'. *Omega: Journal of Death and Dying*, 35 (2):159–171.

Jackson, Charles O. (1977): 'Death Shall Have No Dominion: The Passing of the World of the Dead in America'. *Omega: Journal of Death and Dying*, 8 (3):195–203.

Jacobs, Joseph (1899): 'The Dying of Death'. *The Fortnightly Review*, 66:264–269.

Jacobsen, Michael Hviid (ed.) (2013): *Deconstructing Death: Changing Cultures of Death, Dying, Bereavement and Care in the Nordic Countries*. Odense: University Press of Southern Denmark.

Jacobsen, Michael Hviid (2016): '"Spectacular Death": Proposing a New Fifth Phase to Philippe Ariès's Admirable History of Death'. *Humanities*, 5 (19). Available online at: www.mdpi.com/2076-0787/5/2/19.

Jacobsen, Michael Hviid (ed.) (2017): *Postmortal Society: Towards a Sociology of Immortality*. London: Routledge.

Jacobsen, Michael Hviid and Anders Petersen (2018): 'Grief: The Painfulness of Permanent Human Absence'. In Michael Hviid Jacobsen (eds.): *Emotions, Everyday Life and Sociology*. London: Routledge, pp. 191–208.

Jacobsen, Michael Hviid and Anders Petersen (eds.) (2019): *Exploring Grief: Towards a Sociology of Sorrow*. London: Routledge.

Kammeyer, Kenneth C. W. (2008): *A Hypersexual Society: Sexual Discourse, Erotica, and Pornography in America Today*. London: Palgrave/Macmillan.

Kearl, Michael C. (2015): 'The Proliferation of Skulls in Popular Culture: A Case Study of How the Traditional Symbol of Mortality Was Rendered Meaningless'. *Mortality*, 20 (1):1–18.

Kellehear, Allan (1984): 'Are We a "Death-Denying" Society? A Sociological Review'. *Social Science and Medicine*, 18 (9):713–723.

Killilea, Alfred G. (1980–1981): 'Death Consciousness and Social Consciousness: A Critique of Ernest Becker and Jacques Choron on Denying Death'. *Omega: Journal of Death and Dying*, 11 (3):185–200.

Kübler-Ross, Elisabeth (1969): *On Death and Dying*. London: Routledge.

Laqueur, Thomas W. (2015): *The Work of the Dead: A Cultural History of Mortal Remains*. Princeton, NJ: Princeton University Press.

Lee, Raymond, L. M. (2007): 'Mortality and Re-Enchantment: Conscious Dying as Individualized Spirituality'. *Journal of Contemporary Religion*, 22 (2):221–234.

Lee, Raymond L. M. (2008): 'Modernity, Mortality and Re-Enchantment: The Death Taboo Revisited'. *Sociology*, 42 (4):745–759.

Leget, Carlo (2007): 'Retrieving the *Ars Moriendi* Tradition'. *Medicine, Health Care and Philosophy*, 10:313–319.

Leget, Carlo (2017): *Art of Living, Art of Dying: Spiritual Care for a Good Death*. London: Jessica Kingsley Publishers.

Lifshin, Uri, Peter J. Helm and Jeff Greenberg (2017): 'Terror Management Theory: Surviving the Awareness of Death One Way or Another'. In Michael Hviid Jacobsen (ed.): *Postmortal Society: Towards a Sociology of Immortality*. London: Routledge, pp. 79–96.

Littlewood, Jane (1992): 'The Denial of Death and Rites of Passage in Contemporary Societies'. *The Sociological Review*, 40 (S1):69–84.

Lyng, Stephen (1990): 'Edgework: The Social Psychology of Voluntary Risk Taking'. *American Journal of Sociology*, 95 (4):851–886.

Macho, Thomas and Kristin Marek (eds.) (2007): *Die neue Sichtbarkeit des Todes*. Munich: Wilhelm Fink Verlag.

McIlwain, Charlton D. (2005): *When Death Goes Pop: Death, Media and the Remaking of Community*. New York: Peter Lang.

Mellor, Phillip A. and Chris Shilling (1993): 'Modernity, Self-Identity and the Sequestration of Death'. *Sociology*, 27 (3):411–431.

Meštrović, Stjepan G. (1997): *Postemotional Society*. London: Sage Publications.

Noys, Benjamin (2005): *The Culture of Death*. Oxford: Berg.

O'Mahony, Seamus (2016): *The Way We Die Now*. London: Head of Zeus Ltd.

Prior, Lindsay (1989): *The Social Organization of Death: Medical Discourse and Social Practices in Belfast*. London: Macmillan.

Ritzer, George (1993): *The McDonaldization of Society*. Thousand Oaks, CA: Sage Publications.

Robert, Martin and Laura Tradii (2017): 'Do We Deny Death? I. A Genealogy of Death Denial'. *Mortality*, DOI: 10.1080/13576275.2017.1415318.

Sigusch, Volkmar (1998): 'The Neosexual Revolution'. *Archives of Sexual Behavior*, 27 (4):331–359.

Simpson, Michael A. (1978–1979): 'Dying on Television'. *Omega: Journal of Death and Dying*, 9 (2):93–95.

Sobo, Simon (1999): *The Fear of Death*. New York: Xlibris Corporation.

Stanley, Liz and Sue Wise (2011): 'The Domestication of Death: The Sequestration Thesis and Domestic Figurations'. *Sociology*, 45 (6):947–962.

Steiner, Franz B. (1967): *Taboo*. London: Pelican Books.

Stone, Philip R. (2018): 'Dark Tourism in an Age of "Spectacular Death"'. In Philip R. Stone et al. (eds.): *The Palgrave Handbook of Dark Tourism Studies*. London, Palgrave/Macmillan, pp. 189–210.

Sudnow, David (1967): *Passing On: The Social Organization of Dying*. Englewood Cliffs, NJ: Prentice-Hall.

Tradii, Laura and Martin Robert (2017): 'Do We Deny Death? II. Critiques of the Death-Denial Thesis'. *Mortality*, DOI: 10.1080/13576275.2017.1415319.

Vovelle, Michel (1980): 'Rediscovery of Death Since 1960'. *Annals of the American Academy of Political and Social Science*, 447:89–99.

Wolfram, Sybil (1966): 'The Decline of Mourning'. *The Listener*, 75:763–764.

Walter, Tony (1991): 'Modern Death: Taboo or Not Taboo?'. *Sociology*, 25 (2):293–310.

Walter, Tony (1992): 'Sociologists Never Die: British Sociology and Death'. *The Sociological Review*, 40 (1):264–295.

Walter, Tony (1994): *The Revival of Death*. London: Routledge.

Walter, Tony (2014): 'The Revival of Death: Two Decades On'. Available online at: http://endoflifestudies.academicblogs.co.uk/the-revival-of-death-two-decades-on-by-tony-walter/.

Walter, Tony (2017): *What Death Means Now*. Bristol: Policy Press.

Zilboorg, Gregory (1943): 'Fear of Death'. *Psychoanalytic Quarterly*, 12:465–475.

Zimmerman, Camilla and Gary Rodin (2004): 'The Denial of Death Thesis: Sociological Critique and Implications for Palliative Care'. *Palliative Medicine*, 18 (2):121–128.

2 'A stark and lonely death'

Representations of dying alone in popular culture[1]

Glenys Caswell

Introduction

Most of us would wish as stress-free and comfortable a death as possible for those we care about, and we would probably wish the same for ourselves. Until we encounter death at first hand, however, we have no way of knowing how such a death might be except through the eyes of others. One of the ways in which we learn about how we should die from others is through the consumption of cultural representations of dying. We learn, that is, from the texts that other people create when giving us their accounts. In this chapter, I will explore cultural representations of accompanied dying and of dying alone. In doing so I will suggest that dying alone is routinely situated as a bad death, in contrast to a death surrounded by family and friends, which is portrayed as a good death.

It is not unusual among these different cultural forms to find death dichotomized into good and bad, allowing no room for the consideration of nuances or subtleties. A good death is one which takes place at home, surrounded by family and close friends, while a bad death is one that takes place when the dying person is alone. A bad death becomes a worse death when the dying person's dead body is undiscovered for an extended period of time. Such representations of dying may be read as ideological forms, which present the world in particular ways which signify how the world should be. In doing so, representations help to establish collective ways of understanding what it means to die alone, yet they may do so in ways that are based on a limited or distorted view of reality (Storey 2018). Texts which offer representations of dying alone come in many forms, including television, fiction, film, and news media reporting.

Representations of good and bad deaths as ideological texts will be explored, with particular reference to two scenes from the British soap opera *EastEnders* and to news media descriptions of accompanied deaths compared to deaths which occur when the person is alone. It introduces the concepts of accompanied dying and dying alone in terms of their representations in cultural form as good and bad deaths, before going on to discuss the specific examples. First, however, there is a brief discussion of popular culture and the idea of reading cultural representations as ideological forms (Storey 2018).

Popular culture and ideology

Culture is a complex concept to define but refers to the shared understand-ings and meanings that we develop and encounter as we go about our daily lives. Such understandings, for example, enable us to borrow books from a library or go to the cinema to see a film; we know how to go about it, and we also understand what books and films are and why we might wish to engage with them. Popular culture refers here to the cultural forms that are most commonly used, with television the most popular form, despite the changing ways in which people consume it (Storey 2010:9).

Culture does not only refer to the texts which are cultural products, to the television programmes that we view, and the newspaper articles that we read, but also to our practices in terms of those texts. How we consume and make sense of them is an important aspect of our culture, so that 'to share a culture, therefore, is to interpret the world – make it meaningful – in recognisably similar ways' (Storey 2010:3). This is not to suggest that all members of a social group interpret a text in the same way and share complete agreement and understanding, as any text may be interpreted and understood in myriad ways. What it does mean, however, is that we share understanding of how cultural representations work and we can read them effectively.

All texts, whether formed of words, visual images, or sounds, are under-pinned by ideas about society. The content and medium of texts are informed by values and beliefs held by their creators, although these may not be delib-erately shared (Howells and Negreiros 2012). Efforts to examine and analyze cultural texts must therefore involve delving into their ideological forms in order to expose their underlying values (Howells and Negreiros 2012).

Like culture, ideology is a complex concept with many competing defini-tions. This chapter utilizes the concept of ideological forms in which every text offers a particular view of the world, whether or not the creator of the text is aware of this. Any text therefore presents to consumers a view of how the world is or should be. This is a political act and depends on a view of society as a site of conflict, rather than as a site of consensus, equality, and agreement (Storey 2018).

Linked to the concept of ideological forms is the notion that texts can sometimes present a distorted image of reality, which can lead people to hold ill-informed or erroneous views. This again depends upon a view of society as conflictual, with powerful people able to influence the views of those who are less powerful (Storey 2018). The controllers of television broadcasting decisions and those making decisions relative to the inclusion of stories in the news media are in a more powerful position than the consumers of their products.

Background to representations of dying

The portrayal of death in varied cultural forms to be consumed by read-ers, viewers, and listeners is not new to the 21st century, and neither is the

idea that death can be dichotomized into good and bad. What counts as a good death depends on the social and historical context (Kellehear 2007). In late medieval and early modern England, *ars moriendi* taught people how to die well. The *ars moriendi* were texts which offered a set of moral precepts to people who were dying and those who attended them (Leget 2007). For Catholics, from the Middle Ages onwards, a good death required a sinner to repent so that the dying person could avoid hell, and this made the priest a key figure at the deathbed (Walter 1999). The choice appeared to be clear for Catholic Christians: repent and go to purgatory or heaven after a good death, or fail to do so and go to hell after a bad death.

The Reformation in Britain changed the relationship between clergy and the dying, and gradually medical personnel became more important at the bedsides of those who were dying (Walter 1999). Family members were also key participants at the deathbed, enabling the completion of business, the mending of relationships, and the provision of support (Hallam 1996; Jalland 1996). Today, dying has become the province of the medical profession, which has the power to define and create what counts as normal in terms of disease and death (Bishop 2011). English healthcare policy promises adults access to a good death, which is assumed to include a wish to die at home and to be accompanied by family and friends (Pollock 2015).

The counterpoint to a death attended by a priest or a medical professional alongside family and friends is an unattended death. Dying alone is portrayed as a bad death, particularly when the dead body is not found for an extended period of time (Caswell and O'Connor 2015, 2019). There is therefore a dichotomy between perceptions of good and bad deaths, which persists and is recognizable in portrayals of death over time.

Representations of dying

Representations of accompanied dying

The typical deathbed scene portrays the dying person at the centre of a tableau. They are usually in bed, the business of their life is complete, and they have the company of those family members and friends who are important to them as they approach the end of their life. The scene implies that the dying person is experiencing a good death, yet the scene itself is a construction which draws on cultural understandings and experience. The deathbed scene exists only in the telling of the story about the death; that is, it exists through its cultural representation (Kastenbaum 2000:255–258).

The deathbed scene can be found in a wide variety of sources and types of representation. Charles Dickens was a popular writer during his lifetime who wrote a great deal about death and killed a large number of his fictional characters (Meckier 2015). Dickens's books could be enjoyed by anyone who could read, including members of the working class, as well as the middle and upper classes, thanks to their publication in cheap serial form (Patten 2016).

In his novel *Bleak House*, which was published in monthly instalments, death is one of 'the two fundamental motifs' (Wood 2015:106). There are many deaths in the novel, some of which are described in terms that suggest they are good ones, such as that of Richard Carstone, who dies in the arms of his wife and surrounded by family and friends after having made his peace with the world (Dickens 1853/1996:979). Jo, the crossing sweeper, a poor boy with no home or family, also dies a good death. He dies with a doctor and friends at his side; he is indoors and is encouraged to say a prayer (Dickens 1853/1996:734). These deaths demonstrate how a good death should be, with sufficient time for the dying person to finish necessary business and accompanied by people who care about them.

Alongside fiction, there are also pictorial representations of the deathbed scene, which, during the Victorian era at least, often featured as an illustration in books and magazines aimed at children as well as adults. The death-bed scene showed the dying person accompanied by a priest or a doctor as well as their family, and was instantly recognizable to people at the time (Thomas 2016). With the increasing use of photography, scenes of a good death became more readily available and enabled a wide audience to view representations of such idealized deaths. For example, the photograph by Henry Peach Robinson called *Fading Away* was a popular print at exhibitions during the 1850s. It shows a woman dying from tuberculosis, and it appears to be a good death as her family accompanies her, and she has time to make her peace with the world. The picture does not illustrate, however, the fact that tuberculosis was a painful way to die before the advent of antibiotics (Jalland 1999). This photograph is an example of an ideological form which offers viewers a distorted image of reality, in that it suggests to experienced cultural consumers that the death is a good one by obscuring the painful reality of a death by tuberculosis (Storey 2018).

Paintings such as *Death of a Musician* and *The Death of President Abraham Lincoln in Washington, 1865*, are held in the Wellcome Collection in London and illustrate accompanied deaths. They both appear to show a good death. While the origins of *Death of a Musician* are obscure, we know that Abraham Lincoln was assassinated, which is not apparent from the picture of his deathbed scene. We can deduce, therefore, that this painting is also offering us a distorted view of the reality of his death.[2] More recent representations of accompanied dying are also available, including personal accounts of death. For example, in *Thankful for My Nan's Good Death*, the writer describes the death of her grandmother (Nash, n.d.). She writes: 'My 95-year-old nan had the death I would want: at home, in peace and surrounded by love'. Political advisor Philip Gould wrote an account of his experiences when diagnosed with cancer and approaching the end of his life. After his death members of his family, including his daughter Georgia, wrote postscripts:

And finally it is just the four of us. I am holding on to his left hand, Grace his right. Mum has her arm around his neck, leaning on his chest. The

> Gregorian chant fills the room and as it reaches its last note, Dad gives a shudder and lets go.
>
> Gould 2012:178

Television is a medium which provides a platform for the representation of dying, both in factual and fictional terms. BBC One, a publicly funded television channel in the UK, filmed and broadcast the death of an 84-year-old man in 2011. Gerald, who died of cancer on 1 January 2011, died in a hospice surrounded by his family (Deacon 2011). In an episode of the fictional programme *Doctor Who*, the Doctor's companion Clara is told by the character Tasha Lem that 'he shouldn't die alone, go to him'.[3]

We know, as consumers of culture in early-21st-century Britain, that the deaths described here are offered as examples of the kind of death we should aspire to. They present an ideal deathbed, with the right people being present at the right time (Kastenbaum 2000:270). They present ideological forms, and we have no way of knowing whether or not they offer distorted or oversimplified views of reality; indeed we might not even consider the possibility (Storey 2018).

Representations of dying alone

Representations of dying alone can also be found in a variety of sources. Dickens's aforementioned *Bleak House* furnishes memorable examples. The death of Lady Dedlock, for example, alone and disregarded outside the locked gate of the paupers' cemetery is one such (Dickens 1853/1996:915). Her death in this manner seems inconsistent with her life as the wife of a rich and titled man but makes sense when we recall that she gave birth to a child when unmarried and that she left her home when her secret was in danger of being revealed. Earlier in the book, the law writer who called himself Nemo dies alone and unnoticed in his bare and dank room above Krook's shop (Dickens 1853/1996:165). Nemo, in his previous identity as Captain James Hawdon, was the father of Lady Dedlock's child. He calls himself Nemo, or nobody, which reflects his new lowly social status, and his death alone seems in keeping with his life. Thomas Hardy's character Jude Fawley also dies alone. In the book *Jude the Obscure*, Jude dies alone as his wife goes off to the fair, and he is left alone to call pathetically for water and to die (Hardy 1895/2001).

Contemporary fiction also furnishes examples of characters dying alone. In Robert Goddard's novel *Panic Room*, the father of the main character dies alone, and his body is undiscovered for a number of days: 'the wreckage of his father's body was a terrible sight, decomposing, rotting, almost melting' (Goddard 2018:98). Mary Paulson-Ellis's novel *The Other Mrs. Walker* centres around the lonely death of an elderly woman in Edinburgh on Christmas Day (Paulson-Ellis 2017).

Television and film also carry representations of dying alone. RTD, the Russian documentary channel, made a documentary about people who die

alone in Japan and the people who clean up after such a death has occurred.[4] In the UK, Carol Morley made a film about Joyce Vincent, a young woman who died in her own home in London in 2003 and whose body was not found until three years later.[5] Different forms of news media report instances where someone has died alone at home, and their body has not been found for an extended period of time (Caswell 2013; Caswell and O'Connor 2015). As practiced consumers of popular culture, we know that these ideological forms are guiding us to view dying alone as the kind of death that we should avoid.

Good death, bad death

The deaths briefly described here all have one thing in common, and this is that they each represent a particular perspective on the issue of dying; that is, they offer ideological significations of the way the world should be (Storey 2018). The accompanied deaths present a picture of an idealized kind of death, one that all should aspire to. The instances where people die alone are presented as the reverse of this, as deaths that all should endeavour to avoid. To examine this more closely, the next sections will explore two deaths as shown in a British soap opera, followed by two deaths as represented in the news media.

Death in a soap opera

EastEnders is a British soap opera broadcast by the BBC. Soap operas were originally designated as such because they provided the opportunity to advertise domestic products to what was then assumed to be a female daytime television audience. The soap opera format was of long-running and open-ended serials (Howells and Negreiros 2012). While there is no link with advertising, and the series is broadcast for an evening audience, *EastEnders* is still designated as a soap opera. It is set in the East End of London and concerns the lives and relationships of the residents of Albert Square in the fictional borough of Walford. It has been broadcasting continuously since it began in 1985, and currently airs four times a week.[6]

The accompanied death of Pat Evans

On 1 January 2012, an episode was broadcast in which the long-term character Pat Evans (also known as Butcher or Wicks) died. Pat, played by Pam St. Clement, had joined the programme in June 1986. She was a strong character who had had a number of relationships and borne two sons. Her death took place in her own home, in her own bed. Despite being on her deathbed and dying of metastatic pancreatic cancer, Pat's hair was immaculate, and she wore her trademark earrings. A number of other characters were with her. Almost at the end, the front door of the house opened and one of Pat's sons,

David Wicks (played by Michael French), came in. We could hear that it was raining outside and see the rain on David's hair. He struggled out of his jacket and rushed upstairs to his mother's bedroom.

Here David found his mother lying in bed; she was groaning. He was devastated and hastened to sit beside her and tell her that he had arrived. The camera focused on David's face at first and then moved to Pat's. Her eyes were closed, but she opened them as David spoke to her. He put his arm around her, and again the focus moved to David. He said that he was back and not running any more, he was sorry, and he forgave her. David said that he loved her and kissed her hand. Pat spoke with difficulty, saying that she did not want to die. Her son promised her that she would not die. Pat then said that she was scared. David laid his head against hers, and we heard her take her last breath. David lifted his head up and tried unsuccessfully to rouse his mother by speaking to her; he realized that she was dead and shared this knowledge wordlessly with the others in the room.

All through this scene we were able to hear the heavy rain falling against the window of the room, and at one moment we saw it running down the window, just as tears were running down the characters' faces. David continued to hold his mother, and we became aware not just of the rain, but also of the sound of a ticking clock as the scene moved towards its end. The titles at the end of the episode ran through to the strains of the usual *EastEnders* theme, but played in a solemn way, appropriate to there having been a death.[7]

The death of Pat Evans would, according to many contemporary definitions, be a good death. She died at home in her own bed, and those who were closest to her emotionally were with her at the time. Her son, from whom she had been estranged, returned in time to make his peace with her and to provide her with comfort at the moment of her death. In addition, her death was consistent with her character in that her appearance remained true to Pat Evans with her hair permed and tidy and her earrings in place. She was also aware of what was happening, did not appear to be in pain, and was able to say some last words to her son David and receive comfort from him (Walter 1994; Pollock and Seymour 2018).

Pat Evans's death appeared authentic to her character. The sound and sight of the rain suggested sorrow expressed through tears to viewers, and the sound of the ticking clock reminded us of the passage of time. As an ideological form, this text presents a particular perspective on the world, one in which an accompanied death which takes place in the dying person's own home is automatically a good death. Let us turn now to another *EastEnders* death to examine this further.

The (un)accompanied death of Peggy Mitchell

Peggy Mitchell was another *EastEnders* matriarch, who first appeared in the programme in April 1991 for 10 episodes. She returned in 1994, when she was played by Barbara Windsor. Peggy and Pat Evans were friends who had a

sometimes-rocky relationship. The character of Peggy was not continuously in the series, but she returned in 2016 when she had developed breast cancer. Unable to live with the pain of the cancer or to endure the need for care of her failing body Peggy decided to end her own life.

On 17 May 2016, the death of Peggy Mitchell aired. The scene was short, just a minute and a half. Peggy was immaculately dressed, with her hair styled. The window to her upstairs room was open, and faintly we could hear music from outside. In the background sat Pat Evans, the character who died in 2012. The two exchanged some chat, trading insults, and then Peggy called Pat her dear friend and asked: 'You won't ever leave me, will you?'

Pat responded: 'No, sweetheart. Not for one single second'.

Peggy then sat down and proceeded to take the pills, which were to end her life, slowly.

The camera then moved out the window to show the street. The music became a little louder, but there was no sign of anyone moving about outside. We then heard a loudly ticking clock, and the music faded. A train moved by in the background of the scene, and the camera returned indoors. We saw the empty pill bottle lying on its side and a note addressed to Peggy's son Phil. We did not see Peggy. The camera then moved to show a clock face; we saw the second hand move and heard the ticking. Then the clock stopped, and we knew that Peggy had died.[8]

While we saw Pat Evans die, we did not see Peggy Mitchell die. We knew that the death had occurred through visual cues, including the note to her son and the empty pill bottle. There was also the cue of the ticking clock, which stopped, reminding us not only of the passage of time, but also that for Peggy Mitchell time had stopped. Peggy was accompanied while she is killing herself by what may be construed as either the ghost or a hallucination of Pat Evans. Without the figure of Pat, Peggy would have died alone, and we were left in no doubt that to die alone would be a bad way to die.

The appearance of corpses in fictional television is not unusual (Weber 2014), and it is significant that we see the body of Pat but not that of Peggy. Pat dies well, she does not look particularly ill when she is on her deathbed, and once she dies, her appearance is of a woman sleeping. The appearance of Peggy, however, is left to our imagination. She has died by her own hand by taking pills, so we might wonder whether she had been sick before dying. Suicide is a difficult issue to explore within the confines of a soap opera, and this instance of it might be termed assisted suicide, where the person dying is supported by another. Portraying such deaths within a fictional context and in a socially constructive way is particularly tricky, although a study by Sanna Inthorn (2017) suggests that soap opera viewers' comments on assisted suicide focus on the emotional aspects of the death portrayed.

The deaths of Pat and Peggy were ideological forms, and they each offered a specific view of dying for the consumption of viewers. The writers and producers may not have set out to guide viewers in their beliefs about dying, but the ways in which they portrayed these two deaths clearly set out a perspective

of the good death as accompanied by family and friends and taking place at home in one's own bed, and a death alone as being an automatically bad death. The death of Peggy fits into a trope of the apparently lonely individual who dies alone and whose body is not discovered for some period of time.

In the American series which revolves around the Fisher family running a funeral home from the family home, *Six Feet Under*, an episode aired in 2002 called "The Invisible Woman" concerned the death alone at home of Emily Previn. She was a middle-aged woman who choked to death and was not missed by anyone, so she was found a week later by a neighbour and her landlord. Members of the Fisher family wondered about Emily Previn, what kind of life she had that led to such a bad death and to a funeral which was attended only by the Fisher family and their employee Federico. Different members of the Fisher family offered different explanations for how Emily Previn came to die as she did (Yodovich and Lahad 2017).

As experienced viewers of television fiction, we understand the ideological significations that are used to inform us about the different forms of dying, and we therefore know that accompanied dying is good and that dying alone is bad. Such deaths do not only happen in fictional form, of course, and we turn now to consider the reporting of similar kinds of deaths in the news media.

Death in the news media

In April 2016 comedian, actress, writer, and musician Victoria Wood died of cancer at the age of 62. She was a familiar sight on UK television, and her death was widely reported in the news, as well as in the obituary sections of the media. Reporting was peppered with quotes from celebrities saying how talented she was and how much she would be missed. Her death was reported in different media sources, all saying that she had died peacefully at home surrounded by her family. The source of this story was quoted as being her brother, acting as family spokesperson. The *Guardian* newspaper, the *Daily Mail* and the BBC were among the media that reported Victoria Wood's death in this way.[9]

The first reports of Victoria Wood's death acknowledged that she had experienced difficulties and struggles during her life, but ultimately, she had triumphed, achieving success and fame. The manner of her dying was described in such a way that suggested a good death, despite it being the case that the fact of her death was not good as she would be missed. Such reporting of celebrities' deaths is not unusual in the UK press and, in recent years, has included people such as writer Terry Pratchett and actor Rod Taylor, both in 2015.[10]

There are deaths, however, that are reported in the news in a different manner. One such death was that of William Hunter, a 72-year-old man whose body lay undiscovered in his home for about 14 months. He was an ex-serviceman who lived alone in a Scottish village and had been undergoing treatment for cancer. His body was discovered when his landlord asked the police to effect entry to his home. Neighbours had assumed that Mr. Hunter

was either in hospital or had gone into a care home. The story was covered by the Scottish press and was also included in a BBC Radio 4 programme called *Face the Facts*.

Mr. Hunter's member of the Scottish Parliament, Jamie Stone, was asked for his reaction, as was the First Minister of Scotland, Alex Salmond. A local councillor was also asked for an opinion, as was a representative of Age Concern Scotland (now Age Scotland). Mr. Hunter's situation was said to have raised serious questions and was one which sent out a 'terrifying message' to older people living alone. William Hunter's death was described as a lonely one, which had shocked people locally, leading to questions about who was to blame and how it could have happened. Mr. Hunter himself was described as a private man who lacked close friends and who was estranged from his family who did not live nearby.[11]

The reporting on the death of William Hunter appears congruent with a news media analysis carried out by Clive Seale (2004), suggesting as it does a bad death. Seale's analysis of media reporting of cases where people had died alone was carried out for one week in October 1999, drawing on the Anglophone press and using the Lexis-Nexis database as a source for articles (Seale 2004). The conclusion of this analysis was that media reports construct dying alone as a form of bad death. Dying alone is represented in such reports as a fate to be feared and as being a moral issue, which implies that blame is likely to be attributable. Often a death alone is portrayed as being the outcome of the personal characteristics of the person who died: for example, if someone was staunchly independent and refused offers of help or perhaps had a problem with alcohol. Society was also sometimes considered to be blameworthy, in that the person had been abandoned, and often the death would be because of personal or societal breakdowns (Seale 2004).

The reporting of William Hunter's death can also be read as an ideological form, which situates dying alone as automatically a bad death. In deaths like that of William Hunter, however, it is not just that he died alone, but there is also the fact that his body was undiscovered for over a year. This makes the situation worse, implicating people other than William Hunter for not finding his body. Dead bodies are powerful signifiers of contamination and dirt, confronting the living with the certitude that they must also die (Ahren 2009:4–5). The image of a dead body lying for months on end and gradually decomposing and coming to appear less and less human is an ideological signification of an unacceptable form of dying. In contrast, reporting on the death of Victoria Wood may also be read as an ideological form, but one which presents us with a good death, of the kind to be aspired to by us all (Storey 2018; Walter 1994).

Final thoughts

Programmes on television, such as *EastEnders*, are intended to provide entertainment for their audiences, but they simultaneously offer 'a site through

which contemporary social issues may be considered and negotiated' (Klein 2011:905). Research also suggests that viewers can use what they see in a programme like *EastEnders* to help them interpret the world and make decisions about how to act (Lamuedra and O'Donnell 2012). The representations of life and death that we see in *EastEnders* may not be true to everyday life, but they are realistic enough to be recognisable as pertaining to life in Britain (Lamuedra and O'Donnell 2012).

Reporting the news is not a straightforward process of telling readers what is going on in the world, any more than soap operas directly reflect people's day-to day-experiences. Deciding what constitutes a news story and how to present it to consumers of news is a complex process, one in which 'the act of making news is the act of constructing reality' (Tuchman 1978:12). In terms of news reports, the press themselves decide what information people need to be given and then disseminate this. During the process of dissemination of the news, the press also shapes people's knowledge and understanding, particularly about topics of which readers have little personal experience (Tuchman 1978). In this way, the press may act as instructors, informing their readers about appropriate behaviour in relation to death (Walter, Littlewood, and Pickering 1995).

Some texts present a distorted view of reality, so their ideological formulation presents a particular view of how the world should be which is oversimplified (Storey 2018). The representations discussed in this chapter, of accompanied and (un)accompanied deaths in the popular soap opera *EastEnders*, offer simplified pictures of reality, with nuances omitted. We do not know how Pat Evans really felt about her son's return and whether she forgave him; we do not know what effect taking the pills had on Peggy or whether she may have regretted doing so when it was too late.

The news reports describing the deaths of Victoria Wood and William Hunter also lacked nuance and acknowledgement of the complexities of the situations of the two individuals. The stories were constructions of the two deaths; we cannot know how either of them felt about the experience as they were dying. In the case of Victoria Wood, we were given an interpretation attributed to her brother, and in the case of William Hunter we were offered assumptions made by journalists and the people whom they interviewed (Tuchman 1978; Walter, Littlewood, and Pickering 1995). On this chapter's reading of deaths in *EastEnders* and press reports, death is dichotomized, presenting to us the claim that an accompanied death is good, and a death alone is bad, with no room for the consideration of nuances or subtleties.

For those individuals who have not reflected on modes of dying, the lack of nuance encountered in cultural representations offers an over-simplified picture, which risks perpetuating perspectives which are sometimes inaccurate. Some people do prefer to die alone, while different ethnic groups have differing cultural practices in relation to dying, and older people frequently die after a long period of increasing frailty and chronic illness; the dichotomization of good and bad deaths as described in this chapter obscures these realities (Kellehear 2007; Pollock and Seymour 2018; Caswell and O'Connor 2019).

Notes

1 An early version of this chapter was presented at the 13th *Death, Dying and Disposal International Conference*, which took place at the University of Central Lancashire, Preston, UK, 6–10 September 2017.
2 Wellcome Collection, 'The Free Museum and Library for the Incurably Curious', available online at: https://wellcomecollection.org/works/k68brcs3.
3 'The Time of the Doctor', First Broadcast 25 December 2013. Available online at: www.bbc.co.uk/programmes/p01mj6k8.
4 Dying Alone, 'Kodokushi, Japan's Epidemic of Isolation through the Eyes of a "Lonely Death" Cleaner', available online at: https://rtd.rt.com/films/kodokushi-lonely-death-in-japan-through-the-eyesof-the-cleaners/
5 'Dreams of a Life' a Film by Carol Morley, available online at: https://dogwoof.com/dreamsofalife.
6 BBC Studios, available online at: www.bbcstudios.com/case-studies/eastenders/.
7 Pat Evans's death, available online at: www.youtube.com/watch?v=XzTBZkefQKA, and: www.bbc.co.uk/programmes/profiles/1rPL2rytbtDxgFFvZcS0pH1/pat-evans.
8 Peggy Mitchell's death, available online at: www.youtube.com/watch?v=jJANeow6ytA&t=1s, and: www.bbc.co.uk/programmes/profiles/3VTlQzGfNCyCJvTmN7KgF12/peggy-mitchell.
9 'Death of Victoria Wood', *The Guardian*, 21 April 2016, pp. 1, 8–9, 34, 39, available online at: www.dailymail.co.uk/news/article-3551238/Victoria-Wood-spent-final-evening-cracking-jokes-make-heartbroken-children-laugh-succumbed-cancer-secret-six-month-battle.html, and: www.bbc.co.uk/news/entertainment-arts-36094827.
10 Death of Terry Pratchett, available online at: www.telegraph.co.uk/news/celebritynews/11467688/Sir-Terry-Pratchett-dies-aged-66.html. Death of Rod Taylor, available online at: www.theguardian.com/film/2015/jan/09/rod-taylor-the-birds-time-machine-actor-dies-84.
11 Death of William Hunter, available online at: www.bbc.co.uk/sounds/play/b00lr2g8 http://news.bbc.co.uk/1/hi/scotland/highlands_and_islands/7256682.stm, and: www.scotsman.com/news-2-15012/pensioner-lay-dead-for-14-months-1-1156254.

References

Ahren, Eva (2009): *Death, Modernity and the Body, Sweden 1870–1940*. Rochester, NY: University of Rochester Press.
Bishop, Jeffrey P. (2011): *The Anticipatory Corpse*. Notre Dame: University of Notre Dame Press.
Caswell, Glenys (2013): 'Managing Death in Twenty-First Century Scotland'. In Nate Hinerman and Lloyd Steffen (eds.): *New Perspectives on the End of Life: Essays on Care and the Intimacy of Dying*. Oxford: Inter-Disciplinary Press, pp. 109–128.
Caswell, Glenys and Mórna O'Connor (2015): 'Agency in the Context of Social Death: Dying Alone at Home'. *Contemporary Social Science*, 10 (3):249–261.
Caswell, Glenys and Mórna O'Connor (2019): '"I've No Dear of Dying Alone": Exploring Perspectives on Living and Dying Alone'. *Mortality*, 24 (1):17–31.
Deacon, Michael (2011): 'Why the BBC Was Right to Air Footage of a Dying Man'. *The Telegraph*, 12 May. Available online at: www.telegraph.co.uk/culture/tvandradio/8510546/Why-the-BBC-was-right-to-air-footage-of-a-dying-man.html.
Dickens, Charles (1853/1996): *Bleak House*. London: Penguin Books.
Goddard, Robert (2018): *Panic Room*. London: Corgi Books.
Gould, Georgia (2012): 'Four Days Left to Change the World'. In Philip Gould (ed.): *When I Die*. London: Abacus, pp. 145–178.
Hallam, Elizabeth A. (1996): 'Turning the Hourglass: Gender Relations at the Death Bed in Early Modern Canterbury'. *Mortality*, 1 (1):61–82.

Hardy, Thomas (1895/2001): *Jude the Obscure*. New York: The Modern Library.

Howells, Richard and Joaquim Negreiros (2012): *Visual Culture* (2nd Edition). Cambridge: Polity Press.

Inthorn, Sanna (2017): 'Audience Responses to Representations of Family-Assisted Suicide on British Television'. *Participations*, 14 (2):153–174.

Jalland, Pat (1996): *Death in the Victorian Family*. Oxford: Oxford University Press.

Jalland, Pat (1999): 'Victorian Death and Its Decline: 1850–1918'. In Peter C. Jupp and Clare Gittings (eds.): *Death in England: An Illustrated History*. Manchester: Manchester University Press, pp. 230–255.

Kastenbaum, Robert (2000): *The Psychology of Death* (3rd Edition). London: Free Association Books.

Kellehear, Allan (2007): *A Social History of Dying*. Cambridge: Cambridge University Press.

Klein, Bethany (2011): 'Entertaining Ideas: Social Issues in Entertainment Television'. *Media, Culture & Society*, 33 (6):905–921.

Lamuedra, Maria and Hugh O'Donnell (2012): 'Community as Context: EastEnders, Public Service and Neoliberal Ideology'. *European Journal of Cultural Studies*, 16 (1):58–76.

Leget, Carlo (2007): 'Retrieving the Ars Moriendi Tradition'. *Medicine, Health Care and Philosophy*, 10:313–319.

Meckier, Jerome (2015): 'Death(s) and *Great Expectations*'. *The Dickensian*, 111 (495):42–51.

Nash, Amanda (n.d.): 'Thankful for My Nan's Good Death'. *Dying Matters*. Available online at: www.dyingmatters.org/page/thankful-my-nans-good-death.

Patten, Robert L. (2016): 'Introduction'. In Robert L. Patten (ed.): *Dickens and Victorian Print Cultures*. Abingdon: Routledge.

Paulson-Ellis, Mary (2017): *The Other Mrs. Walker*. London: Picador.

Pollock, Kristian (2015): 'Is Home Always the Best and Preferred Place of Death?'. *BMJ*, 351.

Pollock, Kristian and Jane Seymour (2018): 'Reappraising "the Good Death" for Populations in the Age of Ageing'. *Age and Ageing*, 47:328–330.

Seale, Clive (2004): 'Media Constructions of Dying Alone: A Form of "Bad Death"'. *Social Science & Medicine*, 58:967–974.

Storey, John (2010): *Cultural Studies and the Study of Popular Culture* (3rd Edition). Edinburgh: Edinburgh University Press.

Storey, John (2018): *Cultural Theory and Popular Culture: An Introduction* (8th Edition). London: Routledge.

Thomas, Julia (2016): 'Happy Endings: Death and Domesticity in Victorian Illustration'. In Paul Goldman and Simon Cooke (eds.): *Reading Victorian Illustration, 1855–1875*. Abingdon: Routledge, pp. 79–96.

Tuchman, Gaye (1978): *Making News: A Study in the Construction of Reality*. New York: Free Press.

Walter, Tony (1994): *The Revival of Death*. London: Routledge.

Walter, Tony (1999): *On Bereavement: The Culture of Grief*. Maidenhead: Open University Press.

Walter, Tony, Jane Littlewood and Michael Pickering (1995): 'Death in the News: The Public Invigilation of Private Emotion'. *Sociology*, 29 (4):579–596.

Weber, Tina (2014): 'Representations of Corpses in Contemporary Television'. In Leen van Brussel and Nico Carpentier (eds.): *The Social Construction of Death*. London: Palgrave/Macmillan, pp. 75–91.

Wood, Claire (2015): *Dickens and the Business of Death*. Cambridge: Cambridge University Press.

Yodovich, Neta and Kinneret Lahad (2017): '"I Don't Think This Woman Had Anyone in Her Life": Loneliness and Singlehood in Six Feet Under'. *European Journal of Women's Studies*, 25 (4):440–454.

3 Celebrity deaths and the thanatological imagination

Ruth Penfold-Mounce

Introduction

2016 was an exceptional year in that it bore witness to a large number of high-profile celebrity deaths. It was the year that had the world on tenterhooks over who would be next and how many more celebrities would perish before midnight on 31 December. The United States and Britain had a particularly high unanticipated increase in deaths amongst the well known, including, but not limited to: singer-songwriter David Bowie, actor Alan Rickman, radio and television presenter Terry Wogan, author Harper Lee, Beatles producer George Martin, comedians Victoria Wood and Ronnie Corbett, singer-songwriter Prince, boxer Muhammed Ali, actor Gene Wilder, singer George Michael, actress-comedian Carrie Fisher, and her actress mother, Debbie Reynolds. It was a year when both nationally and internationally beloved celebrities died often with no, or limited, public expectation of their demise. A quick look at obituaries run by the BBC across radio, television, and online from January until March between 2012 and 2016 highlights a notable rise in deaths with only five in 2012 rising to 12 in 2015 and an impressive 24 in 2016. Notably there are flaws in this evidence as not all celebrities get obituaries written, and this only reflects pre-prepared obituaries. However, it does indicate that 2016 was a particularly remarkable year for the number of high-profile deaths.

Twitter was busy with discussions of each new celebrity death and bemoaned the year that claimed so many beloved stars. Even celebrities themselves took to the Twittersphere including UK television presenters Anthony McPartlin and Declan Donnelly, asking: 'Could amazing people just stop dying for a bit? Thanks' (24 March 2016). There were repeated calls for the protection of some celebrities who, due to age, were perceived as vulnerable to the curse of 2016, such as legendary television presenter and zoologist David Attenborough. Tweets included 'Somebody needs to find David Attenborough and keep him safe, I don't trust 2016 anymore' (21 April 2016) and:

> David Attenborough is a National Treasure. Protect at all costs. He needs 24/7 security, if the man sneezes we need to know he's still okay.
> 25 December 2016

Although these tweets reflect a certain light-hearted attitude towards the celebrity deaths of 2016, for David Attenborough cannot really be protected from death, they do reflect an underlying surprise and anxiety at an apparent influx of celebrity losses. President Barack Obama was right when, in a 2009 CBS News interview, he commented: 'There are certain people in our popular culture that just capture people's imagination. And in death, they become even larger'. Death is far from the end of celebrity figures. Instead it is a new realm in which they are a consumable object that inspires curiosity, gossip, and the imagination. The body may be gone, but their image and legacy thrive.

In this chapter, I will examine in three stages the increased attention to high-profile celebrity deaths through the thanatological imagination, a new concept inspired by C. Wright Mills's (1959) sociological imagination. Firstly, by engaging with the thanatological imagination, which is used to highlight that this death-focused imagination is not limited to the academy and which forms a space to explore the social potential of death. Secondly, the thanatological imagination is proposed to be a lynchpin in enabling consumers of popular culture as a 'morbid space' to explore their 'morbid sensibilities' (Penfold-Mounce 2018) and the formation of the dead as productive. Notably, morbid sensibility was originally developed to engage with the Undead – zombies and vampires – but here, in this chapter, the concept is used as a foundation from which to explore how it can also be applied to other popular culture forms, such as celebrity. Finally, the role of the thanatological imagination in the morbid space of popular culture is explored through dead celebrities' posthumous careers. Using examples of how dead celebrities continue to work after death sheds light on how the thanatological imagination has been inspired within a range of non-thanatological professions and highlights its significance as a catalyst for consumers to engage with issues of human mortality.

The sociological imagination and thanatology

Many still hold the statements of C. Wright Mills (1959) on the 'sociological imagination' – now over a half century old – as a call to intellectual arms for the field of sociology. It is important to remember that when he used this term, he was not referring to 'merely the academic discipline' (Mills 1959:19, n2). Indeed, he was often very critical of what passed for academic sociology, and one cannot help but speculate that, were he alive today, he would have been just as disparaging of currently fashionable styles of theoretical work as he was of Talcott Parsons's 'grand theory' and the 'abstracted empiricism' of Paul Lazarsfeld (see Mills 1959, chapters 2 and 3). Neither is it likely that he would have found much of what he intended by a 'sociological imagination' in contemporary modes of statistical reasoning (Uprichard, Burrows and Byrne 2008). Mills was always extremely clear that the sociological sensibility he was concerned with could exist in any number of different cultural

locations. He found it, for example, 'in much English journalism, fiction, and above all history' (Mills 1959:19, n2) and that 'the sociological features of man's fate in our time . . . are carried by men of letters rather than by professional sociologists' (Mills 1959:19, n2).

The functioning of the sociological imagination outside the academy has received attention and been applied to various ideas including cinema sociology as a teaching tool (Prendergast 1986), an exploration of Bauman's poetic sociological imagination (Jacobsen and Marshman 2008), and even J. Edgar Hoover's FBI surveillance as sociologically imaginative (Keen 1999). Olli Pyyhtinen (2016) has even called for the sociological imagination to be restructured in order to aid sociology in responding to an ever-more-complicated world. Interestingly, criminologists have long embraced the value of the imagination in their study of crime, justice, and punishment dating right back to the Chicago School, which produced classic ethnographic and biographical texts (see Thomas and Znaniecki 1918; Anderson 1923; Shaw 1930). In fact, William Thomas and Florian Znaniecki's (1918) work is often acknowledged as the origin of the biographical approach in sociological research and is regarded as the 'founding work' of American Sociology (Zaretsky 1996:ix). The result of a criminological imagination has been that ethnographic, narrative, biographical, and even walking methods (O'Neill et al. forthcoming) have been used as a critical sociological space in which to understand crime and criminal justice (Carlen 2017; Young 2011).

The attention the sociological imagination has paid to popular culture is of particular pertinence to this chapter (Beer and Burrows 2010; Penfold-Mounce, Beer and Burrows 2011; Reed and Penfold-Mounce 2015). The cultural location of a sociological imagination within popular culture has been examined through social experiment television (such as *Big Brother*) to *The Walking Dead* and *The Wire* to celebrity and web-based cultures. The focus in these explorations has been in terms of debating contemporary analysis and the future of sociology as an academic discipline. However, in this chapter, the role of popular culture in the sociological imagination embraces David Beer and Roger Burrows's (2010:245) assertion that 'the sociological imagination has now become a highly prominent part of what contemporary popular culture is'. The sociological imagination within popular culture engages with a broad range of key themes and issues including but not limited to inequalities in terms of class, race, gender, and mortality. Death is a recurring component within a variety of popular culture packaged as entertainment. Consequently, in this chapter, the sociological imagination in popular culture is proposed to have evolved and developed an offshoot imagination – the thanatological imagination. It is in this new imagination, focused on mortality, that what we will call non-professional thanatologists engage with death matters and contribute to the advancement of examining issues of mortality outside the academy. It is where death and the dead are able to engage with and provoke the living to consider mortality despite persistent public belief that death is taboo (Penfold-Mounce 2018).

The thanatological imagination highlights how interests of sociology into mortality have spread beyond the confines of the discipline and contribute to the transformation of expectations and understandings of sociology beyond the academy. It offers a publicly consumed face of 'thinking sociologically' (Beer and Burrows 2010:249–250) through a lens of death. Whilst the sociological imagination focuses on the development of critical thinking beyond the academy, the thanatological imagination also cultivates a space for an exploration of the social potential of death, particularly in terms of consumerism and markets. The thanatological imagination is engaged with and displayed effectively by both popular culture's very direct engagements with death (see HBO's *Six Feet Under*, 2001–2005) and the huge range of subtle insertions of death, dying, and the dead into television drama and children's shows, music, comic books, and films. Sometimes death is explicitly shown whilst at other times it is off screen leaving the consumer to imagine what is occurring. Whether it is direct or indirect, mortality is played out in multiple ways in globally consumed popular culture forms. The thanatological imagination recognizes that death matters matter (Penfold-Mounce 2019) and makes them accessible and consumable by all.

Thanatological imagination, morbid space, and morbid sensibility

The thanatological imagination within popular culture carves out a 'morbid space' (Penfold-Mounce 2016, 2018), in which issues of mortality are consumed. Morbid space conceptualizes spaces that are consumed, lived within, or moved through that are interwoven with death. So this can include cemeteries, morgues, pathology labs, or sites of individual or mass execution or disaster; it is where the dead are or have been. These morbidly inclined spaces enable an exploration of the boundaries surrounding mortality and how these can be crossed or reinforced. They exemplify how corpses and death are far from taboo but are instead ordinary and normalized whilst also becoming popularized, eroticized, and even at times celebrated alongside societal ambivalence (Penfold-Mounce 2016:11). Significantly morbid space is not limited to the actual spaces that contain or have contained corpses. It also includes where death and dead bodies appear in popular culture, including that which targets the young such as children's films, television shows, books, and fashion. Popular culture as a morbid space embraces death with the intent to entertain, divert, and amuse the consumer. Death becomes popularist and an easily consumed 'infotainment commodity' (Foltyn 2008:155) and both a stimulant and space for the thanatological imagination. As a morbid space, popular culture forms a place in which social and cultural issues can be explored by the consumer, but it does not necessarily create a conversational language to talk about mortality. For example, watching crime dramas which portray multiple deaths does not cause all viewers to be more willing to discuss their own personal demise or those of their loved ones. However,

these dramas can facilitate wider discussions about mortality; they become stepping stones to bridge the fissure identified in a society where death is perceived as 'taboo' (see Walter 1991; Kellehear 1984).

Death portrayals within the morbid space of popular culture provide a safe imaginative environment in which consumers can consume mortality without direct consequence or full sensory exposure (see Penfold-Mounce 2018). Death is far from realistic in popular culture despite hinting at authenticity – there is no smell of decomposition or drip of body fluid or the noise of tools opening a skull. The dead remain a visual feast designed to be suitably gruesome (the US television series *Bones*, which focused on a forensic anthropologist, is a prime instance) and aided by music montages that ease the viewer through the forensic science processes of the investigation. The plethora of death content in popular culture has led to Dina Khapaeva (2017:11–12) arguing that it can have therapeutic effects, reflecting Keith Durkins's (2003) suggestion that popularist portrayals of mortality can diminish any lingering 'primordial terror' as they are less frightening than real death. The morbid space of popular culture fosters a safe space in which fear of death is nullified, and the overly dramatic, ostentatious lack of realism highlights the thanatological imagination which created it whilst also feeding consumers' morbid sensibility (Penfold-Mounce 2018).

The thanatological imagination interweaves with morbid sensibility (Penfold-Mounce 2018), in that it allows people to respond to and deliberate death and the dead within popular culture. Together, morbid sensibility and the thanatological imagination offer an abstract framework to encapsulate how feelings, ideas, and beliefs about mortality are processed through consuming or moving through a popular culture–defined morbid space. In the morbid spaces of popular culture, sensibilities about death can be explored without concern of being censured or criticized for being overly macabre. Morbid sensibility within popular culture enables people to look at what is largely avoided in the real world: 'that ultimately all of humanity will eventually rot and decay without thought or control' (Penfold-Mounce 2018:66). The thanatological imagination enables morbid sensibilities to flourish in relation to death within the morbid space of popular culture.

The use of the thanatological imagination to create a morbid space that stimulates morbid sensibility can often be controversial. The use of death as a defining theme in fashion shoots is a prime example. For example, the Dutch supermodel Doutzen Kroes posed as a fetishized child with toy bears in a 2007 for *W*. She appeared to have been ravished by the toys or a human predator and left for dead, evoking a sexual subculture referred to as 'furries' where people wear outlandish fur costumes to have sex (see Foltyn 2011). Likewise, certain types of death are more contentious than others, such as suicide. When *Vice* magazine ran a 'Last Words' fashion spread featuring models re-enacting the suicides of female authors including Virginia Woolf, Sylvia Plath, Iris Chang, and Charlotte Perkins, it was received with outrage.[1] The context of these images as a fashion editorial lay at the heart of the response as

it led to an interpretation of the magazine glorifying and beautifying suicide.[2] In both these examples, the thanatological imagination of those who are not professional thanatologists is provocative of consumers' morbid sensibilities and mirrors Mills's (1959) sociological imagination, in which it is not professional sociologists who lead the way to actively engaging the public with social issues.

The thanatological imagination as a facilitator of morbid sensibility in consumers reflects the aim of Andrew Abbott's lyrical sociology, which is to stimulate and engage the 'emotional imagination' of the reader. His suggestion, similar to Mills's (1959) sociological imagination views, is that this is something that the academy does not do often enough. For Abbott, the focus should be upon capturing the location, the moment, and the emotion unmediated by prior moral sensibilities. Consequently, Abbott's lyrical sociology

> looks at a social situation, feels its overpowering excitement and its deeply affecting human complexity, and then writes . . . trying to awaken those feelings in the minds – and even the hearts – of . . . readers.
>
> Abbott 2007:70

He suggests that sociologists should imagine a kind of sociology that is not just narrative because there is a need to go beyond a standardized telling of sociological ideas and research. This does not mean that it cannot contain narrative elements, but it means that its ultimate framing structure should not be the telling of a story – recounting, explaining, comprehending – but rather the use of a single image to communicate a mood, an emotional sense of social reality (Abbott 2007:73). When applied to the study of death and the thanatological imagination, a lyrical-morbid sensibility becomes possible. It is where 'we hear the whisper of possibility and the sigh of passage. (Abbott 2007:90) as the thanatological imagination offers the chance to form lyrical empathetic connections with consumers' morbid sensibilities.

Adopting a lyrical approach to popular culture–based morbid sensibility enables the thanatological imagination to stimulate morbid sensibilities through representations of the dead of whom the Undead are of particular significance. The Undead – namely zombies and vampires – become a lyrically powerful vehicle to allow people to deliberate their emotions and sensibilities surrounding death, the dead, and human mortality and ultimately how 'death infect[s] life' (Kristeva 1982:4). As a cultural object, their agency is rooted in stimulating and enabling viewers' imaginations about death and mortality as well as wider issues about social life, values, and ideologies (Platts 2013). As reanimated corpses, which are consumed as entertainment, the Undead indulge the morbid sensibilities of viewers whilst allowing for and inspiring very different emotional engagements with shared social and cultural anxieties. The Undead as lyrically imaginative enable consumers to consume mortality and to connect with broader sociological themes. For example, portrayals of vampires as in *True Blood* and *Twilight* encourage

consideration of gender and sexuality, ageing, kinship, and violence (see Durham 2012; Franiuk and Scherr 2013) whilst zombies explore matters of globalization, health and illness, and identity (see Behuniak 2011). As such, the Undead are a useful vehicle for lyrical-morbid sensibilities as cultivated by film and television makers' thanatological imaginations. For, as Nick Muntean and Matthew Payne write, 'to say that the zombie [or vampire] is fictional is not to say that it does not comment on the real' (Muntean and Payne 2009:245). The Undead and other fictional dead in popular culture are effective in reflecting and reproducing aspects of the real social world. Consequently, the thanatological imagination creates a thriving morbid space in popular culture where the morbid sensibilities of consumers exert a lyrical approach to death.

Celebrity deaths, the productive dead, and the thanatological imagination

Celebrity as a form of popular culture has been instrumental in stimulating the thanatological imagination and lyrical-morbid sensibilities in consumers as they become part of everyday conversation and consumed as entertainment (Penfold-Mounce 2016). The celebrity dead are the 'special dead' (McCormick 2015; Heinich 1996) who do not truly die and are capable of labour after death with the input of the living (Penfold-Mounce 2018; Kearl 2010). Dead celebrities are a catalyst for the thanatological imagination amongst their families, professionals in marketing and advertising, and legal professionals, largely due to the financial value of the celebrity even after death. The value of celebrities does not end with the demise of their physical bodies for the images cultivated in life continue in consumable products, including photographs, films and television shows, songs and lyrics, and the images they projected as representations of themselves – e.g., witty and glamourous or sexy and inaccessible. It is the possibilities offered by the existence of celebrity image or 'afterimage' (see Jones and Jensen 2005) once the death of the physical body has occurred that inspires the thanatological imagination and has led to the development of lucrative and busy posthumous careers. The celebrity dead truly are 'the productive dead' in terms of labour and creating a space for consumers to consider issues of mortality.

The thanatological imagination of non-professional death scholars enables death to become a productive stage within a celebrity's working life. In a consumer-driven mediated society apparitions of the celebrity dead are still producing new material as an entertaining consumable. The celebrity dead have never been more active or consumable for if they were well known in life they can be 'the productive dead' after death. Dead celebrities are becoming immortal: a catalyst for the thanatological imagination that cultivates a morbid popular culture–based space where consumer's morbid sensibility can be lyrically explored in relation to the moral, ethical, and legal questions surrounding the implications of the dead continuing to work.

The thanatological imagination is embodied by the active posthumous careers of the celebrity dead as they are endorsers of multiple products – James Dean has worn Lee jeans, Fred Astaire has danced with a Dirt Devil vacuum, Grace Kelly and Marilyn Monroe appear in adverts for Dior perfume, and Steve McQueen has promoted Ford's Puma and Mustang cars. Meanwhile, Audrey Hepburn has endorsed Galaxy chocolate with the help of CGI and the music 'Moon River' from her iconic role in *Breakfast at Tiffany's*. Notable posthumous careers are not limited to Hollywood stars or the music elite; even Albert Einstein has a vibrant career via his own range of T-shirts, posters, and tablets and has lent his name and intellectual status to *Baby Einstein* products. In all these instances, the symbolic value of the dead celebrity, in terms of their face, reputation, and work and accomplishments during life, extends to the products they are associated with after death. Death does not detract from the financial gains that can be made from a union of celebrity image with products, goods, and services which are consumed on a global scale.

The celebrity dead, through the thanatological imagination, go beyond simply being resurrected and used in advertisements and the endorsement activities of various products and services. Dead celebrity musicians now produce music, which is officially recognized as 'new', therefore effectively producing new products that produce revenue. For example, Natalie Cole's recording of *Unforgettable* with her dead father Nat King Cole's vocals won a Grammy for Best Album of the Year in 1991. Meanwhile, in the UK, posthumous number ones have occurred 19 times since 1959, with Elvis Presley achieving the most success since his death in 1977. Presley has produced four posthumous number ones through the reuse of his vocals that are considered new material: *A Little Less Conversation* was remixed by Junkie XL for a Nike television advert (2002) whilst *Jailhouse Rock* (2005), *One Night/I Got Stung* (2005), and *It's Now or Never* (2005) were re-released to mark what would have been Presley's 70th birthday. Notably, the dead can even be rivals on the music charts, with George Harrison's *My Sweet Lord* knocking Aaliyah's *More Than a Woman* off the top spot in January 2002, marking the first time that one deceased artist was replaced by another at number one. The productive celebrity dead emerge from the thanatological imagination of professionals in the entertainment industry who are not necessarily inspired to think critically but to use them as a source of revenue.

Recording new music despite being dead is not the only agency displayed by the celebrity dead. Some even return to the stage and perform live in concert – Tupac Shakur performed at the 2012 Coachella Valley Music and Arts Festival, and Michael Jackson did the same at the Billboard Music Awards in 2014. Meanwhile, world tours have been conducted by dead celebrity musicians in the form of holograms that perform to live audiences courtesy of BASE Hologram, part of BASE Entertainment.[3] For example, opera singer Maria Callas conducted a world tour in 2018 and 2019, as did Roy Orbison, who was accompanied by Buddy Holly on his second tour. The financial value associated with this holographic embodiment of the

thanatological imagination has led to conflict, with two companies entering into a legal battle over the rights to hologram and digital projection technology.[4] Meanwhile there has been a mixed response from audiences to such performances as they grapple with their morbid sensibilities, leading to reports of being both thrilled and uncomfortable.[5]

Perhaps the most controversial expression of the thanatological imagination using dead celebrities, provoking the strongest ethical and moral morbid sensibilities amongst consumers, is acting performances by the dead in film. Here, the thanatological imagination of filmmakers collapses the boundaries between death and life. Film performances by the celebrity dead create new, original performances beyond simply inserting past performances into television adverts. For example, James Dean has starred in a short film by South African investment company executive Allan Grey titled *Legend* (2009), using a body double, makeup prosthetics, and CGI. It was hailed by film critic Barry Ronge as 'the perfect blend of simple story-telling, superlative camera effects, and the smartest use of a celebrity we have seen in a decade'.[6] Peter Cushing, who died in 1994, was digitally resurrected for *Rogue One* (2016) whilst Carrie Fisher, who died two weeks before the release of the film, appeared as her 19-year-old self. In these three instances, the celebrity dead provided a new and original performance after death for consumers to consume. They contributed performances through technological advancements that enable body doubles to stand in for the deceased, combined with motion-capture and facial expression trackers that are then used to animate footage and photographs of the dead. These technological advancements inspire the thanatological imagination as the dead are able to continue to work. They are both absent and present, offering a challenge to post-mortem social death (see Jonsson 2015) and become a new form of the Undead, who interact with the living but with no direct personal agency or sense of self. Consequently, they possess great social potential to contemplate death by consumers.

The thanatologically imaginative morbid space of popular culture where the celebrity dead continue to work provokes ethical and moral considerations within the morbid sensibilities of consumers. Questions emerge over how to grant the celebrity dead dignity and whether their posthumous career accurately reflects choices they would want or they are being exploited for financial gain. A range of defences has been offered regarding the ethics of working with a dead actor without their personal input (although the family or agent of the dead celebrity will be consulted). For example, in relation to Peter Cushing's performance in *Rogue One* (2016), John Knoll, the visual effects supervisor, asserted:

> We weren't doing anything that I think Peter Cushing would've objected to. . . . We know that Peter Cushing was very proud of his involvement in Star Wars and . . . regretted that he never got a chance to be in another Star Wars film because George [Lucas] had killed off his character. . . . This was done in consultation and cooperation with his estate. So we

wouldn't do this if the estate had objected or didn't feel comfortable with this idea.[7]

Dead actors performing new roles after death raises questions of who should profit and who gets a say in how the role is performed. The conflict that can emerge over the posthumous careers of celebrities certainly inspires the legal profession's thanatological imagination. The legal conflict over who owns the celebrity dead flourishes, as illustrated by Marilyn Monroe[8] and Jimi Hendrix.[9] In both cases, litigation ensued regarding how their images should be used and who should control and profit from their posthumous careers, demonstrating that the productive dead have significant legal implications relating to control and financial value.

Notably, the thanatological imagination, as it has been embraced by legislators and legal professionals, has influenced celebrities to develop their own imaginative approach to death matters. For example, actor and comedian Robin Williams was the first case of a celebrity very explicitly and creatively managing their posthumous career. In 2014, two years before his death, Williams safeguarded his posthumous career via a significant revision to the Robin Williams Trust. This revision entailed a detailed description of how he intended to be used in any publicity and passed on his legal 'right of publicity' (which comprises the components of celebrity image: their name, likeness, voice, signature, and photograph) to the Windfall Foundation, set up in his name. These revisions mean that his estate avoids paying estate tax on his 'right of publicity' for up to 70 years after death (see Heller 2007) but also set in motion a post-mortem social death on his own terms (Jonsson 2015). Although he granted his 'right of publicity' to the Windfall Foundation, he forbade them from using the rights until August 2039, thus effecting a significant limitation to his posthumous career and earnings associated with image licensing after his death.[10] Williams appears to have predicted his future after death and used his thanatological imagination to creatively plan and manage his posthumous career by formulating an alternative to passing over full control of his celebrity image to family or a brand management company. Consequently, a dead celebrity can remain in control and ownership of themselves by leaving strict instructions for how they wish their posthumous career to be conducted and their symbolic and financial value to be utilized. However, there is a time limit for such control, with Williams only securing self-governance of himself and his symbolic and financial value for 25 years after his death.

Avoiding, or at least limiting, a career after death is possible, as illustrated by Williams, but needs to be very carefully legally framed. The technological marvels of special effects, allowing celebrities to keep performing after death, challenges consumers' morbid sensibilities as it raises the legal implications of the dead working and the moral obligations the living have towards the dead. Significant questions are raised for those celebrities who have not used their thanatological imaginations like Williams did and have failed to exert control over their posthumous careers. For example, who gets paid and credited for a digital performance of a dead celebrity, especially if a stand-in actor is

used? Does the family or agent controlling the dead celebrity's posthumous career have to grant permission if a likeness is used from pre-existing footage under licence to a movie studio? Could the dead be resurrected and employed instead of the living because a director thinks they would be perfect for the role? Legal protection of a likeness or image is difficult even under evolving intellectual property law unless specific steps are taken prior to death to protect the image. This means that permission from the dead celebrity, their agent, or their family to use footage or images of them might not be legally necessary. The return of the celebrity dead to both the music and acting world reveals a socially important space which engages consumers' morbid sensibilities as a consequence of the thanatological imagination of the film industry, marketing and advertising experts, and legal professionals who keep celebrity careers going, turning them into 'the productive dead'. Significantly, the implication of the dead not remaining dead blurs the boundaries of mortality and ultimately prevents celebrities from truly crossing the boundary into death (see Králová 2015). The celebrity dead linger and are active amongst the living, forming a new type of Undead that sparks the thanatological imagination and consumers' morbid sensibilities.

Conclusion

The celebrity dead and their posthumous careers are an example of popular culture that stimulates not the sociological imagination (Mills 1959) but a thanatological imagination. It is this death-based imagination that is stirred amongst those who do not consider themselves thanatologists, particularly in the professions of filmmaking, marketing, advertising, and law, to engage both implicitly and explicitly with issues of mortality. For these professionals, the thanatological imagination is inspired and evidenced through their critical engagement with matters of death and the dead – challenging the line drawn between death and life as well as pushing at ethical and moral boundaries and deeply held beliefs and understandings of death. The thanatological imagination goes further than critical thinking about mortality; it also generates a morbid space allowing an exploration of the social potential of death, particularly in relation to consumerism. Notably, a key limitation of the thanatological imagination is that it can be exercised without in-depth self-reflection by those using it. Consequently, a role of thanatologists can be to highlight the use of the thanatological imagination in research and public engagement work to aid in discussion and debate about mortality.

The celebrity dead are an effective illustration of a popular culture morbid space and how it stimulates morbid sensibilities amongst global consumers (Penfold-Mounce 2018). They are significant in terms of provoking not just a lyrical sociology (Abbott 2007) that engages the emotional imagination, but a lyrical-morbid sensibility. In the morbid space of dead celebrities' posthumous careers, emotions and views about mortality can be explored in a safe depersonalized space. Through popular culture, death and the dead have never been more accessible or visible, with the celebrity dead playing an

important role as an inventive mobiliser of the thanatological imagination. Singer Nick Cave (1996)[11] sang 'just remember that death is not the end', and this is inherently accurate in terms of celebrities who die. Their deaths are not the end, or even an end, but a catalyst engaging the thanatological imagination as well as morbid sensibilities amongst consumers.

Notes

1 Jenna Sauers (2013): 'Vice Published a Fashion Spread of Female Writer Suicides', *Jezebel* 17 June, available online at: https://jezebel.com/vice-published-a-fashion-spread-of-female-writer-suicid-513888861; Paul Gallaher (2013): 'Vice Pulls "Breathtakingly Tasteless" Fashion Shoot Glorifying the Suicides of Famous Female Authors from Sylvia Plath to Virginia Woolf', *Independent*, 1st June, available online at: www.independent.co.uk/arts-entertainment/books/news/vice-pulls-breathtakingly-tasteless-fashion-shoot-glorifying-the-suicides-of-famous-female-authors-8663905.html.

2 Lexi Nisita (2013): 'VICE's Suicide-Themed Fashion Feature: Art, Offensive, or Both?', *Refinery*, 18 June, available online at: www.refinery29.com/en-us/2013/06/48638/vice-suicide-fashion-photos.

3 https://basehologram.com/.

4 Eriq Gardner (2016): 'Michael Jackson Hologram Dispute Is Settled', *BillBoard*, 17 March, available online at: www.billboard.com/articles/news/7263758/michael-jackson-hologram-dispute-settled.

5 Lisa Respers France (2014): 'Michael Jackson's Hologram: Creepy or Cool?', *CNN*, 19 May, available online at: http://edition.cnn.com/2014/05/19/showbiz/michael-jackson-hologram-billboard-awards/index.html.

6 D. Smith (2009): 'James Dean Lives on in South African–Made TV Commercial', *The Guardian*, 21 September, available online at: www.theguardian.com/media/2009/sep/21/james-dean-television-commercial-advertisement.

7 Andrew Pulver (2017): 'Rogue One VFX Head: We Didn't Do Anything Peter Cushing Would've Objected To', *The Guardian*, 16th January, available online at: www.theguardian.com/film/2017/jan/16/rogue-one-vfx-jon-knoll-peter-cushing-ethics-of-digital-resurrections.

8 Ben Child (2012): 'Marilyn Monroe's Estate Loses Right to Charge for Image Use', *The Guardian*, 3rd September, available online at: www.theguardian.com/film/2012/sep/03/marilyn-monroe-estate-image-rights.

9 Daniel Kreps (2015): 'Jimi Hendrix's Estate Settles Licensing Legal Battle', *Rolling Stone* 15 August, available online at: www.rollingstone.com/music/music-news/jimi-hendrixs-estate-settles-licensing-legal-battle-190748/.

10 Natalie Robehmed (2015): 'Why Robin Williams Won't Be Making Millions Beyond the Grave', *Forbes*, 27th October, available online at: www.forbes.com/sites/natalierobehmed/2015/10/27/why-robin-williams-wont-be-making-millions-beyond-the-grave/#1240b589435f; Hannah Ellis-Petersen (2015): 'Robin Williams Went Above and Beyond to Stop His Image Being Used', *The Guardian*, 31 March, available online at: www.theguardian.com/film/2015/mar/31/robin-williams-restricted-use-image-despite-existing-us-laws.

11 nickcave.Com https://www.nickcave.com/lyric/death-is-not-the-end/

References

Abbott, Andrew (2007): 'Against Narrative: A Preface to Lyrical Sociology'. *Sociological Theory*, 25 (1):67–99.

Anderson, Nels (1923): *The Hobo: The Sociology of the Homeless Man*. Chicago: University of Chicago Press.

Beer, David and Roger Burrows (2010): 'The Sociological Imagination as Popular Culture'. In Judith Burnett, Syd Jeffers and Graham Thomas (eds.): *New Social Connections*. London: Palgrave/Macmillan, pp. 233–252.

Behuniak, Susan (2011): 'The Living Dead? The Construction of People with Alzheimer's Disease as Zombies'. *Ageing & Society*, 31 (1):70–92.

Carlen, Pat (2017): *A Criminological Imagination: Essays on Justice, Punishment, Discourse*. London: Routledge.

Durham, Meenakshi Gigi (2012): 'Blood, Lust and Love: Interrogating Gender Violence in the Twilight Phenomenon'. *Journal of Children and Media*, 6 (3):281–299.

Durkin, Keith F. (2003): 'Death, Dying and the Dead in Popular Culture'. In Clifton D. Bryant (ed.): *Handbook of Death and Dying* (Volume 2). London: Sage Publications, pp. 43–49.

Foltyn, Jacque Lynn (2008): 'Dead Famous and Dead Sexy: Popular Culture, Forensics, and the Rise of the Corpse'. *Mortality*, 13 (2):153–173.

Foltyn, Jacque Lynn (2011): 'Corpse Chic: "Dead" Models and "Living" Corpses in Mainstream Fashion Magazines'. In Jacque Lynn Foltyn (ed.): *Fashions: Exploring Fashion through Culture*. Oxford: Inter-Disciplinary Press, pp. 269–294.

Franiuk, Renae and Samantha Scherr (2013): '"The Lion Fell in Love with the Lamb": Gender, Violence, and Vampires'. *Feminist Media Studies*, 13 (1):14–28.

Heinich, Nathalie (1996): *The Glory of Van Gogh: An Anthropology of Admiration*. Princeton, NJ: Princeton University Press.

Heller, Kathy (2007): 'Deciding Who Cashes in on the Deceased Celebrity Business'. *Chapman Law Review*, 11:545–568.

Jacobsen, Michael Hviid and Sophia Marshman (2008): 'Bauman's Metaphors: The Poetic Imagination in Sociology'. *Current Sociology*, 56 (5):798–818.

Jones, Steve and Joli Jensen (eds.) (2005): *Afterlife as Afterimage: Understanding Posthumous Fame* (Volume 2). New York: Peter Lang.

Jonsson, Annika (2015): 'Post-Mortem Social Death: Exploring the Absence of the Deceased'. *Contemporary Social Science*, 10 (3):284–295.

Kearl, Michael C. (2010): 'The Proliferation of Postselves in American Civic and Popular Cultures'. *Mortality*, 15 (1):47–63.

Keen, Mike Forrest (1999): *Stalking the Sociological Imagination: J. Edgar Hoover's FBI Surveillance of American Sociology* (No. 126). Westport, CT: Greenwood Publishing Group.

Kellehear, Alan (1984): 'Are We a "Death-Denying" Society? A Sociological Review'. *Social Science & Medicine*, 18 (9):713–721.

Khapaeva, Dina (2017): *The Celebration of Death in Contemporary Culture*. Michigan: University of Michigan Press.

Králová, Jana (2015): 'What Is Social Death?'. *Contemporary Social Science*, 10 (3):235–248.

Kristeva, Julia (1982): 'Approaching Abjection'. *Oxford Literary Review*, 5 (1/2):125–149.

McCormick, Lisa (2015): 'The Agency of Dead Musicians'. *Contemporary Social Science*, 10 (3):323–335.

Mills, C. Wright (1959): *The Sociological Imagination*. New York: Oxford University Press.

Muntean, Nick and Matthew Thomas Payne (2009): 'Attack of the Livid Dead: Recalibrating Terror in the Post-September 11 Zombie Film'. In Andrew Schopp and Matthew Hill (eds.): *The War on Terror and American Popular Culture: September 11 and Beyond*. Madison: Fairleigh Dickinson University Press, pp. 239–258.

O'Neill, Maggie, Ruth Penfold-Mounce, David Honeywell, Matt Coward-Gibbs, Harriet Crowder and Ivan Hill (forthcoming): *Creative Methodologies for a Mobile Criminology: Walking as Critical Pedagogy on the Move*.

Penfold-Mounce, Ruth (2016): 'Corpses, Popular Culture and Forensic Science: Public Obsession with Death'. *Mortality*, 21 (1):19–35.

Penfold-Mounce, Ruth (2018): *Death, the Dead and Popular Culture*. Bingley: Emerald Publishing Limited.

Penfold-Mounce, Ruth (2019): 'Mortality and Culture: Do Death Matters Matter?'. In Tora Holmberg, Annika Jonsson and Fredrik Palm (eds.): *Death Matters: Cultural Sociology of Mortal Life*. London: Palgrave/Macmillan.

Penfold-Mounce, Ruth, David Beer and Roger Burrows (2011): '*The Wire* as Social Science-Fiction?'. *Sociology*, 45 (1):152–167.

Platts, Todd K. (2013): 'Locating Zombies in the Sociology of Popular Culture'. *Sociology Compass*, 7 (7):547–560.

Prendergast, Christopher (1986): 'Cinema Sociology: Cultivating the Sociological Imagination through Popular Film'. *Teaching Sociology*, 14 (4):243–248.

Pyyhtinen, Olli (2016): *More-Than-Human Sociology: A New Sociological Imagination*. London: Springer.

Reed, Darren and Ruth Penfold-Mounce (2015): 'Zombies and the Sociological Imagination: *The Walking Dead* as Social-Science Fiction'. In Laura Hubner, Marcus Learning and Paul Manning (eds.): *The Zombie Renaissance in Popular Culture*. London: Palgrave/Macmillan, pp. 124–138.

Shaw, Clifford R. (1930): *The Jack Roller: A Delinquent Boy's Own Story*. Chicago: University of Chicago Press.

Thomas, William and Florian Znaniecki (1918): *The Polish Peasant in Europe and America*. Boston: The Gorham Press.

Uprichard, Emma, Roger Burrows and David Byrne (2008): 'SPSS as an "Inscription Device": From Causality to Description?'. *The Sociological Review*, 56 (4):606–622.

Walter, Tony (1991): 'Modern Death: Taboo or Not Taboo?'. *Sociology*, 25 (2):293–310.

Young, Jock (2011): *The Criminological Imagination*. Cambridge: Polity Press.

Zaretsky, Eli (1996): 'Introduction'. In William Thomas and Florian Znaniecki (eds.): *The Polish Peasant in Europe and America: A Classic Work of Immigration History*. Chicago, IL: University of Illinois Press, pp. ix–xvii.

4 The *Penguin* and the *Wahine*

Shipwrecks, resilience, and popular culture

Ruth McManus, Denise Blake and David Johnston

Introduction

On 12 February 1909, the SS *Penguin* foundered, and 75 were lost. On 10 April 1968, the *Wahine* sank with a loss of 54 souls. Both passenger ferries, they were lost to storms in the treacherous waters of the Cook Strait, Aotearoa New Zealand. On 12 February 2009 and 10 April 2018, crowds gathered on the foreshore of Wellington Harbour as part of the 100th and 50th anniversaries of the *Penguin* and *Wahine* disasters, respectively. Shared through globally syndicated networks, local news media ran special features to publicize the anniversaries. For those who wanted to attend, memorial services were held, and new plaques were unveiled. Locals and tourists alike were also guided to the permanent exhibitions and cultural excursions at local museums and cemeteries. And, for the *Wahine* commemoration, there was a gathering for remaining survivors, displays, and a flotilla steam-past of over 40 boats, including some used in the rescue 50 years before. These commemoration activities were feeding into and off a rich seam of memorialization practices embedded in a diverse range of popular culture forms. News media, documentaries, cemetery tours, and historical exhibitions were all at work normalizing death and the dead in particular ways – as binding the dead in service to the needs of a global, risk-orientated society.

This chapter explores popular culture's impact on how we engage with and understand death and the dead. As argued by Ruth Penfold-Mounce, popular culture generates 'complex cultural conversations that create and perpetuate rich narratives that allow an engagement with what it means to die and what it takes to matter in the world' (Penfold-Mounce 2018:3). When we consider popular culture and disasters together, stories of disasters may work as both models for and models of social practices. This is because mass media and entertainment are important avenues through which people acknowledge significant loss of life. As disasters enter into popular culture, the presence of the dead becomes normalized outside personal experience or the death industry – death is not questioned, but accepted and consumed (Penfold-Mounce 2018). What gets consumed can therefore impact social practice, and stories about disasters can therefore impact how we respond. As Anders Ekstrom and Kyrre Kverndokk (2015) note, within popular culture, the

'myriad of stories about disasters are structured around a limited number of narrative forms and motifs – the theodicy, the apocalypse, the state of exception and trauma. This repertoire of cultural patterns not only structures how we imagine disasters, they also structure how we handle disaster' (Ekstrom and Kverndokk 2015:358). In this chapter, we argue that this funneling of disaster narrative is observable in the current commemorative story-telling associated with two historical Aotearoa New Zealand shipwrecks. While the Penguin happened over 100 years ago and the Wahine over 50, and despite a significant shift from photography and print to live-recording news reportage at the time of the disasters, both are subjected to the same restrictive narratives that repeat through a wide range of interconnected popular culture platforms. The form that this funneling takes, i.e. the kind of narratives that dominate, tells us something about how death is understood in the contemporary globally syndicated age.

Yasmin Ibrahim reminds us that 'the communal consumption and experience of pain and suffering can be fundamentally social . . . enabling human communion through media narratives' (Ibrahim 2010:122). When news of disasters is broadcast, often the tone is of 'factual' information representing the events as they unfold. As hours and days pass, reports broaden to include not just information about, for instance, funerals and inquests, but also human-interest stories particularly of survivors or those who died aiding others in danger. As months and perhaps years pass, commentaries and opinions on investigations, public inquiries, and memorial and commemoration events add successive layers of stories and meanings associated with the disasters – and in doing so connect cultural understandings to material forms such as wreckage, gravesites, tombstones, memorial plinths, and museum displays (Jones 2007). The form and content of these mediated messages serve to shape and be shaped by broader social narratives of disaster and therefore ways in which we cope with them, conventionally understood through concepts of resilience. Cultural domains and social-organizational structures connect in complex relationships as disaster culture and disaster management engage in the interface that is memorialization. It is important therefore to pay attention to how disaster reportage and story-telling guide survivors and broader communities towards particular forms of memorialization that encourage a distinctive understanding of resilience. Furthermore, we examine how those understandings of resilience sit with resilience models that underpin institutional efforts to forestall, manage, and mitigate disasters.

To do this, we closely examine the ways in which two shipwrecks are memorialized and commemorated through mass media news; commemorative public events; communal acts of remembrance; the making, placing, and visiting of public memorials; the publication of memoirs; hosting curated exhibitions; and constructing memorial culture walks. We recount how the two tragedies are commemorated to show how a particularly restrictive narrative of resilience shapes them. We explain that, while each shipwreck is from a different decade, the post-disaster commemorations, as forms of popular culture, collectively constitute how these deaths are understood. We observed

a funneling of available narratives towards theodicy and exceptionalism and away from technological failure and responsibilization. In that narrative limitation, we also observed what we think is a significant cultural tension in how death and the dead are positioned in relation to the living. On the one hand, those killed in the disasters are 'used' to encourage a particular model of resilience in those who consume the narratives. On the other hand, the popular culture narrative of resilience seems to stand against and undermine disaster management narratives of resilience that 'use' the dead as warnings to be heeded by the living. We argue that this discordant relationship between disaster culture and disaster management is an outcome associated with Ulrich Beck's (1999) *World Risk Society*. As the living engage with the dead through multiple forms of resilience-orientated disaster culture, they are offered discourses that construct, contest, and critique the management of risk as they participate as self-reflexive, risk-orientated individuals living in the second modernity (Beck 1999, 2014).

The *Penguin* disaster

SS *Penguin* was an inter-island ferry steamer that sank off Cape Terawhiti after striking a rock near the entrance to Te Whanganui-a-Tara (Wellington)[1] Harbour in poor weather on 12 February 1909. *Penguin*'s sinking caused the deaths of 72 people, leaving only 30 survivors. At the time, this was considered the worst maritime disaster of the 20th century. *Penguin* departed Picton on 12 February 1909, en route to Te Whanganui-a-Tara (Wellington) in good weather conditions. However, by 8:00 p.m., the weather had changed, with very strong winds and bad visibility. At 10:00 p.m., the ship's captain, Francis Naylor, decided to head farther out to sea to wait for the weather to break, but while making the turn, the ship smashed into Thoms Rock, and water poured in. Women and children were loaded into the lifeboats, but the rough seas dragged the lifeboats underwater; only one woman survived, and all the children were killed. Other survivors drifted for hours on rafts before reaching safety. In the following hours, men, women and children climbed or jumped onto waiting lifeboats, and while there were more than enough lifeboats for the number of passengers and crew, many were swamped or capsized as they were lowered into the roughest of seas. People were catapulted into the water, and those who did not drown clung to upturned boats or bits of floating wreckage as the ship quickly sank. As the *Penguin* sank, seawater flooded the engine room, the cold water reached the boilers, and a massive steam explosion violently fractured the ship.

Of the 102 people on board, there were 30 survivors – 14 passengers and 16 crew members. Seventy-two people drowned, including 17 women and 14 children. Of the 25 women on board, only one woman, Ada Louise Hannam, survived:

She was proclaimed in the Wellington Press as the heroine of *Penguin*. Readers were enthralled by the heart-rending account of her struggle

underneath the upturned [life] boat with [the body of her daughter] two-year-old Ruby in her arms and her dramatic rescue of teenager, Ellis Matthews.

Collins 2000:81–82

Survivors were washed ashore, and as day broke some, including Captain Naylor, made their way to an isolated sheep station – the McMenamen Homestead at Terawhiti. The alarm was raised, and while some station hands headed to the shore to help survivors and retrieve the bodies tumbling in the surf, two were sent over the hill to Makara to the nearest telephone to call the police. As there was some delay in the police arriving, Captain Naylor set out around the rocky coastland to the Te Whanganui-a-Tara (Wellington) suburb of Island Bay so as to contact 'the appropriate authorities of the Union Steam Ship Company . . . at 10.17 am' (Collins 2000:43).

Following the disaster, a half-day holiday was declared in Te Whanganui-a-Tara (Wellington) to allow the many funerals to be held as some 40 people were laid to rest in Karori Cemetery. On that Tuesday, 16 February 'at 10 a.m. the funeral procession commenced through the streets of Te Whanganui-a-Tara (Wellington) on the way to Karori Cemetery. Shops were closed, flags were at half-mast and church bells tolled' (Collins 2000:57). Contemporary bystanders were witness to the pain and suffering. The connections between those lost, the survivors, the bereaved, and the networks to which they belonged were woven in the capital city's main newspaper, the *Evening Post*:

> It was plain that the horrors of the catastrophe were still unblurred in the people's minds. Their knowledge of the agonies endured by the stricken was something that reached well down into the heart, and a sorrow was in their faces. The tempest and the sea destroyed a ship and seventy people, but that destruction was at once attended by the creation of a warm feeling of fellowship between the people of New Zealand and the bereaved.
>
> *Evening Post*, 16 February 1909

A public inquiry on the wrecking of the SS *Penguin* took place within days of the wreck. The judgement handed down on Tuesday 2nd March 1909 covered a variety of issues from the causes of the wreck to the seaworthiness of the vessel. The steamer of 45 years was

> found to be 'properly attended to' and sufficient in lifeboats and lifesaving equipment. The cause of the wreck, as determined by the Court, was an exceptionally strong flood tide and Captain Naylor's breach of article 16 (the regulations for preventing collisions at sea) by his 'failure under existing circumstances to put out to sea when he had run a course of 18 miles'. The court added that if Captain Naylor had put the vessel's head to sea at 9.40 p.m. the disaster would have been avoided. The captain's

certificate was suspended for 12 months but he was spared from having
to pay the costs of the inquiry.

<div align="right">Collins 2000:75</div>

In response to criticism that the captain had put the reputation of the com-
pany's punctuality first, the shipping company sent out missives to its many
captains advising them not to put the ship's timetable above the safety of its
passengers, cargo, and crew. While the court of inquiry determined that the
ship had hit Thoms Rock near Tongue Point, Captain Francis Naylor swore
to his dying day that he had struck the submerged wreck of the brigantine *Rio
Loge*, which had been seen floating back and forth across the strait for several
weeks (Wood and McDonald 2009). Subsequent to the wreck of the *Penguin*,
a new lighthouse was built at the foot of Karori Rock.

Memorialisation of the *Penguin*

More than 40 *Penguin* victims were buried at Karori Cemetery, and in the
ensuing days and weeks, newspapers published the names of those lost.
Around the country, Sunday services offered prayers for the dead, especially
in those parishes that had lost members of their congregation. Longer-term
memorials to those who had perished were organized including stained glass
windows in the Church of Nativity Blenheim and Wellington Cathedral. As
effects from the *Penguin* came ashore, passers-by gathered them as mementos
of the wreck (rather than flotsam and jetsam for their own personal use).
Some of these effects are now at the Museum of Wellington City and Sea,
while other artefacts remain in private possession. Generations have come
and gone since that shipwrecking storm, and various commemorative activi-
ties were enacted over the decades. Centennial commemorations left mate-
rial markers such as a plaque cemented into the ragged shoreline nearest to
Thoms Rock and digital ephemera for the curious to click through (Welling-
ton City Council 2009).

While the Thoms Rock plaque was to be unveiled to mark the disaster's
centenary on 12 February 2009, ironically, the event was moved to Makara
Hall because of bad weather. The remote Makera Hall had been a rescue and
recovery point for the original disaster.

Memorials to the disaster also take the form of experiences. Memorializers,
those who come to acknowledge loss, can enrol themselves in a bystander
experience. We can walk around Karori Cemetery in Te Whanganui-a-Tara
(Wellington) to see the graves of some of those who drowned in the *Penguin*
shipwreck (see Figure 4.1). Memorializers are guided through the cemetery
by means of special '*Penguin* Shipwreck' grave markers. At each mark, memo-
rializers can read about the person interred and reflect on the loss of life. They
are hailed as graveside mourners some time removed.

As we stand at the spot where family members mourned the loss of their
loved ones, we also become witnesses to their grief and loss as they themselves

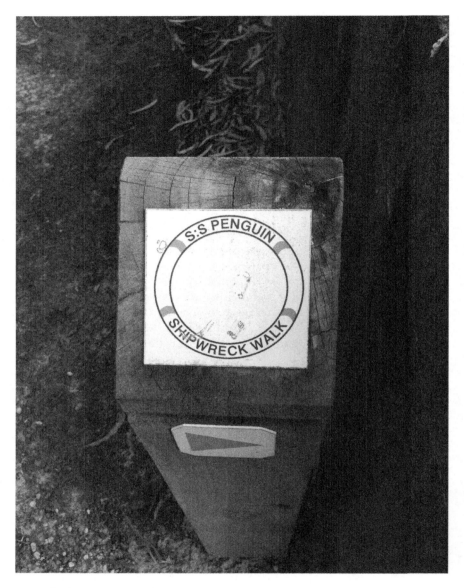

Figure 4.1 '*Penguin* Shipwreck' memorial walk marker. Karori Cemetery, Wellington.

Source: Ruth McManus, author's own collection

stood witness to the disaster over a century ago. The online Cemetery Tour guides the visitor to emotionally connect to the disaster through the shared experience of loss, of being a mourner at the graveside, connecting to any personal experience the visitor may have of standing at the graveside of a

Figure 4.2 '*Penguin* Shipwreck' grave markers. Karori Cemetery, Wellington.

Source: Ruth McManus, author's own collection

loved one. As visitors read the inscriptions, they connect with the disaster as witnesses to and develop personal connections with the departed individuals: (see Figure 4.2).

The collective memory is constituted through the enactment of a shared emotion of loss. Each memorial frames the individual accounts in consistent ways to generate a single unifying message of resilience as a collective memory of the individuals as brave and self-sacrificing in the face of insurmountable odds. The collective memory is clearly articulated on the memorial plaque on permanent display at the Museum of Wellington City and Sea and reproduced on the last page of the *Penguin Self-Guided Walk Karori Cemetery Heritage Trail* (Wogan n.d.):

> To the Glory of God
> and in Loving Memory
> of the Passengers officers and crew
> who were called away by the
> foundering of the S.S. PENGUIN off
> Terawhiti, on the night of Feb. 12th 1909.
> THIS TABLET
> Is erected by friends and members

Of the Missions to Seamen to mark
The splendid heroism and self-denial
displayed in a time of great peril when 75 persons lost their lives.

'GREATER LOVE HATH NO MAN THAN THIS, THAT A MAN
LAY DOWN HIS LIFE FOR HIS FRIENDS'. JOHN XV 13

'TO LIVE IN HEARTS WE LEAVE BEHIND US IS NOT TO DIE'.

The enrolment of the audience as witness to and connection with personal loss in splendid heroism and self-denial focuses the memory work towards a particular kind of person as brave and selfless against the inescapable and supernatural power of God, who called them away. This speaks to a form of resilience as coping with a loss that was unavoidable; who can escape being called away by God? This articulates a theodical narrative of disaster that stands alongside the exceptionalist story offered by Bruce E. Collins:

> Other forms of popular culture including commemorative books, museum ephemera and digital archives reiterate and repeat the collective memory as one of unavoidable loss in the face of insurmountable odds. Bruce E. Collins sums up his investigation of the Wreck of the Penguin by agreeing with the enquiry conducted at the time. 'My opinion is that the court of inquiry came out with the correct verdict, Francis Edwin Naylor was a victim of circumstance beyond his control'.
>
> Collins 2000:94

If the argument of this chapter is to consider the event through the way in which the deaths have been recounted and memorialized, we can see that narratives of theodicy and exceptionalism are privileged over other possible narratives. For instance, a narrative that would emphasize the lack of useful technology and a willingness to ignore warnings is certainly not one that prevails in both the inquiries and the ensuing re-telling of the events over time. Captain Naylor's suspension publicly notes his failure to apply existing safety regulations in light of the fact that the technologies available to him either failed or were unserviceable. Para-ngārehu (Pencarrow) Light was a piece of badly positioned technology as, sitting high on the hills of Te Whanganui-a-Tara (Wellington) Harbour, it was habitually obscured by bad weather. The sequestering of technological failure narratives has the effect of flowing against preventative readings of heeding warnings so central to planning-orientated, preventive models of resilience. When this elision of technological failure combines with narratives that individualize and personalize connection to the lost, the effect is to bolster a narrative of post facto recovery-based

resilience. But does such remembrance belong in a time capsule relegated to those events that are now beyond living memory, when technology was unsophisticated and collective sentiments more explicitly driven by imperial renditions of belonging in colonial outposts?

The *Wahine* disaster

We now turn to consider a more recent shipwreck, the *Wahine*, on a stormy autumn evening in April 1968. The *Wahine* was a purpose-built, first-of-its-kind, roll-on, roll-off passenger service ferry that had the capacity to carry approximately 200 vehicles (such as cars, trailers, caravans, heavy-trade vehicles, containers, and cargo trays) and 'accommodate 928 passengers and 123 officers and crew' (Makarios 2003:9). Since its launch in 1965, the *Wahine* had made numerous sailings between Te Whanganui-a-Tara (Wellington) and Rititana (Lyttleton) without a hitch. On 10 April 1968, the *Wahine*'s master, Captain Hector Gordon Robertson, made the decision to ignore a severe weather warning that gale or storm force winds would hit Raukawa Moana (Cook Strait). Even though the *Wahine* set sail at 8:43 p.m., 43 minutes late, Robertson assumed his ship would be safely berthed before the worst of the storm hit. As the night wore on, and as predicted, Tropical Cyclone Giselle made its way down the Te Ika-a-Māui (North Island), leaving a trail of destruction in its wake. Cyclone Giselle is recorded as the worst storm to hit Aotearoa New Zealand shores.

As the ship sailed through Raukawa Moana (Cook Strait), the worsening weather conditions began to batter the ship. The crew assumed that once in the harbour they would be protected from the wind and that a tugboat would be able to guide the *Wahine* to berth. At 6:10 a.m., the ship sailed past Para-ngārehu (Pencarrow Head), the harbour entrance. Once the ship was in the harbour, the weather continued to deteriorate. With diminished visibility, Robertson put the engines into stand-by and reduced speed, but then the radar stopped working, and the ship strayed off course by 23 degrees. Attempting to rectify this, Robertson turned the helm firmly to starboard, but it did not respond. Robertson then commanded both engines be driven full steam ahead to gain enough momentum to support the ship's steering. While under full power, the ship rolled sharply to starboard. Robertson was thrown across the bridge; crew and passengers were thrown off their feet; and on the vehicle deck, ropes broke causing one truck to topple. Loose cargo and vehicles slid around the deck. Robertson hoped to steer the ship to the open sea to ride out the storm, but as he struggled to control the ship the *Wahine* hit the southern point of Te Raranga o Kupe reef; the starboard propeller severed and the shaft broken, the ship began to take on water. The emergency pumps were activated, all doors were sealed, and crew helped passengers put on life jackets. Eventually, Robertson ordered the anchors to be dropped. While they waited for the anchors to take hold, crew were ordered

to prepare the lifesaving craft. While the *Wahine* was drifting, the tug *Tapuhi* was able to secure a line to the back of the ferry in the hope of towing it to shore. The line snapped, but Captain Galloway, deputy harbourmaster, was able to jump from the pilot launch Tiakina to a lifeboat ladder and climb aboard the Wahine where he offered Robertson his help.

With Galloway onboard, Robertson was able to leave the bridge and inspect his ship. Water was reaching the deck through the ventilation system. The vehicle deck was also covered in water, and the F deck was flooded. The *Wahine* was now tilting. Passengers were now very concerned. At about 1:00 p.m., the *Wahine* was riding her anchors; the ship began to swing, and the starboard list increased. Now in danger of capsizing, at 1:25 p.m., the captains agreed it was time to abandon ship. The *Wahine* had enough lifeboats and life rafts to evacuate all on board; however, the gale force winds blew away many life rafts as they were inflating or before passengers could get on board. Passengers and crew were told to make their way to the starboard side; however, passengers could not hear the announcements, and many went to the wrong side of the ship. Lurching about, they became separated from family and friends, and many panicked. Despite the chaos, the crew managed to get all the passengers off the ship. The last two crew on board, Captains Robertson and Galloway, jumped just before the *Wahine* capsized.

At the mercy of the wind and tide, the life rafts and lifeboats drifted people either to the west side of the harbour or the rocky coast on the east side. And while many vessels attempted to rescue survivors from the water and the rafts, and as people waited onshore to help, 51 lives were lost that day, with most deaths occurring on the easterly Para-ngārehu (Pencarrow) Coast. One person died onshore.

A Court of Inquiry convened on 25 June 1968, ten weeks after the *Wahine* sank. After 26 days and 81 witnesses, the court ruled the exceptional storm was the main cause. The ship sailed off course onto Barrett Reef because of failed radar and poor visibility. Neither the ship's master nor the chief officer was found guilty of negligence and unduly action. The court did rule that there were 'errors of judgement' but justified these by acknowledging the extreme weather conditions, the difficult situation, and the danger (Makarios 2003:50).

According to internet sources such as New Zealand History (Ministry of Culture and Heritage 2019), the Court of Inquiry did focus on the length of time it took for Captain Robertson to give the order to abandon ship; however, it was found that more people would have perished if the decision to abandon ship occurred earlier as there were no rescue boats prior to 12:30 p.m. as the storm was too fierce. It was further reported that Captain Robertson was remiss in not reporting that the deck was taking on water or that the ship's draft was at 6.7 meters after hitting Barrier Reef. Like Emmanuel Makarios (2003), however, the New Zealand History website asserts that the weather event was responsible for what occurred.

As with the *Penguin*, the New Zealand public stopped and paid attention to the funerals for the dead and instigated changes in response to the events. According to the Ministry for Culture and Heritage, there were a catalogue of changes in response to the *Wahine* disaster that included

> improved safety procedures on ships and prompted the creation of two significant rescue services: The Wellington Volunteer Coastguard and the Life Flight Trust. The Wellington Volunteer Coastguard – previously called Wellington Sea Rescue – was formed and its first rescue vessel launched in response to and within a year of the disaster. A trained duty crew – from a pool of more than 60 volunteers – is on Wellington harbour every weekend and public holiday and on-call at all other times, ready to respond to calls for assistance. And it was witnessing the demise of the Wahine and loss of life that motivated Peter Button to take flying lessons and, with neurosurgeon Dr Russell Worth, found a helicopter rescue service able to reach those in trouble as quickly as possible. The service, officially established as the Life Flight Trust in 1982, operates the Wellington-based Westpac Rescue Helicopter and a national air ambulance service, rescuing and airlifting some 1500 people every year. The nation-wide storm – Cyclone Giselle – that led to the Wahine's demise, also triggered the instigation of mandatory civil defence plans by local authorities.
>
> Ministry for Culture and Heritage 2018

Memorialization of the *Wahine*

A key narrative source for the *Wahine* disaster is a well-known story-telling mode, a memoire by Makarios (2003): *The Wahine Disaster: A Tragedy Remembered*. Makarios had personal experience of the Wahine, having travelled across the harbour on the ship as a young boy, just two weeks prior to its sinking. Growing up in Te Whanganui-a-Tara (Wellington), he remembered the *Wahine*, and when he became a Merchant Navy seaman, he worked alongside some of the *Wahine* crew and listened to their tales. Some years later, while working at the Wellington Maritime Museum and the Museum of Wellington City and Sea, he felt compelled to write his book. In this way, Makarios's memoire, to 'respectfully remember that time' and help those to 'understand the trauma that was felt' (Makarios 2003:5), has authenticity and emotional legitimacy that feeds into the ways that the *Wahine* is memorialized and commemorated. The dominant story is an exceptionalist narrative of self-sacrifice and an overwhelming and therefore unavoidable series of tragic events.

As the decades pass, memorials have been fund-raised, organized, and put in position. These include the four main *Wahine* memorial sites around Wellington: JG Churchill Park – Seatoun, Wahine Memorial – Frank Kitts Park, the ship's mast erected in Eastbourne in 2010, and Wahine Memorial

Park – Breaker Bay. The *Wahine* anchor and chain lies at Churchill Part, Seatoun. Each link of the chain represents a victim. The ship's ventilators are also in this area, and the rock the *Wahine* capsized on, Steeple Rock is visible at only a few hundred meters out at sea. A plaque states the anchor is angled so that it directs people towards the rock, while the anchor is partly buried to represent the dragging of the anchors prior to the sinking. Also, the Wahine Memorial – Eastbourne. Most of the passengers – survivors and those who perished – washed up along the Eastbourne Coast on the eastern side of Whanganui-a-Tara (Wellington) Harbour (see Figure 4.3). This memorial is of the foremast of the *Wahine*, painted white. This plaque reiterates the sense of helplessness of the ship, its passengers and crew, and bystanders as events unfolded:

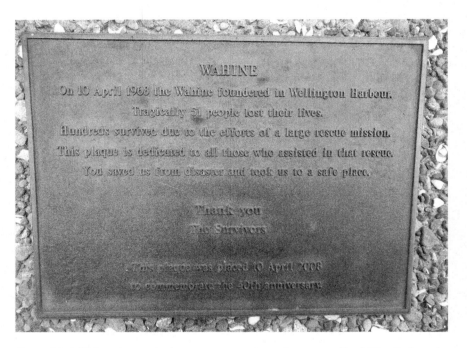

Figure 4.3 A *Wahine* shipwreck plaque to commemorate the rescuers, Frank Kitts Park on the central Wellington harbour front.

Source: Denise Blake, author's own collection

The Wahine Memorial Park is another memorial site which sits at the southern edge of Moa Point Road, Breaker Bay, Wellington, an isolated and craggy bay that provides views of the reef that the *Wahine* struck. One of the *Wahine*'s propellers lies here, with its plaque identifying where the propeller is from and how many people perished (See Figure 4.4).

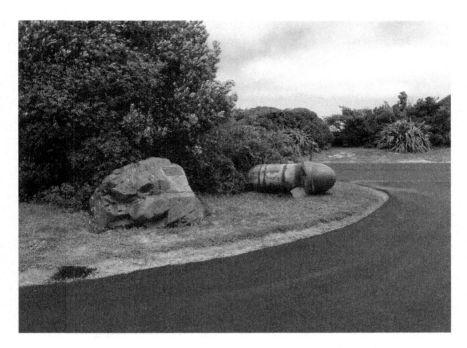

Figure 4.4 A *Wahine* propeller and memorial plaque, The *Wahine* Memorial Par, Moa Point Road, Breaker Bay, Wellington.

Source: Ruth McManus, author's own collection

With the 50th anniversary of the Wahine in 2018, there was a plethora of media attention. Reports on the commemoration focused on re-running the archived reels of live coverage of the disaster, the salvaging of the ship, and the memorials that acknowledged the event. The commemoration ended by listing the names of the survivors. In doing so, it hailed the reader to reflect on those who were lost, as one would scan a list of survivors, searching for loved ones' names after a disaster, in the hope of recognizing a name. Similarly to the way the *Penguin* memorial walks engage the participant as memorializer by walking in the shoes of the loved ones who experienced the loss, readers scan the lists as worried family members would have done 50 years before. The emotional connection achieved through scanning lists places the memorializer as a witness again to the loss of individual lives in the face of an overwhelming turn of events. The narrative effect is to 'entertain' the consumer viscerally to induce feelings of loss, worry, and helplessness.

The Wahine 50 Charitable Trust worked with local councils and others to plan and deliver a day of events to mark the 50th anniversary of the *Wahine* disaster on 10 April 2018: a dawn service at Eastbourne; a

midday event on Wellington's waterfront; a reunion lunch for survivors, rescuers, and family members of those on board; and an afternoon visit to the *Wahine* memorials at Seatoun. In a mode of witnessing made famous by Claude Lanzmann's archetypal *Shoa* (Felman 1994), documentary filmmakers recorded first-hand accounts with survivors, rescuers, and the families of those involved 'to help ensure future generations understand the very intense personal experiences many had 50 years ago, and the impact it had on their lives' (Ministry for Culture and Heritage 2018). The recently elected prime minister, Jacinda Ardern, directs her audience at the commemoration to consider that the

> legacy of the Wahine is one of sadness for the lives lost but also one of gratitude to the rescuer. Recognising events, such as the Wahine tragedy, ensures New Zealanders are aware of our history. It's important that we learn from these tragedies and continue to build our resilience as a country.
>
> One News 2018

Both the *Penguin* and the *Wahine* are significant maritime disasters in Aotearoa New Zealand waters that represent the dangers of crossing Raukawa Moana (Cook Strait). It is beset with strong currents from the convergence of Tasman and Pacific waters and rough weather blown up from the relative proximity of Antarctica. And while Raukawa Moana continues to be a site of heavy water traffic between the two main islands of Aotearoa New Zealand, for some, its perils are looked upon in awe while for others, it is a risk that needs to be managed.

Multi-layered memorials to both the *Penguin* and the *Wahine* call Wellington's rocky coast into broader communities of dark tourism sites where visitors can browse in-depth displays in the local maritime museum or track down the graves of those who were found in local cemeteries and take a refreshing walk round the headlands and bays of the harbour, guided by their favourite tourist app such as TripAdvisor that links the traveller into a network of commercial tours that take them to key memorial sites of the *Wahine* and *Penguin*. Local graveyards and museum displays enmesh world and local travellers together in a specific presentation of the past that connects to specific conceptions of resilience drawn from humble heroes as the base and core of community in contemporary Aotearoa New Zealand. Heroes are made as ordinary people are acknowledged for their acts of bravery and fortitude in the face of unavoidable danger and personal loss.

These maritime disasters, commemorated through the popular culture modes of news, memoirs, memorials, public commemorations, curated exhibitions, and culture walks, offer restricted theodical and exceptionalist narratives that frame resilience as something that comes after a disaster. These narratives structure our imagery of disasters as events that cannot be foreseen or avoided. They are inevitable, unavoidable, unmanageable.

Such popular culture narratives of disaster resilience intersect uneasily with discourses of disaster management that perceive resilience as prevention and as risk-management strategy. It is at this point that we can really begin to get a sense of the impact of popular culture on how contemporary Aotearoa New Zealand, a globally connected community, understands death. Popular culture narratives of disaster memorialization push a model of resilience that contradicts disaster management narratives. This 'social inconsistency' may explain the difficulty that disaster planners have in getting communities to heed warnings and so avoid mortal risks.

The intersection of disaster culture and disaster management seems to display the hallmarks of an emerging global risk society and second modernity. According to Ulrich Beck (1999), societies have changed and are now living in second modernity. No longer concerned with the bourgeoisie or the proletariat, different problems define our world. As advances in science and technology continue, there is an increased awareness of and concern around risks. It is the reflexive nature of modernity which has made it become aware of itself and its unintended consequences or side effects, and, he argues, the mass media are fundamental to processes of reflexive modernization. Coining the phrase 'relations of definitions', 'Beck identifies the mass media as a privileged site for: (1) the social construction, (2) the social contestation, and (3) the social criticism of risks and risk society' (Cottle 1998:7). In our review of popular cultural renditions of resilience, we hope to have demonstrated ways in which these multiple media platforms have simultaneously constructed, contested, and critiqued concepts of risk and risk society. Popular culture narratives of resilience silence the human processes, frames of mind, and attitudes to events constructed and constrained within a context of preparation and risk minimization that aims to avoid situations becoming insurmountable. And so a discourse of planning-based resilience is undeniably absent, denied, challenged, and critiqued through these narratives of memorialization and commemoration.

Conclusion

Through the layers of memorialization of the *Penguin* and the *Wahine*, we in this chapter identified key moments and sites of community imaginings that generate a collective understanding or resilience as repair and recuperation in the face of insurmountable situations and cascades of uncontrollable events. This narrative constantly works against and contradicts narratives associated with disaster planning that seek to generate forms of resilience linked to preparedness and a willingness to heed warnings and instigate evasive action.

These disasters were made meaningful through the translation of news and information into stories and emblems of individual human survival and heroism in the face of nature's wrath and broken technology. While human courage and survival when facing great danger were memorialized, other narratives such as poor judgement, technology blaming, and infrastructural deficiencies were hidden and silenced.

The role of popular culture media as a multi-platformed means through which people today can engage with past disasters is clear and implicates communications media in the ongoing tensions and disconnect between remembering past disasters and planning for future disasters. In so doing, popular culture is implicated in constructing, contesting, and critiquing discourses of resilience associated with risk-management and the turn to risk society of second modernity. As death informs the threat that defines resilience, so death serves the living in second modernity.

Note

1 Maori place names are used, with their English versions given in brackets.

References

Beck, Ulrich (1999): *World Risk Society*. Cambridge: Polity Press.

Beck, Ulrich (2014): *Ulrich Beck: Pioneer in Cosmopolitan Sociology and Risk Society*. New York: Springer.

Collins, Bruce E. (2000): *The Wreck of the Penguin: Holocaust Remembrance: The Shapes of Memory*. Wellington, NZ: Steele Roberts.

Cottle, Simon (1998): 'Ulrich Beck, "Risk Society" and the Media: A Catastrophic View?'. *European Journal of Communication*, 13 (1):5–32.

Ekstrom, Anders and Kyrre Kverndokk (2015): 'Introduction: Cultures of Disaster'. *Culture Unbound: Journal of Cultural Research*, 7:356–362.

Evening Post (1909): 'The Last Rites for the Penguin's Dead: Wellington's Mourning on the Road to Karori'. *Evening Post*, 16 February, pp. 7–8. Available online at: https://paperspast.natlib.govt.nz/newspapers/evening-post/1909/02/16/8.

Felman, Shoshana (1994): 'Film as Witness: Clause Lanzmann's Shoah'. In Geoffrey Hartman (ed.): *Holocaust Remembrance: The Shapes of Memory*. Oxford: Blackwell.

Ibrahim, Yasmin (2010): 'Distant Suffering and Postmodern Subjectivity: The Communal Politics of Pity'. *Nebula*, 7 (1):122–135.

Jones, Andrew (2007): *Memory and Material Culture*. New York: Cambridge University Press.

Makarios, Emmanuel (2003): *The Wahine Disaster: A Tragedy Remembered*. Wellington, NZ: Grantham House Publishing and Wellington Museums Trust.

Ministry for Culture and Heritage (Producer) (2018): *The Wahine Disaster: Catalyst for Change*. Available online at: https://mch.govt.nz/wahine-disaster-catalyst-change.

One News (Writer) (2018): 'Wahine 50th Years On: Jacinda Ardern Pays Tribute to Victims and Survivors of 1968 Ferry Tragedy'. In *1 News Now* (Producer).

Penfold-Mounce, Ruth (2018): *Death, the Dead and Popular Culture*. Bingley: Emerald Publishing.

Wellington City Council (Producer) (2009): *SS Penguin Sinking to be Remembered on South Coast*. Available online at: https://wellington.govt.nz/your-council/news/2009/02/ss-penguin-sinking-to-be-remembered-on-south-coast.

Wogan, Deirdrie. (n.d.): 'Penguin Self Guided Walk Karori Cemetery Heritage Trail'. In Wellington City Council (ed.): *Penguin Self Guided Walk Karori Cemetery Heritage Trail*. Wellington, NZ: Wellington City Council.

Wood, Stacey and Greer McDonald (2009): 'Search for Wreck of Penguin'. *Dominion Post*, February 11. Available online at: www.stuff.co.nz/dominion-post/archive/national-news/1397733/Search-for-wreck-of-Penguin.

Part 2

Aesthetical aspects and mythical structures

5 Healing comes from paradise

Illness, cures, and the staving off of death in naturist remedies advertising

Cristina Douglas

Introduction

If you ever get to walk the streets of any major Romanian city, you will be surprised by the great number of herbalist pharmacies spread along the busy boulevards, displaying their green sign boards like the promise of a breezy walk through boundless pastures. However, these pharmacies and the products they sell, called in Romanian 'naturist' ('of natural origin'), are not a new feature. At the turn of the 20th century, the pages of national and local magazines were filled with advertisements for such remedies. Some were considered nothing more than snake oil, and quite often their consumers were ridiculed for believing the outlandish claims: renewing the vigour of old people; curing people on their death bed, where all other remedies had failed; bringing life to delicate, anaemic bodies or alluring social success to those deemed physically unattractive. Yet their popularity only increased over time, especially after the fall of the communist regime (1989). Named 'old hags' remedies' (Romanian: *leacuri băbești*), thus pointing to a gendered and age-distributed traditional medical knowledge, these remedies exceeded by far any other advertised medicines. In fact, most Romanian pharmacies and supermarkets nowadays still sell natural remedies over the counter, and almost all pharmacists seem to have at least a basic knowledge of the natural raw materials from which they are made. It is at this cultural, historical, and political economy crossroads that the global neoliberal ideology meshes local resources and business ingenuity (Desclaux 2016), contributing to new visions of nature, healing, and staving off death in Romanian contemporary popular culture.

But from where does this enchantment with naturist remedies emerge and, why the allure of the imaginary of nature as healing to contemporary sensitivities? How can naturist remedies find their niche in a highly scientific and medicalized knowledge of body, illness, and health? How are the modern and postmodern positionalities towards health, body, biological death, and nature shaped by the consumption of naturist remedies, and how does this enter into a dialogue with nature's cultural history? How does the historically situated imaginary of nature as a healer appeal to contemporary political stances and community making? In this chapter, I want to offer some explanations by

looking at nature as an imagined source of healing, envisioned as temporarily staving off death. I take a different yet equally meaningful approach to nature than that of anthropology on the ground. I will look at a specific historical-cultural positionality towards nature in which attitudes about illness and death become mingled through a bio-medical model. I show that Romanian advertising for naturist remedies creates a unique cultural-historical inter-section between global and local flows of ideas in popular culture, which adds to a particular profile of representing death. Thus, I argue, the Western model of bio-medicalized death is, in contemporary Romanian popular cul-ture, absorbed into a dialogical process, weaving it into the cultural-historical imaginary of nature as a source of healing, creating a unique cultural repre-sentation of fighting against biological death.

The three main segments of this chapter (i.e., the use of the bio-medical model in naturist remedy advertising, the short history of putting nature on shelves, and the localization of an earthly paradise as source of healing and biological immortality) do not draw inferences from each other. Rather, they should be read as different, albeit converging, angles of understanding con-temporary Romanian popular culture of bio-medicalized death and the allur-ing capacity of nature to enduringly stave it off. Before concluding, I will add a commentary about how the popular sources of nature as earthly para-dise echo imagined communities of healing and the relationship between the advertising of naturist remedies and the renewal of the body politic. Finally, I will draw a few conclusions about the relationship between death and nature in contemporary Romanian popular culture and potential future approaches to this topic.

In arguing the positionality of nature as healing in popular culture, I use examples from media advertising and articles for the popularization of natur-ist remedies covering roughly two distinct periods: 1880–1945, from when advertising became more popular until the installation of the communist regime, and the most recent decade, covering 2009–2019. I have chosen these two particular periods following a methodological logic: while the first period corresponds, roughly, with modernity, the second is illustrative for contem-porary popular culture, dominated by the use of the internet in advertising naturist remedies. Although Zygmunt Bauman (1992) argues that these two periods are dominated by different cultural ways of dealing with death, I show that the bio-medicalized (the staving off of death) model of death is reinterpreted through local medical traditions and the global imaginary of nature as a healer. The most recent decade of advertising chosen for my analy-sis also corresponds to a huge increase in access to 'experiential' tourism (i.e., travelling to places culturally and historically associated with self-discovery, such as India – these have also been associated in the past with the geographi-cal location of earthly paradise), appealing to the Romanian urban (and younger) elite. This form of tourism was sporadic prior to this decade, but it contributes nowadays to a higher popularization of naturist remedies com-ing from these countries. The experiential immortality that Bauman (1992)

speaks about as the dominant form of postmodern attitude toward death, I argue, did not replace its prior deconstruction into curable diseases. Rather, it granted more credibility to naturist remedies by indirectly testifying about the qualities of the places they were coming from. Finally, I have chosen not to include any adverts from the communist period (1945–1989) at all. This is because advertisement from the communist period was heavily employed as a propaganda tool, reflecting a fascinating and absolutely worthy of analysis, but very specific, political ideology of the 'New Man'. Thus, my analysis does not include advertisement from the communist period as this would necessitate a different approach to its cultural and historical imaginary. In addition to advertisement, I will also refer in this chapter to the so-called Romanian popular books,[1] in particular *Alexandria* (the life and travels of Alexander the Great). I will relate these to Western medieval cartography and some of its sources, such as *The Travels of John Mandeville*.[2] This will show the historical journey of ideas and how a specific cultural and religious imaginary becomes woven into a contemporary popular culture of dealing with biological death.

The sources of my analysis could be largely encompassed through Arjun Appadurai's (1990) concept of 'mediascapes'. According to Appadurai, mediascapes are representations of the world or cultural landscapes created by print and electronic media, such as books, magazines, advertising, or cinema. The important aspect of such a concept is that it interprets the mediated global flows of cultural ideas that can not only travel to different cultural landscapes, but also influence these cultural landscapes through how people perceive, understand, and mythologize reality (Rothenbuhler and Coman 2005). In other words, these media help us understand how popular culture emerges and is interlaced in a larger global context of flowing ideas. I argue that the imaginary of nature as a healing paradise and source of biological immortality in Romanian popular culture represents one of the cultural ideas that has travelled over time in a great variability of embodiments between different cultural spaces. This imaginary appears as paramount in the modern and postmodern popular culture of longevity, death, and immortality that animates the advertising of naturist remedies. I deem the cultural construction of nature as the origin of a popular imaginary of biological healing and longevity/immortality not to be a direct source of human practices and beliefs about death and dying, but rather one of the many entanglements of their popular perception and representation in contemporary popular culture.

Staving off death: curing the illness

In *Mortality, Immortality and Other Life Strategies*, Zygmunt Bauman (1992) argues that the modern strategy of dealing with death was to medically deconstruct it into its various biological causes. By identifying the cause through diagnosis, and by finding a cure for it, death was (theoretically and practically) postponed. While longer lives were to be obtained bio-medically through the disease model (Beltrán-Sánchez, Soneji, and Crimmins 2015), resulting in

increased life expectancy (for an overview of increasing life expectancy in the 19th and 20th centuries, see Vaupel 2010), death came to be reframed as an event and the moment of death often that which could be precisely predicted by medical experts. Longevity and immortality ended up being the privilege of the few chosen ones[3] and became the mechanical consequence of fixing the body or replacing its broken pieces. This followed a cultural understanding of health, illness, life, and death articulated through the body-as-machine metaphor (Petersen and Seear 2009:270; for the idea of longevity and immortality through transplant, see McManus 2013) and death as ultimate, irreparable failure. Ivan Illich (1975) and Philippe Ariès (1982) have heavily criticized the medical death paradigm, considering that this model has suppressed any concurrent attitude toward death. However, I believe Illich and Ariès were only partly right. This highly bio-medicalized outlook on body, illness, cure, health, and death was, indeed, only initially setting apart the popular knowledge of healing from that of medical expertise,[4] resulting in what Bryan S. Turner (1995:47) has called a 'social monopoly of expertise knowledge'. At the same time, though, as I will show, it roused popular imaginary into new ways that biological death can be staved off, culminating nowadays in a wealth of bodily and dietary regimens and lifestyle prescriptions.

Bauman (1992) considers that the strategy of staving off death was specific to the modern period but has been replaced by a rather experiential immortality of living in the 'now-moment' in postmodernity. When looking at popular culture, though, it appears that the two paradigms of death – postponed death and experiential immortality – co-exist rather than chronologically following each other. Again, it seems that the deconstruction of death in manageable illnesses/causes of (premature) deaths has pervaded everyday life in postmodernity through the idea of prevention, risk, and risk prevention through public health campaigns. This has been further attached to the rise of a contemporary popular culture of youth, longevity, and anti-ageing in a global culture of death (McManus 2013).

The bio-medicalization of life and death has also bestowed upon contemporary popular culture a revival of an imaginary of staving off death through that of nature as healing. The preoccupation with 'perfect health' through a perfectly healthy body in popular culture, especially mediated by advertising (Gwyn 2002:2), is found across almost all modern advertising for naturist remedies. However, the ideas of perfect health and perfect bodies can be traced all the way back to that of the biblical earthly paradise. Rather than replacing a traditional view of dealing with death, as Illich (1975) and Ariès (1982) have feared, I argue that, in Romanian popular culture, the bio-medical paradigm is woven into a larger cultural-historical imaginary of nature as healing. This creates new popular attitudes towards death as controllable through human-nature symbiosis (the so-called human-nature harmony) by dialogically blending into contemporary advertising the cultural imaginary of an earthly paradise as a source of biological immortality.

In the modern and postmodern climate of the great medical possibilities of staving off death by curing the causes of diseases, the popular imaginary of naturist remedies adapted as well, by specializing their use according to a bio-medical inventory of diseases/illnesses. Not only have the names of these diseases changed over time, but the number of diseases that claim to be healed with naturist remedies has also increased. Quite often, the adverts that I spotted in old popular almanacs and on recent websites selling naturist remedies have extended their lists of diseases that can be cured by the remedy or their names became more bio-medicalized. For example, in an advert from 1923, a naturist syrup is recommended for people suffering from tuberculosis, chest infections, lung disease, asthma, anaemia, scrofula, and 'poor blood' (major anaemia or potential haemophilia) (*Almanachul ziarelor Adevěrul și Dimineața* 1923:77). Another natural remedy, (Saint) Mary's Elixir, was advertised for: lack of appetite; burping; stomach swallowing; hiccups; stomach pressure; stomach pains; acid reflux; chest pain; cough; loss of voice; exhaustion and tiredness; headaches; and arm, leg, neck, and back aches. Saint Mary's Pills, in combination with the aforementioned elixir, were advertised for constipation or other bowel issues (*Almanachul ziarelor Adevěrul și Dimineața* 1925:33). Another advert for a natural remedy obtained from willow extract, the Elixir Vorel, said it was prescribed for venereal diseases or body development issues (e.g., rachitis). This remedy was advertised for its capacity for 'cleaning the poison out of blood', such as for syphilis, but also for rachitic people and for dermatological issues or tumours.[5] For an extra fee, the remedy could be ordered with a leaflet: *How to Clean Our Blood and Strengthen Our Body* (*Almanachul ziarelor Adevěrul și Dimineața* 1925:157). Another advert from 1930 for a sustaining wine, called 'elixir of life', explains the importance of (clean) blood for bodily health. The advert illustrates a supposed image seen under the microscope of a blood sample before and after using the remedy, pointing to the increase in red blood cells. The advert goes on to claim that 'blood is life', and an unhappy life is synonymous with unhealthy blood, resulting in anaemia. The product, then, promises that it will save the sufferer from 'anaemia's claws', the source of a life unworthy of living (*Calendarul ziarului Universul* 1930:234).

Yet another naturist remedy, called the Nervous-Fluid Mary, was recommended for mental morbidity and advertised for its healing power to give 'life strength' against psychological over-demand, insomnia, migraines, nervous shaking, palpitations, anxiety, irritability, upset, and intellectual exhaustion (*Almanahul Adevěrul și Dimineața* 1932:114). The relationship between mental health and 'premature' death (a rather frequent motif in advertising of the era) is clearly highlighted in another advert for a booklet about mental health from 1940 (*Amicul poporului: Calendar pe anul visect 1940* 1940:101), with its title proclaiming: 'Nervous people die young'. In yet another advert from 1932, the entanglements between disease, treatment, and self-responsibility (and its reverse, illness as stigma) were the chief feature. The advertised product was recommended for arthrosclerosis, usually considered a slowly

debilitating, old-age-related disease. The remedy is advertised for health and its maintenance, attributing the cause of death to self-negligence:

> A person does not die; a person kills him/herself. This suicide comes from human negligence, because a person does not care about their health early enough, and then run to the doctor or pharmacy only when they reach infirmity. One of the illnesses that slowly destroy the body is arthrosclerosis, which manifests initially through physical and mental tiredness, numb fingers, pain in the left arm and shoulder, insomnia, headaches, stomach aches etc. All symptoms and morbidity disappear, and even asthma, irregular heart beat [probably arrythmia], [and] liver and kidney diseases can be healed if you use Dr Hechel's tablets.
>
> *Almanahul Adevărul şi Dimineaţa* 1932:226

The names of these diseases have changed over time to a more scientifically sound nomenclature, in order to give more credibility to the products that supposedly cure them (for a similar situation in Senegal, see the anthropological case study of Desclaux 2016). For instance, on a website selling naturist products, each category of products is advertised according to a health issue, using a bio-medical jargon: dermatological issues, ocular issues, osteo-articulation issues, antioxidants, cardio-vascular issues, anti-allergies, amino acids/supplements for sportsmen, anti-humoral, anti-cancer, diuretics and laxatives, hepato-biliary, diabetes, hormonal issues, and haemorrhoids (www.bioportal.ro/produse-naturiste). This product specialization points to an expert knowledge not only of body, its potential illnesses, and health by lay users, but also to an expertise in the specialized knowledge of natural resources in healing.

All the foregoing adverts not only point to historically situated causes of 'premature' death (for example, tuberculosis was one of the main causes of death in the young and middle age populations in the 19th and early 20th centuries; see Daniel 2000), but also bring into contemporary popular culture a complex picture of the entanglements between body, health, nature/natural remedy, and death. The change to disease names, as well as what the products cure/prevent as advertised, also points to a dissolution of expertise from medical professionals to lay consumers. In the last decades, the hierarchical power of medical knowledge has shifted even further through internet use (Hardey 1999; Powell, Darvell, and Gray 2003), incorporating this knowledge into a flow of global ideas. This specific cultural and historical moment offers a great theoretical opportunity to understand the relationship between what has been conceptualized as different stances of knowledge, leaning toward understanding ideas and practices of health, illness, and cure from scientific and popular contemporary positionalities.

Over time, in the adverts that I identified, the healing power of the remedies evolved functionally from curative to preventative, especially through the idea of risk prevention, transforming the consumer into what Illich (1975) has critically conceptualised as a 'lifetime patient': a person who attends to

his/her body over the entire life course through the bio-medical lenses of preventative health maintenance. For instance, on the blog associated with a commercial website for naturist remedies (www.planteea.ro), the Omega 3 products are heavily linked to risk prevention for a great variety of illnesses and medical conditions: reduce the risk of developing Alzheimer's disease (especially through its claimed effects on depression and mental health, indeed an evidence-based link); reduce the risk of stroke and heart attack; reduce the symptoms of metabolic syndrome, associated with insulin resistance, which is a risk factor for developing diabetes; a diet rich in Omega 3 reduces the risk of cancer (colorectal, breast, or prostate). As argued by Alan Petersen (1997), the concept of risk pervades the 'new public health' in late modernity. For many illnesses, the risk is often translated into mortality risk and lower life expectancy, while prevention/staving off of death moves earlier into the lifespan through risk prevention or health maintenance. The relationship between risk prevention, (premature) death, and public health campaigns (which often indirectly support the proliferation of alternative remedies that medicalize lifestyles) becomes, thus, a hallmark of the contemporary culture of health and illness.

The modern cultural pattern of staving off death by curing the disease, described by Bauman (1992) and roughly identified in the advertisements from the late 19th to the early 20th century, has been preserved in contemporary heavily prevention-oriented medicine. In contemporary popular culture, death appears to have become, through this conceptualization of processual death and its prevention rather than its envisioning as an end-of-life event, more manageable but, ironically, more present through a lifetime fight against it. The healthy/natural lifestyle mantra that appears in the advertising of naturist remedies is one of the most obvious materializations of contemporary obsessions with health and implicit staving off of (premature) death in preventative medicine terms.

Putting nature on shelves

Romanian tradition has a great wealth of medicinal remedies. While some of them are man-made, others are taken directly from nature and consumed raw – if one recognizes them and appreciates their healing power. Nevertheless, all traditional remedies, almost without exception, come from nature (Candrea 1944/1999; Ciubotaru 2005). As some postmodern scholars (Latour 2004) have argued, though, nature does not exist in itself. That is, nature comes to be known, constructed, narrated, and experienced as an entity and as a modality through a meshwork of political, economic, scientific, cultural, historical, and subjective entanglements. Ágota Ábrán (2018), for instance, analyzes how spontaneous flora come to be put on shelves as Nature (with a capital N) in Romania. She disentangles how the process of capital accumulation silences the (cheap) labour of marginal groups (especially Roma) in the intricacy of communist architecture (both industrial and

landscape), post-communist agriculture, and spontaneous flora, exposing a more complicated picture of how natural products emerge onto shelves. However, although she acknowledges the use of nature's imaginary as a selling ploy, she does not discuss further how this imaginary becomes woven into the putting of Nature onto shelves. This imaginary, I believe, worked as a starting point and constituted the crucial socio-cultural capital in the development of an industry producing herbalist/naturist products *en masse*. Nevertheless, it was not a simple transfer of a cure prepared in a granny's kitchen to a place where it could be purchased for a fee. During the process, much had to be done about presenting the product and its benefits and finding/creating the right audience. This process of advertising or telling the story of the product (Moraru 2009:20) unveils the strong character of naturist medicine and remedies as a cultural practice, historically situated and culturally and economically driven by a capitalist market. However, this economic opportunity emerged from new possibilities of dealing with illnesses arising from the bio-medicalization of life and death.

In the 19th century, Romanian advertising became more frequent in local and national Romanian magazines, and the first advertising company was established in Bucharest in 1880 (Petcu 2002:57). Amongst some of the first adverts were those promoting cosmetic and medicinal products (Petcu 2002:56). Cosmetic advertising also followed a medicalized view of the body, incorporating health and appearance into social success. Medicinal products, most of them herbalist remedies (e.g., concoctions, tablets, and vegetable 'elixirs'), were instead addressing, as described earlier, a variety of bodily diseases, many of them direct causes of death. At the time, most products were sold directly from magazine offices by post. Others, as advertised, were sold in pharmacies, many of them named after religious characters, long known in traditional medicine as healers: Saint Mary's or Virgin Mary's Pharmacy (*Almanachul ziarelor Adevĕrul şi Dimineaţa* 1923:83; *Calendariu pe anul dela Christos* 1900); (Guardian) Angel's Pharmacy (*Calendarul creştinului ortodox pe anul 1939 dela Hristos* 1939); God's Eye Pharmacy (*Almanach du High-Life Claymoor* 1891:59); Saint Ana's Pharmacy (*Almanahul Adevĕrul şi Dimineaţa* 1932:226); Saint Nicholas's Pharmacy (*Calendariul Românului pe anul comun de la Christos* 1898:22); Our Saviour's Pharmacy (*Calendariu pe anulu dela Christosu* 1882); Saint Apostol's Pharmacy (*Calendar pe anul visect dela Hristos* 1908:6–7). From these names, it would appear that rather than replacing popular knowledge with a secular view, as Illich (1975) and Ariès (1982) feared, the bio-medical model was shaped into a local version of the popular interpretation of divine figures as possessing healing powers and staving off death.

This religious 'affiliation' was thus intended to add to the credibility of naturist products as being offered with the blessing (if not even produced with support and guidance) from a divine figure. In this respect, the production of naturist remedies was, likely unintentionally, abiding by a tradition of incantations, in which a divine figure (commonly Saint Mary) is invoked at

the end as the one ultimately granting effectiveness to the remedy (see incantations from medical folklore in Ciubotaru 2005). This religious connection also pointed to the allotted capacity of the product (mediated by the divine figure) to offer redemption to a debilitated body. Therefore, healing was only a temporary promise of the capacity of divine figures to assist the resurrection of a mortal body after physical death, as made manifest by the effective use of naturist remedies. The faith in an earthly paradise where people await resurrection has animated Christian beliefs regarding death for a long time (Delumeau 1997:24). Thus, there may be an implicit/dialogic link between naturist remedies fixing the body according to a bio-medical model and belief in an earthly paradise/pristine nature with healing powers, although none inevitably supersede the belief in resurrection and afterlife.

In many late 19th and early 20th century Romanian adverts, medical figures were also invoked, sometimes replacing, other times complementing, the divinities. These figures were almost always 'famous' foreign doctors (e.g., French or Austrian), also pointing to a coexistence between medical/healing authority and naturist remedies. Divine figures became (understandably, given atheistic ideology) rather absent during the communist regime (1949–1989) but returned in the advertising of the late 1990s, likely due to the revival of religiosity. Healing divine figures still appear in more recent adverts, although quite often secondary to medical figures or wise old Chinese/Indian men/women (e.g., Dr. Chang, an old Chinese wise man who, in his very late life, decided to share with the world his secret formula for losing weight/against obesity; see the first link under 'Further reading'). In an advert for Graviola from 2013, a widely advertised 'miraculous anti-cancer naturist remedy' imported from the tropical regions of the Americas and the Caribbean, both God and the plant itself grant magical healing to the product consumer. As Susan Sontag (1978) pointed out, cancer has been used as another medical synonym for death, especially in the popular culture of death. The miraculous character of Graviola, then, comes from its capacity to fight against cancer as death itself, often because all other (bio-medical) means have failed. The advert invokes a testimonial from Simona, a young mother who developed a rapid form of terminal cancer. She had been getting worse after chemotherapy but had been miraculously healed by Graviola. The story is narrated almost as a resurrection, a rebirth to a new life through the consumption of Graviola and spiritual self-transformation:

> [Simona's] true story starts just now, with the healing. There is a miracle of nature, Graviola, and since August this year [2013], God has allowed this miraculous fruit from South America to be imported to Romania. Beginning in August, Simona started to take Graviola. . . . An ill person needs courage, confidence in the healing power [of nature], help and compassion, *energy from nature*. When Simona was asked how she administered Graviola juice, she answered: with Love. This strengthened our view that Graviola is not a simple medicine that has to be taken, but

it's the help and support to the biological body in its healing process. . . .
In all this time, [Simona] did not forget to pray, to have faith, gratitude
and to believe that she will recover. . . . On the 25th November 2013,
the colonoscopy showed that instead of a tumour there was only a small
white scar of 1.5/2 cm in the rectal area. . . . [Simona says that] 'I know
I am cured, but I will continue preventatively to take Graviola and I will
continue to be faithful and strong'.

www.produsebiomag.ro; emphasis added

The healing power of the naturist remedy comes, thus, not only from the act
of ingestion, but also through a lifestyle change – a self-transformation that
may last for the rest of the person's life. Although it may seem contradictory,
death can be kept at bay only if life is managed by permanently taking death
into account. Preventative medicine, facilitated by a wealth of naturist rem-
edies put on shelves, it would seem, brought death back into all aspects of life.
While 'premature' death was directly invoked in advertising from the turn of
the 20th century, by the early 21st century, death has become an implicit,
ghostly presence (Gordon 1997) through prevention. Although this does not
inevitably challenge the 'death taboo' theory (Walter 1991), it urges a more
complex picture of the interplay between presence and absence of death in
contemporary popular culture, especially when mediated by consumerism.

Locating the source of biological immortality in popular culture

In comparative studies of religions, some scholars (Eliade 1998; Delumeau
1997) have argued that almost all cultures have a mythical place where human
ancestors live in a state of perfection, untouched by bodily decay and death.
For centuries, Jews and Christians believed that this place is the original para-
dise, geographically located on earth (Delumeau 1997; Scafi 2006). Today,
the imaginary of an earthly paradise has re-emerged through new embodi-
ments, especially the neo-colonial practices of tourist destinations (Deckard
2010), advertised as paradises on earth (Scafi 2006:12). However, this new
form of earthly paradise is not divorced from its earlier relation to biological
immortality, albeit the tourist experience being more related to what Bauman
(1992) identified as experiential immortality:

> Paradise entices the seeker with the promise of immortality and eter-
> nal bliss. The visitor to the Earthly Paradise will experience re-creation
> and self-renewal; he will be rejuvenated or healed and his powers will be
> replenished. Sojourn in Paradise signifies the highest state of individual
> consciousness, the existential experience *par excellence*.
>
> Cohen 1982:3

Although it does not directly mention (or at least is not limited to) a cer-
tain religious tradition of biological immortality, the Judeo-Christian earthly

paradise has been present in Romanian popular culture, including its cor-related motifs of healing, youthful appearance, and longevity. The new (pop-ular) culture of death inspired by recent medical possibilities of restoring health and extending life (McManus 2013:56) is deeply rooted, in the case of naturist remedies, in this Judeo-Christian imaginary of earthly paradise.

Certain biblical texts, earlier Christian writings not included in biblical canon such as *The Book of Adam and Eve*,[6] the popular book of *Alexandria*, and some Romanian folk tradition localize the forefathers on the Eastern side of earthly paradise. This place bears some of the paradisiac qualities by virtue of its vicinity: luxurious flora; abundance of precious metals and stones; temperate climate; and, most importantly, long and healthy lives of its inhabitants. In the era of geographical exploration, the discovery of some places resembling an earthly paradise determined Columbus to note in his journal that he must have reached or been very close to the earthly paradise (Delumeau 1997:51). In fact, Alessandro Scafi (2006) considers that find-ing the earthly paradise (culturally located through Judeo-Christian tradition within the Far East, and in particular in the vicinity of India) was one of the chief motivations of explorers. The history of exploration, its derivative colonial imaginary, and the imperialist exploitation of natural resources from these locations (Deckard 2010) are intimately woven into the religious and scholastic tradition of earthly paradise as a source of biological immortality. Medieval cartography, illustrated and analyzed by Scafi (2006, 2013), also situates the earthly paradise toward the Eastern side of the world, most com-monly close to India. Later cartographers have placed it in locations such as Africa or Armenia, while yet others have further relegated its localization to the top of a mountain or an unreachable hidden island (Delumeau 1997:8). In *The Travels of John Mandeville*, paradise is also located near India. After the discovery of the New World, earthly paradise came to be more frequently associated with the Americas (Nicholls 2009; Deckard 2010). Almost all these locations appear nowadays in various forms in the Romanian advertis-ing of naturist remedies as pristine nature with healing powers or as culturally nature-derived medical systems. While there is a glaring enchantment with these places in the advertising of naturist remedies, their cultural-historical imaginary seems to have been rather dialogically (that is, in this instance, unintentionally) incorporated into these narratives. That means that copy-writers were likely ignorant, or at least did not use this imaginary on purpose. However, this imaginary has been so persistent in popular culture that it has been subconsciously exploited in advertising naturist remedies.

In the Romanian popular novel *Alexandria* (1966), Alexander the Great, travelling towards India, passes by the earthly paradise, but access is denied by Michael the Archangel, who guards its entrance. A more detailed account, however, is offered when Alexander makes a short stopover in the Kingdom of Macaron, situated in the vicinity of the earthly paradise. The fountain of youth/eternal rejuvenation springs exist in this kingdom, which is inhabited by a gentle people that live in perfect harmony with nature. Not accidentally,

the inhabitants have been identified by some authors as the ancient Indian ascetic philosophers known to the ancient Greeks as Gymnosophists (Szalc 2011). The inhabitants of Macaron (Romanian: *nagomîndri*) are portrayed as living simple, long, ascetic lives, in harmony with nature. Moreover, they describe themselves as direct descendants of Adam and Eve, placing them geographically and genetically in an almost unaltered state of bodily and spiritual perfection. The myth of earthly paradise or its vicinity as 'unspoilt' nature has been maintained until today in its relation to that of the 'Noble Savage' living a pristine, Edenic life, untouched by civilization. Not only the place, but the people themselves, given their 'natural' lifestyle, have sometimes been advertised as one of the great attractions of tourist destinations (Cohen 1982:11). Although they are not usually present as much as is shown in tourist advertising, some natural remedy adverts still show Noble Savages/wise men living in harmony with nature (an advert for a detoxifying tea from the site www.acaiverde.com depicts a smiling semi-naked young girl, with dark skin and a large smile, covered by long hair and plants.

Nowadays, this imagined original human/nature symbiosis has been reinvigorated in the advertising of natural remedies. Many of these remedies have been imported from Asian countries, in particular from India. Although the advertising does not revive or directly mention the aforementioned popular books or legends, some of the chief motifs have been preserved: pristine nature, enclosing healing qualities; wise people living in harmony with nature (a lifestyle that has been deemed to contribute to both bodily healing and longevity); and the existence of substances, in particular plants, that heal the body or grant longevity to their consumer. In an advert from 1890, for instance, Indian vegetable tablets and the concoction called 'Amar Indian' are indiscriminately advertised for '[a]ll liver, stomach and heart diseases'. The remedies are recommended for 'hepatitis [Romanian: *gălbinare*; approximate English translation: yellow-skin disease]; stomach acid attacks; stomach gripe; liver tumours; bile inflammation; haemorrhoids; dysentery; inflamed gastritis; indigestion; lack of appetite; stomach ache; headaches; uterine diseases; menstrual disorders; stomach worms; loss of vision caused by blood and liver diseases' (*Calendarul ziarului Universul* 1890:115). In an advert from 1889, a vegetable extract of a 'miraculous' plant from Brazil, Tayuya, is recommended against all diseases caused by poisonous blood (e.g., syphilis or anaemia) and tuberculosis. The doctors invoked in the advert bring proof of a woman who was healed with Tayuya, who could not be cured of syphilis with mercury or iodine (common methods for curing syphilis at the time). The woman had had numerous miscarriages due to her condition, and one of the doctors recommended Tayuya as a precious cure for all of humanity (*Calendarul ziarului Universul* 1889:90). The remedy, then, is not only a cure for an individual body, but also for the entire species under threat of not being able to reproduce. The role of remedy becomes, in this example, to realign the human species to the natural order of things (i.e., perpetuation of species) by fighting an imagined collective potential extinction.

In a more recent article popularizing Ayurveda medicine from a website selling naturist products, the authors instruct the consumer about Ayurvedic principles (more or less similar to the ascetic discipline of *Alexandria*'s Gymnosophists): 'In India, before starting the practice of Yoga, you would study Ayurveda, which helps you maintain the health of your body in harmony with nature'. The healing of the body is, thus, only the first step in a process of healing and self-renewal. In most cases, naturist products come with not only the usual leaflet containing information for the user, but also instructions about the long-term effectiveness of the product when associated with lifestyle changes. In many cases, these instructions are accompanied by an explanation of the cause of the disease, as well as a history of the product/the alternative medicine it is associated with:

> The century we live in is characterised by dynamism, fast movement, change, and each person has to adapt to this rhythm. Stress, not enough time, inappropriate diet, are only a few of the modern world aggressors that negatively influence human health. . . . Natural remedies started to be more sought after, either for diet, or for prevention or cure of various diseases/bodily dysfunctions. Officials statistics show that each person consumes annually approximately 8 to 10 kilos of synthetic substances (medication; preservatives; artificial colourings etc.), which are filtered by the liver. Thus, its function is over-stressed. Ayurveda is probably the oldest, the most elaborate and most complex system of medical knowledge on earth, the most comprehensive and at the same time the most comprehensible system of natural healing. Etymologically, Ayurveda is composed of two words: *ayus*, which means life; and *veda*, which means knowledge; therefore, 'the knowledge of life'. Ayurveda is India's traditional medicine, a multi-millennia science that has surpassed geographical boundaries and been maintained for centuries, becoming more and more organised with each human attempt to understand the human position in the natural/universal course.
>
> www.star-ayurveda.ro

Ayurveda is advertised, in this case, as an efficient medical lifestyle of managing the pressures of daily life while diminishing or curing the negative impact of unavoidable unhealthy diet. Consuming the ayurvedic products and aligning the consumer to its principles, Ayurveda becomes at the same time a way of living a natural lifestyle in a heavily unnatural living environment. In another recent advert, Ashwagandha Rasayan general tonic is advertised as an aid for the body to recover from stress and over-tiredness, to avoid 'premature aging' and, in some cases, even to inhibit the development of carcinogenic tumours (see the second link under 'Further reading'). The advertising of naturist remedies becomes, thus, not only a matter of encouraging consumption, but also a medium of communicating a certain cultural attitude (i.e., preventative) toward body; health; lifestyle; and, most importantly, healing.

In their long-term goal, the advertising and the consumption of naturist remedies offer (more or less imaginary) solutions for how to live a long, happy life, creating an alternative to the modern lifestyle. Even though the consumer will not achieve the same lifestyle as a wise ascetic person, they manage to stave off a premature death.

Although there is no direct association between the myth of earthly paradise as represented in biblical texts, popular books, medieval cartography, and travel and explorer journals and these adverts, one question remains: if, indeed, there is no obvious connection, why is this fascination with naturist remedies originating from these places and their 'miraculous' healing power so recurrent in contemporary Romanian popular culture? As I have argued, I believe that the answer lies in a long-standing cultural tradition that has become almost taken for granted in conceiving these spaces as places that preserve the healing or death-staving powers of an original earthly paradise.

Naturist remedies and imagined communities of healing

The location of an earthly paradise/source of biological immortality has not only been a geographical endeavour. Along with its geography, the earthly paradise and its proximity have also mediated, as in *Alexandria*, a cultural and political emergence of an imaginary of how to live longer or, synonymously in this case, how to live in harmony with nature. Thus, longevity is no longer only a bodily achievement, but a political mirror of a certain lifestyle as a citizen's responsibility towards one's health through prevention. There is no rift between the individual body and the body politic, between individual immortality and community goals. The major difference, in this respect, between the bio-medical medicine and naturist remedies can be located at this junction: while bio-medical healing prompts an individualistic bodily regimen of self-care and self-responsibility, the naturist version meshes the individual into a community of healing even when this community is geographically or temporally distant.

To illustrate my position: almost all adverts that I spotted for a ginkgo biloba product include a short history of its provenience (China), its medicinal use in Chinese medicine (community of healing), its benefits, and its (Westernized) mode of consumption, as adapted to bio-medicine: pills, capsules, tea, or syrup. The modern consumer of ginkgo biloba inhabits simultaneously two cultural and political communities of illness and/or healing: as a modern individual, affected by modern diseases (i.e., the 'diseases of civilization' as cancer/risk of cancer; Alzheimer's/dementia; anxiety; stress and tiredness), the consumer has to be diagnosed through the bio-medical apparatus, thus inhabiting the modern Western-type of world; however, these diseases can be fixed only by a return to nature, by learning from and following the (imagined) lifestyle of a geographically and temporally different community of healing (China, Korea, or India). Like the tourist, the consumer of naturist remedies belongs simultaneously to two different spaces: those of origin

and of destination. The naturist remedies, therefore, come to live in these paradoxical cultural spaces of postmodernity too: they abide by a bio-medical nomenclature and by a logic of capitalist economy, yet they succeed only by offering the imagined healing of communities that deny the values of bio-medicine and capitalism. The imagined communities of healing mediated by naturist remedies thus juxtapose separate cultural, historical, and political spaces: the earthly paradise, its original inhabitants and/or their inheritors; the earthly paradise of colonialized territories; and newly rediscovered places through their medical practices and through their lifestyle of living in harmony with nature.

In recent years, alongside figures of healers associated with other cultural spaces, the advertising of naturist remedies has also used an imaginary of local peasantry (with its variation, the Dacian ancestor) as a source of healing knowledge and, in particular, as a source of naturist medical knowledge. Many of the naturist remedies put on Romanian shelves that are advertised as curing fatal diseases such as cancer are nowadays products made out of local flora (e.g. Romanian: *spînz*; English: *Bear's foot*; Latin: *Helleborus purpurescens*; Roman: *rostopască*; English: *Devil's milk*; Latin: *Chelidonium majus*). Remedies using local flora appear to imagine a sustainable community of healing that theoretically and ideologically profits the local economy, creating a 'healthy' community. This ideology has been continually exacerbated through a post-communist rediscovery of Dacian ancestry, also capitalized on by herbalist producers such as Dacia Plant. These ideologies of healing are nurtured by a renewal of individual and national body politic, via a return to 'origins'. For example, an advert for a tea with armurariu extract (a plant similar to thistle; Latin: *Carduus marianus*), usually recommended for hepatic issues (some caused by chemotherapy), asserts that this product is a 'tea with healthy Romanian attitude' (see the third link under 'Further reading'). Although this might simply be word play, it seemingly suggests that Romanian flora is healthier than other remedies, as is the practice of using it. Marian Petcu (2002:89) has pointed out a similar ideologization of inter-war advertising, given the rise of nationalist political ideologies. In the context of contemporary Romanian advertising, naturist remedies feed an imaginary not only of an individual bodily renewal through nature/local flora, but also of a rebirth and renewal of the Romanian body politic. Quite often, this imaginary is used in conjunction with a demonization of the West as a source of individual and national diseases (e.g., cancer or excessive consumerism resulting in accumulation of toxins and associated diseases).

Postmodernity has also brought into light a somehow newly imagined community, driven by Anthropocenic discourse and environmental activism: the getting-back-to-nature movement, either by accepting our position in nature as mortals (for instance, the humanist movement and the poetic discourses of serene acceptance of death as part of nature as in green burials; see Davies and Rumble 2012) or by re-aligning ourselves with nature and implicitly gaining the benefits of it: living long and healthy. Although not new, the

postmodern imaginary of nature as healing and the social practice of harmonizing oneself with it re-emerges as a political action of building ethical communities. A green, environmentally friendly community becomes, by default, at the level of cultural imaginary, a community of healing for the individual and for humanity. By reinstating nature to its original imagined status of earthly paradise or an environmental multi-species community of healing, humans reap their share of being part of nature: self-regulatory bodily capacities (as imagined in other living beings when natural balance is left to its own devices) or, in other words, bodily renewal/auto-healing (read natural healing) and, implicitly, longevity. In this context, the imaginary of nature as healer and naturist remedies prove to offer an incredibly rich source for theoretical speculation in understanding some of the modern and postmodern attitudes toward our place, as humans, in the larger imagined entanglement with Nature, as mortal beings aspiring to immortality.

Conclusion

In this chapter, I have argued that the contemporary Romanian popular culture, as illustrated in the link between two temporally distinct periods of advertising naturist remedies, offers a specific cultural attitude of staving off death through an original local entanglement between the bio-medical model of illness, cures, and the historical-cultural imaginary of nature as healing. This positionality towards nature, bodily health, healing, and death points to a more complex picture of how globally dominant models (i.e., bio-medical) are absorbed into local cultures and transformed into original versions. As folklorists and popular culture theorists show, this process of the local distillation of global cultural ideas constitutes the very core of popular culture. In my particular analysis of Romanian contemporary popular culture, the bio-medical model of body, health/illness, and cure has been incorporated into the more traditional model of nature as healing and as a source of biological immortality by finding a niche in naturist remedies. In a way, it may be asserted that nature has 'tamed' – to use Philippe Ariès's (1982) term – bio-medical death, offering an instrument in resisting a supposedly hegemonic model of healing through (bio-)medical expertise. In this process, the cultural imaginary of earthly paradise and its link to nature as a healer of the human body (often through its ideologization as 'harmony with nature') plays a paramount, albeit not directly visible, role. The naturist remedies, as I have shown, offer in Romanian popular culture a continuity into late modernity/postmodernity of the bio-medical (modern) model of deconstructing death into curable/manageable diseases. It remains to be seen in further analysis of a more anthropological nature to what extent the bio-medical model of illness and cure is reflected in lay medical knowledge and expertise and how actual consumers perceive and put into practice what is advertised about naturist remedies products.

The contemporary attitude towards illness, healing, and (staving off) death, as I have illustrated in the example of Romanian naturist remedies advertising,

aligns well with new forms of green/environmental activism and sensitivities towards nature. A cultural history of nature deserves an analysis from this particular political environmental movement stance and the importance of Nature as healing paradise as a cultural construction in these discourses. On the other hand, naturist remedies advertising could also be a source for analysis of a more troubling picture of a global rise in nationalistic ideologies, roused by ideas of reviving the body politic. While the use of Nature and its entanglement with attitudes toward death in political discourses is not new, in this particular instance it may point to a political instrumentalization of health that serves nationalistic and anti-Western ideologies. In other words, Nature – as theorized by Bruno Latour (2004) – and its link to ideas of death (i.e., extinction and immortality) in contemporary popular culture and political ideologies can serve either to create a global common goal (e.g., the save-the-planet movement) or to divide it into individual, nationalistic interests. This potential political polysemy, however, reveals the compelling capacity of Nature and its intimate entanglement with death, which allows a continual and ever-renewing imaginary of redemption and healing in popular culture throughout history.

Notes

1 Popular books are written novels or novellas, with unknown authors, that had a widespread circulation across borders, had multiple versions, and entered into folklore (Chiţimia 1966). For example, *Alexandria* is a popular novel about the imagined life and heroic acts of Alexander the Great, including his travels to India and the proximity of earthly paradise. It seems that *Alexandria* was composed in Greece in the last few centuries before Christ. Since then, it has been translated and adapted in Western countries through its Latin version and entered Eastern European countries through Bulgarian and Slavonic translations. It was introduced to Romanian popular culture sometime around the end of the 16th century, although its first preserved version dates back to 1620 (Chiţimia 1966:95). *Alexandria* may be one of the primary sources of the cultural representations of earthly paradise in Romanian popular culture.
2 *The Travels of Sir John Mandeville* is a book written sometime in the 14th century, which acquired great popularity. It is attributed to an English knight, who wrote from memory about his travels beyond the Mediterranean to serve as a guide for other pilgrims travelling to Jerusalem. However, its authentic character has been heavily contested. Most of the encounters of John Mandeville have a fantastical character, unlike some other, more realistic travel writings such as those of Marco Polo. *The Travels of Sir John Mandeville* served as a source of inspiration for Christopher Columbus during his own travels (see Higgins 2011).
3 The bio-medical model of death did not automatically incur a more equalitarian global society, though. Most statistics point to great inequalities in health access and life expectancy across the globe and between different classes. For an illustration of how health access creates great disparities between various American citizens, see Abramson (2017).
4 About the great role of expertise in modernity and late modernity, see Giddens (1991).
5 Most probably, these tumours were not of carcinogenic nature but tumours of lymphatic nodes, often causing tuberculosis, and most commonly known in the period as scrofula.
6 *The Book of Adam and Eve*, also known as *The Conflict of Adam and Eve with Satan*, is a Christian book written sometime in the fifth to sixth century, most probably by Egyptian Christians. The book tells the story of Adam and Eve living on the Eastern side of paradise after they have been driven away by God for their sin (Malan 2008:8).

References

Abramson, Corey M. (2017): *The End Game: How Inequality Shapes Our Final Years*. Cambridge, MA: Harvard University Press.

Ábrán, Ágota (2018): 'Unwrapping the Spontaneous Flora: On the Appropriation of Weed Labour'. *Studia Universitatis Babes-Bolyai Sociologia*, 68 (1):55–72.

Alexandria, Esopia – Cărți populare [Alexandria, Esopia: Popular Books] (1966): București: Editura pentru Literatură.

Almanach du High-Life Claymoor (1891): București.

Almanahul Adevĕrul și Dimineața (1932).

Almanachul ziarelor Adevĕrul și Dimineața (1923): București.

Almanachul ziarelor Adevĕrul și Dimineața (1925): București.

Amicul poporului, Calendar pe anul visect 1940 (1940): Sibiu.

Appadurai, Arjun (1990): 'Disjuncture and Difference in the Global Cultural Economy'. *Theory, Culture & Society*, 7:295–310.

Ariès, Philippe (1982): *The Hour of Our Death*. New York: Vintage Books.

Bauman, Zygmunt (1992): *Mortality, Immortality and Other Life Strategies*. Cambridge: Polity Press.

Beltrán-Sánchez, Hiram, Samir Soneji and Eileen M. Crimmins (2015): 'Past, Present, and Future of Healthy Life Expectancy'. *Cold Spring Harbor Perspectives in Medicine*, 5 (11):1–11.

Calendariu pe anul dela Christos (1900).

Calendariu pe anulu dela Christosu (1882).

Calendariul Românului pe anul comun de la Christos 1899 (1898): Anul XI, Caransebeș: Editura și tiparul tipografiei librăriei diocesane.

Calendar pe anul visect dela Hristos (1908): Anul XXIX, Arad.

Calendarul creștinului ortodox pe anul 1939 dela Hristos (1939).

Calendarul ziarului Universul (1930).

Calendarul ziarului Universul pe anul 1889 (1889).

Calendarul ziarului Universul pe anul 1890 (1890): Anul VI, Bucuresci.

Candrea, Ion Aurel (1944/1999): *Folclorul medical român comparat: Privire generală – Medicina magică [Romanian Medical Folklore in Comparative Perspective: General Overview: Magic Medicine]*. București, Iași: Polirom.

Chițimia, Ion C. (1966): 'Romane populare românești pătrunse prin filieră slavă: Alexandria' ['Romanian Popular Novels Introduced through Slavic Channel']. *Romanoslavica*, 8:93–103.

Ciubotaru, Silvia (2005): *Folclorul medical din Moldova: Tipologie și corpus de texte [Medical Folklore from Moldova: Typology and Texts]*. Iași: Editura Universității A. I. Cuza.

Cohen, Erik (1982): *The Pacific Islands from Utopian Myth to Consumer Product: The Disenchantment of Paradise*. Aix-en-Provence: Centre des Hautes Etudes Touristiques.

Daniel, Thomas M. (2000): *Pioneers of Medicine and Their Impact on Tuberculosis*. London: Boydell & Brewer.

Davies, Douglas and Hannah Rumble (2012): *Natural Burial: Traditional: Secular Spiritualities and Funeral Innovation*. London: Bloomsbury Academic.

Deckard, Sharae (2010): *Paradise Discourse, Imperialism and Globalization: Exploiting Eden*. New York: Routledge.

Delumeau, Jean (1997): *Grădina desfătărilor: O istorie a paradisului [Garden of Delights: A Cultural History of Paradise]*. București: Editura Humanitas.

Desclaux, Alice (2016): 'Cosmopolitan Phytoremedies in Senegal'. In Lenore Manderson, Elizabeth Cartwright and Anita Hardon (eds.): *The Routledge Handbook of Medical Anthropology*. London: Routledge.

Eliade, Mircea (1998): *Mituri, vise și mistere* [*Myths, Dreams, Misteries*]. București: Univers Enciclopedic.

Giddens, Anthony (1991): *Modernity and Self-Identity: Self and Society in the Late Modern Age*. Stanford, CA: Stanford University Press.

Gordon, Avery F. (1997): *Ghostly Matters: Haunting and the Sociological Imagination*. Minneapolis: University of Minnesota Press.

Gwyn, Richard (2002): *Communicating Health and Illness*. London, Thousand Oaks, CA: Sage Publications.

Hardey, Michael (1999): 'Doctor in the House: The Internet as a Source of Lay Health Knowledge and the Challenge to Expertise'. *Sociology of Health and Illness*, 21 (6):820–835.

Higgins, Iain Macleod (2011): *The Book of John Mandeville with Related Texts*. Indianapolis: Hackett Publishing Company Inc.

Illich, Ivan (1975): *Medical Nemesis: The Expropriation of Health*. London: Calder and Boyars.

Latour, Bruno (2004): *Politics of Nature*. Cambridge, MA: Harvard University Press.

Malan, Solomon Caesar (2008): 'Cuvînt înainte' ['Foreword']. In *Cartea lui Adam și a Evei (Lupta lui Adam și a Evei cu Satana)* [*Adam and Eve's Book (The Fight of Adam and Eve against Satan)*] București: Editura Herald.

McManus, Ruth (2013): *Death in a Global Age*. Basingstoke: Palgrave/Macmillan.

Moraru, Mădălina (2009): *Mit și publicitate* [*Myth and Advertising*]. București: Editura Nemira.

Nicholls, Steve (2009): *Paradise Found: Nature in America at the Time of Discovery*. Chicago: University of Chicago Press.

Petcu, Marian (2002): *O istorie ilustrată a publicității românești* [*An Illustrated History of Romanian Advertising*]. București: Editura Tritonic.

Petersen, Alan (1997): 'Risk, Governance and the New Public Health'. In Alan Petersen and Robin Bunton (eds.): *Foucault, Health and Medicine*. London: Routledge.

Petersen, Alan and Kate Seear (2009): 'In Search of Immortality: The Political Economy of Anti-Aging Medicine'. *Medicine Studies*, 1 (3):267–279.

Powell, John A., Maria Claire Darvell and J. A. M. Gray (2003): 'The Doctor, the Patient and the World-Wide Web: How the Internet Is Changing Healthcare'. *Journal of the Royal Society of Medicine*, 96 (2):74–76.

Rothenbuhler, Eric W. and Mihai Coman (2005): *Media Anthropology*. Thousand Oaks, CA: Sage Publications.

Scafi, Alessandro (2006): *Mapping Paradise: A History of Heaven on Earth*. London: The British Library.

Sontag, Susan (1978): *Illness as Metaphor*. New York: Farrar, Straus and Giroux.

Szalc, Aleksandra (2011): 'Alexander's Dialogue with Indian Philosophers: Riddle in Indian and Greek Tradition'. *Eos*, 98 (1):7–25.

Turner, Bryan S. (1995): *Medical Power and Social Knowledge*. London: Sage Publications.

Vaupel, James W. (2010): 'Biodemography of Human Aging'. *Nature*, 464:536–542.

Walter, Tony (1991): 'Modern Death: Taboo or Not Taboo'. *Sociology*, 25 (2):293–310.

Websites

Acai verde [Green Acai]. www.acaiverde.com

Ayurmed. www.ayurmed.ro/products/Ashwagandha-Rasayan.html

Bioportal. www.bioportal.ro/produse-naturiste

Teaspot: Locul in care ceaiul este prețuit la adevărata lui valoare [Teaspot: Where Tea is Known at its True Value]. www.ceai-de-slabire.ro/dr-chang-tea-formula-acasa

Dacia Plant: Forţa binefăcătoare a plantelor [Dacia Plant: The Healing Force of Plants]. www.daciaplant.ro/ceai-armurariu.html

Planteea, plantoteca ta online: Sănătatea este în natura ta [Planteea, Your Online Plant Library: Health is in your Nature]. www.planteea.ro

Produse biomag: Sănătos şi armonios [Biomag Products: Healthy and Harmonious]. www.produsebiomag.ro

www.star-ayurveda.ro

Star International Med. www.star-ayurveda.ro

Further reading

Teaspot: Locul in care ceaiul este preţuit la adevărata lui valoare [Teaspot: Where Tea is Known at its True Value]. www.ceai-de-slabire.ro/dr-chang-tea-formula-acasa

Ayurmed. www.ayurmed.ro/products/Ashwagandha-Rasayan.html

Dacia Plant: Forţa binefăcătoare a plantelor [Dacia Plant: The Healing Force of Plants]. www.daciaplant.ro/ceai-armurariu.html

6 The aesthetics of corpses in popular culture

Devaleena Kundu

Introduction

Mass media in the 21st century shows an almost obsessive fascination with death. While deaths in the real world are increasingly relegated to hospital wards and hospices, visual imageries of death continue to infiltrate our domestic spaces. In their discussion on the shifts in American attitudes towards death during the 20th century, Robert Fulton and Greg Owen state that 'for a whole generation of young people, if death were seen at all, it was observed at a distance through the opaque glass of a television screen' (Fulton and Owen 1987:381). According to them, this generation that was born post World War II has primarily experienced death at a distance. Not only did this generation have better healthcare facilities that improved their life expectancy, they were also largely impacted by the overwhelming presence of the television: '[O]ver the extent of their childhood years', Fulton and Owen noted, 'the baby boom generation . . . [had] viewed 10,000 acts of homicide, rape, or other forms of violence and aggression on television' (Fulton and Owen 1987:381). Thus, encounters with death and violence took place within the comforts of domestic space in the form of filtered images featured on television. Media's liaison with death has only increased since then. Lynne Ann DeSpelder and Albert Lee Strickland (2015:9) observe that death is a 'staple' not only on news channels but also on networks that feature cartoons, soap operas, theological discussions, sports events, and so on. In many of these instances, death is personified or reified. Also, depending on the representation, images of death might seem unacceptable on certain programmes and completely normal on others. Thus, news highlights on murder, suicide, mass killings, or other deaths might draw negative responses of fear and terror, whereas caricatures of death in cartoons aimed for children might draw bouts of laughter from both adults and children alike.

For a considerable number of television shows and programmes, death finds more than just a cursory mention; it is the central premise. Shows such as *Six Feet Under*, *Criminal Minds*, *Bones*, *True Detective*, *The Fall*, and *Game of Thrones* to name a few, are conceived to showcase the event of death in all its macabre glory. Episodes often include brutal deaths; elaborate funerals; and

visits to burial grounds, hospitals, morgues, pathology labs, crime scenes, and funeral homes. There is also an increased visibility bestowed on the dying/dead body. The degree of graphic detailing vis-à-vis aesthetic choreography with which the body is displayed has dramatically transformed death and the dead body into commodities of mass entertainment. To quote Christine Quigley:

> The screen often blurs the distinction between fact and fantasy. . . . The faked corpse is doctored for dramatic effect or toned down for primetime viewing. It is a prop in plots that cater to the vicarious thrill of watching others being killed.
>
> Quigley 1963:39

Within this context of 'doctored' representations of the dead, it becomes imperative to understand whether these rather immediate virtual encounters with death can qualify on a certain level as aesthetic experiences.

This chapter thus attempts to explore the manner in which visual representations of the macabre and gore effect a new sense of beauty. What does it mean for the corpse to emerge as an object of desire? How does the idea of aesthetic distancing facilitate the appreciation of the corpse as an object of art? Does the constructedness of the dead body in the realm of popular culture invite a voyeuristic gaze? These are some of the questions that the present chapter seeks to consider. The chapter begins by looking at the idea of aesthetic distancing and its role in engaging with an object of art. It then deliberates on the emergence of the corpse as an object of desire with close reference to select episodes from popular television shows such as *Hannibal, The Fall*, and *Six Feet Under*. The obsession with the macabre, it will be seen, is tied to a culture marked by a categorical avoidance of death.

Aesthetics and distancing

One of the early definitions of 'aesthetics' was offered by the German philosopher Alexander Baumgarten, who defined aesthetics as 'a science of how things are to be known by means of the senses' (Kivy 2004:15). Baumgarten would later go on to call aesthetics 'the science of sensitive cognition' (Kivy 2004:15). From the beginning of the 18th century onwards, the notion of aesthetics – traditionally associated with the critiquing of beauty – has been closely linked to the idea of the sublime as well as that of artistic genius. 'The central idea to emerge in eighteenth century aesthetics', Paul Guyer writes, '[was] that of the freedom of the imagination' (Guyer 2004:16). And while the freedom of imagination might have raised questions as to the positive and negative conceptions of it, as addressed in the domain of Kantian philosophy, it is perhaps in the 20th century through the works of Edward Bullough, Bertolt Brecht, and, more significantly, Hans Robert Jauss that one finally arrives at the understanding of aesthetics as something that requires a certain degree of distancing.

In the early 20th century, Bullough introduced the concept of 'psychical distance' to signify the space 'separating the object and its appeal from one's own self, by putting it out of gear with practical needs and ends' (Bullough 1912:91). According to Bullough, this separation – which is achieved by distinguishing between one's subjective and objective experience – allowed the same object to be experienced differently depending on the attitude of the observer. Bullough distinguishes between subjective and objective distancing on grounds of conflict between practical needs and ends and one's own hopes and assumptions. He elaborates his proposition by citing the example of a scientist who, in order to arrive at a rightful conclusion, would have to be a dispassionate investigator because an excessive involvement of personal interest in the domain of scientific research leads to biased experiments and results. Bullough, however, maintains that taking a dispassionate stance does not necessarily imply that one has to be entirely detached from the subject. In addition, Bullough also suggests that distancing depends on the character of the object itself. It is by finding the right balance between the two criteria that one can truly appreciate a work of art; however, in its absence, distancing can result in either 'under-distancing' or 'over-distancing'. While under-distancing results in the work being deemed 'crudely naturalistic', 'harrowing', or 'repulsive in its realism', over-distancing 'produces the impression of improbability, artificiality, emptiness or absurdity' (Bullough 1912:94).[1] The inclusion of distance, Bullough argued, brought about a difference in perspective.

Bullough's notion of aesthetic distancing would find a new application in Bertolt's Brecht's idea of *Verfremdungseffekt*, also known as the 'distancing effect'. What Brecht sought was an emotional distance between the audience and the performance that would allow for a space of critical thinking and judgement. A few decades later, Hans Robert Jauss would posit a slightly different understanding of the same in his reception theory. Jauss defined aesthetic experience as '[t]he reader's experience of a work of art' (Rush 1997:67), and he saw reception as a continuous exchange between the readers/audience and the text. He stressed the idea that the aesthetic experience had a wider influence on the reader's/viewer's everyday life and that it could be seen as a means to achieve socio-cultural change. The integration of history and aesthetics, he claimed, played a major role in assessing the horizon of expectations, and the aesthetic merit of a work was to be determined by measuring the distance between the work and the horizon of expectations that the individual brought to that given work. Aesthetic distance, in this regard, referred to the tension caused by the shifts in the horizon of expectations between the first and later receivers, which in effect encouraged new perspectives and criticisms to emerge (Jauss 2005:25).

Interestingly, this tension factors in significantly when the object of scrutiny is the corpse. For a viewer, the presence of a corpse, first and foremost, is met with shock. Subsequently, the corpse might trigger a different set of reactions. As a result, the initial response of shock would serve as the point of reference against which other responses would be measured. Similarly, there

would be a certain kind of expected response to an object that is labelled as art, which would be starkly different from that of absolute shock and horror, which the corpse happens to prompt. However, when a corpse is 'exhibited' for visual consumption, it occupies a dual status – that of an object as well as that of a work of art. Once the viewer's attention is drawn to the compositional aspects of the exhibited 'corpse', the uncanny perturbations it would normally trigger are diluted. In other words, the aesthetic distance brought about by strategic positioning results in an improved appreciation for the corpse. The premise of aesthetic distancing, hence, becomes crucial in understanding not only why the corpse evinces varied responses of terror, aversion, and desire but also why the images of death and the dead portrayed on several television shows are choreographed '[to] conform to a specific visual aesthetic' (Weber 2014:77).

The corpse as an object of desire

In *Death and Sensuality: A Study of Eroticism and the Taboo*, Georges Bataille states that the paradox of feelings that a dead body triggers stems from recognizing in that body the violence that annihilates and 'a threat of the contagiousness of violence' (Bataille 1962:45), feelings of fear and horror that 'are a temptation to overstep the bounds' (Bataille 1962:144). The dead body being inevitably linked to the notion of decay extends a threat of contagion for the living.[2] It is the reminder of mortality and given its ability to pollute, it is exalted as an object of taboo – at once dangerous and sacred, and for Bataille, it is in this feeling of aversion that desire has its roots. Bataille reflects: 'repugnance and horror are the mainsprings of my desire, that such desire is only aroused as long as its object causes a chasm no less deep than death to yawn within me, and that this desire originates in its opposite, horror' (Bataille 1962:59). He identifies and relates the notion of violence to that of the erotic, an idea that resonates with Freudian and post-Freudian thought:

> Men are swayed by two simultaneous emotions: they are driven away by terror and drawn by an awed fascination. Taboo and transgression reflect these two contradictory urges. The taboo would forbid the transgression, but the fascination compels it. Taboos and the divine are opposed to each other in one sense only, for the sacred aspect of the taboo is what draws men towards it and transfigures the original interdiction.
>
> Bataille 1962:68

In filling the spectator with horror and/or disgust, the dead body also invites the spectator to transgress. And it is this affiliation of violence and sensuality that has come to dominate popular culture.

Contemporary media images mark representations of death with sensuality and desire that renders elements of gore, pathology, and morbidity exciting. And while this might appear distinct to the post–World War period,

similar attributes can be traced back to the late 15th and early 16th centuries. Images of death during the late 15th and early 16th centuries, Phillippe Ariès notes, began '[to be] charged with a sensuality previously unknown' (Ariès 1981/2008:370). Focusing primarily on the paintings that were produced during and after this period, Ariès labels them as the 'new category of disturbing and morbid phenomena . . . which was born . . . of the union of Eros and Thanatos' (Ariès 1981/2008:369). The trajectory of this union is interesting because, as one progresses from the 16th to the 19th century, one can notice a gradual shift from an 'unconscious' to a more 'admitted and deliberate' depiction of sensuality in death (Ariès 1981/2008:370). Both in art and in literature, the dead body transforms into an object of desire (Ariès 1981/2008:935), and by the time one arrives in the 18th century, 'the first signs of death will no longer inspire horror and flight, but love and desire' (Ariès 1981/2008:937). In her delineations on 'The Photographed Corpse', Quigley writes:

> Prior to the late 1800s, the sentiment toward the image was not dulled by the visible signs of death. There was no attempt to beautify the corpse before tripping the shutter. . . . Rigor in the limbs, blood on the face, and darkened nails all point to the obvious, despite the deliberate positioning described by Albert Southworth, a daguerreotype artist, to an 1873 audience: 'You may do just as you please so far as the handling and bending of corpses is concerned. You can bend them till the joints are pliable, and make them assume a natural and easy position'. Babies were posed in their carriages, children on their mothers' laps or with their favorite toys, and adults seated or in their coffins. The dead body, a willing model for photographers and a treasured image for their clients, was accepted at face value with or without pros.
>
> Quigley 1963:35

While the idea of staging a dead body for aesthetic reasons is not new, it is the frequency and urgency with which it is undertaken in contemporary popular cultural representations that are of primary concern.

Today, the dead body can be portrayed in varied ways to elicit a certain kind of response from the audience. For example, a television series like *Six Feet Under* focuses more on the processes involved in restoring a dead body for a completely sanitized and cosmeticized presentation. Revolving around a family-owned funeral home, the series is a social commentary on the contemporary Western attitude of doing away with any signs of decay or the uncanny pallor of death in a dead body for its pre-burial display. Bodies in crime shows, on the other hand, in depicting the brutality of death tend to translate them into pieces of homicidal art. Television series such as *True Detective, Dexter, Hannibal,* and *The Fall,* which deal with serial killings, on the contrary, tend to highlight the artistic dimensions of the murders that are committed. While the act of murder in itself might involve extreme brutality,

the ultimate display of the body shows a penchant for the aesthetic. In each of these shows, the depiction of the corpse is extraordinary in its staging. The presentation of the corpse demands that viewers gaze at it. Viewers experience a mixed sense of fear, revulsion, and admiration towards the corpse. Alongside the onscreen spectators, the viewer is invited to analyze it and dissect it (with the help of the forensic investigators), as well as fetishize it (just like the perpetrators). The viewer's oscillation between the roles of a passive onlooker and/or an accomplice is determined once again by the level of engagement with the aesthetic dimensions of the corpse on display. I will be elucidating further on this by analyzing select episodes of *Hannibal*, *The Fall*, and *Six Feet Under*.

Visual consumption of the corpse

Despite its underperforming ratings, *Hannibal* has become one of television's most perversely stylized shows. Almost every episode involves an explicit display of the dead in a manner that recalls the 'established traditions of gothic horror' (Abbott 2018:129). The body as well as the crime scene is a spectacle, grisly yet ornate. Of particular interest in this regard is the opening episode of season 2. Titled 'Kaiseki', this episode shows Jack Crawford, FBI special agent, and Dr. Hannibal Lecter attempting to solve a case that involves partially preserved bodies. On analyzing six such bodies recovered from the river, Hannibal hypothesizes that the killer was in search of perfect bodies, perhaps as part of a larger project of creating 'human models', and that the recovered bodies were possibly imperfect and hence, discarded. Hannibal's comments in this context serve two purposes: first, they establish a distinction between perfect and imperfect bodies; second, they ready the audience for an even grander display of death because if the already-discovered bodies are supposedly imperfect, there ought to be another set of yet-to-be-discovered corpses that are, so to say, perfect. Curiously, though, this distinction between the perfect and the imperfect bodies is never explicitly addressed. The audience is not told why the killer chose to discard a certain number of bodies while retaining the others, and one can only surmise that the discarded bodies did not somehow suit the killer's requisites. Instead, the contrast is emphasized through the depiction of the corpses themselves. The bodies that are fished out of the river are depicted as bloated, patchy, discoloured, covered in a solidified coat of resin. The 'perfect' bodies on the other hand – displayed as part of the killer's artwork at the very end of the episode – are shown to have withstood the process of preservation and, therefore, appear 'alive'. The distinction between perfect and imperfect bodies is made even more intriguing because the imperfect bodies, the ones recovered from the river, are not deemed valuable enough to be part of the larger artistic plan. The interest is shifted onto those bodies that eventually find a place in the mural, and the audience's sympathy is, therefore, reserved for the perfect bodies as opposed to the imperfect ones. Besides, the fact that the bodies in the mural are better

preserved than the ones found in the river also acts as a reminder of the incorruptibility of flesh, a metaphor for the sacred. In their extraordinarily intact form, the dead are exalted, and the event of death is simultaneously presented as tragic and beautiful, although the tragedy of death is diluted by the pursuit of something seemingly artistic: in this case, the killer's desire to create a gigantic structure of the human eye.

The kills are seen as parts of a larger picture with the series of procedures entailed in the treatment of the dead – embalming, sealing them off with resin, sewing the bodies together – seen as quite necessary for its completion. As a result, there is a certain degree of voyeuristic astonishment involved in witnessing the individual bodies transform into the larger mural. While the idea of creating 'human models' is fundamentally disturbing, the ultimate display of those models, neatly arranged in a stylized wholeness, does not elicit a response of empathy for the victims.

'Sakizuke', the episode following 'Kaiseki', picks up where the previous episode ended, with the heart-wrenching scream of the kidnapped man waking up to find himself sewn to a pile of naked dead bodies. As the camera pans out, viewers are quick to notice that the bodies have been meticulously arranged to replicate the human eye. While the victims with lighter skin tones are arranged radially to represent the iris, the darker bodies are placed in foetal positions at the centre to form the pupil. The killer's clever use of skin tones is complemented by the grey interiors of the corn silo serving as the sclerotic area of the eye. In the course of the narrative, the completed mural is portrayed as an exercise in abject creativity and eventually turned into an exhibit. Thus, halfway through 'Sakizuke', viewers are once again made to behold the killer's design; only this time it is through a different lens – the eyes of Hannibal Lecter. Hannibal gazing at the mural as the camera shifts in quick succession between high and low angles to ultimately focus on Hannibal's eye builds an uncanny sense of doubling.

To Hannibal, what he sees is an extravagant pursuit in artistry and therefore, he compliments the killer with the words: 'I love your work'. Hannibal offers a somewhat transcendental explanation of the mural when he says: '[t]he eye looks beyond this world into the next and sees the reflection of man himself'. This analogy of the Creator and his Creation that he draws upon becomes a verbal reiteration of the earlier scene wherein Hannibal looks down into the silo to witness the mural for the first time. Hannibal's remark is crucial on several accounts. First, it qualifies the bodies as material that can be transformed into exhibits; second, it recognizes and establishes the complete arrangement of bodies to be an artistic composition worthy of appreciation, thereby validating the actions of the killer; third, it identifies the onlooker as the consumer indulging in an act of voyeuristic pleasure. Our initial response of horror and disgust is allayed by our inclination to accept the killer's work as a work of art. Like Hannibal, we, too, are willing to revel in such an abject beauty. Moreover, by establishing the killer as a deranged artist of sorts, 'Sakizuke' blurs the lines between what is to be considered art and what is to be

deemed deviant. It is the visualizing of the dead that becomes central to the larger narrative because the dead are primarily seen as means of exposing the identity as well as the twisted psychology of the killer, and by repeatedly drawing viewers' attention to the contrasting representation of corpses, the episode exploits the varied cultural responses to the event of death itself.

In his analysis of *Hannibal* (the movie), John McAteer notes that '[t]here could be no objection to homicidal art *as art*. One could certainly object that an artwork made out of dead bodies is immoral, but, from a purely aesthetic point of view, it could still be a rewarding aesthetic experience and hence a great work of art' (McAteer 2016:106). He further states that 'aesthetic distance means engaging with the art object as an end in itself, not as a means to satisfy your own subjective desires' (McAteer 2016:104), and that '[t]he key to the appropriate aesthetic experience is to get caught up enough in the film to feel the horror without being sent running from the theatre' (McAteer 2016:102). Thus, despite an underlying sense of fear or disgust, the aesthetic component of the work needs to create a space for the audience to experience visceral pleasure. This can be seen not just in *Hannibal* but in other crime shows such as *Dexter*, *The Fall*, and *True Detective* as well.[3]

To consider another instance, Paul Spector, the killer from the British-Irish crime drama series *The Fall*, is shown to be following a particular ritual after his crime. Season 1, episode 2 informs the audience that the routine includes washing and drying the victim's bed linen, giving a bath to the victim, painting her nails, and, thereafter, positioning her body back on the bed to make it appear as though she was sleeping. Once again, there is the notion of staging involved. It is not merely a harmless display of the body. The body is representative of eroticized brutality and is, therefore, made available for viewing to a set of audiences both onscreen and offscreen. Before leaving the crime scene, Spector also photographs his victim. According to Quigley:

> Whether or not they were intended to, many depictions of death cater to the taste for vicarious violence. Some, however, are not shared but hoarded for purpose. Serial killers often photograph their victims after they rape and murder them – the details of the crime, in living color, are etched more vividly on paper than on their minds and serve as catalysts to relive the event.
>
> Quigley 1963:36

Quite compulsively, therefore, Spector is shown pausing to adjust the bedsheet partially covering the victim's buttocks to click what he believes to be a better (or possibly the perfect) picture. The photograph he takes of his victim becomes a token of his success, allowing Spector to reminisce about his deed. Analyzing the practice of photographing the dead, Quigley writes:

> With the use of photography we can get as close as we want to death and yet still remain distant from it. A photograph allows us to satisfy our

curiosity in private, with prolonged stares that would be rude at a wake. We can observe deaths that are distant in time, examining the disfigurement of the victims of Jack the Ripper or the parents of Lizzie Borden. We can give free rein to our inclination to speculate about the nature of death.

Quigley 1963:37

And just like Spector, who can go back to the photograph each time he wants to relive his kill, viewers, too, can satisfy their curiosity about those deaths by replaying the episodes well within the comforts of their individual spaces. Besides, the visual closeness vis-à-vis the physical distance to a corpse seen on television softens the emotional distress that one might experience in the presence of an actual dead body (Quigley 1963:41).

The representation of the dead body, then, is a matter of performance. Keeping this very notion central, the HBO drama series *Six Feet Under* enquires into the dynamics of the funeral business. Once again, what stands out in the show's exploration of the many facets of death – personal, psychological, social, religious, and economic – is the idea of readying the body of the deceased for viewing. In the context of the death industry, the show highlights how the presentation of the dead involves a certain pursuit of almost life-like beauty betrayed only by the inevitable rigidity caused by rigor mortis. David and Federico 'fix' the bodies that are brought to the Fisher & Sons Funeral Home in order to make them presentable for the funeral service.

In the episode titled 'The Will', for example, David is seen discussing the affairs of Mr. Swanson's funeral with his widow. In this scene, David very carefully and subtly tries to convince her to buy a $9,000 casket with the following words: 'It's more than just a casket. . . . It's a tribute really'. Later in the episode, Mr. Swanson's body is shown dressed in a suit, hands folded, laid out in the casket as though he were in a deep sleep. All discernible signs of death are removed. While the entire image of the body laid out in the casket is a definite reminder of death, the body itself is mostly expunged of external signs to suggest the same. '*Six Feet Under* acknowledges', Laura E. Tanner writes, 'the dead body as object only to naturalize the embodied status of the lost subject' (Tanner 2006:220). The underlying idea is to hide from plain sight the reality of death and the fear associated with corpses. In his article 'Encounters with Deadness and Dying', S. D. Chrostowska states:

> In modern undertaking, with its hygienic and aesthetic requirements, art imperceptibly permeates reality. The corpse is *recovered* – restored to view; all marks of putrefaction are covered over and those of aliveness enhanced. This clandestine artifice of preserving, cosmeticizing, and dressing up of corpses to make them inoffensive (given our loathing of decay), and appear dignified, clean, and orderly, offers a glimpse of the life instincts in their rivalry and eventual compromise with the instinct of death. Elaborate dissemblance both prepares for and invites voyeurism.
>
> Chrostowska 2007:64

Although not all drama series present the dead body as 'dignified, clean, and orderly', they do certainly maintain an overall sense of aesthetics. In the context of media representations of the dead, Tina Weber elucidates:

> The term aesthetic refers not only to beautified dead bodies, but also to the selective application of contradictive stimuli, such as the Y incision, the lethal wound or blue shimmering skin. These artificial stimuli are not exactly beautiful, but serve to supplement and enhance beauty. Artificial stimuli signifying death serve to highlight the beauty treatments applied to the body by contrasting disgust and death with what would otherwise be aesthetically appealing.
>
> Weber 2014:77

This means that the televised corpse manifests a certain sense of symmetry, wherein disgust as an experience of 'a nearness that is not wanted' is closely connected to 'a nearness that is wanted', such as love, desire, or appetite (Menninghaus 2003:2). Therefore, viewers can satisfy their morbid curiosity without physically having to be in the proximity of a corpse. In order not to completely repulse the viewer, most visual representations of dead bodies are controlled, with several television series helping viewers recognize that the dead body operates constantly within a double bind. The shows retain a constant tension between the abject body and the proper, clean body; the same body can be classified as both abject and sacred. It is in this play of contradictions that the corpse emerges as a visual spectacle. Ruth Penfold-Mounce claims:

> The exposure of the corpse in various popular culture genres to the consumer feeds an apparent desire for the dead. However, notably this desire to consume the corpse is not physical like a cannibal but instead through the entertainment capabilities of popular culture which provides a controlled and safe environment to explore death.
>
> Penfold-Mounce 2016:20–21

Often these portrayals of corpses invite a synthesis of the voyeuristic, the abject, and the forensic gaze. The autoptic gaze, Penfold-Mounce explains, 'is abject, voyeuristic and forensically inclined by focusing on the eroticising process of the cadaver as a visual spectacle within a forensic science setting' (Penfold-Mounce 2016:28).[4] On the one hand, viewers are encouraged to look at and scrutinize the corpse alongside the forensic scientists or morticians, and on the other hand, they are also made to recognize the very act of gazing at the corpse as intrusive and violating. This creates a paradoxical space where the viewer feels both engaged and repelled. According to Darko Suvin, it is the constant drawing in and pushing away of the audience and the resultant shifts in distancing that 'accounts for central aspects of theatre communication, based on the audience's physical absence from but psychical presence

in the dramaturgic space, which is literally constituted by their minds' (Suvin 1987:329). The popularity of the television dramas under discussion, therefore, could be attributed to such a deliberate play with distance.

Conclusion

This chapter has explored how aesthetic distance is intricately linked to the transformation of the corpse into an object of desire, particularly in popular cultural representations of the dead. In watching a television show, the audience is imaginatively involved with the aesthetic fictionality that reduces the distance and allows them to engage with the constructedness of the corpse. Aesthetic distancing aids the viewer in indulging in morbid voyeurism by creating a space where such an engagement is permissible. Since visual images turn the sensory immediacy of death into a mere illusion, the experience of physical vulnerability in the presence of death is completely erased. As a result, there is an increased willingness among viewers to visually consume the dead. Although the transformation of a corpse into a work of art dilutes the emotive aspects of death, such fictionalized representations of death also generate a template against which the reality of death could be assessed.

In arguing about the role of detective fiction in bourgeois culture, Ernest Mandel explains, 'death . . . is not treated as a human fate, or as a tragedy. It becomes an object of enquiry. It is not lived, suffered, feared or fought against. It becomes a corpse to be dissected, a thing to be analysed' (Mandel 1984:41–42). Whereas crime dramas hold up what are deemed to be unsanctioned excesses, a series like *Six Feet Under* serves as a commentary on the outrageously expensive and exploitative structure of the funeral industry, an arrangement that has been socio-culturally devised. As a result, such shows become representative of various social and cultural sanctions. Given that the socio-cultural context within which these images are generated is in itself saturated with narratives of death and dying, it is only fair that popular cultural representations draw upon and enact such stories. On the one hand, murder, violence, and accidents are everyday occurrences; on the other hand, we as a society systematically deny the inevitability of death. We strive as much as possible to avoid any direct, physical contact with death or the dead. Relegation of the actuality of death to hospital wards and old-age home premises means that we as a society lack the experience of being in the proximity of a dead body. Even when we are, it is usually after the body has been posthumously reconstructed, treated with some amount of mortuary makeup for public viewing. Not only that, enormous amounts of money and resources are being invested in immortality projects to defer as well as defy death. In the context of these contradictory social attitudes, media-induced images of death, dying, and the corpse act as constant reminders of the ephemerality of life. These images and the narratives they choose to tell tap into the existing cultural fears about death and dying. Besides, since it is primarily through indirect experiences – the death of another – that we learn about death and

dying, it is quite tenable to assume that these media-induced images of the dead are in fact influencing and shaping the way we perceive and understand death. By dispelling the viewer's insouciance towards death and the dead, such representations can fundamentally alter the horizon of artistic expectations.

Notes

1 Although, theoretically, there is no limit to the decrease of distance, Bullough states that an average individual is often at the risk of under-distancing. As a result, appreciation for a work of art is either lost or is seen to disappear.
2 The corpse, as Julia Kristeva perceives it, is the ultimate manifestation of the abject. In *Powers of Horror*, Kristeva extensively details that '[the corpse] is death infecting life. Abject. It is something rejected from which one does not part, from which one does not protect oneself as from an object. Imaginary uncanniness and real threat, it beckons to us and ends up engulfing us' (Kristeva 1982:4). It is because the corpse resists any kind of signification that it succeeds in 'disturb[ing] identity, system, order' (Kristeva 1982:4). For Kristeva, the corpse's intermediate status – it is the person on the one hand, and decomposing matter on the other – is what makes it the abject.
3 Joseph Westfall in *Hannibal Lecter and Philosophy: The Heart of the Matter* writes: 'We find in Lecter an unsettling combination of things we would like to be and things that horrify, if not utterly disgust, us' (Westfall 2016:xiii). Hannibal as the protagonist manifests the same qualities that we associate with the events depicted in the series. He also operates within a double bind wherein not just the viewers, but the characters, too, are simultaneously drawn towards him and away from him.
4 Penfold-Mounce borrows from David P. Pierson's categorization of the gazes. In 'Evidential Bodies: The Forensic and Abject Gazes in C.S.I. Crime Scene Investigation', Pierson distinguishes between the forensic and the abject gazes. Pierson notes that while the forensic gaze seeks to control and order crime, death, and abjection (Pierson 2010:185) and offers the audience a sense of control (Pierson 2010:197), the abject gaze disturbs social and physical boundaries (Pierson 2010:197).

References

Abbott, Stacey (2018): 'Masters of Mise-En-Scène: The Stylistic Excess of Hannibal'. In Linda Belau and Kimberly Jackson (eds.): *Horror Television in the Age of Consumption: Binging on Fear*. New York: Routledge, pp. 120–134.
Ariès, Phillippe (1981/2008): *The Hour of Our Death*. New York: Vintage Books (ebook).
Bataille, Georges (1962): *Death and Sensuality: A Study of Eroticism and the Taboo*. New York: Walker and Company.
Bullough, Edward (1912): '"Psychical Distance" as a Factor in Art and an Aesthetic Principle'. *British Journal of Psychology*, 5 (2):87–118.
Chrostowska, Sylwia. D. (2007): 'A Passing Glance: Psychic and Aesthetic Encounters with Deadness and Dying'. In Corrado Federici, Leslie Anne Boldt-Irons and Ernesto Virgulti (eds.): *Beauty and the Abject: Interdisciplinary Perspectives*. New York: Peter Lang, pp. 59–82.
DeSpelder, Lynne Ann and Albert Lee Strickland (2015): *The Last Dance: Encountering Death and Dying*. New York: McGraw-Hill Education.
Fulton, Robert and Greg Owen (1987): 'Death and Society in Twentieth Century America'. *Omega: Journal of Death and Dying*, 18 (4):379–395.
Guyer, Paul (2004): 'The Origins of Modern Aesthetics: 1711–35'. In Peter Kivy (ed.): *The Blackwell Guide to Aesthetics*. Oxford: Blackwell, pp. 15–44.

Jauss, Hans Robert (2005): *Toward an Aesthetic of Reception*. Minneapolis: University of Minnesota Press.

Kivy, Peter (ed.) (2004): *The Blackwell Guide to Aesthetics*. Oxford: Blackwell Publishing.

Kristeva, Julia (1982): *Powers of Horror: An Essay on Abjection*. New York: Columbia University Press.

Mandel, Ernest (1984): *Delightful Murder: A Social History of the Crime Story*. Minneapolis: University of Minnesota Press.

McAteer, John (2016): 'Consuming Homicidal Art'. In John Westfall (ed.): *Hannibal Lecter and Philosophy: The Heart of the Matter*. Chicago: Open Court, pp. 99–108.

Menninghaus, Winfried (2003): *Disgust: The Theory and History of a Strong Sensation*. New York: State University of New York Press.

Penfold-Mounce, Ruth (2016): 'Corpses: Popular Culture and Forensic Science: Public Obsession with Death'. In *Oxford Research Encyclopedia of Criminology and Criminal Justice*. Oxford: Oxford University Press, pp. 1–36.

Pierson, David P. (2010): 'Evidential Bodies: The Forensic and Abject Gazes in C.S.I.: Crime Scene Investigation'. *Journal of Communication Inquiry*, 34 (2):184–203.

Quigley, Christine (1963): *The Corpse: A History*. Jefferson, NC: McFarland & Company.

Rush, Ormund (1997): *The Reception of Doctrine: An Appropriation of Hans Robert Jauss' Reception*. Rome: Gregorian University Press.

Suvin, Darko (1987): 'Approach to Topoanalysis and to the Paradigmatics of Dramaturgic Space'. *Poetics Today*, 8 (2):311–334.

Tanner, Laura E. (2006): *Lost Bodies: Inhabiting the Borders of Life and Death*. Ithaca, NY: Cornell University Press.

Weber, Tina (2014): 'Representation of Corpses in Contemporary Television'. In Leen Van Brussel and Nico Carpentier (eds.): *The Social Construction of Death: Interdisciplinary Perspectives*. London: Palgrave/Macmillan, pp. 75–91.

Westfall, Joseph (ed.) (2016): *Hannibal Lecter and Philosophy: The Heart of the Matter*. Chicago: Open Court.

7 Into the dark side of Pop Art
From Warhol to Banksy

Florina Codreanu

Introduction

The history of art at times enjoys the privilege of being an uncultivated field when it comes to research from outlandish domains, such as death studies or other interdisciplinary studies intended for extensive readings and retrievals from art, literature, and any creative area of interest. The large thematic opening attained in the recent studies has turned art into a land of all possibilities. From marketable death and its many forms taken through mechanization and brandization to death right around the corner, sharing impartially her grinning face, Pop Art presents the history of a dark journey started when most of the established artistic forms and styles reached their dead ends. Between the late 1950s and mid-1960s, the Western popular culture at large inspired and guided a new generation of artists from Great Britain and the United States through the unprecedented change in the way people viewed fine arts. The objects of ordinary life became overnight objects of artistic expression and eternal life. This change of scene affected not only the idea of art, which is then to be found everywhere, but also the very way people perceived their immediate reality, bound to commerce and advertisement, consumption and industrial products.

Not surprisingly, Andy Warhol (1928–1987), the champion of Pop Art, sharply observed that department stores were the new museums, whereas shopping was the new leisure time obsession. After the Great Depression, people strongly believed in the fantastic boom operated by the capitalist economy, and the Pop artists were eager to finger point the phenomenon in its many facets: 'It was boom time in the West, and Warhol and the other pop artists sensed it. All were excited by the vitality of popular culture, and the mass media provided inspiration for their work' (Sooke 2015a).

Following the euphoria of victory and post-war relief, the whole idea of time in the 1960s changed tremendously towards a rush that only multimedia channels were still in capacity to capture accordingly. Afterwards, all these multimedia resources were poured into the everyday art of the pop movement, or *mass-culture art* as the English art historian Eric Shanes insisted on naming it, evidently instead of Pop. Everything started to happen faster than

before, and people rushed over them constantly in a manner that made Pop Art the pioneering artistic trend in adapting to the new changing rhythm of the world and assimilating its best products.

Furthermore, personal time termination became an impossible act due to the anonymity or trivialization of so many endings by news reports and tabloid magazines. Based on a Lacanian prereading, the American art critic Hal Foster defined death in America as a missed encounter with the real: 'It is in this seminar[1] that Jacques Lacan defines the traumatic as a missed encounter with the real. As missed, the real cannot be represented; it can only be repeated, indeed it must be repeated' (Foster 1996:42). Professedly, in Andy Warhol's frame of mind, repeated nothingness was much more intensely comprehensible than one sample of nothingness. Artistic exponent of this repetition of traumatic events and interested in the compromise between anonymity and celebrity, Warhol epitomized for his generation the incomprehensible and unrepresentable type of death. Witness to and survivor of the death of everybody else in the world, he as a distinctive individual was unable to come to terms with his own idea of death: 'I don't believe in it, because you're not around to know that it's happened. I can't say anything about it because I'm not prepared for it' (Warhol 1975:123). In other words, the Pop artist 'dies' through his art and his recurrent themes, never in reality because reality itself is just a mass product and a missed encounter translated into art.

Embracing to a certain extent Warhol's Pop legacy, the self-invented masked persona of Banksy, an anonymous artist of post-millennial-depression Britain, engages with similar topics of mass production and socio-political apocalypse through dark humour and subversive commentary. The way he relates to death as an evanescent theme is mainly dictated by his dystopian view of the world, in which Europe's level of dreaming and hoping is alarmingly decreasing with each passing day: 'His images target governments and police for their own criminal and outrageous behaviour, war and its insanity, poverty, the cult of celebrity, and even adults for forgetting their childhood dreams, among other things' (Ket 2014:5).

All this considered, the present chapter intends to progressively explore, from Pop Art (Warhol) to Pop inheritance (Banksy), the dark side of art echoed through the light, often trivial appearance of the art itself in the wake of mediacracy and ruthless cultural commercialization (Death 'wishes' popping into Pop Art) along with the artists' dominant attitude towards their own time, the Warholian 1960s (Warholian commodities and casualties) and the beginning of the new millennium (The Banksyesque epiphany), including time termination through their favourite selection of themes and subjects. Additionally, the evolution of their artistic personas and the implications of a spectrum of theatrical images created by the Warhol-Banksy artistic mindset (*Tenebrosum theatrum mundi*), informed by the mass culture and focused on the themes of death and disappearance, are discussed at length artistically and historically.

Even though neither of the two artists is a death-related artist or death-specific creator, their indirect contribution to the unlimited field of death studies shines from behind their choice of topics and their branded artistic personas meant to support an intriguing non-physical existence or civil death. In Warhol's case, one can talk about a lost identity, from 'Andy Paperbag',[2] a.k.a. Slovakian-born Andrew Warhola, to plain American Andy Superstar.[3] As for Banksy's case, there is at stake a hidden identity, both a necessity in his early years and a marketing tool thereafter: 'When, in 2010, *Time* magazine selected him for its list of 100 most influential people in the world . . . he supplied a picture of himself with a paper bag (recyclable of course) over his head. For he is an artist unique in the twenty-first century: famous but unknown' (Ellsworth-Jones 2012:1). The former managed to borrow from his cultural surroundings as much as he could in order to add it to his paper bag while the latter just wore a paper bag over his head to prevent his civil identity from taking charge of his artistic one. The refusal to exist as person is translated in both cases into a death wish accompanied by an artistic revival.

Death 'wishes' popping into Pop Art

The apparent paradox of Pop Art consisted in bringing insistently to the fore the bright and celebratory side of life in a period of assassinations and conflicts, nuclear threats and natural disasters, social change and drug abuse. Seemingly, the power of mass media promoting the American dream left no room and no time for melancholy, introspection, or dismay about the actual world. However, Pop artists in general and Andy Warhol in particular sensed the utopian manoeuvres of modern capitalism and democracy. Creating an art based on interrogation and critique of the wider culture, Warhol brought to public attention the dark twist of the American dream by exploring the relation between celebrity and death along with the themes of mediated suicide, capital punishment, and anonymous death. His silly monosyllabic persona accounted for a deadly deconstruction of the essence of the subject and an artistic reconstruction of the tragic figure playing a dumb-and-deep scenario: consumerism-orientated life and death in the spotlight.

When American movie star Marilyn Monroe was found dead from a drug overdose on 5 August 1962, one day before Warhol's birthday and the Monday news, his career went wild with a new theme up his sleeve that not only troubled viewers but also changed the critics' perspective to the matter of triviality and simplicity previously attached to his artwork. As Shanes (2009:42) observed: 'Warhol contrasted the actress's "perfect" and colourful public persona with her messy, disintegrating, uncolourful and gradually fading private self. Any notion that Warhol was never a serious artist is completely confounded by this one picture alone'. With the work *Marilyn Diptych*, realized immediately after her death, Warhol entered the world of industrial print-making, i.e., silk-screening process, which soon enough would become his personal trademark. Using one photograph from the 1953 movie *Niagara*, he

multiplied it to 50, 25 in heavy colour and the other half in black and white as an open book of life-and-death story in the limelight. The impersonal effect of an assembly line and mass-produced piece of art was exactly what he wished for his art to achieve:

> Warhol's goal was always to detach himself – his thoughts, emotions, and actual hand – as much as possible from his work. He was also trying to detach the spectator from the painting. By repeating images over and over on the canvas, Warhol removed all the emotion. Even his later works of car accidents and electric chairs leave the viewer feeling numb and uninvolved, rather than horrified.
>
> Ford 2001:45

To the obviously glaring and colourful side of Pop Art, imbued with a questionable optimism in concordance with the imagery of plenty, Marilyn's suicide and the train of events set off that year brought to light the other side of Pop Art as well: experienced and disillusioned, cold and detached, putting aside for a moment the young and innocent tones. Warhol himself, after coming of age as a Pop painter with *32 Campbell's Soup Cans*, quickly evolved to a more mature artist for whom the power of the image is given by the multiplied confrontation with the image. Moreover, 'in a consumer-led and celebrity-driven world', stated the art critic Alastair Sooke in the documentary on *Modern Masters*, dedicated to Warhol, 'the artist had to find his own way to break into the fine art establishment' (Sooke 2010). And he did break, by turning to the commercial inspiration from which his cartoon-like style developed naturally. Since being just a successful commercial artist had already proven to be unsatisfactory in the 1950s, he quietly embarked on a journey of rebranding and marketing his own artistic persona from which he worked his way up to the rank of fine artist: 'His genius was to realise that in an age of consumerism anything can be turned into a commodity, even a painfully shy and awkward personality like his' (Sooke 2015b). Besides that, being famous was Warhol's greatest lifetime obsession, after wanting to be Matisse or a machine, more exactly a machine-like artist playing with colours; and he truly and rapidly became extremely famous, after brilliantly playing with colours and ideas alike: 'And if there was one thing Andy understood, it was how to be famous. After all, he had turned Andrew Warhola, a poor, shy boy from Pittsburgh, into Andy Warhol: art superstar and international celebrity' (Anderson 2014:4).

Openly against any sort of elitism in art consumption, Andy had cynically grasped that a bottle of Coke is the same for the president, Liz Taylor, or the bum on the streets, so he considered Pop Art to be for everyone, for the mass of the American people and not for a select few. From that point of view, art as an accessible commodity was similar to death, the great democratic leveler: 'I realized that everything I was doing must have been Death' (Warhol quoted in Foster 1996:52–53), said Warhol in a 1963 interview. How to remain

concentrated on the anonymous victims of recent history whilst the mediated ones are taking all the credit was among Warhol's main artistic desiderata. The mass subject fascinated him, both in the direction of fetishism and spectacle, of voyeurism and exhibitionism: 'Warhol was interested in this strange avatar of the mass subject; it is a shame he did not live to see the golden age of hysterical talk shows and lurid murder trials' (Foster 1996:55).

Despite his sudden and unexpected departure on account of routine gallbladder surgery followed one day later by a heart attack, Warhol's legacy of roughly 32,000 paintings and prints left us with manifold artistic traces in terms of mass subject expression and time possession: 'Like the rest of us, he advanced chronologically from birth to death; meanwhile, through pictures, he schemed to kill, tease, and rearrange time' (Koestenbaum 2001:5). What was, for the rest of us, the grammar and language of linear time, was, for Warhol, the colour and picture of timeless explosion specific to art.

Warholian commodities and casualties

Capable of art embodiment in all the spheres of life performance and art practice, Andy Warhol was the artist of his time, beyond any ambition of masterpiece or geniality, not to mention originality. A puzzling artist through his everyday public attitude, his life philosophy, and his creation proper, he straightforwardly materialized the grand themes and obsessions of the contemporary society with a bald passion for all the existing forms of communication. The time to assert himself could not have been better chosen since, after the Second World War, the eagerness to be was growing stronger than ever in America, and in the sixties more specifically, everybody knew everybody in a foolishly intermixed way so that in the seventies everybody lost or abandoned everybody in a disappointedly disturbing manner: 'In the 60s everybody got interested in everybody. In the 70s everybody started dropping everybody. The 60s were Clutter. The 70s are very empty' (Warhol 1975:25–26).

Undoubtedly, during the convenient sixties, Warhol lived his artistic creativity to the fullest so that at the start of the seventies he could declare the death of painting. By striving to remain always the same 'boring' artist and carrying on with the same work procedure, he ensured his long-lasting manufactured celebrity. Extremely sensible of his given environment, he always capitalized on any possible creative opportunity until it went into a decline. For instance, the Marilyn theme was extended from 1962 to 1967 and then 1979. Equally, the dollars theme that had been used in the early 1960s would be used again in the early 1980s. In fact, an inherent artistic crisis together with an inexorable exhausted repetition of his ideas, while desperately in search of new ones, would accompany him all his life as proof of his constant insecurity and anxiety, on both a personal and a creative level.

Fully immersed in the popular culture of the 1960s and the spread of its mass concepts and marketable values, Warhol came into prominence during this decade and remained its flesh-and-blood superstar among other living

superstars, who made him more famous: Elvis Presley, Marlon Brando, Natalie Wood, Liz Taylor, and Jackie Kennedy. Surrounded by celebrities, he had the most visually prolific period and the most consistent social experience of his career. After he had set up the Factory, a working studio for himself and his numerous assistants, including curious visitors, he maintained a distinctive way of combining work and pleasure, art and entertainment, fame and fun. From the Factory emerged the 1964 exhibition, in which the Warholian art touched the bottom limit of commercialization by transforming the Stable Gallery into a real art warehouse or art supermarket, heavily laden with packing for different pieces of merchandise. The carton sculptures, rigorously realized based on their originals, would restate the fond Warholian idea of production line towards a cultural manifesto of mass production and art capitalism. When asked if there was anything else under the surface of his artwork, or even himself, Warhol said blatantly there was nothing more, nothing behind. As far as the can of Campbell's soup was concerned, he admitted without reserve that he wanted 'to paint nothing', and when interior designer Muriel Latow gave him the idea for 50 dollars, he was looking for something that was the 'essence of nothing', and that was actually it. Regarding his artistic commodities, Andy had no desire whatsoever to add value or superior meaning to what, he considered, would exist without his interference or final touch.

Not being present in his artwork made Warhol feel exhilarated about challenging the old-fashioned idea of authorship and liberated from the traditional ways of producing art. He got the same satisfaction from his public appearances, in which he used to say nothing or mumble a few unintelligible words at best. This lack of presence was mimed as well through a certain idleness in his manner of moving and living, through the old age adopted in his green days by wearing silver or white wigs, and through the prolongation of childhood privileges and the happy state of immaturity. Nevertheless, his personal time during the first decade of his fine art career was entirely and enthusiastically dedicated to creating art and finding sources of inspiration.

In Andy's venture of supplying his art with loan ideas, Henry Geldzahler, an assistant curator at the Metropolitan Museum, who later said declamatorily 'Andy was pop and pop was Andy', provided him with the idea of disaster paintings, starting from a 1962 *New York Daily News* issue with a front-page headline '129 Die in Jet!' Totally taken by the news, Warhol turned himself into a death chronicler and painted in acrylic and pencil a plane crash after the Air France Flight 007 accident, in which 130 people died in the end of injuries. The charter flight was sponsored by the Atlanta Art Association along with a one-month artistic tour across Europe and more than a hundred of the passengers were Atlantan art patrons heading home on this plane. It is worth remembering that the disasters around the Pop artist seemed to be inexhaustible at the time, and he certainly succeeded in exploiting them artistically.

His rich background in scrapbooking and collecting really paid off when he proved to be skilful at turning any ephemeral piece of daily news into a

monumental piece of art. A news devourer from childhood, he found with ease the right suicides, car accidents, gangsters' or presidents' funerals, electric chairs, atomic explosions, or food poisonings. For example, the latter derived from a botulism scare reported in *Newsweek* when two housewives from Detroit died as a consequence of eating poisoned tuna fish sandwiches. In *Tunafish Disaster* (1963), Warhol framed the accidental death in silkscreen ink and silver paint on linen overall, using a grid pattern for the purpose of replicating the pictures of the toothy smiling women and of the big tuna cans above them with the warning: 'Seized shipment: Did a leak kill . . . ' and, of course, for exacerbating the sense of terror and loss since both of the tainted cans' victims watched untroubledly over their children while having the sandwiches.

Letting himself be inspired by different types of fatalities taking place in the early 1960s, Andy Warhol treated his casualties the way he treated his commodities, with cold detachment and lack of concern. The brutal facts that turned people into figures, and by extension harmless consumerism into violent death, were identified and processed within an artistic journey of affordable tragedy and mortality: 'Other paintings included car crashes, funerals, and the hydrogen bomb. He used bold, shocking colours, creating grotesque images with such titles as *Vertical Orange Car Crash*, *Purple Jumping Man*, *Green Disaster Twice*. Frequently, the same image was repeated over and over' (Ford 2001:47–48). From the commonplace objects to the celebrities of the day who tend to keep running through everybody's mind, Warhol managed to identify a third popular expression of the mass subject: the one missing in action or representing itself *in absentia*, the one that can attract everybody's attention by not being present among us. In Foster's (1996:51) words, 'Warhol did more than evoke the mass subject through its kitsch, commodities and celebrities. He also represented it in its very unrepresentability, that is, in his absence and anonymity, its disaster and death'. After all, reading about a tragedy in the news is less traumatic than suffering the tragedy yourself, and in the reader's mind, there is undoubtedly a certain thrill of escaping from that particular tragedy in the first place.

Read in terms of traumatic realism, as Hal Foster proposed in his seminal article *Death in America*, Warholian death and disaster paintings become in readers' eyes much more straightforward: 'repetition is both a draining of significance and a defending against affect', and this strategy guided Warhol as early as the 1963 interview: 'When you see a gruesome picture over and over again, it doesn't really have any effect . . . repetition serves to screen the real understood as traumatic' (Foster 1996:41–42). In order to reach out to the viewer and have a touch of the real through the double effect of the colour, Warhol practiced three kinds of repetition, clarified Foster, which in our view would better be called phases of the same repetitive process in dealing with popping images: fixing on the traumatic real, screening it, and producing it. When he chose to take Geldzahler's advice and stop affirming life in his art, he was conscious of the impact that traumatic historical events have on

contemporary culture, so he meticulously documented his engagement with the public sphere and the commodity culture by reflecting as well on the limits of his realistic representations. The result came as a deadly revelation because Warhol decided to produce two art works for the price of one:

> In many of the Disaster pictures Warhol coupled each canvas with an identically-sized support painted all over with the same basic colour as its companion. He claimed to have done so in order to give his purchasers twice as much painting for their money, but that was a diversion; clearly his true intention was to complement each positive image with an utterly negative one. In the context of the tragic events depicted, the blank canvas can only signify the total void created by death.
>
> Shanes 2009:42

A stupendous image manipulator, rejoicing at an early stage in his career the replacement of the hand-made image with the machine-made image, Warhol was at the same time an astute human manipulator and interrelationship master. To all appearances he was trying to fade into his artistic entourage but, in reality, he was swallowing, using, and transforming this entourage to his own advantage, not without any repercussions or frightening casualties as a matter of fact. Both his creative and human diversions entailed sheer confusion and wrong labelling. Either a two-faced character or an isolated star, he gave birth to uncontrolled and opposite emotions. Because of his awkward presence, he got shot by a disturbed female follower in 1968, the same year Martin Luther King and Robert F. Kennedy were assassinated. The moment was fully covered by the tabloid press, and, ironically, he tragically ended up in the front-page news, the same headlines that had inspired his disaster paintings and marked for good his career as a serious, though Pop, artist. Becoming his own living disaster, Warhol barely survived the shooting; he remained physically and mentally traumatized for life, and he made real efforts to consider his afterlife more than a funny dream.

Leaving behind his stardom by the end of the 1960s, Andy Warhol came as close as possible to what he had previously considered impossible in a magic-like treatment of reality: his own unimpressive mortality. Apart from close friends, he experienced before and after two influential, yet repressed, deaths: the one of his father (art sponsor and the provider's figure) when he was thirteen, and he stayed hidden under the bed during the wake to avoid seeing him as the religious tradition commanded; and the one of his mother (caretaker and the supporter's figure) in 1972, and again he did not attend the funeral, pronouncing himself completely free to socialize and travel. Keeping himself aloof from mourning over dear ones, Warhol seemed nonetheless to be fond of remembrance, such as the hope of being kept alive in the memory of others as a can of soup, the same soup he painted and ate on a daily basis for years.

In the Warholian logic, 'Death, for instance, had always been one of Warhol's principal themes – ever since the start of his career as a Pop artist around

1960' (Sooke 2015a), but concurrently 'Andy had a fantasy: death didn't exist, and people at the ends of their lives simply vanished or floated away. This fairy-tale hypothesis came in handy when he needed to confront the deaths of family and friends' (Koestenbaum 2001:171). In the end, death went through the same process of commodification as art did, so who needs to embrace death in a period of protest, anti-war movement, and counter-culture? If for Warhol an artist is somebody who kills time by producing things people do not need to have, and, consequently, art is what you can get away with, why should death be something more than a tautology, death on death, in a mass-cultural imagery?

The Banksyesque epiphany

In response to Andy Warhol's influence over time and space, the art prankster and proponent known as Banksy unfolds the history of contemporary art as part of daily life after the modern master heralded its complete democratiza-tion. In a matter of several years, Banksy's intrusive and deceitful style easily conquered spaces that the art industry and market did not own before. Tak-ing street art to art galleries and underground graffiti to mainstream culture was by itself a revolution, and without his outstanding presence, spontaneous artistic activity, and socio-political actions, all this would not have happened so smoothly.

A man of many faces, a half-truth character, and the perfect tabloid figure, Banksy was born in the midst of legends and myths, carefully collected in two volumes by the English academic, journalist, and publisher, Marc Lever-ton. If, in the first volume, the author planned to feature the Banksyesque spirit in all his overwhelming glory ('this book is a celebration of that anar-chic, rebellious spirit' (Leverton 2011:9)), in the second he moved forward to the Banksy phenomenon that he had already acknowledged as such. To put it otherwise, art and politics entertained each other on his creative and, at times, surrealist journey, in a comical and satirical manner, causing an inter-national stir. Both speculative and situationist, Banksy had the unique ability to stage the crime of the day and toy with the hottest celebrity in the world. It was not like nobody had seen or imagined anything like Banksy before, sometimes quite the contrary. According to fellow artist Run Dont Walk, he possessed the talent of primacy by being able to give shape and colour to what was on everybody's mind or on the tip of their tongue: 'Banksy is very intel-ligent and I feel an affinity to some of his ideas which tend to be more general critique of society and the human race than attacks on politicians. He knew how to capture ideas that were floating in the air and thought of by many, but he expressed them first' (Ket 2014:115).

No matter the opinion, Banksy had the unhesitating courage to row two boats at once: the one of art world based on exhibition and genius and the one of graffiti community fed on vandalism and balls. His statement about succeeding in either of the two was pretty clear from the start: 'The time of

getting fame for your name on its own is over. Artwork that is only about wanting to be famous will never make you famous. Fame is a by-product of doing something else. You don't go to a restaurant and order a meal because you want to have a shit' (Banksy 2005:237). Using absolute anonymity as an accomplice to his genuine talent, Banksy obtained a remarkable unprecedented effect, which propelled him directly to fame. His invisibility guaranteed him superpowers in the urban jungle of today's reality, which helped him act effectively in any of the possible worlds he would like to accede to, or, as the author Patrick Potter noted in the eighth unpaged edition of *Banksy You Are an Acceptable Level of Threat and If You Were Not You Would Know About It*, compiled and edited by Gary Shove: 'Banksy didn't so much knock on the closed doors of the art world. He kicked them down' (Potter and Shove 2018). In addition, he maintained all through his artistic career a fresh alliance between street art (non-commercial and contextual) and studio art (commercial and out of context), considering the street, even after becoming embarrassingly famous, his main canvas and his primary exhibition space, wherein he could display work for free to his heart's content.

In light of everything ever said, written or believed up to nowadays about Banksy, he really followed in the footsteps of the Pop Art father and superstar, becoming the most important art liberator of the new millennium, accessible and easy to comprehend by his fellow creatures, a mysterious epiphany of the Artist to the humankind. Trespassing on world properties and museums, performing incredible stunts around the world, 'Banksus Militus Vandalus' or 'Moniker Banksymus Maximus' or simply Banksy had a dream of a long-lasting marriage of graffiti artist, painter, and political activist, in a parodical good old fashion: 'He travels widely, painting in anonymity, while his art serves as a commentary on the state of local and national affairs' (Ket 2016). Thanks to artists like Banksy, all the suffocating corporate advertisement mounted in the daylight has finally got a powerful counterpart in the bright spots of art created in the dead of night. What is more, and perhaps unsurprisingly, before the Banksyesque revelation there was only a street art movement and hardly afterwards a street art market rapidly took shape. So, what was considered from its outset a transient, impermanent, and disappearing street affair, by virtue of the subsequent Banksy-led enterprise, gained social relevance and power. Banksy's direct contact with the street simplified the task, and all the mystification about his true identity intensified the power of his message. His art was about to conquer uninhabited, deserted spaces and convince simple, unartsy people. A pleading about possession and loss, presence and absence, his art challenged the limits of art, life, and death in an unsophisticated but radical manner. A provoker *per se*, Banksy succeeded to dynamite all our little conformities, starting with our herd instinct and finishing with our pretentious life standards. His theatrically vivid pieces do not tackle big world problems frontally, but from the back as a circus puppeteer.

Taken as an example, the following ironical notice about consumption market on one of his London-based pieces does not address any big issue or

solve any present problem: 'Sorry! The lifestyle you ordered is currently out of stock' (2011) or, previously, 'The joy of not being sold anything' sprayed on a billboard in 2005. The same holds true within the approach to the labour market that came into question in Toronto through the representations of a businessman with a suitcase, who appeared wearing a sign around his neck that read 'Will work for idiots' or '0% interest in people' (2010). Admittedly, Banksy is concerned about the degree of humanity our species has arrived at, with all the inherent hypocrisy and greed, war price and injustice, insidious corporate capitalism and corruption.

Tenebrosum theatrum mundi

When Banksy decided, amid a series of other internationally successful stunts, to place on the third floor of the Museum of Modern Art in New York, home of Andy Warhol's *32 Campbell's Soup Cans* (1962), his own painting version of *Discount Soup Can* (2005), in which he depicted a tin of Tesco Value cream of tomato soup, he was not only repeating against the grain the famous Shakespearean statement about all the world being a stage, but he also initiated an artistic rendezvous with his predecessor. An unlawful installation that lasted for six days in the most popular museum in the world engendered perplexity among the visitors, who 'walked up, stared and left looking confused and slightly cheated', the way Banksy himself amusedly declared, and right there in those five minutes of spying, he 'felt like a true modern Artist' (Banksy 2005:179). The anarchist and the rebel (Banksy) encountered on the glorious field of art the unadapted and the anti-social (Warhol). Their sick and tired views of the world are so similar and their concealed identities entertainingly kindred. Amongst all the dark similarities, one cannot forget the way Warhol said his disenchanted farewell to painting in the 1966 exhibition by converting the work of art into a decorative wallpaper with cows, which equally marked the absurd termination of the pastoral tradition in Western art, and by inflating silver balloons with helium, which were left to float adrift, a clear signal of the visual art decline on the whole. Also, one cannot forget the way Banksy created, with the help of 58 other global artists, the 2015 grotesque Dismaland, a bemusement family park unsuitable for children, which welcomed visitors with the safety notice: 'It's not art unless it has the potential to be a disaster'.

With all the bright pretentions nurtured by the popular culture of hyperexposure and financed by the contemporary world of ultra-capitalism, Pop Art and its offspring are replete with dark images that process the subject of death differently in terms of sensations and thoughts. Despite being caught in ostensible imitation, it is not television or newspaper death as it may seem. In Banksy's pop-up exhibition on a derelict site, a funny replica of a street museum, the death theme gained a totally new meaning and thrill. The death of Princess Diana, which turned Britain into a grieving nation by the end of the 1990s, was imagined by Banksy as a blonde long-haired Cinderella

theatrically falling from a capsized carriage near two white horses twisting and writhing on the ground in front of an army of paparazzi equipped with blinding flashlights. A far cry from the clichéd idea of artistic tribute or social recognition, the piece is destined to speak out about reality manipulation: since Diana's life meant to be a fairy tale had proved all wrong, the artist saved her death to accomplish the mission. Life is not a fairy tale, but death is, or at least it can become one with the right mediation.

A short walk from heaven to hell, Banksy's art irrespective of the location holds the appeal of truthfulness and unease. Dismaland harboured in total ten new art works signed by him, and all addressed contemporary issues of urban violence, endangered species, migration crisis, pollution, and the cruel reality of dreaming: 'The fairytale is over, the world is sleepwalking towards climate catastrophe, maybe all that escapism will have to wait. Think of this as a fairground that embraces brutality and low-level criminality – so a fairground then', said Banksy on the occasion. After a grisly rabbit had eaten the magician and the grim reaper had taken to the dodgems in other of his works, the Dismaland art show had indeed a great potential to be a disaster; after all, it succeeded in destroying our dearest fantasies.

Both characters in the drama of life and art, Warhol and Banksy are magnificent energy collectors, and they used to rehearse extensively for the play of art birth and decay. What has become of this world, and what is the role of art in all the craze are two fundamental questions of their artistic repertoires. Thoroughly sensitized to the continuous repeatability and imitation, conformism and standardization, promoted by the mass culture of the last century, these two artists chose to 'mechanize' their art processes as a measure of success in obtaining the effect of photographic realism, which makes the artistic more real than the reality. The way Warhol remarked at one point, the process of creation from commercial art was mechanic, but the attitude was endowed with emotion (Nemțuț 2008:28). In their cases, a certain emotion emanates from each of their works, even in the static and passive Warholian images caught in a dramatic repetition. As regards Banksy, his dark humour and implied self-humour play the link role, and pieces with 'No Future' or 'Follow your Dreams Cancelled' have the power to bring back to the viewer the forgotten emotion of life, corrupted by indifference and weariness.

While extracting the dark narratives of a fully-fledged pop culture in full-blown, it looked like Andy Warhol's shooting in 1968 was an emblematic moment for the Pop Art movement, falling from mainstream to worn-out. That was the beginning of the end if we take into account that 'The New York Times declared Pop Art to be officially dead', and, rather metaphorically, Alistair Sooke translated the shooting into the dark heart of Pop Art, and he concomitantly revealed the excessive killing the movement had already suffered from: 'Influencing the appearance of everything, from fashion and furniture to movie posters and record covers, Pop Art was suffering from overkill' (Sooke 2015a). 'Play to the full, get fashionably dressed, and eat junk food until you die' was the inherent message of a trend that managed to overpass

the overkill and remained part of our day-to-day culture. Recent exhibitions from Tate Modern, London, such as 'The World Goes Pop' (17 September 2015–24 January 2016) and 'Pop Life: Art in a Material World' (1 October 2009–17 January 2010) are living proof that Pop Art is not at all stone-dead but rediscovered periodically and reinterpreted through the art works of contemporary brand artists such as Takashi Murakami, Damien Hirst, or Jeff Koons. As long as commerce plays a leading role in the world's economy, Pop Art will continue to quantitively grow and expand its stylistic range and fields of action. As *Guardian and Observer* writer Sean O'Hagan said about Warhol, we may say as well about any other Pop artist who is both a 'popist' through theme and a pop critic through message: 'In a culture in thrall to advertising, marketing and celebrity, Warhol made art that mirrored that hyper-real world of commodification even as it critiqued it' (O'Hagan 2009).

As concerns Banksy, any 'Pop' label attempt is nipped in the bud since the artist prefers to be recognized as a vandal and an outlaw, more an outsider than an insider of the art world. Otherwise, he would not have produced a piece of art such as the one with the message *I Can't Believe You Morons Actually Buy This* Shit (2007) written on a blank canvas that is theatrically lifted by a schoolboy at an auction house, crowded with people on the brink of bidding and purchasing the piece. The irony made it to be sold at Sotheby's within an unauthorized Banksy retrospective for an obscene sum of money. All the gloomy circus the street artist enacted with each art show or exhibition, organised in total secrecy and allegedly without official consent, turns the spotlight on the heightened sense of irony he might possess, even by letting his followers stand and wait in endless queues for crumbs that one day may be turned miraculously into gold. To be true, each art piece attributed to Banksy turns the attention to the present upside-down world of artistic creation at the hands of a consumer-orientated culture. A man with a bucket and a sponge who washes away the last word of the saying 'What we do in life echoes in Eternity' is the most faithful appropriation of street art: ephemeral, but with an echo.

As Banksy became unintentionally famous, Banksy's art has the potential, despite the zealous town cleaners or revengeful peers, to become eternal. When he smuggled *Rock with Marker Pen* (2005) into The British Museum among original prehistoric artefacts, he accompanied the 'post-catatonic' piece, which ironically presents a hunter-like stick figure with a shopping trolley, with the following information label: 'Most art of this type has unfortunately not survived. The majority is destroyed by zealous municipal officials who fail to recognise the artistic merit and historical value of daubing on walls' (Banksy 2005:185). The prank lasted eight days, but after 13 years, the hoax caveman art returned to display in the museum for Ian Hislop's exhibition, which aimed to illustrate various stories of satire, dissidence, or subversion, pertaining to British history.

A peace and hope advocate, Banksy had the genius to rest his case in a grotesque but appealing style, using his anti-consumerist and anti-inequalitarian

views in an instantly catchy mockery. In his fourth[4] book *Wall and Piece* (2005), he included some of his most powerful social pieces: an African boy with a Burger King crown ('Sometimes I feel so sick at the state of the world I can't even finish my second apple pie'), a naked crying girl caught between a Disney character and a McDonald's one ('Can't beat the feelin"), a clown taken down by the police ('You told that joke twice'), Jesus on the cross carrying shopping bags in both arms ('We don't need any more heroes, we just need someone to take out the recycling'), and people throwing bombs instead of bowling balls ('People who get up early in the morning cause war, death, and famine') (Banksy 2005:188–207). The irreverence and dark wit spotted in the majority of his art works are likely to bring to life a feeling of artistic compensation and human satisfaction against all the bad and ugly in the world (not to be forgotten that the same Banksy painted the Palestinian Segregation Wall, apparently to make it look beautiful, with imaginary stairs or escaping havens).

In a culture of irritating branding and strong desire for brands, either new or established ones, artists like Warhol and Banksy make a memorable appearance on the scene of art to 'rebrand' the nature of art and 'debrand' the reality of everyday life. In this respect, both had a talent for killing and embalming past masters' iconographies and humanizing ads and commodities. For instance, Warhol depicted the depreciation of the world through the death of a bottle of Coke, a democratic symbol that unites the richest with the poorest: 'In a paint of a spilled Coke, executed sometime in the 1980s, Warhol seemed to be narrating Coke's death – its mortal liability, as a liquid, to leak; as a bottle, to crack; and as a product, to flop' (Koestenbaum 2001:201). The shiny and superflat, six feet tall and iconic, American trademark–registered *Coca Cola No. 3* from the 1960s dropped and left the pouring traces of the culture of accessibility it had emerged from. If Warhol was fundamentally drawn on aesthetic or commercial death, as staged cinematically by an objective force called the artist, Banksy has a thing for daily or routine death through our guilty and inhumane actions, all meant to bring more harm to the already-sick-to-death world. In his view, we can live impassibly the American fulfilled dream, but at the same time, we must endure the quotidian nightmare: 'The greatest crimes in the world are not committed by people breaking the rules, but by people following the rules. It is people who follow orders that drop bombs and massacre villages' (Banksy quoted in Potter and Shove 2018), said Banksy. Without a doctor regularly taking the pulse[5] of love and peace in the world, we might one day all end up in the final frontier of our worst nightmare.

Conclusion

After Pop Art assumed full responsibility for bringing the real world back into art, Andy Warhol became the well-branded embodiment of everything you wanted, with the special mention that for him everything was nothing,

life itself was nothing and death alike. Though the latter was far more em-
barrassing because someone else has to take care of all your details after you
are gone. That is why it was much easier to think that people never die; they
just go to department stores for a change.

Bearing in mind the general perception of Warhol as the iconic Pop Art
master who died in 1987, his influence lives in almost every contemporary art-
ist who followed him, and it is shamefully simplistic to relate him to Banksy.
All in all, both put on a nice theatrical spectacle of art, and Banksy in particu-
lar put even a nice Mona Lisa smile on our faces after the infamous prank at
the Louvre in 2004, when he put out his version of the famous Leonardo da
Vinci painting *Mona Lisa Smile* with an acid smiley face inspired by the chat
emoticon. The same emoticon face reappeared in Banksy's representations of
the grim reaper – renamed *grin* reaper – either standing on a pendulum clock
with the guarantee of telling the time at least twice a day or showing her claw
demonstratively to the unknown spectator.

Proficient at intermingling obvious problems from real life with the act of
life in their artistic work, these two artists used to exaggerate their status as
artists and convert their art into a moral, spiritual, and intellectual barometer
of the world. The open invitation to reflection on the world we all live in, feel,
and create was initially extended by the modern master: 'Andy's artwork and
films made many people take a look around them and think about what really
was and wasn't important in their lives' (Venezia 1996:32). The American
post-war media patriotically sold plenty of illusions to a recovering nation.
Win the Cold War and create a better America weren't among the Pop art-
ists' objectives; nor was covering up disaster stories or beating down voices of
truth.

In a society pervaded by superficiality, moral emptiness, and nihilism,
there was small wonder that Andy Warhol had chosen in the light of his post-
shooting traumatic experience to be a society portraitist and an art business-
man, respectively to rely his creation on the supply-and-demand management.
From an idealistic point of view, the same artistic blame of money-spinner
hangs over Banksy's head as well, even though, at first, money and celebrity
weirded him out completely, as he later confessed. More than that, both were
faced with the presumption of profiting from 'the whiff of mystery that wafts
around them' (Ellsworth-Jones 2012:104) and using people to good account.
After he commodified his own anxieties and personal traumas, Warhol pro-
ceeded to glamorize death in the Skulls series of the 1970s and to beautify
the violence in American society through the Knives and Guns series of the
1980s. Nothing remained alien to this artist – maybe only his own life when
he started to paint self-portraits one year before his death to remind himself
that he was still around.

Deeply entrenched in the dark side of Pop Art, Warhol was visionary enough
to see that Pop Art is not just 'Popular (designed for a mass audience), Tran-
sient (short-term solution), Expendable (easily forgotten), Low-Cost, Mass-
Produced, Young (aimed at youth), Witty, Sexy, Gimmicky, Glamorous, Big

Business' (Ford 2001:40–41), as British artist Richard Hamilton struggled to classify it in 1957. In accordance with the majority of the critics, the Hamiltonian definition fails when applied to Andy Warhol:

> To take but one example, Andy Warhol would certainly create an art that was popular, mass-produced, aimed at youth, witty, sexy, gimmicky, glamorous and Big Business, but he would also deal with hero-worship, religious hogwash, the banality inherent to modern materialism, world-weariness, nihilism and death, all matters that certainly did not figure in Hamilton's shopping list. . . . Moreover, much of the art to come would prove to be anything but transient, easily forgotten, cheaply priced or mass-produced.
>
> Shanes 2009:18

Through the mechanical and repetitive, apparently robotic and mindless, advertisement-like treatment of his subjects, Warhol proved with a vengeance that people like the drama of death and dying and all the negativity of the world around them as much as they like the full colours of life, the glitz and glamour, the celebrity and the cult of personality: 'Warhol himself observed: it's surprising how many people want to hang an electric chair on their living room wall, especially if the background colour matches the drapes. In other words, Pop Art has two faces: it can be as deep or as shallow as the viewer wanted to be' (Sooke 2015b). For someone who 'celebrated' his birthday with Marilyn Monroe's suicide (6 August 1962) and with the atomic bomb commemoration (6 August 1965), it is crystal clear where he lay in the normal run of things. As Banksy provocatively remarked about baby Jesus with a bomb attached by him on his chest from an old 'vandalized' painting of Madonna and Child: 'Suicide bombers just need a hug', we simply don't have to question anymore the level of seriousness or the one of frivolity as far as the Pop artists and their followers are concerned.

In perfect harmony with Warhol, Pop Art is not prepared for unilaterally dramatic and seriously appropriated death, and most likely it will never be. Be it a synonym for nothingness or the desire to do nothing, of daily void and life denial, death and its horrors as a major theme are instantly gratifying, albeit unsettling, and sell way much better than any joyful life-related topic, although they always remain at the border between acceptance and denial, reality and artificiality. Seeing that, after the many-sided experience of Pop Art, death cannot be simply glorified or ignored. Does Pop Art educate people on the history of death and its physical remnants after being used, removed, or destroyed? It definitely raised awareness and remembrance but, most importantly, it dislocated our idealized perceptions on fame and money, pointing out their precarity and dissolution in the face of death's inevitability and distortion. If we consume the theme of death the way it is served to us, through the medium of an image, it does not pass unquestioned as the voracious art consumers are quite responsive and their perceptions, habits and

expectations are easily shaken and widen. It seems, indeed, while consuming Warhol or Banksy, Hirst or Murakami, that the image of death and disappearance is more important than the subject of it, but after the effect of satiation is gone, the studied subject faithfully evokes the image. To conclude, we never consume Pop Art themes the way they are served but the way we want them to be served.

Notes

1 Jacques Lacan held the seminar in 1964, and this one was entitled 'The Unconscious and Repetition'. Later on, the series was published under the title 'The Four Fundamental Concepts of Psychoanalysis'.
2 As he was nicknamed by his roommate, Philip Pearlstein, back in the days when he moved to New York City and was always in search of jobs.
3 What became of him after realizing his path to celebrity needed urgent image improvements.
4 Banksy also published *Banging Your Head Against a Brick Wall* (2001), *Existencilism* (2 volumes, 2002), *Cut It Out* (2004), and *Pictures of Walls* (2005).
5 The artwork appeared in San Francisco in 2010.

References

Anderson, Kirsten (2014): *Who Was Andy Warhol?* New York: Penguin Random House.
Banksy (2005): *Wall and Piece*. London: Century, The Random House Group Limited.
Ellsworth-Jones, Will (2012): *Banksy: The Man Behind the Wall*. London: Aurum Press.
Ford, Carin T. (2001): *Andy Warhol: Pioneer of Pop Art*. New York: Enslow Publishers.
Foster, Hal (1996): 'Death in America'. *October*, 75:36–59.
Ket, Alan (2014): *Planet Banksy: The Man, His Work and The Movement He Inspired*. London: Michael O'Mara Books Limited.
Ket, Alan (2016): *Street Art: The Best Urban Art from Around the World*. London: LOM Art.
Koestenbaum, Wayne (2001): *Andy Warhol: A Biography*. New York: Open Road. Integrated Media.
Leverton, Marc (2011): *Banksy Myths & Legends: A Collection of the Unbelievable and the Incredible*. London: Carpet Bombing Culture.
Leverton, Marc (2015): *Banksy Myths & Legends, Volume 2: Another Collection of the Unbelievable and the Incredible*. London: Carpet Bombing Culture.
Nemţuţ, Paula (2008): *Warhol (1928–1987)*. Oradea: Editura Aquila'93.
O'Hagan, Sean (2009): 'The Art of Selling Out'. *The Guardian*. Available online at: www.theguardian.com/artanddesign/2009/sep/06/hirst-koons-murakami-emin-turk.
Potter, Patrick and Gary Shove (2018): *Banksy You Are an Acceptable Level of Threat and If You Were Not You Would Know About It*. London: Carpet Bombing Culture.
Shanes, Eric (2009): *Pop Art*. New York: Parkstone Press International.
Sooke, Alastair (2010): *Modern Masters* (Episode 1 of 4: Andy Warhol). London: BBC One.
Sooke, Alastair (2015a): 'Inside the Dark Heart of Pop Art'. *The Telegraph*. Available online at: www.telegraph.co.uk/art/artists/inside-the-dark-heart-of-pop-art-andy-warhol/.
Sooke, Alastair (2015b): *Soup Cans and Superstars: How Pop Art Changed the World*. London: BBC Four.
Venezia, Mike (1996): *Andy Warhol*. New York: Grolier Publishing.
Warhol, Andy (1975): *The Philosophy of Andy Warhol (From A to B and Back Again)*. New York: A Harvest Book-Harcourt.

8 Towards a cultural theory of killing

The event of killing in Quentin
Tarantino's movies

Martin Bartelmus

Introduction

It is obvious that Quentin Tarantino likes killing. Most of his movies are structured, not only in terms of narrative, but also in terms of aesthetic perspective, by and through killing. Why and how, I ask, is killing used in these movies? Is it used just to shock the audience, to create guilty pleasure in seeing blood? Or does it have the potential to critically overlook aesthetics and constructions of bodies, gender, and experience of death? Therefore, I find myself not only ethically but also aesthetically challenged, in a zone which I have to transcend to get to the point of talking about killing, not because I want to justify brutal violence (Brooker and Brooker 1997:91–92), but to deconstruct the meaning of killing in contemporary pop-cultural artefacts like Tarantino's movies.

His movies deal with the contempt of the sixth commandment, 'Thou shalt not kill', by transgressing it ethically and aesthetically. To transgress a cultural taboo is not only to surpass the laws of power and the enigmatic sovereignty of performing the capital punishment, but also to show that killing itself does not come alone. In the following chapter, I will discuss killing within three modes of cultural representation which seem to domesticate the potentiality of killing as an aesthetic transgression to undermine the (pop-) cultural construction of body, gender, religion, justice, and death. I understand the aesthetic transgression in a manner similar to Georges Bataille and Michel Foucault. In his *Préface à la transgression*, the latter writes that

> transgression is an action which involves the limit, that narrow zone of a line where it displays the flash of its passage, but perhaps also its entire trajectory, even its origin.
>
> Foucault 1977:33–34

I broaden the understanding of Foucault's transgression as a 'flash of its passage' with Jacques Derrida's conception of an event (Derrida 1978; see also Khurana 2004:235; Mersch 2010:68). Killing as an event is not just a forced transition from life to death. It shows the discursive construction, the agencies and actors involved, producing a 'zone' in which the discourses about

language, body, and gestures are uncertain (Foucault 1977:30). Killing in works of art, we could say – and even this is a performative act at this point – allows us to surpass limits to get to what was limited. What was limited is something that cannot be said or is not allowed to be said in the discourse on life and death. Thus, the event of killing has an effect on 'that zone which our culture affords for our gestures and speech' (Foucault 1977:30). My goal is to discover the mechanisms of discursive and therefore language-based attributions of an event of killing. Regarding these deadly events, I want to show that a theory of killing could have an explanatory use for anthropological and cultural problems. The deictic function of almost every gesture of killing indicates these problems. Since pointing a gun at someone, often and foremost in movies, constitutes a subject as a speaking subject, this subject follows an old tradition of becoming an autonomous self-reflecting 'I', a cogito by speaking as well as using his hand. I refer to Jacques Derrida's analysis of Martin Heidegger's fetish of connecting thinking, speaking, and writing with one hand (Derrida 1987). That cultural and anthropological tradition is inscribed in Western philosophy. The lethal gesture, which is always deictic, points at the limits between life and death, between showing and telling, between what happens to someone who is killed and someone who kills. It 'de-monstrates' with the full meaning Derrida gives the word *monstrare*, by also linking it to the 'Monster' (Derrida 1987:168–169). At the same time, the symbolic order has to clean up that uncertainty of the subject. In doing so, the subject gains power and sovereignty by performing a symbolic form of killing: murder, sacrifice, slaughter.

What is there to see when we watch movies or read literature in which someone kills someone or something else (animals or monsters)? Why do we watch so much killing in movies – whether gritty or sanitized – without ever reaching the reality of killing? The complexity of killing lies within the meaning of transgression: killing confirms the fact of life by taking it, but it is 'an affirmation that affirms nothing, a radical break of transitivity' (Foucault 1977:36) because it also, by granting it, says yes to death. Bringing death by taking life is the condition of sovereignty itself, which was transformed into bio-political power during the 19th century. Contemporary pop culture killings, however, are not acts of sovereignty. Maybe they are just reminiscences of a lost sovereignty, especially that of the white male subject (Onderdonk 2004; Imboden 2005:81).

Here, I get closer to an answer to the question of why there is so much killing in pop culture and especially in Tarantino's movies. It is because some of those scenes of killing open up an opportunity 'for finally liberating our language' (Foucault 1977: 39). According to Foucault's understanding, language is dominated by the larger field of discourse. Tarantino takes refuge in the 'language' of motion pictures to tackle the contemporary prevalence of discourse. Talking about multiple killings should establish a vocabulary enabling us

> to speak of this experience and in making it speak from the depths where
> its language fails, from precisely the place where words escape it, where

the subject who speaks has just vanished, where the spectacle topples over before an upturned eye.

<div align="right">Foucault 1977:40</div>

Here, Foucault points out how to see those events of killing. Therefore, every killing is different, even if it is repeated not only through the movie but through re-watching it multiple times. Via repetition, the killing becomes singular, surpassing the capitalistic structures of production and entertainment. It is because of repetition that killing more and more loses its value as an intriguing part of (pop-)cultural media. It gains a singularity by becoming more and more unfamiliar (Kristeva 1982:5) to the discursive Western knowledge of truth, justice, and life itself. Seen as a singularity, every event of killing returns the focus on the materiality and mediality of its staging.

Understanding killing as a singularity provides the opportunity not only to reflect on death as a consequence of a certain intention of an acting subject, but to reveal the cultural circumstances of death as an *aporia* (Derrida 1993). Death, or in my terms, the event of killing, changes what has been told and what will be told and how. It is a threshold, and by transgressing it actively with the act of killing, semantic traces, symbolic and discursive breaches, and visual distortions become perceptible.

For every movie, I insist on using a different methodological 'tool' because every combination of killing and the socio-cultural mode (laughter, law, love) demands a different approach. Otherwise, those transgressions will not be noticeable. Focusing on laughter, I will combine Henry Bergson's theory on laughter with Tarantino's *Pulp Fiction*. Focusing on law, I will use Jacques Derrida's thoughts about the death penalty and relate them to the construction of law in *Inglorious Basterds*. Eventually, I will discuss the lust of killing in Oliver Stone's *Natural Born Killers* within a wider framework of body politics as elaborated by Elisabeth Grosz. Finally, I relate my elements of a theory of killing to Julia Kristeva's concept of the abject and give the unseeable or unsayable a name.

'The Bonnie Situation'

I start with Quentin Tarantino's *Pulp Fiction* (1994). Here, the event of killing comes with laughter. Henri Bergson tackles the question of laughter in an intriguing way that suits my interpretation of Tarantino's sense of humour (Kaul and Palmier 2016:21) and especially one of the movie's scenes where laughter and killing come together to expose (pop-)cultural constructions of masculinity, power, race, religion, and humour (Willis 1997:191). Bergson should help decode that particular transgression. Let me cite a passage from Henri Bergson's *Le rire. Essai sur la signification du comique*. Bergson writes:

> For comic spirit has a logic of its own, even in wildest eccentricities. It has a method in madness. It dreams, I admit, but it conjures in its dreams and visions that are at once accepted and understood by the whole of a

social group. Can it then fail to throw light for us on the way that human imagination works, and more particularly social, collective and popular imagination?

<div align="right">Bergson 1914:2</div>

Laughing enforces a form of imagination which can manifest in the material-semiotic field of films. The mediality of movies as pictures in motion – as 'action- and time-pictures', as Gilles Deleuze (1986, 1989) calls them – produces a form of laughter which opens up an opportunity to understand the workings of the imagination, to understand 'pulp fiction' not only as a mass media product, but as a mode of reflecting the construction of masculinity, power, race, religion, and humour in (pop) culture.

Furthermore, Bergson gives us three reasons laughter is fundamental to life and art: first, it is exclusively human (Bergson 1914:3). Therefore, Bergson's theory is slightly anthropocentric. Secondly, for laughter, Bergson continues, the 'absence of feelings' (Bergson 1914:4) is crucial: whenever we are involved emotionally, we cannot laugh. This seems to be important for the moment when someone kills someone else. If we feel pity for the victim, we won't laugh. Someone who laughs at a killing scene in a movie might laugh either because of their inability to feel for the victim or due to their ability to understand the situation as fiction. Is laughter then a question of intelligence or of moral competence?

The situation is more complex than those two options indicate. This is the point where Bergson's third reason is relevant: 'You would hardly appreciate the comic if you felt yourself isolated from others' (Bergson 1914:5). Laughing about killing, no matter how oddly it is staged, only works if the laugh is shared. When nobody else laughs, you feel that you overstepped a moral or social or even aesthetic boundary. But whether or not your laugh finds an echo in the rest of the cinema audience, you are able to reflect on the situation either way. Laughter opens up the chance of reasoning itself. Laughter does not need an actual physical echo – we often find ourselves laughing upon remembering a joke or a situation.

The scene I would like to talk about takes place in the last third of the movie. The screen is black, showing only the title 'The Bonnie Situation' (Tarantino 1994:01:51:45). A 'Bonnie Situation', as it is explained in urban dictionaries, is a highly risky and problematic situation one is stuck in and where one has to think and react quickly in order not to get caught. We can apply the title to everyone in the scene. But it is worth mentioning that it is called '*The* Bonnie Situation', not '*A* Bonnie Situation', which would have made sense too. *The* points out the singularity of the situation: it seems to be the most complex and problematic situation a human being could be caught up in. It seems that the life-or-death situation, framed by questions of determination, criminal inclinations, and Christian spirituality, presents the quintessential Bonnie Situation – philosophical and anthropological 'pulp fiction'.

There is obvious tension in the scene: there are two killers, Vince and Jules, who are pretty experienced in doing crime business. At a moment's notice, they turn into young wannabe gangsters who did something stupid. This is a common turn of events in 'pulp fiction'. But the intertwining of the simple observation that committing crimes leads nowhere and the profane understanding of Christian salvation climax when we see, after another black screen with a title, a close-up of a young white man sweating and shaking. He holds up a revolver with, as we know, six shots. We hear Jules interrogating one of the wannabe gangsters as we already saw at the beginning of the movie. The timeline is therefore split and rearranged in the movie. Jules recites Ezekiel 25:17. Then Vince and Jules shoot the young man sitting in front of them on a chair in the living room of the small apartment. Behind Jules, pressed into the corner, is a young black man named Marvin Vincent. While we see the killing through different cuts and camera angles, Marvin has to watch the execution directly, looking over Jules' shoulder. Marvin breaks down, cursing and shaking, which does not please Vince. As Jules tells him to stop mumbling and Vince asks for his name, the man we already saw at the beginning of the scenes storms out of the bathroom and into the living room. He holds up his gun and shoots his six bullets at Vince and Jules, but nothing happens. Not a single bullet hits the protagonists of the movie.

It seems odd that the main characters in a movie cannot get hurt, but at this point, the Bonnie Situation turns into holy exaltation: Vince and Jules look at each other. They check their bodies and see that they did not get hurt. They shoot the boy in the chest with two bullets, fired simultaneously from their guns. After that epiphany, Jules wants to change his life. So far, so good, but we forgot about Marvin, who has survived as well. And that is where the fun happens: Vince, who is not as religiously impressed as Jules, bows down to Marvin and asks him why he didn't tell them that somebody was hiding in the bathroom. The camera goes back to Jules, and as he turns his back to the camera and faces the wall, we see that there are exactly three bullet holes in the wall behind him. They should have hit him. The wall behind Vince looks just the same. Therefore, not a single bullet was shot at Vince. The epiphany (Imboden 2005:77) was meant to happen to Jules, not Vince, and the bullet holes support that interpretation. Jules asks Vince if he knows what divine intervention is, and Vince answers that question ironically: 'That means that God came down from Heaven and stopped the bullets' (Tarantino 1994:1:54:19).

This scene transforms the classical *deus ex machina* effect into a 'deus ex media' effect, which amplifies the deconstruction of the life-and-death Bonnie Situation. It is because of this supposed 'divine intervention' that viewers understand the situation they are in: 'deus ex media' acts like a Brechtian *Verfremdungseffekt* (Carney 2005:14–21).[1] It is the cinematic configuration which allows for such tricks. Therefore, the epiphany of Jules is a comic relief for the secularized setting and vice versa. As Bergson says: 'Now, comedy is a game, a game that imitates life' (Bergson 1914:68–69). The scene is a

hyperbolic imitation of a highly fragile situation. Bergson's following conclusion applies to that scene: 'Any arrangement of acts and events is comic, which gives us, in single combination, the illusion of life and the distinct impression of mechanical arrangement' (Bergson 1914:69). That mechanical arrangement is enhanced by the medial transformation into a movie scene, which is known as a movie scene by the *Verfremdungseffekt* (Brooker 2006:217) of bullets which do not kill.

Some might want to argue that the acts of killing in this scene do not allow a comic view or interpretation and that, therefore, killing is not funny. The scene following the Bonnie Situation shows the grotesque hyperbole of killing as an event of laughter. *Pulp Fiction* follows a strategy of situational comedy or slapstick paired with the aesthetics of simplicity in showing the event of killing. Jules and Vince seem to start a 'theological discussion' about the 'miracle' that Jules survived the gunshots. The police are on their way because of all the gunshots fired in the apartment, and Vince wants to leave as quickly as they can. But Jules hesitates. Only when Vince acknowledges the 'miracle' do they finally get going, though not without Marvin. It is worth mentioning that this scene also tries racial clichés by making the black man believe, depicting him as a spiritual person, and showing the white man as a secularized individual who only believes in luck as a form of contingency. Nevertheless, the discussion about what happened in the apartment continues in the car while they are driving away from the crime scene. Vince tells a similar story, arguing that such inexplicable situations have occurred before. Jules is not impressed as he tells his partner in crime that his 'eyes are wide fuckin' open' (Tarantino 1994:1:55:34) – meaning that he wants to retire. Picture the scene: two men in black suits in the front seat of a car, one of them driving, arguing about whether or not they survived a 'miracle', one of them saying he wants to quit his 'job' as a killer. Picture sitting in the rear of the car held hostage by those two men. What would we answer when asked the question: 'Marvin, what do you make of all this?' (Tarantino 1994:1:55:56).

Marvin answers that he does not have an opinion on the topic. Vince turns back in his seat to face Marvin, holding the gun on the backrest of his seat. The gun hangs loosely in Vince's hand while he keeps insisting that Marvin should have an opinion on that topic as 'boom', he accidentally fires his gun and blows the kid's head off. A loud bang comes with a fast cut to the rear window of the car, which is splattered with blood (Kaul and Palmier 2016:65). Marvin is dead.

What is funny and at the same time absolutely brutal is how the deictic gesture of someone pointing a gun at a victim is twisted. The colloquial situation, the tension of the conversation between Jules and Vince on whether or not they experienced a divine intervention and them asking a third party leads to an effect of discharging (King 2004:134). The uncontrolled, contingent situation literally blows up in Marvin's face and inverts the 'divine' experience of the scene before. As if the bullet was really meant for Marvin, this horrific ac(ciden)t of killing contains a morally controversial element

of humour. We are shocked by this scene. The reason here is not a 'divine intervention', not a 'deus ex media', but just a street bump their car drove over too fast, accidentally making Vince pull the trigger as he started to argue with Marvin. That scene inverts the Kantian definition of laughter, which Bergson returns to. Immanuel Kant says: 'Laughter is the result of an expectation which, of a sudden, ends in nothing' (Kant quoted in Bergson 1914:85). Bergson explains:

> Lack of proportion between cause and effect, whether appearing in one or in the other, is never the direct source of laughter. What we do laugh at is something that this lack of proportion may in certain cases disclose, namely, a particular mechanical arrangement which it reveals to us, as through a glass, at the back of the series of effects and causes.
>
> Bergson 1914:86

At the end of this ac(cident)t of killing, we look at a glass screen which we cannot see through because of all the blood, as if Tarantino was reacting to the definition mentioned earlier. Herein lies point zero of the entanglement of comedy, pseudo-religious experience, and contingent action. To use Bergson's words: we laugh to correct the fatality of the scene (Bergson 1914:87), to laugh away the sudden death produced by a loose gun. The 'deus ex media' effect spins its wheel: it makes us question whether there really was a street bump which caused Vince to pull the trigger. But neither can we say for sure whether the shot was the result of a human subject's conscious action. The accident reveals the movie's strategy to show a human existential crisis: not to fully understand all life's accidents. In this, the movie simultaneously deconstructs the medial production of a contingent world, directed by the filmmaker in the place of God. It turns out not to be the filmmaker's sovereign decision whether or not someone lives or dies (Foucault 1978:135–140), but it is the complex medial and material agency of the movie itself, in which the director himself is just a part of a contingent game, which makes us laugh in 'wrong' situations – for instance, when someone is shot in the head.

Hitting a head with a baseball bat

A similar moment occurs in Tarantino's *Inglourious Basterds* (2009): the so-called 'Bear Jew' from the *Inglourious Basterds*' task force kills a captured Nazi with a baseball bat. The meaning of killing, however, does not exhaust itself here in a certain kind of dark humour, but also concerns the construction of an archaic principle of law and order: it seems that this killing opens up an abyss between bio-political and thanato-political formations, which questions the construction of sovereign power itself – represented by a wooden bat. Following, I will talk about the tension between law and killing.

'Bang'. 'Bang'. We hear dull blows as the camera swings from a close shot of a German soldier to the source of the sound: a dark tunnel entrance

(Tarantino 2009:00:33:24). The architecture of the tunnel amplifies the sound of something hitting the ground or the walls in rhythmic beats. We see how scared the German soldier is. The camera swings back and forth between the dark entrance and the German soldier sitting cross-legged on the ground. The baseball bat is, to quote Derrida, a very special

> apparatus . . . for legally putting to death that men have ingeniously invented, throughout the history of humanity as history of techniques, techniques for policing and making war, military techniques but also medical, surgical, anesthesial techniques for administering so-called capital punishment.
>
> Derrida 2014:2

It is a rather cruel instrument, though, and here used in a horrible act of invisible 'beheading'. The scene is clearly structured like a theatre scene, as Greek theatre specifically, with its architecture where the ranks form a half-round focusing on the scene. The σκηνή in its Greek meaning, as *tent* or *hut*, is represented by the tunnel, the 'Bear Jew's den. 'Bear Jew' is the nickname of Sergeant Donny Donowitz, one of the Inglourious Basterds. He has received his nickname precisely for killing Nazis with a baseball bat.

The killing here is inscribed into that Greek formation and tradition to materialize the fact that, for a capital punishment, 'spectacle and the spectator are required' (Derrida 2014:2). And, frankly, what the Inglourious Basterds want is precisely that: to be seen. They show each other and us as their audience in those backlands, where enemies can be ambushed, the procedure of sovereign power. Derrida explains how seeing and watching the death penalty works:

> It best sees itself, that is, it acknowledges and becomes aware of its absolute sovereignty and that it sees itself in the sense in French where 'il se voit' can mean 'it lets itself be seen' or 'it gives itself to be seen'.
>
> Derrida 2014:2

The killing scene thus should reflect the mediality and poetics of the movie itself, of watching the movie, by showing the scene as to-be-seen/scene. But do we actually see the death penalty, the beheading? The important moment, the event of killing, is not shown, not because it is censored, but because it suddenly does not matter anymore whether the Nazi gets killed in the sense of the death penalty. Donny Donowitz kills the German soldier by hitting his head with the baseball bat over and over again (Tarantino 2009:00:34:43). While we do not see the first hit, we see every single hit after that. The skull is crushed, and the camera flies off into the sky, revealing the scene, the *theatron*, and the staging of the death penalty.

This situation has a deconstructive effect with and through the event of killing, the simulation of the death penalty in a movie about World War II

(Woisnitza 2012). It deconstructs the genre itself; therefore, the whole film is not only about a fantasy of revenge. It is also a film about what European colonists did to indigenous people in North America. The Inglourious Basterds, after all, use a number of references to Native American culture that are common in Western pop culture: scalping, giving yourself speaking names, using the ethical war code of Native Americans.

Tarantino mixes the symbolic orders in his cinematic imagination. We can say that this movie speaks two languages at the same time, which are both perfectly understandable to those living inside the discursive framework of Western history. Not only does the baseball bat reflect cultural and discursive constructions in Hollywood movies, it also plays with a US-American cliché and the ethnic mix of New York in the 1940s. It embodies the difficulty of making a movie about the topic of revenge without getting trapped in canonical narratives. What we see is not what we understand: the death penalty as it is executed in the scene with the 'Bear Jew', therefore, is not predominantly a capital punishment; it is first and foremost a killing scene. This pre-discursive killing, as well as the way it is staged, allows us to reflect on the workings of cruelty and violence within law and order. This scene does not represent any legal act of punishment or any legal punishment in times of war. It is the death penalty as it is administered in a distorted order behind enemy lines. It is the capital punishment within a malfunctioning system of law and order, that of a fascist and national-fascist regime which kills people regularly on a governmental basis and with governmental precision (Arendt 1963). It is the anti–death penalty or even the death penalty within the death penalty, which leads to an implosion of the manipulated system (something which we can also read about in Franz Kafka's famous short story *In the Penal Colony*, 1919).

This killing does not serve the restauration of the law or the sovereignty of the law, which was destroyed by German cruelty, because they killed within the law and in the name of the law. Neither is this killing here a 'murder' which transgresses the law. This killing transgresses both these understandings: it neither reconstitutes the law, nor does it break it. It reveals what is immanent in the law itself: killing the soldier with a baseball bat is not only absurd and grotesque, but it also undermines the structure of a failed system of law, which allows the killing of human beings, which makes people killable just by sorting them out as different (Agamben 1998). It reconstitutes no system of law because it transgresses the death penalty itself, and therefore the law, and proceeds into a zone behind the enemy's lines, where the law does not exist, where the Inglourious Basterds actually do not exist. But they are nevertheless there, subverting the death penalty by killing a soldier with a baseball bat. Even the staging itself emphasizes the mediality of law and leaves behind the conventions of showing the death penalty, or the act of murder in movies, showing everything from God's point of view.

It is not unimportant to mention that this kind of death penalty, this punishment without the law, kills the German soldier as if he was no human being

and deserved the death penalty (Derrida 2014:9). However, this is only one way of reading this scene, and it implies the old Eurocentric view on law and punishment (de Certeau 1988:45–46). Throughout the movie, though, the Inglourious Basterds not only avenge the Jews, they also avenge the American natives, who were killed by Europeans colonizing North America. Therefore, there is a different law inscribed into that scene which traverses the comprehensible quotations of violence and law, revenge and justice, which we expect to find in an anti-war movie such as *Inglourious Basterds*. That law is not only represented but without a doubt transferred in raw agency: the baseball bat. Not only does the bat mark the American soldier as American. It transgresses that reference because it is, in the diegesis of the filmic world, an uncommon tool. Therefore, it does not unconditionally count as a Eurocentric cultural artefact, and the death penalty it administers is set outside the common Eurocentric understanding of law.

That means that we see not only two deaths, one of which is, as Derrida explains, ruled out by the Decalogue's 'Thou shalt not kill' and the other by the law of the death penalty, which installs and stabilizes law itself and avenges transgressions of the law. We see two forms of killing: one that could be understood as revenge for the transgressions of the Nazis and the second as a stabilization or re-stabilization of human law in the raw act of violence, a reading which is in line with political philosophy since Thomas Hobbes and a killing which is a construction of a Native American practice of destabilizing the Eurocentric framework itself. The use of a baseball bat, in particular, as one of the most common sports gears and crime tools, doubles the semiotic play with its pop-cultural significance. It refers to pop culture without being pop culture in the diegesis of the movie. And it works as a primitive tool to kill someone, to put someone to death, to carry out a death penalty. Reference and imagination are keywords of cinematic aesthetics. Without references, there is no imagination, and without imagination becoming real on the screen, we cannot enjoy the movie. We have to be captured by the movie's references to produce an intrinsic imagination of the movie.

The killing which is staged but not really seen reflects on the capacity of filmic aesthetics to problematize, as political philosophy does, the transgression of law and the making-killable of human beings. Killing a Nazi with a baseball bat 'is perhaps, *perhaps* the deconstruction of the death penalty, of the logocentric, logonomocentric scaffolding in which the death penalty is inscribed or prescribed' (Derrida 2014:23). This is contrasted by the next event of killing that the film presents after the baseball bat scene, when one of the captured Nazis tries to escape. He is shot by one of the Basterds completely without any form of staging involved in the filmic presentation. This is more or less the counterpoint to capital punishment. A clean shot with a rifle gives a clean death, a death understandable inside the symbolic order, whereas the baseball bat is messy, bloody – a transgression of the symbolic presentation of violence in anti-war movies, a presentation of violence as real.

Love kills the TV star

In *Natural Born Killers* (1994), directed by Oliver Stone and based on a screenplay by Tarantino, the killing is a matter of body, gender, and love. Elisabeth Grosz's perspective on affective bodies (Grosz 1995:214) tackles the performativity of killing with the body as well as the urge of killing as a natural desire as represented in the movie.

Therefore, love is not only understood as a metaphysical concept that a heteronormative couple shares, but also a bodily and violently acting out of lust. That lust leads to a seemingly natural desire to kill. That desire determines the aesthetic and poetic development of this road movie. The so-called natural born killers, Mickey and Mallory, who are a couple, are driven by sexual and erotic lust evoked in the moment of killing as the moment of decision between life and death. This puts the body into the focus of a lust of killing as the surface of discursive inscriptions (Grosz 1995:33–36).

The focus on the killing bodies (Butler 2011), male and female, brings up the question of the exploitation of those natural born killers for the purpose of entertainment. Therefore, the movie not only negotiates the term 'natural born killer' by asking whether or not that couple is naturally evil; it also discusses the medial production of a female and a male body fit to kill and to be broadcast as natural born killers. In the first scene, every aspect of 20th-century media culture is brought together in a diner where Mickey and Mallory start their killing spree. Mickey reads a newspaper headlining the murder. In the background, a television is on. Mallory starts the jukebox and dances to the tune. Television, jukebox, newspaper: watching, listening, and reading are the media practices which frame the killing spree. But it is Mallory's body which inspires one of the male guests to come closer and engage in an awkward dance. He dances with the girl, and Mallory plays along until she has had enough. She smacks his beer out of his hand as he takes a sip. The pseudo-sexual situation turns into a fight scene. She dominates the man in the fist fight – she literally destroys him. Instead of becoming a 'neutral body' (Grosz 1995:38) on which the male's gaze as well as the gaze of the viewer inscribes its power of sexualization (Grosz 1995:38), Mallory produces a situation of uncertainty. In the discursive framework of action movies, her female body signifies male power.

As the male friend of the dancer wants to interfere, Mickey cuts the other guest's finger off and kills him with his hunting knife as if he wants to carve wood. He shoots the chef and kills a man looking through the window by throwing a knife at him. Mallory remains the one killing 'naturally' (Grosz 1995:48), meaning with her body, and not 'culturally' with a tool/weapon. As Mickey seems to be the reading cultural born killer, who reads about their previous killing spree in the newspaper before he kills everyone in the diner, Mallory is the dancing natural born killer who uses her body to kill. While Mickey seems rational and calm, Malory is freaking out, raging and making fun of the victims. So far, so bad: the movie projects established gender-based

narratives of killing and aggression onto the protagonists (Friedrich 2008). While on the one hand, the woman appears just as aggressive as the cultural cliché suggests for male brutality, the difference lies in the use of tools. Therefore, the first scene reveals that the title of the movie is actually more of a question than a statement.

On a closer look, a natural born killer is produced by media configurations as well as by the paradigm of nature versus culture: the mass media produce the natural born killer and shows his or her killing spree. The film allows us to be voyeurs of a heteronormative spectacle (Chaudhuri 2006) in which a male and female couple are 'naturally' evil. We watch them doing whatever they want (King 2004:141). Their two bodies are staged in an erotically appealing fashion, but Mallory in particular embodies the pop-cultural discourse of sex appeal of the 1990s, her body skinny but fit in tight jeans and bikini top, her hair in blonde braids.

At the end of the movie, as they escape from prison along with television reporter Wayne Gale, Mallory becomes the camera's eye as she takes over the camera from Gale's staff. They have killed the cameraman, and now they are going to kill Gale live in front of a big audience. The camera broadcasts what Mallory sees. She gives the camera back to Gale, telling him and the audience her side of the story, her desire to live with Mickey alone and become a mother. Gale comments on her seemingly mad ideas and at the same time keeps asking questions regarding their future. As she starts to explain their escape via an 'underground railroad' (Stone 1994:1:51:00) as if they were slaves escaping the plantations, Mickey shuts her up with a hand over her mouth and disrupts the interview. As Gale wants to record the wrap-up for the show, Mickey interrupts him and takes the camera. He puts it on the ground facing Gale, telling him he is going to shoot him in front of the camera as the final scene of their escape. The camera will record this death because 'killing you [Gale] and what you represent is a statement' (Stone 1994:1:52:17).

The killing here seems to transgress not only the heteronormative concept of 'love' which 'beats the devil', which led the couple to kill all those people, but also the (pop-)cultural mass media discourse and customs that Gale represents. In that sense, Mickey and Mallory turn out to be natural born killers because they kill culture, because they use culture's most prolific institution, mass media, against it. Frustrated and scared, Gale screams at Mickey: 'The day you (two) killed, you belonged to us! To the public! To the media!' (Stone 1994:1:52:45).

Ultimately, Mickey and Mallory's bodies, their love, their sexuality come down to the relation of killing and media. That aspect becomes even clearer because Gale insists on being the one 'that tells the tale' (Stone 1994:1:53:14). But Mickey and Mallory are a few steps ahead of him. The camera becomes the one to tell the story. Gale is not important; he is killable. The camera made Gale killable, the media system made him killable, and Mickey and Mallory are just the mediators of that fate. Killing, that is what movies and 'the media' are about.

Mickey and Mallory's bodies, as they transform during the movie, are the battleground of good and evil, true and false, right and righteous. On the one hand, the movie reproduces a distinction between body and soul by making the road movie into a spiritual journey for their souls and minds. On the other hand, the road movie is also about the flesh; the body, male and female; and its materiality, its ability to suffer and to kill. The flesh within the framework of desire, lust, and sex shows the dimensions of the body-mind distinction. The flesh, which combines killing and love, transgresses the question of natural versus cultural born killers while deconstructing pop culture and the mass media and their desire for killing. In other words: it is the *différance*, the consonance, and mishearing of 'fake' (Stone 1994:1:50:04) and 'fate' (Stone 1994:1:50:18) which not only describe the riot allowing Mickey and Mallory to escape, but also describe the relation between the symbolic order which uses killing as a factor of mass media entertainment and the rift produced by killing within that order. In other words: killing deconstructs the pop-cultural frameworks of love, gender, and eroticism/sexuality, in regard to the female and male body as mediatized products. But the bodies which perform the killing not only undermine the consumable aesthetic of mass media, but also deteriorate the (pop-)cultural industry (Horkheimer and Adorno 1944/2002) with and through a deadly pleasure.

Conclusions: elements of a theory of killing

Let me here recapitulate the content of this chapter: I looked at three representative cultural modes of killing: first, morality and laughter; second, law, sovereignty and power; and third, erotic and sexual desire, framed by the mass media. All three modes are narrated by and with killing. With regard to the last movie mentioned, it seems that it is not useful to speak of natural born killers. We need to speak of cultural born killers because every time we look closer at the event of killing, the cultural construction becomes more visible. To make use of those new perspectives, a *theory* of killing seems to emerge. Quentin Tarantino's movies especially give a pop-cultural opportunity to catch a glimpse of killing, which is not intended by the symbolic order of movies and their aesthetics.

A theory of killing therefore starts with the event of killing to deconstruct frameworks of society, language, and viewing habits. It binds killing to the real, which makes it a problem for the imaginary and the symbolic order (Vojković 2009:179–180). Therefore, it is productive to combine deadly events with cultural modes, like laughter, love and, law, as we then can understand why we often do not talk about killing, but talk about murder, slaughter, or sacrifice.

We can tell that Vince's accident in the car was an accident *and* also a murder. We can say that Bear Jew's revenge was a capital punishment. And we can say that killing Gale was a weird sacrifice for the love and freedom of individuals not fit for mass media culture. Killing has to be shown and narrated,

but killing is, to speak with Julia Kristeva, an *abject*, the event, 'where meaning collapses' (Kristeva 1982:2):

> The abject threatens life; it must be 'radically excluded' from the place of the living subject, propelled away from the body and deposited on the other side of an imaginary border which separates the self from that which threatens the self.
>
> Creed 1993:9

As Barbara Creed explains, killing understood as abject has to be seen as a murder, a sacrifice, slaughter, or an accident in order to ban its power to dissolve the cultural construction of body, gender, law, power, and emotions. Every murder, sacrifice, slaughter, or accident is surrounded by a discourse and a narration positioning a subject as a delinquent and an object as a victim. Moreover, desire/love, laughter/humour, and law/power as modes of cultural discursive representation and framing crave that subject-object dichotomy (Kristeva 1982:6). Killing, though, transgresses those modes, not only in terms of language (symbolic order) and motion pictures (imagination), but also with and through the mediality and materiality of that event. Therefore, the event of killing becomes abjective as a relation to the cultural and discursive unconsciousness (the *real*). It articulates what murder, sacrifice, slaughter, or accident would not or could not speak of. Killing articulates what those frameworks want to conceal with regard to laughter, law, and love: namely that we are cultural born killers. A theory of killing reveals those subversive events by narrowing laughter, law, and love and killing within pop-cultural movies as a potentiality to reframe the symbolic order of imagination. Tarantino's *Pulp Fiction* shows that laughter at the seemingly ethical wrong moment points at the singularity of a sudden death. Such an existential experience forces a situation in which rational reasoning seems a bit odd, and laughter marks that uncertainty of life and death.

In *Inglourious Basterds*, the baseball bat becomes a key actor which deconstructs the configuration of law and justice and leaves us with an uncertainty about justice. We cannot rely on the sovereignty of the law; we have to reflect and re-think the law in order not to become servile.

Last but not least, *Natural Born Killers* reveals the construction of sexuality and lust within the mass media. By and with the events of killing, lust, gender, and sexuality are altered. They become as uncertain, as uncontrollable, and ultimately deadly. A theory of killing understands every killing scene as an event. These events are singularities. As singularities, they have to be reconsidered continuously. They can no longer be classified as murder, slaughter, or sacrificial ritual to determine their hermeneutic meanings. Instead, they challenge renewed confrontations with the material and semiotic components of the deadly scene. This confrontation gains a surplus of meaning and critical understanding of the aesthetics and ethics of killing in movies and other cultural artefacts. Potholes, baseball bats, and video cameras reveal a material agency to show what discursive frameworks of mass media do not want to be

seen: that killing transgresses the rational subject and reveals it as a cultural born killer. Tarantino uses killing not only as an act or gesture, but also as an event, which he intertwines with cultural modes. In doing so, he deconstructs the anthropological value of these modes as well as the result of seeing someone kill: namely, to see someone die. Death is left as an aporia (Derrida 1993:21–22), but within a theory of killing, the living and the dying become articulated. On the verge of a transgression, Tarantino puts them in scene.

Note

1 The term *Verfremdungseffekt* does not translate easily, as Peter Brooker stated. It can be best translated into 'defamiliarization' or 'estrangement', 'but in fact that is no reason for avoiding Brecht's own term' (Brooker 2006:2017).

References

Agamben, Giorgio (1998): Homo Sacer. *Sovereign Power and Bare Life*. Stanford, California: Stanford University Press.

Arendt, Hannah (1963): *Eichmann in Jerusalem: A Report on the Banality of Evil*. New York: Viking Press.

Bergson, Henri (1914): *Laughter: An Essay on the Meaning of the Comic*. New York: The MacMillan Company.

Brooker, Peter (2006): 'Key Words in Brecht's Theory and Practice of Theatre'. In Peter Thomson and Glendyr Sacks (eds.): *The Cambridge Companion to Brecht*. Cambridge: Cambridge University Press, pp. 185–200.

Brooker, Peter and Will Brooker (1997): 'Pulpmodernism: Tarantino's Affirmative Action'. In Peter Brooker and Woll Brooker (eds): *Postmodern After-Images: A Reader in Film, Television and Video*. London: Arnold, pp. 89–101.

Butler, Judith (2011): *Bodies That Matter*. London: Routledge.

Carney, Sean (2005): Brecht & Critical Theory. *Dialectics and Contemporary Aesthetics*. Routledge: London.

Certeau, Michel de (1988): *The Practice of Everyday Life*. Berkeley, CA: University of California Press.

Chaudhuri, Shohini (2006): *Feminist Film Theorists*. London: Routledge.

Creed, Barbara (1993): *The Monstrous-Feminine: Film, Feminism, Psychoanalysis*. London: Routledge.

Deleuze, Gilles (1986): *Cinema 1: The Movement-Image*. Minneapolis: University of Minnesota Press.

Deleuze, Gilles (1989): *Cinema 2: The Time-Image*. Minneapolis: University of Minnesota Press.

Derrida, Jacques (1978): *Writing and Difference*. Chicago: University of Chicago Press.

Derrida, Jacques (1987): 'Geschlecht II: Heidegger's Hand'. In John Sallis (ed.): *Deconstruction and Philosophy: The Texts of Jacques Derrida*. Chicago: University of Chicago Press, pp. 161–196.

Derrida, Jacques (1993): *Aporias: Dying: Awaiting (One Another at) the 'Limits of Truth'*. Stanford, CA: Stanford University Press.

Derrida, Jacques (2014): *The Death Penalty* (Volume 1). Chicago: University of Chicago Press.

Foucault, Michel (1977): 'A Preface to Transgression'. In Donald F. Bouchard (ed.): *Language, Counter-Memory, Practice: Selected Essays and Interviews*. New York: Cornell University Press, pp. 29–52.

Foucault, Michel (1978): *The History of Sexuality. Volume 1: An Introduction*. New York: Pantheon Books. pp. 135–140.

Friedrich, Kathrin (2008): *Film – Killing – Gender: Weiblichkeit und Gewalt im zeitgenössischen Hollywoodfilm*. Marburg: Tectum Verlag.

Grosz, Elisabeth (1995): *Space, Time and Perversion: Essays on the Politics of Body*. New York: Routledge.

Horkheimer, Max and Theodor W. Adorno (1944/2002): *Dialectic of Enlightenment: Philosophical Fragments*. Stanford, CA: Stanford University Press.

Imboden, Roberta (2005): *The Dark Creative Passage: A Derridean Journey from the Literary Text to Film*. Trier: Wissenschaftlicher Verlag.

Kaul, Susanne and Jean-Pierre Palmier (2016): *Quentin Tarantino: Einführung in seine Filme und Filmästhetik*. Munich: Wilhelm Fink Verlag.

Khurana, Thomas (2004): '". . . besser das etwas geschieht": Zum Ereignis bei Derrida'. In Marc Rölli (ed.): *Ereignis auf Französisch: Von Bergson bis Deleuze*. Munich: Wilhelm Fink Verlag, pp. 235–256.

King, Geoff (2004): '"Killingly Funny": Mixing Modalities in New Hollywood's Comedy-with-Violence'. In Steven Jay Schneider (ed.): *New Hollywood Violence*. Manchester: Manchester University Press, pp. 126–143.

Kristeva, Julia (1982): *Powers of Horror: An Essay on Abjection*. New York: Columbia University Press New York.

Mersch, Dieter (2010): *Posthermeneutik*. Berlin: Akademieverlag.

Onderdonk, Todd (2004): 'Tarantino's Deadly Homosocial'. In Steven Jay Schneider (ed.): *New Hollywood Violence*. Manchester: Manchester University Press, pp. 286–303.

Vojković, Saša (2009): 'Reformulating the Symbolic Universe: *Kill Bill* and Tarantino's Transcultural Imaginary'. In Warren Buckland (ed.): *Film Theory and Contemporary Hollywood Movies*. London: Routledge, pp. 175–191.

Willis, Sharon (1997): *High Contrast: Race and Gender in Contemporary Hollywood Films*. Durham, NC: Duke University Press.

Woisnitza, Mimmi (2012): 'Messing Up World War II-Exploitation: The Challenges of Role-Play in Quentin Tarantino's *Inglourious Basterds*'. In Daniel H. Magilow (ed.): *Nazisploitation! The Nazi Image in Low-Brow Cinema and Culture*. New York: Continuum, pp. 258–278.

Films

Stone, Oliver (1994): *Natural Born Killers*. Warner Brothers.

Tarantino, Quentin (1994): *Pulp Fiction*. Miramax Films.

Tarantino, Quentin (2009): *Inglourious Basterds*. Universal Pictures.

Part 3

Death as a significant narrative device

9 'The radio said, "there's another shot dead"'

Popular culture, 'rebel' songs, and death in Irish memory

E. Moore Quinn

Introduction

'What's the news? What's the news?' These opening words to the song 'Kelly, the Boy from Killane' – also known as 'Kelly of Killann' and 'Kelly from Killane' – were penned by Patrick Joseph McCall in 1911 to commemorate a rebellion that had taken place in Ireland more than 100 years before. 'The Rising of '98', as that conflict is often called, took place in the heady spirit of nationalism that had inspired the successful revolutions of America (1776) and France (1789). Oliver MacDonough characterizes the period as being motivated by a strong romantic sensibility:

> The new emphasis was on cultural division and cultural hostility; on emotion rather than rationality; on group rights rather than individual; [and] on the subjective and creative rather than a formal and negative concept of independence.
>
> quoted in White 1998:54

The Rising of '98 occurred when a group called the United Irishmen under the leadership of one Theobald Wolfe Tone sought the aid of the French in overthrowing the rule of the British in Ireland. Motivations for revolt included a corrupt parliament, its inertia in enacting full religious equality, and the enduring structures of tithes and taxes that kept the country people in abject poverty (Milner 1983:131).

In the opening lines to 'Kelly from Killane', the questioner is seeking information about the success of the Irish in their military endeavours. He receives this favourable answer:

> Goodly news, goodly news, do I bring, Youth of Forth,
> Goodly news shall you hear, Bargy man!
> For the boys march at dawn from the South to the North,
> Led by Kelly, the Boy from Killan!
>
> *Soodlum's Irish Ballad Book* 1982:78

The song ends on a heroic flourish for, despite the fact that the strategies Kelly and his men had put into place foundered, the song's accolades acknowledge that he was 'the bravest of all in that grim gap of death'. With such lines, not only is his memory kept alive; so, too, are those of the stalwarts who paid the ultimate sacrifice of giving their lives for Irish freedom:

> Glory o, Glory-o to her brave sons who died
> For the cause of long downtrodden man,
> Glory-o to Mount-Leinster's own darling and pride
> Dauntless Kelly the boy from Killane.
> *The Clancy Brothers and Tommy Makem*
> *Song Book* 1962:26

'Kelly, the Boy from Killane' is but one of many songs that have remained on the Irish music popular-cultural circuit through the years. In January of 1963, the Clancy Brothers and Tommy Makem sang it for then-president of the United States, John Fitzgerald Kennedy, in a live performance called 'Dinner with the President'; the musical group the Dubliners sang and recorded it in Montreux, Switzerland, in 1977, with Luke Kelly introducing the song by saying, 'The Irish have never stopped rebelling . . . that's the way we are' (Live at Montreux 1977). And as recently as March 2019, the song was performed live in New York City by an Irish group called the High Kings.[1] Such is the impact of inspirational words set to engaging melodies for, as Guy Beiner insists, even 'minor heroes', when immortalized in song, can endure in popular memory for centuries (Beiner 2018:337, see also McMahon 2007). Although their lives and actions are praised on and off the battlefield, it is their deaths that earn the highest accolades. To understand why such encomia are awarded is to grasp the important role that death plays – and has played for centuries – in Irish culture as a whole and to become apprised of the role of popular culture in narrative dissemination.

This chapter commences by considering several songs that have been written in honour of the memory of the 'heroes' who died in the Rising of 1798. Arguably, in terms of sheer output, that insurrection provoked more songs than did any other Irish military event or campaign, with rhetoric commemorating not only the Rising's aforementioned leader, Wolfe Tone, but also the subsequent efforts of those like 'Bold Robert Emmet', who attempted another stand against Britain five years later. Although the lyrics respecting Emmet's campaign admit its ultimate defeat, they, like those of 'Kelly, the Boy from Killane' and many others, serve to galvanize memories of former struggles, proclaim repeatedly the desire to be free from England, foster the ideals of one's obligation to serve Ireland with manliness and fortitude, and offer one's life in the process (Zimmerman 2002:66). Just as it was in the bardic traditions of old, when the inclination was 'to laud the deeds of outlaws and rebels' (Cooper 2009:35), death is interpreted as a badge of distinction as well as a culmination of all that came before:

I am proud of the honour, it was only my duty –
A hero I lived and a hero I'll die.
Soodlum's Irish Ballad Book 1982:20

This chapter continues by analyzing Irish popular-cultural songs that proclaim the virtues of dying in service to Ireland. As shall be revealed, the subject of death is ever present, not only in songs about the Rising of 1798, but in 'hero-martyr songs' and 'hunger strike songs', to name a few. At the present time, social media sites provide ubiquitous opportunities to avail oneself of these kinds of popular 'rebel' songs, as do the more standard venues of recordings, festivals, concerts, and music sessions in Irish drinking establishments at home and abroad (Boyle 2002:188; Rolston 2001:54). Although musical genres overlap and cannot be held distinct, what emerges is the fact that many Irishwomen and men remain in nearly constant acknowledgement of warrior heroes deemed worthy of remembering and even emulating because they lived – and, more importantly, died – for Ireland. In this way, the role of death in song narratives is to lend credence to blood sacrifice for, as Sean Farrell Moran indicates, self-immolation, legendary and religious in nature, is both a reaffirmation of and a dedication to violent struggle in order 'to bring redemption to the individual and the country' (Moran 1994:84; see also Moran 1991). The specifics of battles and the remarkable figures who died in them over centuries may be conflated in ballads; yet, by virtue of a confluence of myth, religion and politics, the overall task is achieved: the rebel hero is immortalized because he died for Ireland.

Before we begin to explore the nature of specific songs held in Irish memory, a word is in order about terms. In Ireland and elsewhere, the word *rebel* is a social construct aligned with the concept of an Irish 'hero' extolled with superlatives like *bravest, fearless,* and *dauntless.* Similarly, the Irish 'rebel song' constructs a socially understood label found replicated on book and album covers and in liner notes and play lists. A brief perusal of printed source materials that utilize the term produced, among others: *50 Greatest Ever Irish Rebel Song, 60 Greatest Ever Irish Rebel Songs, The Best Irish Rebel Songs,* and *50 Irish Rebel Songs of Freedom.* Even songs without the word *rebel* in their title, such as *Popular Irish Songs,* manage to include songs that purportedly align with the 'rebel' genre, such as Thomas Moore's early 19th century classic 'The Harp That Once through Tara's Halls' and his often reprinted 'The Minstrel Boy' (Leniston 1992).[2] One also finds the word *fighting* used as a synonym for *rebel,* as in Hal Leonard's *50 Great Irish Fighting Songs* (Hal Leonard Corporation 2005).[3] By purchasing, listening to, or merely perusing materials like these, those doing so index membership, however fleeting, in an '[imagined] community of resistance', which shares similar demographic interests like class, ethnicity, gender and, place (Sivanandan 1990). Within the larger world of popular culture, that community is able to find a modicum of fulfilment for, even if the cause for which its heroes laboured failed to achieve its wished-for results, the fact that they died trying is lauded and

validated. Bill Rolston argues: '[W]hen preferred meaning, consumer inter-pretation and political community come together, pop music has the ability to articulate and celebrate political aspirations and causes' (Rolston 2001:51). This is how Irish 'rebel' songs, as forms of popular culture, function for the imagined communities they serve.

Songs of the Rising of 1798

As noted earlier, although the 1798 rebellion had its impetus in a late-18th-century moment, its impact and legacy stretched into and beyond the follow-ing centuries. In its aftermath, the Irish landscape, real and political, changed in significant ways. Loss of inestimable lives – accounts vary as to the actual death toll – enervated the entire island. Although Tone and Emmet were Protestants who sought Roman Catholic support for uniting Ireland, their inabilities to do so hardened sectarian positions such that working together for a common goal became highly unlikely. More problematically, a law called the Act of Union, enacted on 1 January 1801, succeeded in 'making Ireland formally subordinate to Westminster [England] and turning Dublin – with drastic social and economic results – into a provincial backwater rather than a proud and bustling capital' (Bartlett, Dawson, and Keogh 1998:148).

It is against these conditions that many of the songs celebrating the Ris-ing, its leaders, and its followers were composed. In addition to those already alluded to, one dedicated to the memory of 'The Boys of Wexford', a song collected by Robert Dwyer Joyce, harks to sentiments favoured by fans of rebel songs:

> We are the Boys of Wexford,
> Who fought with heart and hand,
> To burst in twain the galling chain,
> And free our native land.
> *Songs of the Irish Nation* n.d.:10

Similar sentiments are expressed in the popular 'The Shan Van Vocht' (Irish: *seánbhean bhocht*), a song wherein Ireland is both disguised and mytholo-gized as a long-suffering woman (Quinn 2015:4). This feminized trope of Ireland has a long history, one that contributes to the religious dedication of those who die for 'her':

> [H]undreds of patriotic songs and poems, from the eighteenth century to the twentieth, describe Erin as a fair maid with 'the walk of a queen' or an old woman uttering lamentations and commands.
> Zimmerman 2002:53

The image of Ireland as suffering woman will be discussed in greater detail later. Suffice it to say here that the lyrics of 'The Shan Van Vocht' affirm that she will be liberated by the French, who are coming to 'throw off the red and

blue/and swear that they'll be true' to her and her immortal colour: green. The chorus echoes the longings of the period:

> Yes! Ireland shall be free
> From the centre to the sea,
> Then hurrah for Liberty!
> Says the Shan Van Vocht.
> *Songs of the Irish Nation*
> n.d.:22–23

Even as Ireland's search for freedom is extolled repeatedly in rebel songs and ballads similar to these, there is also a reminder of her unfinished destiny. Patrick J. McCall's song 'Boolavogue', for instance, tells the story of one Father John Murphy, a Roman Catholic priest who, like the aforementioned Kelly, led a successful effort against the British at Wexford (Bartlett, Dawson, and Keogh 1998:134–135). Like many others of its type, 'Boolavogue' prays that Murphy be rewarded with a glorious afterlife, and those who fought with him are wished an 'open heaven'. Such benefits are considered 'proper payments' for the willingness to die for Ireland. The song's final lines hint at the need for kindred actions in the future:

> God grant you glory, brave Father Murphy,
> And open heaven to all your men;
> The cause that called you may call to-morrow
> In another fight for the green again.
> *Songs of the Irish Republic* 1975:71[4]

Paralleling the recognition that more effort on behalf of Ireland's liberty may be required at a later date, songs exhort living men to undertake not death-defying but death-resulting behaviours. In the final verse of the well-known 'Who Fears to Speak of Ninety-Eight?' songwriter John Kells Ingram praises ancestral memory and the masculine guidance, leadership, unity, and truth that it preserves. In the final eight lines, however, laudatory words are combined with a bidding to listeners to undertake corresponding tasks that will benefit the homeland. Regardless of the outcome, male listeners are urged to emulate their former champions:

> Then here's their memory – may it be
> For us a guiding light,
> To cheer our strife for liberty,
> And teach us to unite.
> Through good and ill, be Ireland's still,
> Though sad as theirs your fate,
> And true men, be you, men,
> Like those of Ninety-Eight.
> *Songs of the Irish Nation* n.d.:10

Such a summons functions as a reminder that a 'debt' of sorts is owed by 'true men . . . you men' compelled to honour the sacrifice of earlier 'hero-martyrs' (Ó Cadhla 2017b:276; Boyle 2002:189). Up-and-coming warriors should, the verse suggests, embrace their 'fate' and die for Ireland. In effect, the words of the song hold out the promise of immortality if one were but to emulate physically 'those of Ninety-Eight'. Implied is the idea that to do so is to live forever. If Lawrence J. Taylor would understand this 'specifically religious model for martyrdom and mourning' as a prevalent 'motif which echoes through both Irish folklore and literature' (Taylor 1989b:181), Jack Zipes would add that song lyrics, like folk tales, 'inhabit' their listeners (Zipes 2006:19). Narratives dealing with debts – such as the obligation to pay with one's blood – and rewards – like the promise of immortality to be received in the afterworld – encode, among other things, complex patterns of communal knowledge about one's country and one's place within it. In effect, Irish rebel songs can be understood as tales that index 'a system of interlocking units of narrative, practice and belief' (Bourke 1999:29).

Coverage of rebel song materials in subsequent periods

As for the prevalence and dissemination of many 1798 songs, they were accomplished via broadsheets, or 'penny broadsides' as they were also called. Handbills that sold for a penny or even a half penny dealt with a wide range of topics that 'appeal[ed] to the popular fancy'; they 'became as familiar a feature in the countryside as they had previously been in the towns, being eagerly bought up at markets and fairs and other places where the people congregated' (O'Sullivan 1960:6). The paper on which 'political and republican sentiments' were printed wrapped country people's purchases and littered their roadsides. Broadsides could even be found, like today's morning newspaper, delivered at cottage doors (Zimmerman 2002:37):

> The ballads . . . are to be found in the pockets of every peasant in the country – read and sung by each fireside . . . they keep alive in the heart of the Irish peasant the sense of bondage [and] the deep, unquenchable hatred of the oppressor. . . . The same spirit pervades them all – love of country, hatred of the tyrant, and a firm belief in 'the day to come'. [The ballads] are the literature of the peasantry, and a ballad singer . . . is a more powerful and useful missionary of the cause in the rural districts than a thousand pamphlets.
>
> quoted in Murphy 1979:84

Not surprisingly, those in power feared this kind of dissemination for not only were the broadsides attractive to the country folk in general; they motivated the young in particular. One balladeer from County Cork, having been arrested in 1841 for street singing, revealed that he and his fellow balladeers 'always sing seditious songs' because 'young persons of the country generally

prefer [them] to any other' (quoted in Murphy 1979:96). By 'seditious', the ballad monger was referring to songs of a political, inflammatory, or treacherous nature. Even when composed many years after the praiseworthy incidents they chronicled had occurred, they still commanded insurrectionary power.

Such was the case for a song for Theobald Wolfe Tone, the leader of the '98 Rising. It was written half a century after Tone's death by another 'upstart', the young Irelander Thomas Davis, also founder and editor of yet another avenue for ballad dissemination: *The Nation* newspaper. After visiting the place where Tone was interred and finding no marker there, Davis published in 1843 'Tone's Grave', also known as 'Bodenstown Churchyard':

In Bodenstown churchyard there is a green grave,
And freely around it let winter winds rave –
Far better they suit him – the ruin and the gloom –
Till Ireland, a nation, can build him a tomb.
Songs and Recitations of Ireland 1961:26

In this song, a 'churchyard' which contains a 'green grave' is described with words like 'gloom', 'ruin', and winter's raving 'winds'. Such desolation is deemed appropriate until the time when the 'nation' of Ireland can honour Wolfe Tone rightly by constructing a suitable 'tomb' for him. Albeit subtle, the goading to action is unmistakable, as is the implication of shame that such a final resting place has not yet been erected.

Interestingly, this song is kept alive in Irish popular culture by the highly successful and popular band equipped with an appropriately eponymous name: the Wolfe Tones. The group performs in Ireland and Northern Ireland and also on an international stage circuit that ranges from Europe to the United States and Australia (see Boyle 2002:175). Likewise, it would not be unusual for the band to play Thomas Davis's song 'A Nation Once Again'; its lyrics, like some of the aforementioned, yearn for 'our fetters' to be rent 'in twain' so that 'Ireland, long a province', might become 'a nation once again'. In a 2002 British Broadcasting Corporation (BBC) poll, the Wolfe Tones' 1972 version of 'A Nation Once Again' was voted 'the world's most popular song' (Brennan 2016). Its final stanza harks back to the aforementioned religious spirit by speaking of an 'angel voice' that contrasts 'dark' and 'lowly' sentiments with those of service to the cause of 'freedom's arc', identified as 'high' as well as holy'. Then comes the call to action:

For, Freedom comes from God's right hand,
And needs a Godly train;
And righteous men must make our land.
A Nation once again!
100 Irish Ballads 1981/1985:9

This song, along with the aforementioned 'Who Dares to Speak of '98?' and numerous others, laid the sentimental groundwork for imagining a new Ireland; their energy stretches to the early decades of the 20th century. It reaches a kind of apotheosis during Ireland's Easter Rising of 1916. As shall be revealed, it continues to be mobilized in subsequent efforts to secure complete independence from Great Britain.

The impact of *An Gorta Mór* on Irish popular culture in song

It must be borne in mind that, just at the time when Thomas Davis was penning 'A Nation Once Again,' the Great Irish Famine in Ireland (Irish: *An Gorta Mór* or the Great Hunger/Starvation) was raging. It resulted in the loss of over two million people to death and emigration. How that climactic event exposed the injustices of the system, as the people who witnessed and wrote about them, is best exemplified by a 'call and response' ballad of despair at one's circumstances on the one hand and a righteous urge for vengeance on the other. 'Dear Old Skibbereen' commences with a son's query to his father to explain why the latter had emigrated despite his love for Ireland. The sire's response, coupled with his descriptive loss of land and loved ones, prompts the son's promise to address his father's experience:

> Oh, father dear, the day may come when in answer to the call
> Each Irishman, with feeling stern, will rally one and all
> I'll be the man to lead the van beneath the flag of green
> When loud and high we'll raise the cry –
> 'Remember Skibbereen!'
> *100 Irish Ballads* 1981/1985:9; quotation in original

In another version, the final verse contains a more powerful response to the family's fate; the word *answer* in the first line is replaced by *vengeance*, and in the final one, *revenge* takes the place of *remember*:

> Oh, father dear, the day will come when *vengeance* loud will call,
> When Irish men with feelings stern will rally one and all
> I'll be the man to lead the van beneath the flag of Green,
> When loud and high we'll raise the cry –
> *Revenge* for Skibbereen.
> *Songs of the Irish Republic* 1975:57; emphasis added

How does one square the circle regarding a son's patriotic fervour for liberating Ireland and his personal desire to rectify the travails of his father? How does one utilize the musical platform to keep alive the memory of the alleged 'sins' that the perceived enemy is believed to have perpetrated against one's kin?

In her article 'Visible Death: Attitudes to Dying in Ireland', Patricia Lysaght attends to the customs that surround the end of life there (see also Ó

Súilleabháin 1967; Ó Crualaoich 1999; Kelly and Lyons 2013; Ryan 2016; Griffith and Wallace 2016). Lysaght emphasizes the desire to procure certain food for the dying and the urge to settle debts; to deliver proper care to the body; and to recognize the 'signs' that death may be near, such as 'rambling', a sort of 'mental wandering' (Lysaght 1995:27–59; 87–99). Many of these aspects are fulfilled in the lines of 'Dear Old Skibbereen': the father's mental perambulations through the travails of his life culminate in his being granted a sort of metaphorical 'food' on his proverbial deathbed: the son determines to settle his father's accounts by interpreting the latter's words as a summons to 'lead the van' that may bring about the son's own death. Here we witness what Nina Witoszek considers 'the most evident hallmark of Irishness in Irish culture': 'a persistent, centuries-old preoccupation with death' (Witoszek 1987:207).[5]

Evidence as to the veracity of this 'cult of death', as Witoszek labels it, is found as a recurring theme in Irish popular culture. For instance, in the Irish toast *'Bás i nEireann!'* the speaker's expressed wish is: 'May you die in Ireland!' Taylor asserts that this aspiration possesses a double meaning for, although on the one hand it refers to coming home to be buried in Ireland, it also implies dying *'for* Ireland' (Taylor 1989b:183; emphasis in original):

> This sort of death may or may not be sudden, but if it is, the life of the martyr and the manner of his death – for the faith – insures good separation from this life, and of course the best destination on the other end for the soul's journey.
>
> Taylor 1989b:181

These kinds of religio-political attitudes toward death, the good death, and the soul's journey emerge in more 'rebel' songs to be unpacked later. Before doing so, however, it behooves us to turn briefly to the aftermath of *An Gorta Mór* because memories and emotions like those represented and expressed in 'Dear Old Skibbereen' prevailed well after the famine years.

Still-extant folkloric archival materials testify to the suffering and travail that the people endured. The great loss of life was not forgotten. Moreover, the people remembered that during *Am an Drochshaoil* (the bad time; the time of the famine), food continued to leave Ireland under armed guard; accessing it often meant converting to Protestantism in order to be fed (see Quinn 2001:72, 74). Moreover, the people continued to agitate for reform for, although emancipation for Roman Catholics had been granted in 1829, other rights, such as those related to land ownership and political representation, were slower to materialize. Not surprisingly, at the dawn of the 20th century, there were calls for more radical approaches to solving 'the Irish question', which Benjamin Disraeli had defined half a century earlier as, 'a starving population, an absentee aristocracy, and an alien church, and in addition the weakest executive in the world' (quoted in Scott 2016:232). Complete revolution was promulgated by some, and particularly as the century unfolded

and World War I loomed large, the idea that 'England's difficulty is Ireland's opportunity' began to gain credence. Could a revolt liberate Ireland? Could the centuries of struggle with the perceived oppressor gain sway? And what role would popular culture, particularly popular 'rebel' songs, play in the lead-up to the conflict?

The leaders of the Easter Rising

Answers emerge in the Easter Rising of 1916 and its aftermath, when 'death for the cause' took on increasing significance. One person whose legacy redounds still is the poet, educator, and Irish speaker *Padraig* (also spelled *Padraic*; English: Patrick) Pearse. A member of *Conradh na Gaeilge* (the Gaelic League) in his youth, Pearse became the editor of its newspaper *An Claidheamh Soluis* (The Sword of Light) in 1903. In keeping with well-known musical as well as cultural ancestral tradition, Pearse chose a song with martial rhythms: '*Óró Sé do Bheatha 'Bhaile*' (Oh-ro! You're Welcome Home). Its popular lyrics had varied over the years and been utilized for multiple purposes, including welcoming brides to their new dwellings and showing hospitality to 'Bonny Prince Charlie' (Charles Edward Stuart) during the Jacobite Era (see *Songs in Irish* 2019).

Recall that the aforementioned Shan Van Vocht (*seanbhean bhocht*) served to keep the memory of 1798 alive. In like vein and to inspire his followers, Pearse chose the trope of Ireland as woman, '[t]he most important traditional allegory' (Zimmerman 2002:53). In Pearse's hands, the Irish legendary seafarer queen Grace O'Malley (Irish: *Gráinne Mhaol*) becomes the symbolic representation of Ireland. In the opening verse, she is personified as someone who, having been robbed of her territory, has been made servile and suffering as a result: 'Welcome, oh woman who was so afflicted/It was our ruin that you were in bondage/Our fine land in the possession of thieves/And you sold to the foreigners!'[6] However, in Pearse's reworked motivational lyrics, her state will be transformed by the *Irish* – not the French or Spanish – who are invited to 'rout the foreigners' in the 'better weather' of summer and to return home from abroad to do so (see *Songs in Irish* 2019; see also *Celtic Women* 2016).

Pearse's Irish-language lyrics and employment of the woman's name *Gráinne Mhaol* – Grace O'Malley – hark to the *aisling*, an 'allegorical representation of the Irish cause' (Vallely 2011:9); Ireland's name is rendered metaphorically as a young woman in distress (see Quinn 2015:4). She may be called *Roisín Dubh* – the little black rose – for instance or, in poet Ó Raithaille's hands, 'Brightness of Brightness' (O'Connell 1988:91). After appearing to a young man (i.e., Irish patriot) in a vision or a dream, she bemoans her fate at the hands of her tormenter (i.e., England).[7] Smitten with love, he vows to aid her plight (i.e., the cause for Irish freedom).

For Padraig Pearse, '*Óró Sé do Bheatha 'Bhaile*' was but one hortatory piece in his creative arsenal. In all likelihood he would have agreed with the belief that 'Those in power write history; those in pain write songs' (quoted in

Beiner 2007:241–242). Imbued with the notion of blood sacrifice, especially as it was understood in the Christian tradition as the path to liberation as well as redemption, he conceived of an insurrection which would, he believed, liberate Ireland from her shackles. His poems were written with that kind of zeal in mind; they would serve not only for those in his own time but also, even more importantly, for future generations.

Pearse's thinking seems to have taken root. For instance, since at least 2010, the band Flying Column has opened its rendition of Tommy Makem's song 'Four Green Fields' – an *aisling* type that characterizes the 'old woman' bemoaning the fate of her 'fields', which symbolize the four provinces of Ireland – with Pearse's poem '*Mise Éire*' (English: 'I Am Ireland'):

Mise Éire:
Sine mé ná an Chailleach Bhéarra

Mór mo ghlóir:
Mé a rug Cú Chulainn cróga.
Mór mo náir:
Mo chlann féin a dhíol a máthair.
Mór mo phian:
Bithnaimhde do mo shíorchiapadh.
Mór mo bhrón:
D'éag an dream inar chuireas dóchas.

Mise Éire:
Uaigní mé ná an Chailleach Bhéarra.
PoemHunter 2019

In this poem, Pearse characterizes *Éire* (Ireland) as older than the '*Cailleach*' (wise woman) of Beare, who bore the great warrior *Cú Chulainn* but whose former glory has been replaced by the shame of having children who not only '*a dhíol a máthair*' (sold their mother) but also '*a chuireas dóchas*' (destroyed hope).

Can this be the legacy of 'Kelly of Killane'? '*Mise Éire*' seems to represent a shift in sentiment from the songs written to commemorate the Rising of 1798. The poet's mood is sombre as well as indicting; Pearse's Irish woman resembles the woman of the *aisling* who speaks of suffering and sadness, but she is embarrassed by the fact that her children have 'sold' her into bondage. If, as Andrew Bennett argues, music 'serves to stimulate collective memories of traditional Irish culture, thus becoming a crucial link with notions of heritage' (Bennett 1997:111), it is important to understand what this poetic/musical shift might mean in terms of the trajectory of the Irish rebel song being pursued here.

'*Mise Éire*' may not be so much a shift as a refraction or deflection to another aspect of Irish traditional culture. Pearse was no stranger to the Irish literary movement that blossomed in the late 19th and early 20th centuries.

That renaissance reinvigorated interest in Ireland's ancient heroes. Preserved in myth, they include the warrior *Fianna*, a band that followed the legendary hero Fionn Mac Cumhaill (Finn Mac Cool); they also include the inimitable *Cú Chulainn*. The latter's willingness to die for a cause, his 'bravery and his victories against foreign invaders, captivated the literary imagination' (Sweeney 1993:12). For Pearse, who had been steeped in a Christian ethos as well as an Irish Gaelic sensibility since his youth, *Cú Chulainn*'s self-sacrifice and subsequent death in his efforts to save fellow warriors were to be imitated physically. On the symbolic date of Easter Monday, 24 April 1916, he and others of similar persuasion expressed their willingness to die for Ireland through the Catholic Church's theology of 'martyrdom and [its] doctrine of blood sacrifice' (Witoszek and Sheeran 1998:39). Indeed, it was Pearse who read aloud the document of liberation, the 'Proclamation of the Provisional Government of the Irish Republic', which he and six others had signed. Days later, on 3 May, Pearse was executed by firing squad; by 12 May, 14 of his fellow revolutionaries had died the same way (Century Ireland).

Following Pearse's execution, his 'religio-political based self-immolation [was] elevated to a . . . sacred position in Irish history and mythology' (Sweeney 2004:343). A case in point is the fact that '*Mise Éire*' was used to aid and encourage Irish political prisoners detained in Northern Ireland's Long Kesh Detention Centre (a.k.a. The Maze).[8] Another indication of Pearse's 'hero-martyr' status can be gleaned from Leo Maguire's 'Patrick Pearse', which is replete with many of the encomia witnessed in earlier rebel songs. In it one finds the lines: 'Now may God be my guide as I sing of the glory/The goodness, the grandeur of bold Patrick Pearse' (*Ballads of an Irish Fireside 4* n.d.:25–26).

The legacy of James Connolly

Although there is no doubt that Pearse's place in history is assured, John Loesberg, in describing how one of the Rising's comrades-in-arms was treated before his execution, suggests another exemplary figure worth emulating: 'On May 12, 1916, James Connolly, unable to stand, due to injuries, was strapped to a chair in the yard of Kilmainham Jail and executed by a firing squad. . . . [He was] arguably the most important leader of the 1916 rebellion.' (Loesberg 1989:100 ; '14 Men Executed in Kilmainham Gaol' (1916)). To lend credence to Loesberg's point, one might suggest that, in Irish popular cultural memory, there is no greater exemplar of an Irish rebel song than the eponymous 'Ballad of James Connolly'. In concert, the Wolfe Tones preface their popular rendition of the ballad with a recitation of 'The Poem of James Connolly', written by Liam Mac Gabhann:

> The man was all shot through that came today
> Into the barrack square;
> A soldier I – I am not proud to say

We killed him there;
They brought him from the prison hospital;
To see him in that chair
I thought his smile would far more quickly call
A man to prayer.
Maybe we cannot understand this thing
That makes these rebels die;
And yet all things love freedom – and the Spring
Clear in the sky;
I think I would not do this deed again

For all that I hold by;
Gaze down my rifle at his breast – but then
A soldier I.
They say that he was kindly – different too,
Apart from all the rest;
A lover of the poor; and all shot through,
His wounds ill drest,
He came before us, faced us like a man,
He knew a deeper pain
Than blows or bullets – ere the world began;
Died he in vain?
Ready – present; And he just smiling – God!
I felt my rifle shake
His wounds were opened out and round that chair
Was one red lake;
I swear his lips said 'Fire!' when all was still
Before my rifle spat
That cursed lead – and I was picked to kill
A man like that!

<div align="center">Murphy 2016</div>

In this poem, one encounters the vividness played by the role of death in Irish popular rebel song. Words like 'wounds . . . opened out' and 'red lake [of blood]' are juxtaposed to the 'cursed lead' that brought James Connolly down. Furthermore, one recognizes 'the many ways in which public recreational space [can become] intensely politicised', a fact that contradicts the belief that Irish traditional music is mere 'diddle-de-dee' music (Stokes 1994:9). Rather, as Taylor notes, 'ritualized political death' has a symbolic usage: it can engender a communal discourse that possesses nationalistic rhetoric and fervour (Taylor 1989b:184). In the case of the 'Ballad of James Connolly' and its concomitant poem, that discourse extends far beyond Ireland's borders for, as noted earlier, the Wolfe Tones perform on a global stage, as do many other groups that make use of this highly mnemonic material.[9]

The significance of Kevin Barry's model of self-sacrifice

Although the deaths of the Easter Rising operatives were important at the time, four years later, a young Trinity College medical student produced not only the rhetoric of self-sacrifice for one's country but what Ó Cadhla refers to as an ensuing 'cult of martyrdom' (Ó Cadhla 2017b:273–279). Having become smitten with the nationalist cause, Kevin Barry was captured in Dublin during a botched raid of British troops. Despite numerous interventions, clerical and otherwise, which sought to commute his sentence, he was hanged on 1 November 1920, the first person to be treated in such a manner since 1916. This debacle earned international attention and outrage and inspired an anonymous ballad; its final lines return us to the pattern we have witnessed repeatedly:

> Another martyr for old Ireland
> Another murder for the crown,
> Whose brutal laws may kill the Irish,
> But can't keep they're spirit down
> Lads like Barry are no traitors
> From the foe they will not fly;
> Lads like Barry will free Ireland;
> For her sake they'll live and die.
> Cole 1961/1969:102

The song not only recounts Barry's torture, his refusal to reveal comrades' names, and his 'calm standing to attention', but also his walk, while 'softly smiling/That old Ireland might be free' (Cole 1961/1969:102–103). Such a demeanour, coupled with a repeated emphasis on his youth (e.g., 'Just a lad of eighteen summers') insured that the ballad would become 'the most popular rebel song, especially in America' (Cole 1961/1969:102). Allegedly, it was sung so often among British Army soldiers (many of whom were of Irish descent) that the ballad was banned; likewise, the Irish radio station *Raidió Teilifís Éireann* removed 'Kevin Barry' from its playlists during 'The Troubles' in Northern Ireland (to be discussed later), a decision which only served to increase the people's desire to hear it (O'Dowd 2017). At one point it had become so popular that it produced a now-folkloric query: 'What used they sing before they sang "Kevin Barry"?'

Moreover, actual circumstances seem not to have differed greatly from the song's lyrics, for Kevin Barry, much like others of his ilk 'who gladly [laid] down their lives so that the "cause: might live' (Zimmerman 2002:70), is reported to have belittled his impending death by saying to his sister shortly before his hanging: 'It is nothing, to give one's life for Ireland. I'm not the first and maybe I won't be the last. What's my life compared with the cause?' (O'Dowd 2017). In comprehending the meaning of Barry's words, one witnesses a 'movement away from self-doubt to one of self-sacrifice' (Sweeney 1993:12).

One can apply Barry's final words to four aspects of Daniel J. O'Neill's (1989) model of self-sacrifice (see also Sweeney 1993). First, the young rebel

makes a virtue of necessity, meaning that he utilizes the only means left at his disposal or what amounts to his one remaining 'weapon of the weak' (Scott 1985). In Barry's case, that 'weapon of necessity' equates to a patterned embrace of the trope of dying for the cause of Irish freedom. Second, because Barry's end is peaceful, it aligns well with his plea for what he deems to be a legitimate and non-violent cause; third, both the lad's death and the song's lyrics provide followers with role models for their own behaviours in terms of the encouragement to adopt an heroic stance in the face of violent opposition; and finally, Kevin Barry's life and death are reiterations of those of earlier heroes, the legacies of which are paralleled in their collective song lyrics.

Self-immolation through Irish hunger strike

Kevin Barry's hanging occurred just a few days after the death of another Irish patriot, Lord Mayor of Cork Terence MacSwiney. In August 1920, the latter was arrested on charges of possessing seditious materials. Detained at Brixton Prison in London, MacSwiney immediately began a hunger strike to protest his internment and treatment at the hands of the British.

Why a hunger strike? Why then? In his consideration of the various ways of causing serious harm to oneself, or self-immolation (e.g., altruistic, samsonic, etc.), anthropologist Arthur Hocart suggests that the religio-political type occurs in societies where the dead occupy a higher status than the living; they are accorded 'a kind of moral advantage over the living' (quoted in Sweeney 2004:343). To understand how this kind of sacrifice of the self might be understood in Ireland, we turn to early Irish law, at a time when structures existed for members of various strata to air their grievances, both real and perceived. Those without official power could seek redress, especially against the more powerful persons (*nemed*) within the society by means of *troscad* (fasting). The ritual operated in the following manner: the commoner established himself near the *nemed*'s territory and began to fast, a scene which publicly broadcast the complaint of the aggrieved as well as the behaviours of the transgressor. For a variety of reasons, including taboos regarding pollution, the *nemed* were likely to acknowledge the faster's – or in more recent parlance, 'hunger-striker's' – demands before the condition deteriorated to its fateful conclusion (Sweeney 1993:11; see Binchy 1973).

Unfortunately for Terence MacSwiney, the British in 1920 felt no such compunction to redress the complaints of the wronged, nor did they possess the mechanisms to do so. Although international outrage was expressed in response to the Lord Mayor's plight, like Barry's, that consternation produced futile results (Gannon 2013). After 74 days,[10] on 5 October 1920, MacSwiney died from 'the longest recorded fast to death by a Republican political prisoner' (Ó Cadhla 2017a:116 n7). Billings calls it a 'triumph' in the sense that, even though it was not the first, it 'brought hunger striking to the forefront of public consciousness and proved an exemplar for others'

(Billings 2016). Daniel Corkery harks to the religio-political as well as to blood sacrifice in his honouring of the hunger striker's memory:

> Any great movement toward a spiritual end, such as Ireland's push for freedom . . . endows itself with creative power. . . . [I]n such movements men like Terence MacSwiney act out the desires of their souls, express their desires in living matter, [in] the dearest that is, *flesh and blood*. Such men we speak of as master-spirits, master minds.
>
> <div align="right">Corkery 1920:513–514; emphasis added</div>

Corkery concludes his praise piece by acknowledging the 'hero-martyr's' status:

> We have as yet but roughly, very roughly, estimated [MacSwiney's] *Martyrdom*. . . . Yet those who went to see him lying on his bed of torture came home . . . dazzled by the constant activity of his mind, at the serenity of his spirit.
>
> <div align="right">Corkery 1920:520; emphasis added</div>

The parallels with Kevin Barry's demeanour are clear.

The Irish hunger strike in song

George Sweeney, in writing about how self-immolation emerges in the popular political ballad, notes the existence of a 'meshing of religious practice with aspirations of nationalism and militant republicanism' (Sweeney 1993:12). In the song in honour of Terence MacSwiney, such blending is expressed in the very title: 'Shall My Soul Pass Through Ireland?' (*Songs of the Irish Republic* 1975:46). The Lord Mayor is represented in the opening verse as an 'Irish rebel' who murmurs the titular question to his priest. Concern with the journey of his soul through Ireland takes centre stage; its importance is repeated in verse as well as chorus. In the second verse, the rebel claims his identity:

> 'Twas for loving dear old Ireland
> In this prison cell I lie,
> 'Twas for loving dear old Ireland
> In this foreign land I die.
> *Songs of the Irish Republic*
> 1975:46

After a return to the chorus and the question that haunts the dying hero, the last eight lines are delivered with a third-person description of his condition; they amount to a combination of panegyric and prayer and a bow once again to the religio-political spirit exposed repeatedly in other songs:

> With his heart pure as a lily
> And his body sanctified,

In that dreary Brixton prison
Our brave Irish rebel died.
Prayed the priest that wish be granted
As in blessing raised his hand:
'O Father, grant this brave man's wish
May his soul pass through Ireland'.
Songs of the Irish Republic
1975:46

This final verse calls to mind Taylor's observation regarding the Irish desire for a 'good separation from this life' as well as 'the best destination on the other end for the soul's journey' (Taylor 1989b:181). Words like *lily* and *sanctified* are evocative of the Christian notion of blood sacrifice and the Easter Rising of 1916. Also, by directing attention to the rebel's physical parts (e.g., 'heart'; 'body'), the words anticipate his own 'resurrection from the dead'. In turn, they hark to his achieved immortality. The song insures that MacSwiney will live forever in communal memory for his willingness to face death for Ireland.

A sampler of Irish hunger strike songs

Although various dictionaries describe *hunger strike* in relatively simplistic terms, focusing on refusing to eat in order to protest or agitate, Terence Mac-Swiney's hunger strike transcends these definitions for his eschewal of food was but one aspect of a much larger context that both preceded and followed him. Of salience is the fact that significant songs have been written in respect to the hunger strikers who died in 1981 at the Maze Prison's H-Blocks in County Down. These include Francie Brolly's 'The H-Block Song', one that addresses the 'eight hundred years' of British occupation; 'Bobby Sands MP', an autobiography of the first Irish political prisoner to die on hunger strike during that time, and 'The Time Has Come'; a nostalgic ballad characterizing the final meeting between hunger striker Patsy O'Hara and his mother (Boyle 2002). In one particular verse, many of this chapter's motifs can be recognized:

The flame he lit by *leaving*
Is *still* burning strong
By the lights it's plain to see
The suffering still goes on.
Irish Folk Songs;
emphasis added

Likewise, the final lines of Christy Moore's 'The Boy from Tamlaghtduff' (a.k.a. 'The Ballad of [hunger striker] Francis Hughes') align with several of the hero-martyr themes discussed in this chapter:

His will to win they could not break no matter what they tried
He fought them every day he lived and he fought them as he died.
Irish Song Lyrics

And one verse from the song about hunger striker 'Joe McDonnell' blends the previously discussed religio-political perspectives with those of words like *fame*, *glory*, and *courage* (repeated twice):

> May God shine on you Bobby Sands
> For the courage you have shown
> May your glory and your fame be widely known.
> And Francis Hughes and Ray McCreesh who died unselfishly
> And Patsy O Hara and *the next in line is me*
> And those who lie behind me may your courage be the same
> And I pray to God my life is not in vain.
>
> Celtic Lyrics 2019a; emphasis added

This 'sampler of song similarity' requires a slight qualification for, although the culled poetic messages of these later 'hunger striker' songs can be perceived to resonate with the spirit of '*Óró Sé do Bheatha 'Bhaile*' and the songs of the '98 Rising, they also express the querying hues of 'May My Soul Pass Through Old Ireland?' and the darker and more sober sentiments of '*Mise Éire*'. There is a more pronounced awareness that, although the 'martyrs' continue to die in the struggle for Irish freedom, the battle has not been won; nor has the surety of everlasting glory and symbolic immortality been bestowed on the 'heroes' with the same confidence expressed in songs about earlier campaigns for Irish freedom (see Beresford 1977). The question as to the ultimate result of the protesters' sacrifice is expressed in lines written by Irish women political prisoners. Tim Pat Coogan, in his book *On the Blanket: The Inside Story of the IRA Prisoners' 'Dirty Protest'*, collected four lines from 'A Wing' of the women's jail in Armagh:

> I am one of many who would die for my country
> I believe in fighting the fight to the end
> If death is the only way I am prepared to die
> To be free is all I want and many like me think the same.
>
> Coogan 1980:231

One finds in these lines a personal identity revealed in terms of a collective will to 'fight' and give one's life for Ireland, coupled with the expressed belief in the importance of prevailing 'to the end': in other words, to death. The subjunctive 'if clause' of having to face termination of one's life in the words 'if death is the only way' is followed by the 'then clause' of acceptance: 'I am prepared to die'. Such a willingness is collectively shared for, as the writer reveals in the final words, 'many' are of the same persuasion. Yet a scintilla of ambivalence can be detected all the same.

Conclusion

This chapter has focused on Irish 'rebel' songs as forms of popular culture, arguing that, for the imagined communities of resistance they serve, they

function to reassert the fact that '[i]f everything else is broken and fractured, the Irish conversation with the dead, at least, has never ceased' (Witoszek and Sheeran 1998:11). Popular musical forms express and validate what consumers of shared persuasions and interpretations prefer to believe: in an inauthentic world, 'the dead assume a very important role as bridges to an Otherworld that is' (Witoszek and Sheeran 1998:11).

The chapter has demonstrated how narratives of Irish 'rebel' songs align, interlock, and dovetail with one another such that resistant communities are able to find a modicum of purpose and fulfilment. For even if the cause for which communal heroes laboured failed to achieve its wished-for results, the fact that they died trying is lauded and, most importantly, understood as an assurance of their immortality. The final verse to the song that lends its words to the title of this chapter, 'The Ballad of Billy Reid', echoes many of these themes, including the assurance of the mnemonic of 'blood sacrifice':

> If you think he was right come and join in the fight
> And help to free Belfast
> Cause the blood that he shed although he was dead
> In our hearts sure his memory will last.
>
> Rebel Lyrics 2013

Several scholars have seen the importance of suffering by virtue of shedding blood for Ireland as a predominantly Roman Catholic phenomenon (Moran 1994; Kearney, quoted in Witoszek and Sheeran 1998:45). At the level of the psychological, ideas like blood sacrifice, national martyrdom, and redemption, which were obvious to the Irish, were 'alien and obscure' to the British (Moran 1994:94). The latter failed to appreciate the unique mythical quality of such dedication, which was periodically renewed in a variety of battles and skirmishes. In this manner, 'heroes' as diverse as John Kelly, Robert Emmett, Padraig Pearse, and Kevin Barry continue to be immortalized in song. Although space limitations preclude discussing numerous others, it is important to mention their existence in the repertoires of those who sing rebel songs. Equally important as those discussed here, they include, to name but a few, 'Seán South of Garryowen', 'Roddy MacCorley', Michael Gaughan (featured in the ballad 'Take Me Home to Mayo'), and Fergal O'Hanlon (of 'Patriot Game' fame). Of course, bands and troops are validated repeatedly in rebel songs too; they include, among many others, 'Legion of the Rearguard', 'Bold Fenian Men', and 'Boys of the Old Brigade'. They all died for Ireland.

Especially as they have been maintained in popular-cultural memory since the late 18th century, Irish 'rebel songs' express tropes and motifs like the 'cult of death', the search for liberty, the understanding that Ireland's destiny is unfinished, and the realization that the 'call' to participate may arise at any time. In the contemporary era, venues for mnemonic preservation include innumerable outlets that range from print to recordings and from sites for social media to concerts, public houses and the like.

Although what remains to be heard cannot be assessed with certainty, we might wish to proffer some thoughts about rebel music's future. As world music becomes ever-more dominant, Irish groups seeking to foreground heroic struggles and rebel sensibilities face huge challenges. For instance, 'Kelly the Boy from Killane', the song that opened this chapter, may be experiencing a certain 'fade' as the result of taste change and the emergence of newer soundscapes. Likewise, although songwriters still compose songs about the 'cause' as defined here, it has been argued that they 'comprise an extremely minor element in the wider global world of pop music' (Rolston 2001:64, 67n). Even Paul David Hewson, a.k.a. 'Bono', leader of the band U2 and composer of 'Sunday Bloody Sunday', a song about 'the Bogside Massacre', an incident that occurred on 30 January 1972 in County Derry, Northern Ireland, which resulted in the deaths of 14 unarmed peace demonstrators, introduces the song by insisting, 'This is not a rebel song'. And as noted in the body of this chapter, tonal shifts or refractions can be detected in the rhetoric of certain hunger striker songs such that claims to 'glory' for 'fearless' and 'dauntless' warriors retreat under moods of circumspection, which leads one to wonder if Yeats's words will hold sway in the years to come:

> Some had no thought of victory
> But had gone out to die
> That Ireland's mind be greater,
> Her heart mount up on high.
> And yet who knows what's yet to come?
> For Patrick Pearse had said
> That in every generation
> Must Ireland's blood be shed.
> Yeats, 'Three Songs to the One
> Burden', quoted in Edwards
> 1990, frontispiece

On the other hand, the 1981 'hunger strike' songs continue to be heard in public venues like concerts by the Wolfe Tones. These show no signs of abating; the band appeared in a sold-out performance in Belfast, Northern Ireland, during the summer of 2019 (Wolfe Tones Official Site 2019).[11] And Stephen Millar, in a case study of a few performances of current 'rebel' songs, argues that specific neighbourhoods in the North of Ireland 'continue to use Irish rebel music as a means to engage in a dialectic with "official culture", challenging the narrative that Northern Ireland's citizens enjoy parity with their British counterparts in favor of the notion that the North of Ireland remains a colony of Great Britain' (Millar 2017:85; see also McCann 1995; Griffith 2016; McCarthy 2018; Grant 2019).

In the final analysis, even though the religious aspect of the Irish religio-political equation may not be as balanced as it was in former times, and even though 'mourning is still an unfinished business lacking in the kind of closure

that is usually brought about by detaching memories and hopes from the dead' (Witoszek and Sheeran 1998:8–9), the genre of the Irish 'rebel' song continues to circulate among imagined communities of resistance both in Ireland and abroad. Despite – or perhaps because of – its stylistic similarities and variants and, most of all, its messages, it is maintained as a popular-cultural form, capturing the imaginations of singers and listeners alike. For those with little cultural capital who are far from the positions of power, and especially for disenfranchised youth, dreams of immortality by dying for a cause and enjoying fame in the afterlife motivate still.

Notes

1 'Dinner with the President', available online at: www.youtube.com/watch?v=P2-8HwN jMIM; 'The Dubliners Live at Montreux concert 1977', available online at: www.you tube.com/watch?v=ghYdcdrB2XU&t=29s; the High Kings' performance of 'Kelly, the Boy from Killane' at the Bartlett Performing Arts and Concert Centre 2 March 2018, available online at: www.youtube.com/watch?v=0zgt0nYZznI.
2 Thomas Moore published 'The Harp that Once Through Tara's Halls' in 1808; 'The Minstrel Boy' saw the light of print in 1813. Both songs deal with the loss of Irish culture both musically and militarily. For more publication information on these songs, see Florence Leniston, *Popular Irish Songs* (1992: iii, iv).
3 Available online at: www.irishexaminer.com/lifestyle/artsfilmtv/music/from-kilmichael-to-the-foggy-dew-irelands-favourite-rebel-songs-389292.html.
4 The priest, Father Murphy, had initially rejected the insurrectionary cause; however, he later embraced it when he witnessed the atrocities committed by the enemy, including the burning of his church.
5 Nina Witoszek cites numerous aspects of her label, the 'cult of death', such as the cry of the banshee (Irish: *bean sí*, death messenger); the importance of the space wherein the deceased is interred; the desire for an Irish wake that will honour the departed one's memory, and even disinterment and re-interment of those whose lives were deemed to have been improperly honoured at the initial time of burial (Witoszek 1987).
6 The Irish words of the first verse are: *Sé do bheatha, a bhean ba léanmhar, Do b' é ár gcreach thú bheith i ngéibheann, Do dhúiche bhreá i seilbh méirleach, Is tú díolta leis na Gallaibh.*
7 Fintan Vallely notes that the woman appears as a 'fairy personage' to a 'sleeping poet'. He also notes that the *aisling* is 'particularly associated with the Jacobite period of Irish history' (Vallely 2011:9).
8 The prison operated from about August 1971 until the time when the final prisoners were released (circa 2000).
9 The Irish group Black '47 also has a song dedicated to the memory of James Connolly. It is available online at www.youtube.com/watch?v=wukfdjJv340.
10 Daniel Corkery puts the number at 73 days (Corkery 1920:513).
11 'Féile 2019!', available online at: www.wolfetonesofficialsite.com/.

References

'14 Men Executed in Kilmainham Gaol' (1916): *Century Ireland: A Fortnightly Online Newspaper*. Available online at: www.rte.ie/centuryireland/index.php/articles/14-men-executed-in-kilmainham-gaol.
100 Irish Ballads (1981/1985): Dublin: Walton's Manufacturing Ltd.
Ballads of an Irish Fireside 4 (n.d.): Dublin: Walton's Ltd.

Bartlett, Thomas, Kevin Dawson and Dáire Keogh (1998): *The 1798 Rebellion: An Illustrated History*. Boulder, CO: Roberts Rinehart.

Beiner, Guy (2007): *Remembering the Year of the French: Irish Folk History and Social Memory*. Madison: University of Wisconsin Press.

Beiner, Guy (2018): 'The Enigma of *Roddy McCorley Goes to Die*: Forgetting and Remembering a Local Rebel Hero in Ulster'. In Éva Guillorel, David Hopkin and William G. Pooley (eds.): *Rhythms of Revolt: European Traditions and Memories of Social Conflict in Oral Culture*. New York: Routledge, pp. 327–355.

Bennett, Andrew (1997): 'Bhangra in Newcastle: Music, Ethnic Identity and the Role of Local Knowledge'. *Innovations: The European Journal of Social Science Research*, 10:107–116.

Beresford, David (1997): *Ten Men Dead: The Story of the 1981 Irish Hunger Strikes*. New York: Atlantic Monthly Press.

Billings, Cathal (2016): 'Terence MacSwiney: Triumph of Blood Sacrifice'. *Independent.ie*, March 3. Available online at: www.independent.ie/irish-news/1916/thinkers-talkers-doers/terence-macswiney-triumph-of-blood-sacrifice-34495537.html.

Binchy, Daniel (1973): 'Distraint in Irish Law'. *Celtica*, 10:22–71.

Bourke, Angela (1999): *The Burning of Bridget Cleary: A True Story*. London: Pimlico.

Boyle, Mark (2002): 'Edifying the Rebellious Gael: Uses of Memories of Ireland's Troubled Past among the West of Scotland's Irish Catholic Diaspora'. In David C. Harvey, Rhys Jones, Neil McInroy and Christine Milligan (eds.): *Celtic Geographies: Old Culture, New Times*. New York: Routledge, pp. 173–191.

Brennan, Marjorie (2016): 'From Kilmichael to the Foggy Dew, Ireland's Favourite Rebel Songs'. *Irish Examiner*, March 25. Available online at: www.irishexaminer.com/lifestyle/arts filmtv/music/from-kilmichael-to-the-foggy-dew-irelands-favourite-rebel-songs-389292. html.

Celtic Lyrics (2019a): 'Joe McDonnell'. Available online at: http://celtic-lyrics.com/lyrics/269. html.

Celtic Lyrics (2019b): 'The H-Block Song'. Available online at: www.celtic-lyrics.com/lyrics/227.html.

Celtic Women (2016): 'Celtic Woman – Óró Sé Do Bheatha Bhaile'. Available online at: www.youtube.com/watch?v=nbcPlb0OQw4.

The Clancy Brothers and Tommy Makem Song Book (1962): New York: Oak Publications.

Cole, William (ed.) (1961/1969): *Folk Songs of England, Ireland, Scotland and Wales*. New York: Cornerstone Library.

Coogan, Tim Pat (1997) (1980): *On the Blanket: The Inside Story of the IRA Prisoners' 'Dirty Protest'*. Boulder, CO: Roberts Rinehart.

Cooper, David (2009): *The Musical Traditions of Northern Ireland and Its Diaspora: Community and Conflict*. Farnham: Ashgate Publishing.

Corkery, Daniel (1920): 'Terence MacSwiney: Lord Mayor of Cork'. *Studies: An Irish Quarterly Review*, 9 (36):512–520.

E. Moore Quinn (2001): 'Entextualizing Famine, Reconstituting Self: Testimonial Narratives from Ireland'. *Anthropological Quarterly*, 74(2):72–88.

E. Moore Quinn (2015): 'The Irish Rent . . . and Mended: Transitional Textual Communities in Nineteenth-Century America'. *Irish Studies Review*, 23 (2):209–224.

Edwards, Ruth Dudley (1990) (1977): *Patrick Pearse: The Triumph of Failure*. Dublin: Poolbeg Press.

Flying Column (2010): *'Four Green Fields'* (Compact Disc). Templepatrick, County Antrim: Emerald Music.

Gannon, Joe (2013): 'Terence MacSwiney: Irish Martyr'. *The Wild Geese* (blog post), January 19. Available online at: www.youtube.com/watch?v=wukfdjJv340.

Grant, Kevin (2019): *Last Weapons: Hunger Strikes and Fasts in the British Empire 1890–1948*. Berkeley, CA: University of California Press.

Griffith, Lisa Marie and Ciarán Wallace (eds.) (2016): *Grave Matters: Death and Dying in Dublin, 1500 to the Present*. Dublin: Four Courts Press.

Irish Folk Songs (2019): 'The Time Has Come Lyrics and Chords'. Available online at: www.irish-folk-songs.com/the-time-has-come-lyrics-and-chords.html.

Irish Song Lyrics (2019): 'Irish Song Lyrics for: "[The] Boy from Tamlaghtduff"'. Available online at: www.traditionalmusic.co.uk/irish-songs-ballads-lyrics/boy_from_tamlaghtduff.htm.

Kelly, James and Mary Ann Lyons (eds.) (2013): *Death and Dying in Ireland, Britain and Europe: Historical Perspectives*. Sallins/Kildare: Irish Academic Press.

Leniston, Florence (ed.) (1992): *Popular Irish Songs*. New York: Dover Publications.

Leonard, Hal (2005): *50 Great Irish Fighting Songs*. Dublin: Feadóg.

Loesberg, John (ed.) (1989): *Folksongs and Ballads Popular in Ireland*. Cork: Ossian Publications.

Lysaght, Patricia (1995): 'Visible Death: Attitudes to the Dying in Ireland'. *Marvels and Tales* 9:27–59; 87–99.

McCann, May (1995): 'Music and Politics in Ireland: The Specificity of the Folk Revival in Belfast'. *British Journal of Ethnomusicology*, 4:5–75.

McCarthy, Mark (2018): 'Making Irish Martyrs: The Impact and the Legacy of the Execution of the Leaders of the Easter Rising, 1916'. In Quentin Outram and Keith Laybourn (eds.): *Secular Martyrdom in Britain and Ireland from Peterloo to the Present*. Cham: Palgrave/Macmillan, pp. 165–202.

McMahon, Timothy G. (2007): 'Religion and Popular Culture in Nineteenth-Century Ireland'. *History Compass*, 5 (3):845–864.

Millar, Stephen R. (2017): 'Irish Republican Music and (Post)colonial Schizophrenia'. *Popular Music and Society*, 40 (1):75–88.

Milner, Dan (1983): *The Bonnie Bunch of Roses: Songs of England, Ireland and Scotland*. New York: Oak Publications.

Moran, Sean Farrell (1991): 'Patrick Pearse and Patriotic Soteriology: The Irish Republican Tradition and the Sanctification of Political Self-Immolation'. In Yonah Alexander and Alan O'Day (eds.): *The Irish Terrorism Experience*. Brookfield, VT: Dartmouth Publishing, pp. 9–29.

Moran, Sean Farrell (1994): *Patrick Pearse and the Politics of Redemption: The Mind of the Easter Rising*. Washington, DC: Catholic University of America.

Murphy, Maura (1979): 'The Ballad Singer and the Role of the Seditious Ballad in Nineteenth Century Ireland: Dublin Castle's View'. *Ulster Folklife*, 25:79–102.

Murphy, Pauline (2016): 'The Man Was All Shot Through'. *Ireland's Own*, May29. Available online at: www.irelandsown.ie/the-man-was-all-shot-through/.

Ó Cadhla, Seán (2017a): '"Young Men of Erin, Our Dead Are Calling": Death, Immortality and the Otherworld in Modern Irish Republican Ballads'. *Studi irlandesí: A Journal of Irish Studies*, 7:113–144.

Ó Cadhla, Seán (2017b): '"Then to Death Walked, Softly Smiling": Violence and Martyrdom in Modern Irish Republican Ballads'. *Ethnomusicology*, 61 (2):262–286.

O'Connell, James (1988): '"In the Shadow of One Another the People Live": Irish Folk Songs and Human Rights: 1600–1800'. *Études Irlandaises*, 13 (2):87–99.

Ó Crualaoich, Gearóid (1999): 'The Merry Wake'. In J. S. Donnelly and Kerby A. Miller (eds.): *Irish Popular Culture 1650–1850*. Dublin: Irish Academic Press, pp. 173–200.

O'Dowd, Niall (2017): 'Irish Rebel Hero Kevin Barry's Mother Was Refused an Irish Pension New Records Show'. *Irish Central*, October 25. Available online at: www.irishcentral.com/roots/irish-rebel-hero-kevin-barry-s-mother-was-refused-an-irish-pension-new-records-show.

O'Neill, Daniel J. (1989): 'The Cult of Self-Sacrifice: The Irish Experience'. *Éire-Ireland*, 24:89–105.

Ó Súilleabháin, Seán (1967): *Irish Wake Amusements*. Cork: Mercier Press.

O'Sullivan, Donal (ed.) (1960): *Songs of the Irish: An Anthology of Irish Folk Music and Poetry with English Verse Translations*. New York: Bonanza Books.

Pamphlet. (n.d.): *Songs of the Irish Nation*. n.p.

PoemHunter (2019): 'Mise Eire (I Am Ireland): Poem by Patrick Henry Pearse'. Available online at: www.poemhunter.com/poem/mise-eire-i-am-ireland/.

Rebel Lyrics (2013): 'Ballad of Billy Reid with Lyrics'. Available online at: www.youtube.com/watch?v=8-y5jzGFDcM.

Rolston, Bill (2001): '"This Is Not a Rebel Song": The Irish Conflict and Popular Music'. *Race and Class*, 42 (3):49–67.

Ryan, Salvador (ed.) (2016): *Death and the Irish: A Miscellany*. Dublin: Wordwell.

Scott, Derek B. (2016) (2013): 'Irish Nationalism, British Imperialism and Popular Song'. In Pauline Fairclough (ed.): *Twentieth-Century Music and Politics: Essays in Memory of Neil Edmunds*. London: Routledge, pp. 231–248.

Scott, James C. (1985): *Weapons of the Weak: Everyday Forms of Peasant Resistance*. New Haven, CT: Yale University Press.

Sivanandan, Ambalavaner (1990): 'All that Melts into Air Is Solid: The Hokum of New Times'. In Ambalavaner Sivanandan: *Communities of Resistance: Writings on Black Struggles for Socialism*. London: Verso, pp. 19–59.

Songs and Recitations of Ireland No. 1 (1961): Cork: Coiste Foillseacháin Naisiúnta (The National Publications Committee).

Songs in Irish (2019): '*Óró Sé do Bheatha 'Bhaile*'. Available online at: https://songsinirish.com/oro-se-do-bheatha-bhaile-lyrics/.

Songs of the Irish Republic (1975): Cork: C.F.N. Coiste Foillseacháin Naisiúnta (The National Publications Committee).

Soodlum's Irish Ballad Book (1982): London: Oak Publications.

Stokes, Martin (1994): 'Introduction: Ethnicity, Identity and Music'. In Martin Stokes (ed.): *Ethnicity, Identity and Music: The Musical Construction of Place*. Oxford: Berg, pp. 1–28.

Sweeney, George (1993): 'Self-Immolation in Ireland: Hunger Strikes and Political Confrontation'. *Anthropology Today*, 9 (5):10–14.

Sweeney, George (2004): 'Self-Immolative Martyrdom: Explaining the Irish Hungerstrike Tradition'. *Studies: An Irish Quarterly Review*, 93 (371):337–348.

Taylor, Lawrence J. (1989a): 'The Uses of Death in Europe'. *Anthropological Quarterly*, 62 (4):149–154.

Taylor, Lawrence J. (1989b): '"*Bas InEirinn*": Cultural Constructions of Death in Ireland'. *Anthropological Quarterly*, 62 (4):175–187.

Vallely, Fintan (ed.) (2011): *Companion to Irish Traditional Music*. Cork: Cork University Press.

White, Harry (1998): *The Keeper's Recital: Music and Cultural History in Ireland 1770–1970*. Cork: Cork University Press.

Witoszek, Nina (1987): 'Ireland: A Funerary Culture?'. *Studies: An Irish Quarterly Review*, 76 (302):206–215.

Witoszek, Nina and Patrick F. Sheeran (1998): *Talking to the Dead: A Study of Irish Funerary Traditions*. Amsterdam: Rodopi.

Wolfe Tones Official Site of the Irish Music Legends (2019): 'Féile 2019!'. Available online at: www.wolfetonesofficialsite.com/.

Zimmerman, Georges Denis (2002) (1966): *Songs of Irish Rebellion: Irish Political Street Ballads and Rebel Songs, 1780–1900*. Dublin: Four Courts Press.

Zipes, Jack (2006): *Why Fairy Tales Stick: The Evolution and Relevance of a Genre*. New York: Routledge.

10 Locating death in children's animated films

Panagiotis Pentaris

Introduction

Modern societies experience a simultaneous debate regarding the place of death and dying in childhood. On the one hand, societies distance their children from death with the intention of protecting them from the impact of loss and separation (Papadatou and Papadatos 1999). On the other hand, though, popular culture continuously presents children with the concepts of loss, separation, and death and the impact these have on individuals and the relationships between them. In other words, children find themselves experiencing a binary position between silence and projection: the former as a method of dealing with the issue and the latter as an outcome of exposure to popular culture.

Earl Grollman (1991:3) posits that 'traumatic experiences belong to both adulthood and childhood'. Yet modernity has led not only to death taboo (Feifel 1959), but to exhaustive protective measures for children, even from concepts, like loss, death, and separation, which are directly linked with their lives. It is not new knowledge that children naturally advance anxieties, fears, and concerns, especially about things they do not know anything about (Kastenbaum and Moreman 2018). It is equally not a new realization that parents and guardians go to extensive lengths to protect their children from being exposed to the impact of loss. However, is this an active approach to the subject or a coping strategy and for whose benefit?

Avoidance is a reflection of underestimating children's intellectual capacities and the need to know, as well as manage emotions of grief: a healthy response to separation (Parkes and Prigerson 2013). It is, though, not possible to generalize and suggest that all parents or guardians avoid discussing this topic with their children. Yet those who do may be doing so because of personal fears, doubts, and anxieties, which are not linked with the child's capacity to adequately process a loss and their grief.

This is reflected in the fairly recent work by Paige Toller and Chad McBride (2013). They explored what motivates parents to either talk or not talk to their children about the loss of a family member or any other loved one. The authors concluded that when parents choose to talk with their children, they

do so because they wish them to be informed. However, they use selective criteria in order to protect their children from the impact of loss, which parents do not think their children are able to respond to. Paige Toller and Chad McBride (2013) emphasize that parents carefully select the criteria which will inform both the content and style of their communication of death to their children when they decide to do so. These authors do not identify the criteria in question but rather highlight that conversations about death with children are constructed to protect children from the impact of loss.

There is, indeed, abundant work that places emphasis on the separation of death and childhood in modern societies, on social and cultural levels. There is, however, equally extensive literature which suggests that children should be involved in conversations about death and their fears explored to avoid trauma. Wendy Charkow (1998) emphasizes the need to talk with children about loss and death and the option to grieve, for example. More recent literature maintains this position; Robert Kastenbaum and Christopher M. Moreman (2018) continue to argue the need for adults to engage children in these conversations and refrain from robbing them of the opportunity to express their feelings and construct meaning for their experiences of loss and separation.

So far, we have identified two oppositions; children are kept from the experiences of death and dying, with the intention of being protected, and research and expert practitioners suggest that adults should engage children with this topic and allow them the space to explore, learn, and overcome their fears and anxieties. A third argument emerges, though, which helps build the core of this chapter. While societies strive to protect children from death, loss, and separation, media like films, music, books, and games continue to introduce to them all aspects of social life, extensively (Wojik-Andrews 2002; Thomas and Johnston 1995).

Two of the most prominent media that give children the chance to familiarize themselves with concepts that are otherwise distant in their daily life are literature and films. These two media have many similarities, the most important of which is that they mirror the social world and its particularities in a given time and place. Lois Gibson and Laura Zaidman (1991) echoed this some 30 years ago and identified that children's literature appears to avoid overt discussions about death, especially as people tend to live longer. According to the same authors, in the 17th century, when children's literature started growing, death was presented vividly and expressed explicitly in literature; an example is *A Token for Children* by James Janeway.

The aforementioned practice changed when children started being perceived as individuals with their own stories and not simply as small adults. During the late 19th and early 20th centuries, childhood was reconstructed, and children were starting to enjoy culture specific to their status and needs (Marshall and Marshall 1971). With the turn of the century, in other words, societies started paying more attention to the cultural objects, among other things, directed to children. In a short period, childhood was shaped up to be

a period of innocence and pureness, and the state's responsibility to protect this period became stronger. Part of this process was to try to minimize the exposure to traumatic events via literature, and now via animated films, as the latter only emerged for the first time in 1906 and expanded a decade later. This is where fiction and animated films are similar: in the course of the 20th century, both sets of cultural objects attempted to hide concepts traumatic to children – or concepts that adults and the state considered to be traumatic for children. Books and films started basing their stories on fairy tales and happy endings. Yet the concepts of loss and trauma remained – cultural objects, as mentioned earlier, mirror the circumstances present in the time and place of the creation of the object or the creator of it.

Closer to the 21st century, literature showed the benefits of an open and honest communication with children about death and bereavement (Kastenbaum and Moreman 2018). It was during the 21st century that some societies enfranchised the need to talk about death with children a little further, and we see this mirrored in fiction and animated films both; yet experiences of disenfranchised death and grief remain in the stories.

Animated films introduce death to children, even before children have reached the developmental stage (i.e. ten years old) when they have a healthy understanding of the permanence and inevitability of death (Kastenbaum and Moreman 2018; Brent et al. 1996). This chapter is built around this argument and explores the communication of death via popular culture, and specifically animated films, while it seeks to signify the tensions between societies' tendencies to protect children by distancing them from the concepts of death, loss, and separation while animated films, as well as other cultural objects, continuously engage children with an introduction and analysis of various social issues, inclusive of death.

Of course, modern societies vary, and this discourse may differ from one society to the next. Put differently, an animated film may have different social functions based on the multiple and complex socio-political circumstances in which the film was created (e.g. *Sing*), and its intended audience (e.g. *My Neighbour Totoro*). The following discussion is developed in the premises of Western countries and modern societies that emphasize diversity and modernity and are characterized by an everyday dialogue with popular culture.

Animated films as a means to popular culture

During the second part of the 20th century and to date, the number of animated films for children has increased exponentially. The swelling number of these films is coupled with advanced technology, as well as accessibility; there are not only increased numbers of these objects, but also increased accessibility. This raises many and varied questions, some of which are concerned with the information communicated via the films and the values promoted. Animated films present both implicit and explicit ideologies, which promote certain values and standards. This, without doubt, calls for exhaustive exploration of

what values are communicated to children and what those values represent. Equally, how congruent are those values and standards to the ones introduced to them in real life, within family systems and wider societies?

Jillian Hinkins (2007) suggests that animated films for children have a pedagogic function about various issues. Text in films is didactic; it provides directives about how different social issues should be approached. This may be both beneficial and perilous. As a pedagogic tool, animated films may teach valuable lessons to children and highlight the principles of belonging-ness, family, and friendship. On the other hand, though, are these the only values which animated films present? Quite religiously, animated films present the binary between evil and good. This said, alongside the aforementioned principles, such films also introduce, and maybe promote, hatred, bullying, destruction, loneliness, and social isolation. Jillian Hankins explores things more widely and concludes that:

> [an] animated film produced for children can provide a window for examining societal structures and cultural practices by the adult audi-ence, while at the same time instructing and guiding children in regard to an understanding of themselves and their place in the society that they inhabit.
>
> Hinkins 2007:43

Hinkins's view is confined to her analysis of consumerism in animated films, but the generalizability of this quote is not questionable. However, what may be ambiguous from this is the way children interpret the concepts and values introduced to them via animated films.

Elizabeth Freeman (2005) holds similar views to Hinkins's. In her analysis of *Monsters, Inc* and neoliberal arts education, Freeman (2005:85) suggests that 'children's films are themselves "portable professors" of a sort, offering diagnoses of culture for adults even as they enculturate children'. Once again, Dana Brabcova et al. (2013) offer that animated films are an educational tool, and they suggest so via exploring the increase of awareness of epilepsy via video use and films.

Undoubtedly, animated films appear to be actors for education and aware-ness building yet there are some critiques to accompany these suggestions. First, when discussing animated films and popular culture, one has to look at the Walt Disney Corporation and its impact. Joel Best and Kathleen Lowney (2009) acknowledge the good reputation of the company, worldwide but examine the criticisms against it. The authors argue that the Walt Disney Corporation produces films and other popular culture products that essen-tially perpetuate social inequalities and injustices in society. Such cultural products reflect the lack of equilibrium experienced in real life, and this is embedded as a coherent value for survival, which subsequently is sustained for the same reason. Not far from these criticisms, Shumaila Ahmed and Juli-ana Wahab (2014) explore the portrayal of gender roles on Cartoon Network,

one of the largest, if not the largest children's network. In their study, the authors find that male and female characters are portrayed in a biased and stereotypical way, which, thereafter, is acted out by children as they grow into their adulthood.

Conclusively, animated films often function as educational material, whether acknowledged as such or not. These films present ideas, values, perspectives, and beliefs, as well as contemporary dialogues about varied subjects, including death, dying, and bereavement.

Death in animated films

Children's films represent current social phenomena while, through such depictions, capturing aspects of life with death left in it. This is reminiscent of Ian Wojik-Andrews's (2002) analysis of how capitalism is presented to children and adults via animated films. These films are not simply a means of entertainment – even though for many this may be the only conscious perception of them – but a cultural product informed by the many and varied levels of the social world in which they were conceived. Drawing on phenomenological explanations (Merleau-Ponty 2013), the way the information is presented to the audience impacts future attitudes, views, and hence behaviours, which shape one's conception of the world all over again.

Gary Laderman (2000) reminds us that the pioneer in the American – and worldwide – animation industry, Walt Disney, was immensely influenced by death in his creation. This is not a surprising argument, if one looks at *The Skeleton Dance*. This is a 1929 Silly Symphony short subject produced and directed by Walt Disney himself. This film aims at depicting medieval European 'dance macabre' and highlights Disney's association with the macabre, which continued with *Mickey Mouse and the Haunted House*, as well as the *House of Mouse*.

To further appreciate the association of animation with the macabre or death, one does not need to go far but simply attend to the widely renowned book by Frank Thomas and Ollie Johnston, titled, *The Illusion of Life: Disney Animation*. Alan Cholodenko reminds us of this and suggests that

> animation cannot be thought without thinking loss, disappearance and death, that one cannot think the endowing with life without thinking the other side of the life cycle – the transformation from the animate into the inanimate – at the same time, cannot think endowing with motion without thinking the other side of the cycle movement – of metastasis, deceleration, inertia, suspended animation, etc.
>
> Cholodenko 1991:21

Such binaries are persistent in animation films and introduce children not only to the concepts but also to the complex associations between them. At large, the stories that unravel in animation films are based on the separation

from or the death of a loved one. Some examples include *The Lion King*, *Beyond Beyond*, *Bambi*, and the more contemporary film *Paranorman*.

An exceptional example of this is embedded in the making of the *Toy Story* films. According to Paul Flaig (2013:1), 'nothing suggests this possibility of death more than the toys being at the mercy of their human playmates, since whenever they are with people the toys must play dead'. It is the binary of animate and inanimate objects that highlights life as functionality, presence, and a complex experience. The frequency with which toys in these films shift from 'dead' to 'alive' is remarkable, and through that, we view death as reversible and, perhaps, situational.

Animated films present many and complicated notions of death and grief. The following sections discuss death conceptions and grief portrayal in such films, following on from Meredith Cox, Erin Garrett, and James Graham's (2005) coding system, as well as the ambiguities that emerge from this discourse.

Death and grief conceptions

Cox, Garrett, and Graham (2005) examine how Disney films influence children's conceptions of death. With their study, they found that death scenes often mask the permanence and irreversibility of death with notions of the opposite. In other words, death in Disney films appears to have nonconventional qualities to it, which leaves children's understanding of the concept precarious of the magical thinking that is promoted instead. Of course, this is not a problematic reality in itself. Yet, when coupled with the lack of dialogue about death and grief in the home setting and with family members, children may risk perpetuating magical thinking about death into adulthood and have their experiences of loss skewed in the long term.

In addition, Cox, Garrett, and Graham (2005) attest to the disenfranchised death of villains in Disney films. According to their investigation, deaths of villains are often left emotionally unacknowledged and without grief attached to them. Instead, we often view the death of a villain as a liberating moment, a time for celebration in the film. This highlights two problematic areas. The first is that films, in this way, celebrate the polarization of death – death of the good and death of the bad. The latter is celebrated as something that is desired and does not require or is not worthy of the grief of the others. The values that this teaching offers are questionable yet not actively contested. To illuminate this point further, think about the criminal justice system and the portrayal of individuals who are incarcerated as 'villains', not uncommon in the media and in the press. Public opinion is shaped by the media and follows on to express liberty with the death of a 'villain' and celebrate that society is rid of them. The Marshall Project, a non-profit agency focusing on the criminal justice system, offers numerous such stories and records the inhumane notifications of death to inmates'

family members. The deaths of villains like Buddy Pine (a.k.a. Syndrome) in *The Incredibles*, who dies in an explosion; Judge Claude Frollo in the *Hunchback of Notre Dame*, who falls into the fire; and Mother Gothel in *Tangled*, who is purposefully made to fall out the window of Rapunzel's tower, follow a similar pattern. The villain dies – commonly a tragic death – and the protagonist(s) celebrate having gotten rid of the villain and the evils that are associated with their character.

The association between the portrayal of death conceptions of villains in animated films and current patterns of societal behaviours towards individuals that experience social exclusion and perhaps purposeful isolation is worrisome. If the values of exclusion and disenfranchisement are introduced to children so early on, and drawing on the arguments of Dana Brabcova et al. (2013) that films act as educational tools, at what point do we intervene to ensure that society embraces the value of all living beings?

Cox, Garrett, and Graham (2005), following the analysis of 25 death scenes in Disney films, introduce a coding system that facilitates our understanding of the depiction of death conceptions in children's films. Table 10.1 shows this coding system with minor adaptations that enhance character status (e.g., supporting character) and death status (e.g., reversible death-different form).

It is evident from this graph that the comprehension of death, loss, and grief in animated films can be a rather complex experience; a death is not simply explicit, for example, but follows a combination of the characteristics listed. For instance, in *Monster House*, the backstory introduces us to a lady named Constance. Due to becoming a laughingstock for being overweight, she and her husband, a central character in the film, withdraw to an isolated location. However, before their home is built, Constance's death takes place onscreen; angry at the children who curiously tease at their new neighbours (Constance and her partner), Constance trips backwards and falls into the pit

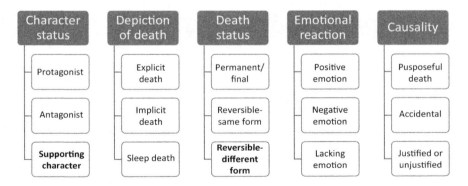

Table 10.1 Death conceptions in children's films: a coding system

Source: Adapted from Meredith Cox, Erin Garrett, and James Graham (2005)

of the foundation of their new home. Right before she falls, she accidentally pulls a lever releasing a large amount of wet cement, which covers her dead body when it reaches the bottom of the hole. Interestingly, Constance is the protagonist in this film as her soul animates the new home, and her husband endeavours to devote his life to caring for her and keeping children away from their home. Constance's death crosses a few of the categories offered by Cox, Garrett, and Graham (2005): this is the death of a protagonist, it is an explicit death, it is reversible-different form, both positive and negative emotions are expressed by different characters in the film, and the death was accidental and unjustified.

It is noteworthy that, when the character who dies is either the protagonist or a supporting character, the death is extensively explored in the course of the story. In *Beyond Beyond*, we are introduced to death in the form of a sea monster named Mora that lives under the island called Beyond, a representation of heaven. Mora selects whoever is due to die next, and the undertaker, the Feather King, fetches them to the island; this takes the form of his delivering tickets to Beyond. The story begins with the death of a supporting character, the mother of Johan, the protagonist. It is then that Johan sets out to find and bring back his mother. The presentation of death in this film is somewhat polarized and may fit more than one code across the various categories offered in table 10.1. Once in the Feather Kingdom (i.e. the island called Beyond), no one can leave. This highlights the permanence of death, indeed. In the course of looking for his mother, Johan continuously writes letters to her and sends them off in bottles into the sea. Robert A. Neimeyer's work (2001) about continuing bonds and meaning construction is key here. Neimeyer argues that all reactions to a loss have meaning-making significance and that behaviours often lead towards continuing bonds with the deceased, in an attempt to emotionally support the living. Johan depicts this but moves beyond it. He finally succeeds in accessing the island and finds his mother. When they meet, he suggests that she return her ticket to the Feather King and depart with him back to their home. This dialogue illustrates the innocence of a child's conception of death, and the film beautifully progresses to explain the irreversibility of death; the mother supports her child to reach the exit from the Feather Kingdom, and before Johan ascends to the gate, he realizes that his mother cannot join him. This becomes a reminder of the permanence of death once again.

In addition, the film explores death as the natural process to something, instead of nothing. Johan's mother says, 'he does not understand what the Feather Kingdom is. If the Feather King does not pick you, you become nothing'. The mother's expressions of the social functions of the Feather Kingdom are clear and directly illustrate that dying and being in this place mean that one is remembered. This element of the film has a highly religious component to it, of course. As the island is depicted as an alternative to heaven, and in order 'to be picked', one needs to believe, the film may be alluding to the lack of remembrance due to the lack of believing and transcendence as described by Raymond Paloutzian and Katelyn Mukai (2017).

Another film worth exploring is *Frankenweenie*. In the film, we meet Viktor and Sparky, a boy and his dog, respectively. The two of them are inseparable and seem to share a very strong bond. Following Viktor's father's pressure that he joins sports, during a game of baseball, Sparky chases the ball into the street and gets hit by a car. The scene that follows is intense, with Viktor screaming in agony, kneeling next to Sparky. At this point, the film introduces the explicit death of the protagonist, Sparky, which is both accidental and unjustified. In the scene that follows Sparky's death, we are at the pet cemetery, with Viktor and his parents present. What is striking in the next few scenes is that we view the expression of grief not only from Viktor but also from the neighbour's dog, which is looking for Sparky, highlighting grievers where not expected.

To this point, the concepts of death and grief seem to follow a traditional and expected path. Yet, influenced by his interest in science, Viktor runs an experiment to try and bring Sparky back to life – a representation of Frankenstein. Viktor exhumes Sparky and brings him to the attic of his house, where he performs the experiment, which succeeds. However, Sparky does not recognize that he has been revived but continues as if his death never occurred. Very quickly, the film moves us from a place of conventional dying, burial, and mourning (Howarth 2007) to a place of paranormal activity and non-scientifically proven doctrines. This film moves further by allowing Viktor to do what Peter Marris (1974) identifies as the revival of the dead through imagination, and we witness the actual revival of Sparky through what Gillian Bennett and Kate Bennett (2000) see as the presence of the dead. Viktor collected items associated with Sparky, as well as his own body, to keep him present by reviving him. It is this conception of death which children may find more difficult to comprehend, though.

Due to an unexpected event, Sparky runs off to the pet cemetery, where he comes across his own gravestone. This is a powerful moment in the film as Sparky realizes that he is dead, and we confirm that he did not know prior to this point. Following this moment of self-actualization and heightening of self-identity, Sparky will die for the second time, in a fire. It is this time that the death of Sparky is almost purposeful, but accidental in the scenario, explicit and permanent. Viktor shows emotion and positively accepts the loss and moves on without the desire to revive Sparky again.

Mary Sedney (1999) examines the vast portrayal of grief in young characters in animated films. Mary Sedney argues that animated films illustrate the possibility of a happy life after the death of a loved one, either animated human or pet. *Frankenweenie* concludes with that, offering a happy ending, indeed. The film does, nevertheless, rely on the polarization of dying, presenting the reversibility of death as an option, and death's permanence as a person's choice to 'let go'. This film touches on a number of concepts related to death, including pet loss, cemeteries and burial sites, and mourning. It is the ambiguity of death's permanence, however, which does not allow for it to be perceived as real.

Ferdinand is another contemporary film, which depicts the story of a bull who is simply different from other bulls and attempts to find happiness in the

experience of his difference. The life of the bull, whose name is Ferdinand, is marked by the implicit death of his father (a supporting character) at the beginning of the film. Devastated by this loss, Ferdinand makes choices that are led purely by his determination to allow himself to thrive and not be led by the social roles assigned to a bull. Drawing on Ned Schultz and Lisa Huet (2001), majority of portrayals of grief in films are unrealistic and sensational. Animated films do not necessarily make a difference. In both *Frankenweenie* and *Ferdinand*, we see grief portrayed sensationally at times (i.e., not necessarily compatible with everyday experience.) There are, however, more diverse ways to perceive this.

In *Coco*, an award-winning animated film that launched in Mexico in 2017, we experience a fascinating tension between death and grief. Situated in the Day of the Dead, death is depicted via magical thinking. The film emphasizes family and friends and the art of remembering as a form of grief but also continuing bonds (Neimeyer 2001). The Land of the Dead, where the protagonist is trying to find his great-great-grandfather, is carefully constructed to present an afterlife, which children may require in order to make sense of the death of a loved one. In this Land of the Dead, the film illustrates not only the relationship between the dead and the living, but also how the dead 'live' their deadhood until they are no longer remembered by anyone in the living world. Once this occurs, the dead move on to a state of 'final death': the time when their stories do not live with anyone in the world.

The film *Coco* presents two types of deaths: reversible-different form and permanent/final. Yet these two types are not presented as separate but sequential. Each dead person keeps returning to the Land of the Living on the Day of the Dead (reversible-different form – e.g., spirit and skeleton), until they are no longer remembered by anyone, at which time they move on to dissolving (permanent/final death). It is remembrance that predominates this film. This said, remembrance is portrayed as the coping strategy for death – a solution to the risk of permanent/final death. With remembrance, one remains in the Land of the Dead forever, and both living and dead continue their bonds. This appears to be the well-examined anthropological concept of symbolic immortality. Sergei Kan (1989), as many others, investigated rituals and practices that aim to bridge the enactors with the receivers, the former being the living and the latter the dead. Sergei Kan's account of the memorial feasts of the Tlingit Indian people argues that as long as people have memorials (in this case, memorial feasts) to remember the dead by, the latter will live on. The film *Coco* shows such thinking. The ending is positive and promising: the great-great-grandfather avoided permanent/final death, and the bonds between the dead and the living continue with visits to the Land of the Living every Day of the Dead.

Numerous animated films exemplify the prevalence of death and grief, as well as other concepts such as violence and fear, in children's popular culture. These examples are rooted in the most classic films, like *Snow White*, and the more contemporary, like *Coco*. Ian Comlan et al. (2014) carefully craft this

conversation. They emphasize that since the beginning of the 20th century, animated films were influenced by the trauma and violence that was present in the world. The first World War was an important influence which led to the need to illustrate not the lack of loss and trauma, but the possibility of a positive outcome. This is evident at the start of numerous films which begin with a loss: the death of a character. This loss instantly starts shaping the story in the film. Some examples include *Snow White* and *Finding Nemo*.

Moreover, the American animation historian Michael Barrier (2003) has extensively investigated the influencing factors of animated films, what affected Walt Disney's creativity since the start of the 20th century, and how socio-political circumstances shaped not only the experience of the maker/ creator, but the experience of the viewer of the films as well, who is typically subjected to the constructs of reality of the former.

Ambiguities and controversies

Animated films are undeniably a platform where death, grief, and loss are presented but not always explored. This may leave viewers, especially young viewers, with more questions than answers while their comprehension of these concepts may be skewed. Following the analysis of 18 animated films, table 10.2 depicts the types of deaths in the films, which give rise to certain ambiguities and controversies concerning the communication of death via animated films.

Death in animated films is presented as a permanent condition, one that can be changed, or both. It is the permanence/reversibility continuum which we need to be mindful of. On the one hand, death is permanent, as far as we know it, and the griever will not see the deceased again. This view seems to be associated with a traumatic death as well, as in *Big Hero 6*, *Tarzan*, and *How to Train Your Dragon 2*. On the other hand, death is presented as a reversible event, one which is not definite, and with the right amendments the situation can alter. *Frankenweenie* and *Monster House* are good examples of this. The former shows the reversibility of death and the return of the deceased in the same form. The latter, though, shows the return of the dead in a different form, focusing on a more spiritual presence of the deceased.

Further, animated films present death either as an unexpected or sudden event or as an expected outcome of a situation. In *Frozen*, Anna unexpectedly freezes, and we are left with her sister's grief. Equally, in *The Lego Movie*, Vitruvius is still defending his group, and without any expectation, he is beheaded by the enemy, leaving the viewers shocked by this outcome. On the other hand, in films like *Up* and *Tangled*, we view an expected death, one that is almost the expected outcome of the storyline. The binary of unexpected and expected is truly a representation of how death impacts life and addresses either circumstance. When death is unexpected and reversible, though, children may be perceiving death as an avoidable event, which poses less fear and/ or anxiety.

Permanent death

- Beyond Beyond
- Transformers
- The Lego Movie
- Tarzan
- Big Hero 6
- The Land Before Time
- How to Train Your Dragon 2
- The Lion King
- Bambi

Reversible death (different or same form)

- Frankenweenie
- Ferdinand
- Monster House

Unexpected death

- The Lego Movie
- Frozen
- How to Train Your Dragon 2

Expected death

- Up
- Tangled
- A Bug's Life

Traumatic or Sudden death

- Tarzan
- The Land Before Time
- How to Train Your Dragon 2
- The Princess and the Frog
- Inside Out
- Frozen
- Tangled
- A Bug's Life
- Big Hero 6

Humorous death

- The Lego Movie

Conventional death

- Tarzan
- The Land Before Time
- Up
- Monster House

Paranormal death

- Frankenweenie
- The Lego Movie

Table 10.2 Types of deaths in animated films

The way death is presented in animated films may also be traumatic – either because of the intense and unresolved grief other characters experience thereafter or due to the way a character dies – or humorous, like Vitruvius in *The Lego Movie*. Once he is beheaded, a humorous dialogue follows which

defuses the tension, and the film continues in a lighter tone. Another example of a series of humorous deaths is that of Igor's first experiment friend in the film *Igor*. This contrasts the traumatic deaths we view in *The Land Before Time*, for example. In this film, we view a child losing their mother, and the tension and anxiety increases when the child-dinosaur begs his mother to get up and go home. A very similar experience unravels in *Bambi*. Equally, in *Big Hero 6*, Tadashi runs into a flaming building, only to die in the explosion that follows moments later, while his younger brother is devastated by his loss. A similar event is presented in *Tarzan* with the death of Kerchak, when the viewer is left with varied emotions to deal with. A different kind of trauma is present in *How to Train Your Dragon 2*; Stoick the Vast is killed instantly, sacrificing himself for his son. He is killed before our eyes by Toothless, the main dragon character in the films, whom the viewers have come to love.

Lastly, animated films portray death in two forms; one that is conventional, which we might experience in everyday life as well, and one that is paranormal. The latter is evident in films like *Frankenweenie*. The return of Sparky to the screen in the same form but as the outcome of a science experience parallel to that of Frankenstein is distant from our reality and detached from the choices one has once their loved one dies.

Death, as discussed earlier in this chapter, is presented in a complicated fashion and invites viewers to experience a complex reality of the concept in the given film and storyline. The more elaborate way in which death is viewed in these films suggests many and different ambiguities about death, loss, and separation. These uncertainties are many and dependent on the type of death, the way of death, and the aftermath, all of which inform children's comprehension of these concepts and their value base about loss and grief altogether.

Noteworthy is the selective acknowledgement of deaths in animated films. In other words, not all deaths are acknowledged and not all deaths are celebrated or associated with grief. In films like *A Bug's Life*, death is sometimes collateral damage and is not only not followed by an emotional reaction, but is not followed by any reaction at all. An example from the aforementioned film is that of the flies dying on the bug zapper. Disenfranchisement of death and grief, as first explored by Kenneth J. Doka (1989), is not uncommon in animated films. This portrayal of death causes uncertainties and perhaps presents values distant from those of human rights and social justice (Mapp 2014). It is the value of life that is under debate here. The representation of death in animated films shows ways in which society responds to death as well, an area that raises concerns if children are subjected to a lack of social acknowledgement of death.

Conclusions

Children's experience of death and dying is split into two realities. On the one hand, they are kept from funerals, cemeteries, grief, and death in societies and conversations within family systems, and on the other, they are offered

the chance to view death in animated films and left to make their own judgement, often without conversation or dialogue about concepts that may not be well understood otherwise. In other words, children's experience of death and dying is found on the tensions between avoidance of and exposure to the subject.

Robert Kastenbaum and Christopher M. Moreman (2018) argue that most families follow a rule of silence regarding death and childhood. This approach, the authors argue, benefits adults, who often choose not to talk about death with children because of their own fears and conflicts. Specifically, Kastenbaum and Moreman suggest that adults manage their own convenience by avoiding the inclusion of children in such conversations.

As Elissa Brown and Robin Goodman (2005) suggest, life events, like the 9/11 tragedy in the United States, will inevitably draw children into the place of death and grief. Children are exposed to trauma – especially family violence – which often leads to posttraumatic stress (McCloskey and Walker 2000). Death is the natural outcome of life, and it affects all, children included. It is indeed in an attempt to protect children that magical thinking becomes more and more pertinent. Yet this creates more tension and uncertainty when death is experienced in a child's family home. In the case, which is not uncommon, that someone suddenly dies, children are left outside the conversation and, indeed, away from the mourning rituals that would allow them to form a healthy emotional response to their loss. Sheila Hollins and Lester Sireling (2018) highlight that in such cases children are more frightened than they would be otherwise as they are not informed about what happened.

Chris Askew, Anna Hagel, and Julie Morgan (2015) suggest that vicarious learning occurs from animated films. The development of social anxiety was evident in their study of how the outcomes of the activities shown in an animated film increased social fear beliefs. This said, the portrayal of death and grief in animated films, and the outcomes of this experience for the characters in the film, equally cause an increase or neutrality of social fear beliefs about expressing grief or responding to death and loss. It is without doubt that what we are facing is an ongoing challenge; children are exposed to the concepts of death, loss, and separation under the terms of an animated film's design and delivery, but adults remain under the assumption that they have found ways to protect children from the impact of death and loss on their lives. This is a problematic reality which this chapter has attempted to surface.

Animated films, among other contemporary cultural objects, become the means to an end. They support children's understanding of various aspects of life, death included. This places children in high risk of misconceptions, misunderstandings, and/or higher levels of anxiety and fear related to death and grief.

This chapter has focused on exploring the aforementioned tensions and finding ways to identify the risks and challenges involved in the direct links between animated children's films and death, loss, trauma, and violence, the

latter two often being part of the experiences of death and loss depicted. The chapter introduced a contemporary taxonomy of the types of death and grief viewed in animated films, drawing on Cox Meredith, Garrett Erin, and Graham James's (2005) work. Further, this section of the book added to the conversation about how children receive information about death, dying, and bereavement, as well as the functions of animated films in childhood. It is conclusive from the discussion in this chapter that there is a missing link between children being exposed to these areas of life concern and the parents, guardians, and other adults in their lives either avoiding or not recognizing the opportunity to have an open and honest dialogue.

Murray Bowen (2018) examines how children are included in this discourse. It is family emotional equilibrium that is missing in order to have a system of open communication and to enable adults to have discussions with children and address queries, curiosities or doubts, before those turn into fears and anxieties. It is adults' confidence in their own response to death and loss that needs honing, to enable them to address this *tête-à-tête* relationship of death with life. Children are continuously exposed to this relationship but without the right resources to better understand it, and this is of ongoing concern, especially when the information available to children may be inferring values that are not always positive towards the value of life.

Future trends

Drawing on current literature and knowledge about the functional role of animated films in childhood and children's conceptions of life (with death left in it), as well as resources concerning society's regulation of the relationship between children and death, a significant gap emerges in research and, therefore, knowledge. It is evidently unknown how the ways in which death, dying, and bereavement are portrayed in animated films impact a child's value base and, hence, morale when moving into adulthood. It is unclear how the presented values and principles of grief, death, disenfranchisement of losses, and punishment with death, to name a few, influence individual children. Equally, as stated earlier, it remains unclear how this influence feeds into one's adulthood and overall attitudes, perceptions, and behaviours.

Another area that emerges from this chapter is that the portrayal of death, dying, and bereavement in animated films appears to be shifting since the beginning of the 21st century, from a place of covert reference to a place of direct discussion. This shift is yet to be explored to tease out the societal constructs, symbolism, and values which are mirrored in this shift. Additionally, the more apparent prevalence of the subject of death in animated films does not necessitate a realistic approach. From the films explored for the purposes of this chapter, it is evident that magical thinking and reversibility are key aspects of the varied ways in which death and grief are illustrated in these films.

References

Ahmed, Shumaila and Juliana A. Wahab (2014): 'Animation and Socialization Process: Gender Role Portrayal on Cartoon Network'. *Asian Social Science*, 10 (3):44–53.

Askew, Chris, Anna Hagel and Julie Morgan (2015): 'Vicarious Learning of Children's Social-Anxiety-Related Fear Beliefs and Emotional Stroop Bias'. *Emotion*, 15 (4):501–510.

Barrier, Michael (2003): *Hollywood Cartoons: American Animation in Its Golden Age*. Oxford: Oxford University Press.

Bennett, Gillian and Kate M. Bennett (2000): 'The Presence of the Dead: An Empirical Study'. *Mortality*, 5 (2):139–157.

Best, Joel and Kathleen S. Lowney (2009): 'The Disadvantage of a Good Reputation: Disney as a Target for Social Problems Claims'. *The Sociological Quarterly*, 50 (3):431–449.

Bowen, Murray (2018): 'Family Reaction to Death'. In Peter Titelman and Sydney K. Reed (eds.): *Death and Chronic Illness in the Family: Bowen Family Systems Theory Perspectives*. New York: Routledge, pp. 33–50.

Brabcova, Dana, Vladimira Lovasova, Jiri Kohout, Jana Zarubova and Vladimir Komarek (2013): 'Improving the Knowledge of Epilepsy and Reducing Epilepsy-Related Stigma among Children Using Educational Video and Educational Drama: A Comparison of the Effectiveness of Both Interventions'. *Seizure*, 22 (3):179–184.

Brent, Sandor B., Mark W. Speece, Chongede Lin, Qi Dong and Chongming Yang (1996): 'The Development of the Concept of Death among Chinese and U.S. Children 3–17 Years of Age: From Binary to "Fuzzy" Concepts?'. *Omega: Journal of Death and Dying*, 33 (1):67–83.

Brown, Elissa J. and Robin F. Goodman (2005): 'Childhood Traumatic Grief: An Exploration of the Construct in Children Bereaved on September 11'. *Journal of Clinical Child and Adolescent Psychology*, 34 (2):248–259.

Charkow, Wendy B. (1998): 'Inviting Children to Grieve'. *Professional School Counseling*, 2 (2):117–122.

Cholodenko, Alan (ed.) (1991): *The Illusion of Life: Essays on Animation*. Sydney: University of Sydney/Power Institute of Fine Arts.

Colman, Ian, Mila Kingsbury, Murray Weeks, Anushka Ataullahjan, Marc-Andre Belair, Jennifer Dykxhoorn, …, James B. Kirkbride (2014): 'Cartoons kill: casualities in animated recreational theatre in an objective observational new study of kids' introduction to loss of life'. *BMJ*, 2014(349):1–7.

Cox, Meredith, Erin Garrett and James A. Graham (2005): 'Death in Disney Films: Implications for Children's Understanding of Death'. *Omega: Journal of Death and Dying*, 50 (4):267–280.

Doka, Kenneth J. (1989): *Disenfranchised Grief: Recognizing Hidden Sorrow*. Lanham, MD: Lexington Books.

Feifel, Herman (ed.) (1959): *The Meaning of Death*. New York: McGraw-Hill.

Flaig, Paul (2013): 'Life Driven by Death: Animation Aesthetics and the Comic Uncanny'. *Screen*, 54 (1):1–19.

Freeman, Elizabeth (2005): 'Monsters, Inc.: Notes on the Neoliberal Arts Education'. *New Literary History*, 36 (1):83–95.

Gibson, Lois R. and Laura M. Zaidman (1991): 'Death in Children's Literature: Taboo or Not Taboo?'. *Children's Literature Association Quarterly*, 16 (4):232–234.

Grollman, Earl (1991): *Talking about Death: Dialogue between a Parent and Child* (3rd Edition). Boston, MA: Beacon Press.

Hinkins, Jillian (2007): '"Biting the Hand That Feeds": Consumerism, Ideology and Recent Animated Film for Children'. *Papers: Explorations into Children's Literature*, 17 (1):43–50.

Hollins, Sheila and Lester Sireling (2018): *When Dad Died*. London: Books Beyond Words.

Howarth, Glennys (2007): *Death and Dying: A Sociological Introduction*. Cambridge: Polity Press.

Kan, Sergei (1989): *Symbolic Immortality: The Tlingit Potlatch of the Nineteenth Century*. Washington, DC: Smithsonian Institution Press.

Kastenbaum, Robert and Christopher M. Moreman (eds.) (2018): *Death, Society and Human Experience* (12th Edition). London: Routledge.

Laderman, Gary (2000): 'The Disney Way of Death'. *Journal of the American Academy of Religion*, 68 (1):27–46.

Mapp, Susan C. (2014): *Human Rights and Social Justice in a Global Perspective: An Introduction to International Social Work*. Oxford: Oxford University Press.

Marris, Peter (1974): *Loss and Change*. London: Routledge and Kegan Paul.

Marshall, Joanne and Victor Marshall (1971): 'The Treatment of Death in Children's Books'. *Omega: Journal of Death and Dying*, 2 (1):36–45.

McCloskey, Laura A. and Maria Walker (2000): 'Posttraumatic Stress in Children Exposed to Family Violence and Single-Event Trauma'. *Journal of the American Academy of Child & Adolescent Psychiatry*, 39 (1):108–115.

Merleau-Ponty, Maurice (2013): *Phenomenology of Perception*. London: Routledge.

Neimeyer, Robert A. (2001): *Meaning Reconstruction and the Experience of Loss*. Washington, DC: American Psychological Association.

Paloutzian, Raymond F. and Katelyn J. Mukai (2017): 'Believing, Remembering, and Imagining: The Roots and Fruits of Meanings Made and Remade'. In Hand-Ferdinand Angel et al. (eds.): *Processes of Believing: The Acquisition, Maintenance, and Change in Creditions*. New York: Springer, pp. 39–49.

Papadatou, Danai and Constantine J. Papadatos (eds.) (1999): *Children and Death*. London: Taylor & Francis.

Parkes, Colin Murray and Holly G. Prigerson (2013): *Bereavement: Studies of Grief in Adult Life*. New York: Routledge.

Schultz, Ned W. and Lisa M. Huet (2001): 'Sensational! Violent! Popular! Death in American movies'. *Omega: Journal of Death and Dying*, 42 (2):137–149.

Sedney, Mary A. (1999): 'Children's Grief Narratives in Popular Films'. *Omega: Journal of Death and Dying*, 39 (4):315–324.

Thomas, Frank and Ollie Johnston (1995): *The Illusion of Life: Disney Animation*. New York: Hyperion Books.

Toller, Paige W. and Chad M. McBride (2013): 'Enacting Privacy Rules and Protecting Disclosure Recipients: Parents' Communication with Children Following the Death of a Family Member'. *Journal of Family Communication*, 13 (1):32–45.

Wojik-Andrews, Ian (2002): *Children's Films: History, Ideology, Pedagogy, Theory*. New York: Routledge.

11 Death in Don DeLillo's *White Noise*

A literary diagnosis of contemporary death culture

Michael Hviid Jacobsen and Nicklas Runge

Introduction

Does art imitate life, or is it rather the other way around that life imitates art? This question, despite being posed at least 1,000 times before, still remains as insufficiently and unsatisfyingly answered now as at any time in the past. Despite their seemingly different histories, methods, and ambitions, literature (art) and sociology (science) share the same purpose of wanting to shed light on the human condition, and in this way, they each in their way provide important pieces to the puzzle of understanding the way in which human beings live in the world and participate in society (Bauman and Mazzeo 2016). The relationship between literature and sociology is indeed a tricky one that has, at least for the past century or so, been rather strained, most often either non-existent or even downright hostile. In mainstream sociology's determination to pass as a real 'science' (that is, as a 'natural science'), rather than merely as an 'art form' (in Robert Nisbet's famous 1976/2002 terminology), thereby avoiding the unpleasantness of the inferiority complex so widespread within many social sciences throughout the 20th century (Machlup 1956), it has desperately tried to remove itself as far away as possible from its literary sibling in understanding the human condition by insisting on the superiority of its own methods, theories, and appeals to 'data', 'evidence', and 'proof'. Literature, on the other hand, by many practitioners of the more positivist-informed strains of the social sciences, has been seen as a dubious or conjectural source of knowledge due to its inability to prove its 'findings', its 'fictional' foundations, and its 'subjectivity'.

Although the many so-called 'rhetorical', 'reflexive', 'literary', and 'poetic' turns taking place within literary criticism, philosophy, and also the social sciences throughout the latter part of the 20th century (as offshoots of the great showdown with positivism in the 1960s and 1970s) and more recently the rise of 'storytelling sociology', have entailed that other forms of knowledge have increasingly informed sociological practice and obtained scientific recognition (perhaps especially within the realms of qualitative sociology), there is nevertheless still a 'hierarchy of knowledge' privileging 'truth', 'reality', 'explanation', the 'objective', and 'proof' at the expense of notions of 'beauty', 'symbolism', 'interpretation', the 'subjective', and 'insight' (Brown 1977).

Most, however, who have consulted Wolf Lepenies's (1988) impressive historical account of the rise of sociology will know that sociology and modern literature in fact grew up together and obtained their natal nourishment from the same soil: the society of industrialization, early capitalism, emerging nation states, urbanization, and bureaucratization in the 18th and 19th centuries. Often classical names such as Charles Dickens, Émile Zola, Gustave Flaubert, Fyodor Dostoyevsky, and Honoré de Balzac from the 'Golden Age' of European literature are invoked in order to illustrate the unmistakable kinship between early literary 'social commentary' on the one hand and the rise of modern sociology associated with the works of Karl Marx, Émile Durkheim, Max Weber, and Georg Simmel on the other. However, many contemporary writers – now writing in the late-modern age of information technology, global capitalism, social media, and international terrorism – have also excelled in the art of combining the literary genre with social commentary. A prominent example hereof is the work of Michel Houellebecq, which despite its fictional foundation nevertheless abounds with dystopian and critical observations on contemporary society (Petersen and Jacobsen 2012). Sociologists, then, are not the only ones capable of grasping – and perhaps not even the ones most qualified to grasp– the historical moment in which we live. Also, novelists have always tried to understand their time and age and often with more elegance and less pretension than their sociological counterparts. Their kind of knowledge may not be as 'statistically significant', 'reliable', or 'generalizable' as that of the social sciences, but it contains other virtues. As once poignantly observed by Danish organizational researcher Torben Beck Jørgensen:

> Research-knowledge is distance-knowledge, based on papers or more or less specialized forms of data gathering. It is often heavy knowledge because of the demands for documentation, and even more often it appears as unreadable knowledge, because it is intended for professional peers. . . . Compared to this, literature – and art more generally – holds a tremendous advantage. It is rich in forms of expression and this goes for the description of the smallest as well as the most comprehensive matters. The writer may use irony, understating or exaggerating, writing in an ambiguous way, working on different levels at the same time in order to take the reader to those particular experiences of reality, he intends. By using a variety of forms of expression, the writer, in a precise way, is capable of describing that exact 'core of being' he has seen.
>
> Jørgensen 1986:234

The many qualities of fictional work listed here, as compared to those of 'heavy' or 'dry' research, are indeed noteworthy and may be used for research purposes irrespective of the specific topic of one's research focus, be it sexuality, illness, deviance, violence, alienation, emotions, identity, social structure, life crises, or death for that matter. Obviously, fiction-based knowledge

cannot 'prove' to us how the world 'really is', but it can provide us with invaluable hints, snippets of insight, interpretations, associations, oblique angles, spot-on observations, and food for thought. As American sociologist Lewis Coser once rightly commented: 'Fiction is not a substitute for systematically accumulated, certified knowledge. But it provides the social scientist with a wealth of sociologically relevant material, with manifold clues and points of departure for sociological theory and research' (Coser 1963:3). In this way, reading novels, short stories, poems, or other literary genres (or watching films and television series, for that matter) provides the sociologist or social researcher with a wealth of imaginative clues that may work wonders for setting a drowsy sociological imagination in motion, broadening its scope and sharpening its teeth (see, e.g., Mills 1959; Jacobsen et al. 2014). Trying to 'read' and understand society through other, more creative sources than those taught in research methods textbooks or officially deemed 'scientific' is therefore recommended as a useful supplement to more conventional modes of conducting social research.

For several obvious reasons, death and dying are not easy topics to investigate. First, it is difficult to obtain first-hand information about death and dying in a modern society that has increasingly institutionalized and sequestrated these experiences. Second, death is and remains a sensitive and emotionally challenging experience at times, making it difficult for researcher and research subjects alike to engage in actual research situations. Third, explaining and understanding as compact and complex a phenomenon as 'death culture' with extrapolations from surveys, interview studies, or observation data is a daunting task requiring not only analytical skill but also restraint. For this reason, it is advisable to seek knowledge about death and dying from other more 'unobtrusive measures' than those of conventional social research (Webb et al. 1966). Here, literary texts may serve as a valuable source of information and inspiration. The topic of death has indeed been a recurring theme within modern literature. For some writers, death remains a continuous concern, for others merely a one-hit preoccupation. Just think of the likes of Leo Tolstoy, Hermann Hesse, D. H. Lawrence, Samuel Beckett, Simone de Beauvoir, Vladimir Nabokov, Thomas Pynchon, Don DeLillo, José Saramago, and so many others – the list is almost endless – for whom writing, each in their own unique way, about death has been a trademark. Sometimes death has been treated metaphorically, at other times more explicitly, but always with a keen eye as to how death, particularly for modern man, has increasingly become an existential problem and absurd. They have provided us with insightful accounts of death as an individual experience and a social event. It seems as if death (but also grief) continues to constitute an inexhaustible source for the literary imagination. Therefore, there is a lot of 'death literature', classic as well as contemporary – and many different variants and qualities of it – around that may provide the analyst of our death culture with multiple inroads for interpretation and understanding (see, e.g., Hakola and Kivistö 2014; Jernigan, Wadiak, and Wang 2018; Skelton 2003; Teodorescu 2015; Weir 1980).

In this chapter, we want to explore, by way of an important piece of modern literature, how fiction may inform and sharpen our understanding of the contemporary culture of death. The centrepiece of the chapter is constituted by American writer Don DeLillo's 1985 book *White Noise*. This critically acclaimed book contains many different angles and multiple layers. However, the topic of death is indeed one of the most conspicuous themes running throughout the novel. We are far from the first ones to describe the centrality of the topic of death in DeLillo's novel (see, e.g., Helvacioglu 2015; Rossini 2016; Sakaama 2018; Sundberg 2014; Weekes 2007), but we here want to use the book's literary genre as a sort of 'vicarious' source of sociological knowledge for understanding contemporary death culture. In the chapter, we will first present the main storyline of the book, then we delve a bit deeper into several death-related topics of the novel (death anxiety, medicalization, mediatization/commodification, simulation of death and disaster, and immortality). Then we discuss the book's 'findings' in comparison with some selected sociological perspectives; then, towards the end, we discuss how *White Noise* in particular and fiction in general may provide us with important insights into contemporary society's continuously constrained efforts to create meaning with the phenomenon of death.

White Noise – storyline and 'plot'

There are many different approaches to narrating the topic of death in literature from the more realistic of representations to the purely fictional. First published in 1985, *White Noise* is among the most critically acclaimed pieces of contemporary literature. The topic of death in many different shapes and forms has constituted and remains an underlying concern in many of Don DeLillo's novels, such as *Underworld* (1997), *The Body Artist* (2001), *Cosmopolis* (2003), and *Zero K* (2016). It is, however, in *White Noise* that death becomes the most central theme and can be said to be the very foundation from which various other themes such as technology, consumerism, entertainment, disaster, and simulation are developed and explored. Death as a prominent topic in *White Noise* serves as a tool for analyzing various aspects of contemporary American culture and postmodern life in general, but during this process, much is also revealed about death itself, where it is from the very outset made out as something external, foreign, and incomprehensible to both society and the individual, as underlined by the capitalist splendour of the milieu of the novel's central characters.

In true American-sitcom style, *White Noise* introduces the characters as they go about their daily business in the archetypical, Rockwellesque American suburb of Blacksmith, where white picket fences and consumer goods reign supreme in a scenery echoing the can-do spirit and sense of American capitalist victory of the Pax Americana (Bilton 2002:23–24). In the first part of the tripartite novel, the reader is taken swiftly through a series of short chapters introduced to the story's protagonist Jack Gladney, a middle-aged

college professor and Director of Hitler Studies at the fictitious 'College-on-the-Hill', his reconstituted family consisting of his wife, Babette; four children, all from different past marriages; and his colleague, the quintessentially postmodernist professor Murray Jay Siskind, who studies and teaches American popular culture. Through this circle of characters, the reader is made to partake in a world where sliding doors of supermarkets part 'photoelectronically', refrigerators throb 'massively', and mysterious chemicals seem to be 'woven into the basic state of things' (DeLillo 1985/2001:290, 101, 35). A kind of mystical and even mythological presence seems to shroud this American existence of consumerist abundance, and never is one left without the sense of a 'waning of affect' (Jameson 1984), which serves to create the characteristic sense of ironic distance and satire found in most of DeLillo's oeuvre.

On the surface of it all, death seems utterly out of place in this existence of material excess, 'brightly coloured food' (DeLillo 1985/2011:7), and technological progress while paradoxically remaining an integral part of the very structure of society and the people within it. Consequently, it is not long before this quondam stability is jeopardized by the very consumerist societal structure serving to instate it in the first place. The hubris of American capitalism and the alienation of mankind from death manifests itself as 'the airborne toxic event': the title and pivotal point of the second part of the novel. This part also inaugurates a stylistic shift from the initial sitcom narrative towards a style more closely resembling that of classic 1970s disaster movies, with its uninterrupted sequence of events maintaining the momentum and sense of urgency throughout the entire second part. This interesting choice of genre serves, as in the previous part, to accentuate the role of death in (post)modern society for, in the middle of the pandemonium that is the evacuation of Blacksmith following 'the airborne toxic event', a familiar irony and ironic distance, which also appears in the first part, re-emerges as a result of the use of a cinematic genre in the portrayal of death. This time, death is depicted as ominous, chaotic, and menacing; it is in a practical sense made tangible in its looming visibility, but by depicting it through a genre of entertainment, death is ultimately reduced to exactly that: entertainment detached from reality.

Having created a series of different plotlines all revolving around death and all seemingly moving 'deathwards', as Jack states as being the nature of all plots (DeLillo 1985/2011:26), the novel in its third and final part once again switches genre and style of narrative into what can best be likened to the *film noir* detective films of the 1940s and 1950s. The most strikingly ironic part of this part of the book is, however, that no resolve or proper climax is reached in any of the plots. After having failed to murder his wife's lover, as he had been planning and fantasizing about, Jack keeps visiting his doctor to keep track of his developing 'nebulous mass' after a brief exposure during 'the airborne toxic event', and he keeps drifting around in malls of capitalist mystique: the only thing which seems certain and reliable in an otherwise perilous world, where radios, televisions, and magazines jag everyday life with an incessant white noise.

Throughout *White Noise*, it is obvious that DeLillo deliberately shifts between different styles and genres in order to show us the many different faces of death as a 'plot' in postmodern social life. *White Noise*, often described as a 'postmodern novel', presents a gloomy vision of American society, and the book has been accurately described as a 'microethnographic treatment, however satirical, of social relations in American suburbia during the final decade of the Cold War' (Alworth 2010:307). Even though this 'microethnography' relies on the observations and ideas developed by the author himself through what can be characterized as a non-systematic and fictional approach, the book nevertheless provides food for thought for those wanting to understand postmodern society in general and postmodern society's problematic relationship with death in particular. The book is thus, we want to argue, bridging the literary with the sociological, the purely fictional with the diagnostical. Let us look in some more detail at some of the death-related plots in the book.

The age of death anxiety

White Noise is, as already established, a book about death. The remarkable thing here, however, is that while being a book about death, *White Noise* does not actually contain any deaths at all other than those seen on television by the Gladney family during their Friday night take-away dinner. Even though the question 'Who will die first?' is repeated many times by Jack and Babette throughout the book, nobody actually dies. Thus, *White Noise* is not a book about death directly experienced; it is instead an exploration of how the anxiety of death in an age of medico-technological progress, where death is oppressively contradictory to the rationale of the modern man, has become more problematic than death in itself. As Norbert Elias once stated in his book *The Loneliness of the Dying*: 'It is not actually death, but the knowledge of death, that creates problems for human beings' (Elias 1985/2001:5). How this knowledge of death impacts both the individual and the wider society has, however, changed from one generation to another *pari passu* with both technological and societal developments. Consequently, there is a clear distinction to be made between the death anxiety of Jack and Babette, representing the older generation in *White Noise*, and that of the younger generation, which is best and most extremely represented through their son Heinrich's friend Orest Mercator in his endeavour to 'break the world endurance record for sitting in a cage full of poisonous snakes' (DeLillo 1985/2011:182).

For Jack and Babette, death is most of all something utterly incomprehensible to and irreconcilable with their lives in the archetypical American suburb of Blacksmith. In her reaction to the annual 'caravan' of middle-class families in station wagons streaming towards the College-on-the-Hill to offload their children after the summer vacation, Babette brings up the topic of death for the first time by remarking that she has 'trouble imagining death at that income level' (DeLillo 1985/2011:6), a notion which is later supported

by her husband during their discussion of the possible outcomes of 'the airborne toxic event' when he asks: 'Did you ever see a college professor rowing a boat down his own street in one of those TV floods? We live in a neat and pleasant town near a college with a quaint name. These things [floods, hurricanes, etc.] don't happen in places like Blacksmith' (DeLillo 1985/2011:114). Thus, when Jack and Babette are inevitably confronted with the threat of death – in Jack's exposure to the mysterious and lethal chemical Nyodene D and through the gradual revelation of Babette's pathological fear of death – it is this aforementioned irreconcilability between the blissful safety of the American middle-class existence of material excess on the one hand and the fact that death is, at least for now and for a long time to come, ultimately undefeatable despite the exertions of what Polish-British sociologist Zygmunt Bauman (1992a) has termed modernity's 'drive to mastery' on the other, which creates an oppressive and disruptive fear of death. To Babette, it seems absurd that people should be able to function normally beneath this existentially oppressive fear of death, but as T. Z. Lavine (1984:332), in a paraphrasing of Martin Heidegger's famous insight on death, stated: it is exactly when we acknowledge death and take it into our lives that we can overcome the fear of it. Nevertheless, most people instead tend to suppress any notion of death through various strategies, with an extreme example being Babette's use of the psychopharmaceutical Dylar, designed to chemically inhibit the fear of death.

While Babette puts her faith in medico-technology to 'treat' her fear of death, Jack instead becomes increasingly disillusioned by this technology as he goes through more and more tests and examinations, which do nothing to help him comprehend his potentially lethal exposure to Nyodene D. Instead, Jack seeks answers through a lengthy satirical-dialectical dialogue spanning the entirety of chapter 37 between himself and his fellow college professor and friend, Murray. In this bizarre dialogue, Murray Jay Siskind advises Jack to free himself from his death anxiety by simply subscribing to beliefs such as reincarnation, transmigration, hyperspace, or indeed any other belief system which may help to make the thought of a finite life more palatable, even though neither Jack nor Murray actually believes these things to be true.

In stark contrast to this struggle experienced by Jack and Babette stands Orest Mercator and his aforementioned endeavour to beat the Guinness world endurance record for sitting in a cage filled with poisonous snakes. Through his concise and matter-of-fact dialogue, Mercator conveys a complete and utter disregard for the potentially lethal consequences that his endeavour might have. Death is simply not something that worries him; neither is it ever considered a realistic outcome, for the very act which will put him at a risk of dying will, at the same time, also immortalize him, thereby rendering death insignificant. In this way, Mercator has in quite an absurd way subverted the fear of death as an existential condition by letting his whole being be defined by a single spectacular act, which will put him in a position where either death or survival will earn him immortality. Ultimately, Mercator's attempt fails miserably when he is bitten within only four minutes by a

snake, which turns out to be nonvenomous, and he retreats into seclusion, never to be heard from again for it is this insignificance of his attempt which compromises his struggle for immortality and forces him to reckon with his mortality and death anxiety.

As mentioned, these very different ways of both feeling about and dealing with the anxiety of death reveal a lot about the generational differences between Jack and Babette on the one hand and their children and friends on the other. Common to both Jack and Babette is that they perceive death as a condition or an illness to be cured, instead of a natural and uncircumventable part of life, and they thus resort to medico-technological measures in order to 'treat' it. At the same time, Mercator utilizes the effects of the public spectacle to transform the inevitability of death into a situation where he can gain symbolic immortality no matter the outcome. But once again, any such attempts at circumventing mortality prove to be equally futile efforts in an ultimately unwinnable fight against death.

The medicalization of death

Technology and medicine are, as exemplified through Babette's use of Dylar and the whole secrecy surrounding it, a vital part of *White Noise* and its depiction of man's relation to and perception of death in postmodern society, but it is perhaps in Jack's encounter with modern medical imaging and testing after having been exposed to Nyodene D that the true problem with medico-technology is revealed with great acuity. To put it briefly, technology has for many years been at the forefront of the battle against human mortality, and it has developed at an increasingly accelerating rate, making it ever more complex and ultimately almost as incomprehensible as the very things it tries to combat. In *White Noise*, death has become so complex, all-encompassing, and almost mystical that it has to an even higher degree made it impossible for man to relate to his own death. Medico-technology has, as it were, separated the illness, ailment, or cause of death from the person, and this is where the concept of medicalization comes into play. In *Mortality, Immortality and Other Life Strategies* (1992a), Zygmunt Bauman states that the medical fight against death is one of the primary life strategies of the modern age, where mortality in itself can no longer be accepted as a cause of death. Rather, people exclusively die of their diseases. Citing Lindsay Prior's (1989) study of medical discourse, it is now the doctor rather than the priest who is called when death is approaching, and the doctor must then with all his/her professionalism fight every potentially lethal condition as a lawyer would fight a case in court. In this way, death becomes a problem to be tackled, a task to be performed, a job to be done, thereby inaugurating an instrumental approach to the problem of death. Death is nowadays thus mostly regarded as a technical and medical phenomenon (Ariès 1974), and we are thus no longer fighting death as such but rather the multiple 'causes of death' (Bauman 1992b).

Through its portrayal of the myriad of different types of medical machinery and technology experienced especially by Jack, *White Noise* exposes this medico-technological regime and the doctors who operate it as an almost mythological and self-sustaining entity, which in its own eco-system creates more illnesses than it cures. During his trip to the medical facility Autumn Harvest Farms, Jack notes that 'all those gleaming devices are a little unsettling. I could easily imagine a perfectly healthy person being made ill just taking these tests' (DeLillo 1985/2011:277). Thus, it seems that despite being held in great reverence by many, especially those professionals who worship it unquestioningly and religiously, the very nature of the development of modern medicine into becoming ever more complex and incomprehensible renders it incapable of ever being able to provide relief from the anxiety of death – quite the opposite in fact. This paradoxical discrepancy between the goal of modern medicine and what it actually achieves is revealed early in the book through the bizarre conclusion to the story of how the old man Treadwell, to whom Babette regularly reads aloud from various tabloids, and his sister got trapped in a mall: 'Mr. Treadwell's sister died. Her first name was Gladys. The doctor said she died of lingering dread, a result of the four days and nights she and her brother had spent in the Mid-Village Mall, lost and confused'. Because modern medicine renders a diagnosis an absolute necessity, a nonsensical one is invented, which in this particular case becomes 'lingering dread', when a sensical diagnosis cannot be found. Along the same line, Jack mentions the lieutenant governor of the state, who died of 'undisclosed natural causes, after a long illness' and that 'we all know what that means' (DeLillo 1985/2011:99), together with a series of other absurd obituaries, all of which lack a satisfying medical diagnosis and thus demand nonsensical or absurd ones in order to cover up the inadequacy of modern medicine, whose failure would be an admission of man's mortality. Furthermore, the whole process of diagnosing in the first place, and not just the diagnosis itself, is portrayed in *White Noise* as an absurd experience for the individual who is to be diagnosed and a confirmation of the (in many aspects) blind faith of professionals who are ingrained in the system of medico-technology to such a degree that they do not themselves fully understand it and instead rely on empty phrases and jargon to keep up the charade. In his meeting with a so-called SIMUVAC technician (SIMUVAC is the abbreviation of Simulated Evacuation) after having been evacuated, Jack is told that exposure to Nyodene D 'can send rats into a permanent state' and that he is 'generating big numbers' (DeLillo 1985/2011:139–140), whatever that might mean. In the end, Jack is left without any clarification whatsoever, only empty words from a computer, thus leaving him to ponder the nature of death as experienced through modern technology in one of the most incisive and profound parts of the book:

> Death has entered. It is inside you. You are said to be dying and yet are separate from the dying, can ponder it at your leisure, literally see on the X-ray photograph or computer screen the horrible alien logic of it all. It

is when death is rendered graphically, is televised so to speak, that you sense an eerie separation between your condition and yourself. A network of symbols has been introduced, an entire awesome technology wrested from the gods. It makes you feel like a stranger in your own dying.

DeLillo 1985/2011:141–142

Thus, in their quest for immortality and the conquering of death as an existential condition irreconcilable to their lives, the characters in *White Noise*, with Jack being the prime example, come to experience many of the pitfalls of Bauman's modern life strategies, such as the slicing of death into its constituent parts or diagnoses and the ensuing development of ever-more-complex medicine, which will forever have its goal of immortality right outside its reach.

The mediatization and commodification of death

In medieval times, humans encountered death as a very physical confrontation with the inescapable reality of mortality. To them, death was a very concrete thing – people died before their very eyes, and in their close proximity, they could see it, hear it, touch it, smell it – something that constantly reminded them also of their own mortality. In fact, this situation lasted until well into the 20th century, with the invention of modern information and communication technologies increasingly mediating between reality and recipient. This, together with a host of other social processes touched upon earlier, has meant that death nowadays is most often something we hear or read about or witness as a second-hand experience at a safe distance and through a screen. It happens somewhere else to someone else but only seldom in our own immediate environment.

Our direct exposure to real death has thus gradually been reduced to a bare minimum throughout human history. However, this does not mean that death has disappeared, but it now primarily appears to us in diluted, filtered, mediated, and mediatized ways. According to Benjamin Noys, 'in modern culture death is not simply invisible or taboo but bound up with new structures that expose us to death' (Noys 2005:3). This is very clear also in *White Noise*, in which death is something watched and consumed with a striking sense of unreality from afar – as some strange sort of entertainment. Thus, as someone who likes to draw out the peculiarities of contemporary culture and satirize them accordingly, DeLillo naturally makes television and entertainment play a significant role in *White Noise* by describing the new ways in which mass entertainment influences the postmodern individual's exposure and relation to death. For example, the entire Gladney family is, as their usual Friday evening ritual, gathered around the television set:

That night, a Friday, we gathered in front of the set, as was the custom and the rule, with take-out Chinese. There were floods, earthquakes, mud slides, erupting volcanoes. We'd never before been so attentive to

our duty, our Friday assembly. Heinrich was not sullen, I was not bored. Steffie, brought close to tears by a sitcom husband arguing with his wife, appeared totally absorbed in these documentary clips of calamity and death. . . . Every disaster made us wish for more, for something bigger, grander, more sweeping.

DeLillo 1985/2011:64

Later in the novel, Jack watches news coverage on television from a police excavation of a serial murderer's backyard in Bakersville: 'The reporter said two bodies had been found, more were believed buried in the same yard. Perhaps many more. Perhaps twenty bodies, thirty bodies – no one knew for sure' (DeLillo 1985/2011:222). Some nights later, Jack watched the news again with his son Heinrich, but the reporter now revealed that no more bodies – despite methodical and skilled digging – had been found. As Jack drily observed: 'The sense of failed expectation was total. . . . I tried not to feel disappointed' (DeLillo 1985/2011:222–223). These passages testify to the fact that, in a postmodern world, in which real and actual death has disappeared from most people's lives, they instead crave their daily dose of death through surrogates such as news stories of murders, disasters, and other human tragedies – it is a desperate craving; one constantly needs more.

Not only does televised death unite the Gladneys, it unites all families in America and the Western world in general, for such is the power of mass media. According to an American study by John Hick, quoted by Bauman (1992a), children in 1971 had by the age of 14 watched around 18,000 cases of death on television, most of which were murders, and as seen in the earlier quotations from *White Noise*, these cases of violent death and calamities are experienced through the television screen with intense fascination, signifying that the projection of death through this medium has removed death from reality, adiaphorized it, and stripped it from its gravity in real life, making it instead a spectacular, sensational phenomenon to be witnessed vicariously as part of mass entertainment. Thus, death televised has become a family activity, an act of unity even, in that it unites all the members of the Gladney family into one death-as-entertainment-consuming entity. In this way, DeLillo portrays exactly how man's relation to certain aspects of death has changed radically in postmodernity while other aspects have remained the same. In premodern times as well as in postmodernity, death in many ways was and remains a unifying force bringing together families and acquaintances, but whereas this unification in premodern times took place around the deathbed where families including children would gather in order to keep the dying company during his/her final hours on earth and subsequently mourn their loss openly and compassionately, thereby accepting death as a natural and inevitable companion of life, DeLillo shows us that the situation looks very different in postmodernity. Now families instead come together in front of the television screen to digest the mediatized and spectacularized death, while

the average or natural death has been exiled to the backstage of postmodernity through a continuation of the medicalization, institutionalization, and professionalization of human mortality. When discussing news and news media in postmodernity, Bauman draws on Helmut Thielicke's observation that 'a centrifugal tendency of a continually enhanced dissipation' is in the works (Bauman 1992a:189). Today, death has truly become a 'spectacle' – something we watch rather than experience (Jacobsen 2016). At least, this is what we can see in the Gladneys' Friday night ritual, not all that different from the entertainment patterns of most other families.

As mentioned, despite its shadowy and mediated/mediatized presence, death has not totally disappeared – it is there in dramatic news reports of natural disasters and man-made atrocities. It is also there in the never-ending shopping experiences in the sanitized and deodorized supermarket described by DeLillo, who, in Jack's voice, notes: 'Here we don't die, we shop' (DeLillo 1985/2011:38). In this way, death has been commodified – it has become part and parcel of contemporary consumer society and is now commercialized like everything else (Baudrillard 1970/1998). Shopping and consumer lifestyle is by DeLillo seen simultaneously as a bulwark against death as well as death incarnate. Hence, death is present in all the seemingly insignificant and almost inaudible background noise of tranquil, idyllic, and happy suburban middle-class life. Thus, the notion of 'white noise' (from the book's title) serves as a metaphor for this unheard and unseen death that is nevertheless still there. In the book, a conversation between Jack and Babette captures this dimension:

> 'What if death is nothing but sound?'
> 'Electrical noise'.
> 'You hear it forever. Sound all around. How awful'.
> 'Uniform, white'.
> 'Sometimes it sweeps over me', she said. 'Sometimes it insinuates into my mind, little by little. I try to talk to it. Not now, Death'.
>
> DeLillo 1985/2011:198

Throughout his novel, DeLillo develops this idea of 'white noise' as a term to describe the phenomenon of having one's thoughts continuously disrupted by the never-ending streams of information and commercials from radios, televisions, cars, and even people as they, too, as a result of being enmeshed in a capitalist society and 'system' have had their consciousness pierced and saturated by various brand names and slogans. This constant sound, as DeLillo (1985/2011:4) writes in the book, is like 'dead souls babbling at the edge of a dream'. Or, as Mark Osteen has put it in his analysis of *White Noise*: 'Postmodern death – just as a Panasonic quality in the air – yields no clean denouement' (Osteen 2000:184). In this way, death is there all the time, not only mediated/mediatized, but also commercialized/commodified, turned into endless consciousness-disturbing codes, signs,

and sound waves that illustrate the extent to which postmodern life has become a hyperreality of sorts.

The simulation of death and disaster

There are plenty of real disasters around in the world each year, killing unimaginable numbers of real people, and there are plenty of disasters in the world attracting the attention of millions of viewers to television screens. German sociologist Ulrich Beck (1992) once stated that we now live in a so-called 'risk society', which characterizes a society that has a heightened awareness of real as well as imagined risks. In such a world, everything carries the potential for risk. In *White Noise*, however, the seemingly real disasters most often end up being unreal or 'hyperreal', and this allusion to Jean Baudrillard's (1983) ideas on simulations and simulacra is in no way accidental. In a postmodern novel like *White Noise*, postmodern social theory, as we will show later, lurks beneath the surface. Death in *White Noise* is thus also simulation – it is mostly a potential, an imitation, or a simulation, something difficult to witness, determine, and prove but nevertheless still there. Even though the characters are not 'officially dying', death is always already there, inside them. In the book, as we saw earlier, Jack is briefly/potentially exposed to poisonous radiation from the 'black billowing toxic cloud'. When he sees a SIMUVAC technician at the emergency centre where he has sought shelter with his family, he is to his great surprise told that he is already dying. Based on a computer-simulated analysis of his exposure and its potential impact on his body, the technician states: 'You are generating big numbers', thereby indicating that, despite the brevity of Jack's exposure – only a few minutes – the consequences are already severe. The technician continues after punching numbers into a computer, stating: 'You are the sum total of your data. No man escapes that'. No physical examination has taken place, only a computer-generated result based on Jack's 'whole data profile' (DeLillo 1985/2011:141). So the computer contains the truth about one's health. As Jack later contemplates after seeing his own doctor, who could find no objective signs and no 'startling numbers' on the printouts of his tests: 'This death is still too deep to be glimpsed' (DeLillo 1985/2011:204). In this way, death *is* there – it can be simulated by a computer well before it erupts and becomes objectively visible in the body.

Beck (1992) has also insisted that the exposure to risk – natural as well as man-made – is far from equally distributed, the poor always being more at risk of dying unexpectedly or prematurely than those well off from disasters, pollution, and diseases. DeLillo also corroborates this point in his novel when, in a discussion between Jack and Babette, they make it clear that death from disaster always happens to those living in developing countries or being otherwise disadvantaged. In the words of Jack: 'Society is set up in such a way that it's the poor and the uneducated who suffer the main impact of natural and man-made disasters. People in low-lying areas get the floods, people in

shanties get the hurricanes and tornados' (DeLillo 1985/2011:114). For the well off, most disasters are no real problem, only a distant potential. Despite this fact, or perhaps rather because of it, the awareness of death, as we touched upon earlier, the fear of it, seems to haunt the well off and well educated in a way that makes it impossible for them to live peacefully with this knowledge. The knowledge that something *could* in fact happen to *them* is as intensely scary as it is statistically unlikely.

Two other examples from the novel may serve to illustrate this point about the simulation of death and disaster. First, the aborted plane crash-landing. Jack's teenage daughter Bee from one of his previous marriages is set to arrive at the airport of the neighbouring city by plane on a visit. However, during the descent of another flight, something goes terribly wrong, and the plane prepares for a dramatic crash-landing. In the end, however, nothing – despite tumultuous and desperate scenes on board the flight – happens, and everyone is safe. As DeLillo satirically shows, the re-capturing of the potential disaster by one of the 'surviving' passengers in the airport after the event becomes nothing less than a spectacle, even though the media never turns up to report it. Thus, in the apt words of Bee: 'They went through all that for nothing?' (DeLillo 1985/2011:92). Another example from the book shows how the potential for death and disaster puts the world in a state of constant alert. For example, after the 'airborne toxic event', the company Advanced Disaster Management appears in the streets of Blacksmith in order to rehearse real disasters with 'radioactive steams, chemical cloudlets, a haze of unknown origin'. One of Jack's daughters, Steffie, serves as a volunteer 'victim' in these rehearsals, and Jack overhears the amplified voice of one of the consultants of the disaster management company: 'The more we rehearse disaster, the safer we'll be from the real thing'. Later that day, Jack's son Heinrich repeats this insight when saying: 'The more you practice something, the less likely it is to actually happen' (DeLillo 1985/2001:204–207). In this way, simulations of emergencies and rescues in themselves paradoxically become grim reminders of death, and technology – which plays an overarching role throughout *White Noise* (Henneberg 2011) – is almost in itself imbued with the anticipation of death and disaster. As Peter Boxall has thus suggested in his analysis of *White Noise*, the characters of the book continuously end up finding 'deathly possibility inhabiting those very technologies that promise to eradicate death' (Boxall 2006:10). Death simply cannot be rehearsed or simulated away. The novel was written well before the 9/11 events of 2001, but it can in many ways still shed light on the bizarre way in which this terrorist attack subsequently put the whole planet in a state of permanent emergency (Devetak 2009).

Intimations of immortality

There is no doubt that Don DeLillo's interest in the topic of immortality permeates not only *White Noise* but also many of his other books. For

example, as he stated in an interview a few years ago just before turning 80: 'Why do we have to die? And if the science exists that enables us to pursue life extension in a serious way, we have to follow it' (Brown 2016). This human quest for immortality/postmortality is, however, not only a technological phenomenon; it is also a historical phenomenon which comes in many different guises and has been central in the formation of many aspects of society and culture. As Arthur Schopenhauer stated in *The World as Will and Representation* (1819/1966:463), 'without death there would hardly have been any philosophizing', for it is precisely man's certainty of death and the consequent striving for immortality that are responsible for the formation of most philosophy and religion as 'antidotes' to this certainty. Today, the dream of postmortality lives on through an ever-more-diverse set of behaviours, technologies, and phenomena (Jacobsen 2017), of which a few have already been discussed in relation to *White Noise*. The novel does, however, contain many different takes on the nuances of postmortality, which extend far beyond medicalization, technology, simulation, or the public spectacle that was Orest Mercator's 'record attempt'. In its preoccupation with technology and its role in relation to immortality, *White Noise* attempts to connect these aforementioned symptomatic approaches into a whole, consisting of an overarching 'system', which ties together all people in a singular postmortal project of community wholly reliant on the capabilities of technology and globalization.

This 'system' makes itself apparent – despite it being, as Jack explains, 'invisible' (DeLillo 1985/2001:46) – throughout the text in many different ways. One instance is the effect of 'white noise' created by the sudden and often untimely recitation of brand names and mystical-sounding technologies – for example, as heard through the radio or television – such as when it reads: 'Mastercard, Visa, American Express' (DeLillo 1985/2011:100) in the middle of a deep discussion of who will die first between Jack and Babette or in the middle of Babette's confessing of her affair with Mr. Gray/Willie Mink, the inventor/provider of Dylar, where it reads: 'Leaded, unleaded, super unleaded' (DeLillo 1985/2001:199). Another instance is when Jack checks his bank account at an ATM and feels 'waves of relief and gratitude' flow over him when his own 'independent estimate' of his balance corresponds to that of the system, thus tying him together in harmony with a system powered by a mainframe 'sitting in a locked room in some distant city' (DeLillo 1985/2001:46) and ultimately also with every other person whose money and identity are also stored away in ATMs. Together with other systems such as mass entertainment and medical databases, Jack, his family, and every other Western citizen become incorporated into one omnipotent, omniscient, and infinitely complex 'system' of technology in all its shapes, forms ,and capabilities, which in its communal nature and God-like properties fends off death and restores some sense of order in otherwise uncertain times.

This idea of a postmortal communal project is not, however, in its foundation exclusively late-modern or postmodern; far from it, for it draws heavily,

as Stacey Olster (2008) has pointed out, on the quintessentially modern Nazi party rallies of the 1920s and 1930s – a topic taught by Jack in his Hitler Studies course at the College-on-the-Hill with a special emphasis on death as a defining factor. As such, the idea of being drawn into a kind of 'system' in search of immortality seems to be a much more fundamental part of human behaviour than one created by the hyper-capitalism, mythical consumerism, and technological development found in *White Noise*. 'To become a crowd is to keep out death. To break off from the crowd is to risk death as an individual, to face dying alone. Crowds came for this reason above all others. They were to be a crowd' (DeLillo 1985/2011:73). It is, of course, known that humans are a gregarious species, but this idea of a communal postmortal project as conveyed by the quotation seems to extend beyond mere biological dispositions and into more of an existential condition to be faced individually before such a project can be realized. While people of modern times, such as during the Nazi party rallies of which Jack speaks, could unite under one banner and face death together by being willing to give away their own lives for a greater purpose that extends beyond death – what Bauman (1992b) defines as the survival strategy rooted in the 'common cause' – people of late-modern or postmodern times do not, despite having arrived at an age where technology and globalization have created the perquisites for communal projects on an heretofore unseen scale, share this same conviction. Instead, people have now perhaps become lonelier than ever before for, as Murray eloquently puts it: 'Once you're out of school, it is only a matter of time before you experience the vast loneliness and dissatisfaction of consumers who have lost their group identity' (DeLillo 1985/2011:50). Therefore, the striving for immortality has quite paradoxically gone from being an exclusively communal project, in an age where communities were reliant on physical proximity, to first and foremost being an individual project within the impersonal structure of 'the system', in an age where technology and the concomitant globalization have made communities possible across time and space. So when each person is left alone to deal with their own mortality, and the dream of dedicating their life to a 'common cause' has been shattered by the withdrawal of collective ideologies into the shadows, one must either fully commit to this new modernity as the children of *White Noise* do, or one must, as Jack does through his Hitler Studies, strive for a kind of second-hand immortality at the hands of the immortals of history who remain 'larger than death' and whom one can 'grow out into' as Jack does with Hitler (DeLillo 1985/2011:287, 17).

Thus, *White Noise*, more than dealing with only the specific, symptomatic approaches to or strategies towards dealing with death, attempts to identify the very structure of our society as an essentially late-modern or postmortal project through the idea of the all-encompassing 'system' which has permeated everyday life with consumer brands and complex technologies. This 'system' ties all consumers together into one grand postmortal project, in which everything is recorded and nothing forgotten, thus echoing Bauman's description of postmodern death as a mere 'suspension, a transitional state' (Bauman

1992a:173). Yet, this 'system' is, as must be expected, not without its faults. The technology which allows 'the system' to function has, as already pointed out, become too complex and unwieldy for man, and one must then either distance oneself from it or, as the doctors and technicians in *White Noise* do, worship it religiously and uncritically. But perhaps more fundamentally, the potency of the communal project has in postmodernity become insipid and far removed from the idea of giving away oneself to the 'common cause' prevalent in modernity. Instead, now more than ever, each individual is left alone within 'the system' to try to achieve immortality, be it through technology, medicine, made-up tales of reincarnation or salvation, transhumanism, 'edgework', the public spectacle, or any other such ultimately futile endeavour which is nonetheless an essential part of the existence of man as a species conscious of death.

Don DeLillo's 'literary death' – a sociological discussion

There are undoubtedly many different ways to understand and appreciate Don DeLillo's work. An author's 'real intentions' for writing a piece of literature only rarely reveal themselves to the readers, and unless the author in subsequent interviews discloses their motivations and their own interpretations of the work in question, we are as readers left to speculate for ourselves. Moreover, as Italian writer Italo Calvino once reminded us, there is not only one (in the singular) level of reality in literature, but many different levels that obfuscate any clear-cut and accurate description of the complex nature of the real world (Calvino 1986:121). Based on our treatment of several death-related topics from *White Noise*, how are we then to assess DeLillo's book as a contribution to understanding our contemporary death mentality and death culture in the Western world? How may we claim that DeLillo's fiction, his literary treatment of death, does in fact provide us with useful information on real society's relationship to real death? How can we seek to 'sociologies', as it were, the intriguing insights provided by DeLillo? Here, we need to resort to a few useful sociological perspectives and theoretical distinctions that can provide us with a framework for understanding what is (perhaps) at stake in *White Noise*'s compact storyline.

For example, Zygmunt Bauman, whose work we have referred to several times already, in *Mortality, Immortality and Other Life Strategies* (1992a) differentiated between what he called a 'modern deconstruction of mortality' and a 'postmodern deconstruction of immortality'. Whereas the former strategy refers to the way in which modern society, modern science, and modern medicine have attempted to conquer death through the control of nature (human and non-human), treatment regimens, and survival strategies, the latter rather refers to the way in which postmodern society instead deconstructs immortality into a daily task that may perhaps not provide any long-term guarantee of a heavenly afterlife or to live forever, but which nevertheless leaves the impression that nothing really disappears forever, thereby nullifying

death. Immortality is now, as everything else, a transient and evanescent experience, not a fixed state finally to be arrived at. We do need to stress that Bauman (1992a:10) emphasized in his book the mutual coexistence, historical overlap, and internal conflict between these different strategies, rather than insisting that they have replaced each other entirely. By toying with and applying this analytical template, we may say that DeLillo's treatment of death in *White Noise* clearly underscores the point of the coexistence but also internal contradiction between the modern deconstruction of mortality strategy and the postmodern strategy of deconstructing immortality. From our reading of *White Noise*, it is evident that the characters in the novel draw on a plethora of different strategies of immortality, modern *and* postmodern, in order to annihilate death and the fear of it in their lives. On the one hand, DeLillo, with his focus on the increasing medicalization of death, clearly positions his literary universe within the modern deconstruction strategy aiming to defeat and annihilate death, and Dylar is just one of the ways – although unsuccessful as it turns out – this may be attempted. However, with his insistence on the pervasiveness of death (as continuous 'white noise'), there are also many examples of the postmodern strategy of deconstructing immortality. For example, in *White Noise*, although the book is permeated with numerous death-related scenarios and plots, no one actually dies. Everything ends up as a peculiar extended near-death experience. The toxic cloud kills no one, the plane crash-landing is aborted, Orest Mercator survives his rendezvous with the snakes, Jack's own seemingly terminal illness does not kill him, his stepson Wilder is unscathed despite a crazy tricycle ride across a densely trafficked motorway, and not even Mr. Gray/Willie Mink – whom Jack towards the end shoots several times at close range – ends up dying. So death (or the potential for death) is definitely there all the time, but everybody still survives. In this way, death and immortality, as Bauman suggested, are daily rehearsed, and the boundaries separating them are increasingly blurred. And the question 'Who dies first?' repeatedly exchanged between Jack and Babette throughout the book, remains unanswered, and thus in Bauman's (1992b) perspective, the only real measure of a successful life strategy today is, in the end, very much dependent upon ultimately outliving all the others.

A few years after the publication of Bauman's book, British sociologist Tony Walter in *The Revival of Death* (1994) – challenging the claim that death had been hidden and forbidden for most parts of the 20th century – distinguished between two types of 'death revival' in contemporary society: a 'late-modern' and a 'postmodern' revival (the former owing its basic pillars to the ideas of late-modern social theory such as that of Anthony Giddens, whereas the latter derived its basic tenets from postmodern social theory such as those of Jean-François Lyotard, Jean Baudrillard, and Zygmunt Bauman). According to Walter, the late-modern revival strand draws on ideas of individual and institutional reflexivity, biography as a life project, and not least the importance of expert systems (medical, psychological, and so on) in the understanding and handling of death, whereas the postmodern strand instead relies on an

accentuation of the subjective, unpredictable, and ambivalent and how private consumer choices increasingly inform the structural/systemic level. Just as we stressed that Bauman insisted on the coexistence of his two deconstruction strategies, so also Walter in his work emphasizes the overlap and internal conflict between these two different 'revival strands', rather than claiming that they have replaced each other entirely (Walter 1994:186). Invoking Walter's ideas, it is clear that the notion of 'expert systems' from the late-modern death revival plays a significant role in the plot of *White Noise*. For example, Jack is constantly anxious about his condition, consulting not only his own doctor but also other specialists after his apparent exposure to Nyodene D. Besides these medical experts, the many men dressed in protective Mylex suits constantly scanning for traces of the toxic cloud in the streets are also evidence of the importance of expertise in dealing with invisible dangers and threats to life. However, there are also voices in the book pointing to a more postmodern understanding of death as something the individual will have to sort out for himself, as in the cases of Murray Jay Siskind and Orest Mercator, who each in their way argues for the right to find their own solution to the problem of life, death, and immortality.

The final theoretical framework to be briefly applied here is the more recent contribution by Russian-American sociologist Dina Khapaeva, who in *The Celebration of Death in Contemporary Culture* (2017) shows how death in current society in heretofore unprecedented manner has been commodified and made into a cornucopia of entertainment and spectacular celebrations. She claims that we now witness a new 'cult of death' in which death is publicly celebrated and displayed in ever more ingenious ways that in many respects, however, seem to make us less familiar with the reality of death. Particularly within popular culture directed at teenage audiences (dealing with vampires, monsters, robots, mass murderers, 'dead walkers', and so on), she claims, has violent and blood-dripping death become a prevalent preoccupation intended to provoke a nightmarish sensation in the reader/viewer, perhaps as a substitute for the lack of first-hand experience with real and actual death. Khapaeva states that this 'celebration of death emerges as a new strategy in entertainment and a prominent element in the culture of nightmare consumption, which presents violent virtual death as fun for the whole family' (Khapaeva 2017:174). According to her, this contemporary cult of death is actually not so much about our attitude towards death in and by itself, but rather about how we understand human life and human beings. This new 'cult of death' described by Khapaeva is also something that can be seen in *White Noise*, not least in the way the Gladneys celebrate and consume mediatized death at their Friday night television ritual, in which death and disaster constitute the very source of family entertainment.

To summarize, these sociologically informed insights developed from our reading of DeLillo's book: death is, perhaps more than ever before, now an insoluble and invisible part of our lives despite tireless efforts at exorcizing it.

As DeLillo has Murray Jay Siskind state as perhaps the most telling testimony of how death nowadays permeates every nook and cranny of our lives:

> 'This is the nature of modern death', Murray said. 'It has a life inde-
> pendent of us. It is growing in prestige and dimension. It has a sweep it
> never had before. We study it objectively. We can predict its appearance,
> trace its path in the body. We can take cross-section pictures of it, tape
> its tremors and waves. We've never been so close to it, so familiar with
> its habits and attitudes. We know it intimately. But it continues to grow,
> to acquire breadth and scope, new outlets, new passages and means. The
> more we learn, the more it grows'.
>
> <div align="right">DeLillo 1985/2011:150</div>

So despite the fact that Don DeLillo's *White Noise* is a piece of pure fiction (albeit a remarkable exemplar), it nevertheless, on the one hand, provides us with many intriguing insights into the complexity of our contemporary death culture, which have since been corroborated by sociologists studying death from a more scientific perspective, and, on the other hand, contributes with flesh and blood to the often dry bones of sociological theory about the role of death in individual life and society through its surprising plots and colourful gallery of characters.

Conclusion

In this chapter, we have sought to tease out some of the affinities between fiction and social commentary or sociological diagnoses of the times by way of a review and an analysis of Don DeLillo's novel *White Noise*. Obviously, we need to stress that literature is *not* sociology, and sociology is *not* literature. There is, however, an unmistakable 'elective affinity' (Max Weber's concept) between the two worlds of representation and interpretation that makes it interesting to see where they diverge and where they meet. We have attempted to show how the novel – despite its fictionality – provides the reader with a wealth of hints and clues with which to decipher and understand some main characteristics of our contemporary culture of death. In this way, *White Noise* can be read as an extended and exquisite socio-literary exposé of contemporary ambivalent Western death culture with a focus on the increasing cultural alienation towards death but also towards life itself. We have specifically focused on the topics of death anxiety, the medicalization of death, the mediatization/commodification of death, the simulation of death and disaster, and the intimations of immortality. Many other death-related themes could have been teased out of the novel as death is all over in it. It is evident that the plot of the book contains many pathways and asides but that death is always there somewhere between the lines. As DeLillo has Jack subtly comment in the book, 'all plots tend to move deathwards. This is the nature of plots' (DeLillo 1985/2011:26). Or, as Zygmunt Bauman has argued, death

is perhaps at its most potent when we do not talk about it and when we manage to live our lives as if death did not really matter (Bauman 1992a:7).

As this chapter has shown, Don DeLillo's *White Noise* is not just a piece of fiction, but also a kind of social commentary that makes it possible through the novel to glimpse many important aspects – that are sometimes difficult to document or study through conventional research methods – of our culture's complicated relationship to death and dying. Despite its impressive and insightful inventory of ideas, it is questionable if DeLillo's *White Noise* delivers a mirror image of contemporary death as it is experienced and reflected in real life, but in its own deliberately distorted way, it points to some of the ways in which our understanding of and approach to death have changed, culminating in a culture that simultaneously fears death and embraces it. It captures the very core of our innate ambivalence towards death. In the beginning of the chapter, we quote an insight from Torben Beck Jørgensen on the advantages of fictional texts as compared to conventional 'research knowledge'. Let us here towards the end once again resort to an insight from him on why we should appreciate the wisdom found in literary texts:

> It is meaningless to claim that a novel should be verifiable! . . . Literature does not necessarily create 'truthful' knowledge, which means correct or detailed descriptions of objective, identifiable outer aspects of reality. . . . Literature creates provocative knowledge – meaning knowledge that does not fit into existing schemas of thought. It raises problems and asks questions about that which exists. Is it really like this? Does it have to be like this?
>
> Jørgensen 1986:233–234

White Noise, without explicitly posing this question, makes us consider if our relationship to death really has to be the way DeLillo describes. It makes us contemplate if there are other – perhaps more reasonable, healthy, and meaningful – ways of living life with death.

References

Alworth, David J. (2010): 'Supermarket Sociology'. *New Literary History*, 41 (2):301–327.

Ariès, Philippe (1974): *Western Attitudes toward Death from the Middle Ages to the Present*. Baltimore: Johns Hopkins University Press.

Baudrillard, Jean (1970/1998): *Consumer Society: Myths and Structures*. London: Sage Publications.

Baudrillard, Jean (1983): *Simulations*. Cambridge, MA: MIT Press.

Bauman, Zygmunt (1992a): *Mortality, Immortality and Other Life Strategies*. Cambridge: Polity Press.

Bauman, Zygmunt (1992b): 'Survival as a Social Construct'. *Theory, Culture & Society*, 9 (1):1–36.

Bauman, Zygmunt and Riccardo Mazzeo (2016): *In Praise of Literature*. Cambridge: Polity Press.

Beck, Ulrich (1992): *Risk Society: Towards a New Modernity*. Cambridge: Polity Press.

Bilton, Alan (2002): *An Introduction to Contemporary American Fiction*. Edinburgh: Edinburgh University Press.

Boxall, Peter (2006): *Don DeLillo: The Possibility of Fiction*. London: Routledge.

Brown, Mick (2016): 'Don DeLillo: "If Science Makes Life after Death Possible, We Have to Follow It"'. *The Telegraph*, June 12.

Brown, Richard H. (1977): *A Poetic for Sociology: Toward a Logic of Discovery for the Human Sciences*. Chicago: University of Chicago Press.

Calvino, Italo (1986): *The Uses of Literature*. San Diego: Harcourt, Brace & Company.

Coser, Lewis (ed.) (1963): *Sociology Through Literature: An Introductory Reader*. Englewood Cliffs, NJ: Prentice-Hall.

DeLillo, Don (1985/2011): *White Noise*. London: Picador.

Devetak, Richard (2009): 'After the Event: Don DeLillo's *White Noise* and September 11 Narratives'. *Review of International Studies*, 35 (4):795–815.

Elias, Norbert (1985/2001): *The Loneliness of the Dying*. London: Continuum Books.

Hakola, Outi and Sari Kivistö (eds.) (2014): *Death in Literature*. Newcastle upon Tyne: Cambridge Scholars Publishing.

Helvacioglu, Banu (2015): '"Modern Death" in Don DeLillo: A Parody of Life?'. *Mosaic: An Interdisciplinary Critical Journal*, 48 (2):179–196.

Henneberg, Julian (2011): '"Something Extraordinary Hovering Just Outside Our Touch": The Technological Sublime in Don DeLillo's *White Noise*'. *Aspeers: Emerging Voices in American Fiction*, 4:52–73.

Jacobsen, Michael Hviid (2016): '"Spectacular Death": Proposing a New Fifth Phase to Philippe Ariès's Admirable History of Death'. *Humanities*, 5 (19):1–20.

Jacobsen, Michael Hviid (ed.) (2017): *Postmortal Society: Towards a Sociology of Immortality*. London: Routledge.

Jacobsen, Michael Hviid, Michael S. Drake, Kieran Keohane and Anders Petersen (eds.) (2014): *Imaginative Methodologies in the Social Sciences: Creativity, Poetics and Rhetoric in Social Research*. Farnham: Ashgate Publishing.

Jameson, Frederic (1984): 'Postmodernism, or, the Cultural Logic of Late Capitalism'. *New Left Review*, 1 (146):53–92.

Jernigan, Daniel K., Walter Wadiak and W. Michelle Wang (eds.) (2018): *Narrating Death: The Limit of Literature*. London: Routledge.

Jørgensen, Torben Beck (1986): *Magtens spejl: Myndighed og borger i skønlitteraturen*. Copenhagen: Nyt fra Samfundsvidenskaberne.

Khapaeva, Dina (2017): *The Celebration of Death in Contemporary Culture*. Ann Arbor, MI: University of Michigan Press.

Lavine, Thelma Z. (1984): *From Socrates to Sartre: The Philosophical Quest*. New York: Bamtam Books.

Lepenies, Wolf (1988): *Between Literature and Science: The Rise of Sociology*. Cambridge: Cambridge University Press.

Machlup, Fritz (1956): 'The Inferiority Complex of the Social Sciences'. In Mary Sennholz (ed.): *Freedom and Free Enterprise*. Princeton, NJ: Van Nordstrand, pp. 161–172.

Mills, C. Wright (1959): *The Sociological Imagination*. New York: Oxford University Press.

Nisbet, Robert (1976/2002): *Sociology as an Art Form*. New Brunswick, NJ: Transaction Publishers.

Noys, Benjamin (2005): *The Culture of Death*. Oxford: Berg.

Olster, Stacey (2008): 'White Noise'. In John N. Duvall (ed.): *The Cambridge Companion to Don DeLillo*. Cambridge: Cambridge University Press, pp. 79–93.

Osteen, Mark (2000): *American Magic and Dread: Don DeLillo's Dialogue with Culture*. Philadelphia: University of Pennsylvania Press.

Petersen, Anders and Michael Hviid Jacobsen (2012): 'Houellebecq's Dystopia: A Case of the Elective Affinity between Sociology and Literature'. In Michael Hviid Jacobsen and Keith Tester (eds.): *Utopia: Social Theory and the Future*. Aldershot: Ashgate Publishing, pp. 97–120.

Prior, Lindsay (1989): *The Social Organisation of Death: Medical Discourse and Social Practice in Belfast*. London: Macmillan.

Rossini, Jon D. (2016): 'DeLillo, Performance and the Denial of Death'. In Lisa K. Perdigao and Mark Pizzato (eds.): *Death in American Texts and Performances: Corpses, Ghosts and the Reanimated Dead*. London: Routledge, pp. 45–62.

Sakaama, Hassen (2018): 'Death as an Overarching Signifier in Don DeLillo's *White Noise*'. *International Journal of Humanities and Cultural Studies*, 4 (4):232–244.

Schopenhauer, Arthur (1819/1966): *The World as Will and Representation* (Volume 2). New York: Dover Publications.

Skelton, John (2003): 'Death and Dying in Literature'. *Advances in Psychiatric Treatment*, 9 (3):211–217.

Sundberg, Antti (2014): '"Every Disaster Made Us Wish for More": Cinematic Deaths in Don DeLillo's *White Noise*'. In Outi Hakola and Sari Kivistö (eds.): *Death in Literature*. Newcastle upon Tyne: Cambridge Scholars Publishing, pp. 169–180.

Teodorescu, Adriana (ed.) (2015): *Death Representations in Literature: Forms and Theories*. Cambridge: Cambridge Scholars Publishing.

Walter, Tony (1994): *The Revival of Death*. London: Routledge.

Webb, Eugene J. et al. (1966): *Unobtrusive Measures: Nonreactive Research in the Social Sciences*. New York: Rand McNally.

Weekes, Karen (2007): 'Consuming and Dying: Meaning and the Marketplace in Don DeLillo's *White Noise*'. *Literary Interpretation Theory*, 18 (4):285–302.

Weir, Robert F. (ed.) (1980): *Death in Literature*. New York: Columbia University Press.

12 Narratives of death and immortality in the 'Islamic State' discourse on Twitter

Adriana Teodorescu

Introduction: investigating the personal dimension of terrorist discourse in the context of popular culture

Since death usually tends to be set against an ethical background within the Western world, as the Latin expression de *mortuis nihil nisi bonum* suggests (*of the dead, nothing unless good*), the deaths of those considered to inflict violence, terror, and ultimately death risk poor documentation. A kind of taboo composed of fear, disgust, and a self-sustaining lack of knowledge encumbers scholarly investigations into the personal configurations of death and dying for terrorists, criminals, and other people considered to be agents of evil (Vollum and Longmire 2009; Bourrie 2016) so that the reasons and thanatic imagery of the perpetrators are overlooked or non-assimilated by the social interpretations of such violent acts. Generally speaking, the sociological and counter-terrorist explanations and theories regarding the terrorist approach to death (such as, for example, the demotion of the Other from being to object as a necessary step for motivating and committing the crime) remain, of course, valid, but as their main focus is not on the personal death conceptions of individual terrorists, they are unable to cover all nuances. Therefore, they often miss observing that consenting to commit acts of terrorism is most of the time a matter of psychological process and the crystallization of an unflinching idea of death and otherness or that, when it comes to social media, there are multiple interactions between, on one side, the (potential) supporters of terrorism and, on the other, those interested in them.

However, one must be careful not to mistake the notion of 'personal' (personal level, personal conception, personal reactions, etc.) with what is frequently deemed the fundamental feature of the personal: namely, the 'genuine', the 'authentic'. Besides the fact that any personal level is socially conditioned (Berger and Luckmann 1966), the personal level of the ways in which the terrorists assign meanings to life and cope with death frequently implies propaganda in at least two major ways. On one hand, propaganda that they had internalized and, on the other, propaganda that they are producing in order to persuade the readers to endorse their views and actions, as well as to reassure themselves. Especially in recent years, social media has proven

to be an excellent tool for radical groups to promote their ideas. This happens not only because the visibility of extremism increases significantly, but also due to the illusion of authenticity: no matter how socially manipulated and stereotyped, the fact that Twitter or Facebook accounts could address issues regarding life and death from an individual perspective was, from the start, a strategic asset to terrorist organizations. These organizations now have the power to generate emotions with the effect of offering personal representations and images of (presumably flesh-and-blood) people suffering for their beliefs, from finding the courage to take the path of extremism – which always correlates with social proscription – to fighting and sometimes dying for their convictions.

The present chapter aims to explore the online discourse of the Islamic State (ISIS) militants – namely, supporters of the group, as well as fighters – and at pointing out the fundamental role played by the references to death and the afterlife and representations of dying in constructing this discourse. The chapter emphasizes the fact that purposely thinking about and evoking death and dying generate strong emotions that are consciously used by ISIS militants to persuade the public (and also themselves) to think and act according to their own principles and rules. Also, the chapter desires to spotlight the (perhaps) unprecedented role played by social media, particularly by Twitter, as a growing part of popular culture (see Gaudin 2012; Coen 2016), in disseminating images and visions related to death and in impacting negatively on the ways in which people react to certain events and make meaning of their lives. In this way, the chapter contributes to the general topic of the volume – death in contemporary popular culture – revealing the urgency to address both the popular culture's heavy influence on individuals' attitudes towards life and death and its neglected potential to penetrate various aspects of society (see Patalay 2009; Cross 2012).

From late February 2015 to early July 2015, I collected data and analyzed 300 Twitter accounts of English- and French-speaking militants (due to the author's linguistic limitations), men and women, irrespective of their current location – be it Western or non-Western countries or territories that may or may not have been under ISIS control. The majority of the 300 explored accounts belonged to men. Some 15 accounts were owned by 'celebrities' – hate preachers – based in London, including Anjem Chouadary, Mizanur Rahman, and Abu Baraa. Many accounts belonged to foreign fighters joining ISIS from France, the United Kingdom, the Netherlands, Belgium, Australia, and other Westerners (including women) planning to join the Islamic State in the near future. There were accounts for which I could not identify the owner type, possibly belonging to professional recruiters – although I tend to believe recruiting was a goal for all of them – and others to supporters that had not yet joined the Islamic State army but manifested a consistent sympathy towards the Islamic State's doctrine.[1]

I believe many readers of this chapter are familiar with the Islamic State extremist group, which has gained fame in the Western world in recent years,

most notably with attacks committed in Europe by people pledging allegiance to the Islamic State and, earlier, with the grim videos of the beheadings of four Western citizens (John Foley, David Haines, Steven J. Sotloff, and Alan Henning), which circulated from 2014 to 2015 throughout mass media all over the world. I will relate some basic facts about them, without touching on controversial issues such as whether they are truly religious and Islamic (Harris and Wood 2015; Wood 2015; Hamid 2014) or anti-religious and non-Islamic (Gilsinan 2015; Moghul 2015). Known as ISIS (Islamic State of Iraq and Syria/Islamic State of Iraq and ash-Sham), ISIL (Islamic State of Iraq and the Levant), IS (Islamic State), or Daesh (the Arab acronym) – please note that in this chapter I will use the acronym ISIS to refer to the Islamic State group – they are a Salafi jihadist extremist militant group. Since 2013–2014, they have seized large swaths of territory in Syria and Iraq and gained limited control in Libya and Nigeria, having affiliates also in other parts of the world, including South Asia. As a self-proclaimed Islamic State and caliphate (June 2014), it claims authority over Muslims all over the world. The Islamic State is committed to purifying the world by killing those who do not want to live according to their extremist religious lifestyle. Contrary to the perceptions of popular culture and self-centred Western mass media, the most common victims are, in fact, alleged Muslim apostates, rather than Western citizens. ISIS is held responsible for war crimes and has been identified as a terrorist organization by the United Nations, European Union, United Kingdom, United States and many more (see Weiss and Hassan 2015; Cockburn 2014). Since 2017, when the group lost control of their headquarter, Mosul, ISIS territorial dominance has strongly diminished.

Scholars and journalists underscore the fact that the Islamic State has excellent, unprecedented skills in the use of social media to promote their radical massages of ultra-violence as a means to achieve a better world, and to recruit followers. The 'jihadi chic' phenomenon, as scholars J. M. Berger and Jessica Stern (2015) called it, refers to the seductive way in which ISIS constructs its social media discourse having primarily Western audiences in mind – exactly the audiences of the 300 accounts analysed in this chapter. Indeed, since 2014, more than 20,000 foreign fighters, including those from Western countries, have joined the Islamic State in Syria and Iraq, and it seems that the skilled use of social media has played an important role (Berger 2014; Irshaid 2014). The number of Twitter accounts linked to the Islamic State varies. The minimum estimated number is 9,000 (Cuthbertson 2015), while the maximum is 90,000 (Hall 2015). A study from 2015, conducted by Jonathon Morgan and online extremism expert, J. M. Berger (Berger and Morgan 2015), found around 45,000 ISIS accounts operated by supporters/fighters of ISIS (see also: Varghese 2015; Alfred 2015; *Nearly 50,000 Pro-Islamic State Twitter Accounts* 2015).

The investigation was conducted from a cultural and death studies perspective and not from a firm criminological or counter-terrorist point of view, although the findings of this research may very well be of interest to

specialists in these fields as well. The readers of this chapter must be warned that this is by no means a work that covers all aspects related to Islamic terrorism, or to the terrorism practiced by the Islamic State group. There is no such pretence in this chapter which, more modestly, directs its focus toward analysing the configurations of death and the most important connected topics, dying, immortality and the afterlife, within the discourse of the Islamic State militants active on Twitter – a discourse considered to be extremist and ideological, yet, at the same time, almost paradoxically, highly personalised. An ethical disclaimer is needed at this point: the approach of this chapter is analytical and descriptive in the sense that it lacks strong critical and moral tones towards its subject – establishing the criminal nature of the discourse and actions of the Islamic State militants does not fall under the scope of this chapter. Rather it seeks purely to document a social, popular culture phenomenon in terms of the use of online personalised text, revealing social media's ability to shape popular culture and the latter's capacity to promote problematic narratives of death and dying.

In the following sections I will discuss some of the results of the undertaken research. Part two is dedicated to observing the linguistic features of ISIS discourse on Twitter – the syntactical, morphological and stylistic redundancy, the humour and the ways in which the text constructs its reader. Part three deals with the narrative of the heroic and glamorized death of the ISIS fighter – discussing the processes of idealization that underpin it both at the textual and imagistic level, and the most frequent and powerful death representations of ISIS: the Hollywood-like superhero, the medieval knight and the beautiful death. The forth section analyses the narrative of the terrestrial paradise of the caliphate/'Khilafah' and the fundamental and intriguing role played by symbolic immortality in its configuration. The final section presents the conclusions of the chapter, underlining the methodological challenges encountered in collecting the data.

Language features of the ISIS discourse

After spending a considerable amount of time amongst ISIS tweets, the reader may get the impression that they begin to form a large chorus. The most prominent and blatant feature of the ISIS language is definitely redundancy. The ISIS militants seem to never be tired of insisting on the same ideas and images over and over again. This redundancy manifests itself on one hand at the semantic and morphological level, and, on the other, at the stylistic level. On the morpho-semantic level, it is to be noticed that the most used words belong to one of the following three semantic registers that are polarized in their structure, by a positive and a negative axis. (1) The spiritual register: on the positive axis, there are words (and for many of them the Arabic synonyms) such as afterlife/*Akhirah*, heaven/*Jannah*/paradise, hereafter, believers, while on the negative axis: *Dunya* (refers to this existing and negatively connoted world), hell, *Shaytan* (Satan), *kuffar*/*kuffr*/*kaffir* (unbeliever or disbeliever, referring to those who reject the teachings of the Islamic

Prophet Muhammad), rage. (2) The social and political register: on the positive axis, *Khilafah* (the Caliphate; the political system in Islam, responsible for implementing the Islamic system), *Sharia* (the Islamic law, part of the Islamic tradition), Muslims, *Ummah/Umma* (the community of Muslims from all over the world), brothers, *Jihad* (the Holy war in the cause of Allah and His command), and on the negative: US, West, innovation (which is a kind of demon constantly trying to lure believers). (3) The warlike register: on the positive axis: martyrdom, soldier, lions, *mujahid* (with the plural *mujahideen*, the soldiers engaged in *Jihad*), sacrifice, death, dying, slaughter, kill, guns (all employed with a strong positive meaning), while on the negative: kill, die, death, murder, dogs (referring to the non-believers). In one way or another, death crosses all these semantic registers. I found only a few accounts that did not make references to death and dying. The explanation is that those were fresh, new accounts, with small number of tweets. Anyway, for a very good introduction both in explaining aspects regarding the use and meanings of Arabic words and the basic characteristics of Islam the reader can consult the work of Malise Ruthven (2012).

As for the stylistic characteristics of the ISIS discourse, these are pedagogical and aphoristic in tone. Regardless of their age, the ISIS militants seem to be urged to spread teachings throughout the internet and are confident of their pedagogical role, never fearing inadequacy. Judging by the frequency of appearance, there are three main teachings: (1) How to be a good Muslim – without references to war/*Jihad* but from an ultra-conservative perspective: strictly respecting the schedule for Islamic praying, rejecting and denouncing all that is new and of Western nature, etc. (2) How to be a good *mujahid* – with plenty of references to war, death and paradise. (3) How to treasure death – the key element which makes visible, according to ISIS logic, the ontological superiority of an eternal afterlife compared to the fleeting human life. In many accounts, I found a strange humour. It is mostly directed against Western values and occasionally succeeds in being quite appropriate and intelligent in its criticism. Here are some samples from the data collected from Twitter:[2]

Worrying about the *dunya* is a darkness in the heart, while worrying about the *akhirah* is a light in the heart.

U1

The life of this world is just a temporary test from Allah, the real life is the hereafter & only the believers (Muslims) will enter paradise.

U2

Death is around the corner, people don't like to talk about it, but its not something to hide.

U3

Born alone. Die alone. Resurrected alone to be judged alone.

U4

There are five types of implied reader (i.e. the addressee, the textual position allocated to the reader, or the reader constructed by the text) in the ISIS discourse on Twitter. First, they address their discourse to a general, strong enemy which is the Western World and often the United States. This enemy cannot be tamed or convinced to adhere to ISIS, therefore it must be destroyed, yet still warned. Not for an eventual, belated redemption or conversion, but for the pleasure that ISIS takes from symbolically and linguistically killing the enemy. 'Die in your rage', is a common expression of ISIS supporters when indicating the general enemy (but frequently used when referring to a particular one as well). The great advantage offered by such a verbal murder is that the murdered (collective and cultural) witnesses their own assassination. An interesting aspect that is worthy to be noticed is that what happens is an emotional transfer from the producer of the discourse (the ISIS militant) to the receiver or the implied reader. Revealing both how ISIS perceives alterity and the way ISIS believes itself to be perceived by it, the rage indeed belongs to the enemy (*your rage*), but only because of the emotional transfer. A transfer which seems to leave ISIS in a state of transitory frailty:

> You can kill our parents, destroy our houses but you can never defeat us . . . We are waiting . . . Die in your rage
>
> U5

Secondly, the general, weak, enemy – namely Western citizens – that can be threatened, but for which there is still hope to be converted to Islam, as understood by ISIS. The third type of implied reader is the close/kindred enemy which are either the Shia Muslims or the reluctant Sunni Muslims. Let us not forget that the greatest problem for ISIS is not Western citizens, but Muslim communities from the Middle East, Africa, Europe and the United States, who do not recognize an Islamic essence in the group's actions and ideas. There are, however, two types of implied reader that are seen in a positive light: the global community of Muslims (*Ummah*), and the ISIS fighters (also called *mujahideen* or brothers). Almost every ISIS Twitter account has all five types of implied reader. From this point of view, no matter how awkward it may sound, we can speak of a polyphonic discourse. No matter how simplistic and narrow, we are witnessing a call for dialogue from the part of ISIS, which is quite innovative if we compare it to previous types of communication practiced by other terrorist groups. This does not alleviate the violence of their discourse and does not embellish the caricature-like, schematic portrayal of the implied reader, this one representing the textual figure of their psychological and cultural perception of Otherness. In fact, this poor and artificial linguistic openness was correlated with ISIS desire to determine Westerners joining their troops (Trianni and Katz 2014).

The language that ISIS militants employ is more pragmatic and normative than descriptive and natural. It does not reflect a genuine self, but rather the utopian self for which they strive. Nevertheless, this does not mean that one

can conclude that ISIS militants lack sincerity. It's just that their sincerity does not totally dwell in language; it largely transcends it. The logical consequence is that at least some of their individual linguistic expressions are obscured or underdeveloped. The stylistic and morphological redundancy is the linguistic correlative of a feeling of total, ontological certainty, conveyed to the readers of ISIS tweets. Not of a real, present one, but, again, of a desired, conjured certainty, which is not indebted to language. We can imagine the possible impact of these strategies of proposing a world without any nonsense, a world so coherent in itself that nobody could doubt its structure and purpose, for Western people (Muslims or not), living in a society that often seems to lose direction and fails to provide the sense of life's meaning to its citizens. It seems that the impact can be even bigger for young Muslims living in the West, who are confronted with discrimination, poverty, or who did not accommodate to Western way of living, as well as for young Muslims from the modern Muslim countries (Syria might be the best example), characterized by political chaos or corruption. Of course, the risk grows for youngsters, who experience problems with their identity and sense of purpose (Trianni and Katz 2014; Napoleoni 2014).

In fact, there are journalists, social analysts and social activists who explain the process of radicalisation – including specific cases such as that of British citizen Mohammad Emwazi (dubbed 'Jihadi John'), responsible for the footage of Western prisoners being beheaded whilst uttering threats towards Western governances – by developing the idea of a symbolic compensation for the weakening of social ties and for the dissolution of truth, a compensation that Western people are encouraged to find in the ISIS discourse (Selby 2015; Krol 2015). All these strategies exploit the thin line between individual agency and social power, a line that, on the other hand, is very much discussed by journalists and scholars interested in seeing if it is indeed possible for a person to be completely evil (see Stanley 2015; Cottee 2015).

The heroic and glamorized death of the *mujahid*

Marco Lombardi, a specialist in terrorism issues, contended, in an interview, that part of the communication philosophy of ISIS is deeply rooted in our times. He thus terms ISIS as being postmodern (global and delocalised), with a strong asset in its capacity to understand its Western enemy and in attracting followers (Alvanou 2015). They are not the first to have used media and technology to convey their messages – Al-Qaeda, says Lombardi, used them even more, in terms of quantity. Nevertheless, they learned to employ social media in a competent and efficient, professional manner. Lombardi stresses that, despite this, we should not consider ISIS as being innovative. However, one could disagree, if taking into account that ISIS are the ones who discovered and exploited the very postmodern potential of social media to function as a platform where stories are promoted. Numerous similarly themed stories exist – often gruesome, but always presented from a personal standpoint (or

from an interpersonal standpoint, as in the case of the wives of the ISIS fighters), a fact that makes them powerful versions of the same meta-narrative – which portray ISIS taking over the world.

> The whole world will one day be under the authority of the Muslims implementing the divine law of Islam!!!.
>
> U6

Moreover, what is specific is that these stories call for participation, are open structures permeating into reality, combining a sort of fictional character (at least for the Western audience, they are exotic), with the suggestion that this fiction itself could be an illusion (because these stories are a form of live transmission, they are always happening now), thus oscillating between concrete reality and a realm of stories. Using tweets to create (fragments of) stories can be quite dangerous, because, as Jonathan Gottschall (2012), summarising a number of studies, observes, there are many circumstances in which fiction can modify the most profound beliefs and moral values of those consuming it more than real facts are able to do. This hybridity eases the process of identification and encourages imitating behaviours:

> Social Media became virtual rooms open to the world where fighters tell their stories from the battlefield . . . [the] Islamic State granted more time online to these stories from the battlefield. They are captivating and they focus on single individuals, thus boosting viral imitating behaviors that are crucial in the recruiting process.
>
> Alvanou 2015

The heroic and glamorized death of the *mujahid* is, along with the figuration of the terrestrial paradise that ISIS strives for, one of the most powerful narratives that ISIS militants construct within their Twitter messages. The Arabic *mujahid* (plural: *mujahideen*) – originally means: the one who struggles for the sake of Allah. ISIS uses this term as a label for those fighting to implement the ISIS ideology. The *mujahideen* themselves present glimpses of their own lives and aphorisms concerning death from the battlefields or their surroundings, or they are referred to by their wives (or women willing to marry a *mujahid*), and by militants who do not disclose whether they are ISIS fighters or just supporters. A brief portrait of the ISIS *mujahid*, as emerging from the observation of the 300 accounts, has to be discussed by taking into consideration three dimensions playing a significant part in his online representations: the axiological, the social and the spiritual dimension. Axiologically, the *mujahid* endorses the extremist idea of religiously and politically necessary violence against the enemies of ISIS, be they Muslims or Westerners. Socially, the *mujahid* has a constructive, essential role for the future of the Islamic State, in the sense that he is the main instrument necessary for establishing a caliphate. Without the *mujahid*'s will to fight and face death, there would be no hope of building a perfect Islamic realm. Nevertheless, the *mujahid* has also

a destructive role: he is considered to be entitled to avenge the presumed evil
suffered by Muslims over time by threatening and killing Western citizens or
Muslims apostates

> The West is always telling the Muslims to condemn the beheadings by
> Jihadi John! Why doesn't the West condemn their murders of Muslims??.
>
> U6

Spiritually, he embraces and praises death. This means he is always ready to
die either by being killed or martyred, which in ISIS discourse is, most of the
time, tantamount to deliberate self-destruction in order to take enemy targets
with you. Moreover, death is seen as the favoured, most sure way to achieve
paradise/*Jannah*. The *mujahid* symbolically diminishes his individual impor-
tance by submerging his life meaning into that of the group.

The *mujahid*, as displayed by the ISIS discourse, undergoes a psychologi-
cal, rhetorically articulated, process of idealization, with the help of which
ISIS tames and morally justifies its acts of violence. This idealization can
be observed within the three intertwined cultural imageries that underpin
the Twitter figure of the brave *mujahid*: (1) the Hollywood-like superhero,
(2) the medieval knight, and (3) the beautiful death.

The first of the three imageries we need to discuss is the Hollywood-like
superhero, which needs to be explored both at the textual and imagistic levels.
This imagery is rendered visible at the textual level by the multiple references
to Hollywood figures such as Rambo, Superman, Batman

> No they don't play as spider man or superman. They play as *mujahideen*:)
>
> U7

by the strong positive emphasis on guns, especially the Kalashnikov as the
perfect means of protecting cultural values and people, by the dehuman-
ization of the enemies which, ISIS says, resemble cockroaches (if they are
Muslim apostates) and dogs (if they are Westerners). As scholars like Philip
Zimbardo (2008) and Albert Bandura (2015) have observed, this dehuman-
ization of the Other is one of the main techniques that terrorists use to dis-
engage themselves from the consequences of their actions. At the imagistic
level, the Hollywood imagery can be perceived in the staged photos of ISIS
fighters, always posing, extremely self-confident, with sophisticated gear in
the background. Often, the *mujahideen* are represented in digitally manipu-
lated drawings (i.e., not real photos), with garish, unnatural colours, together
with their dead enemies. Their specific mask or hood that surrounds the head
is frequently present, however not always.[3] What is conveyed at both levels
(textual and imagistic) is that the *mujahid* is a hero because, while facing
death, he is endowed with the ability to bring justice into the world. How-
ever, the Hollywood-like imagery primarily triggers death representations of
the enemy. In other words, when this imagery is active, the textual and imag-
istic representations of the death of the enemy prevail.[4]

The second imagery associated with the *mujahid* corresponds to the medieval imagery of the knight. Logically speaking, the medieval imagery appears to be in sharp contradiction to the Hollywood imagery. Because the whole idea of falling back upon a medieval symbolism is to express disavowal and hatred against Western modernity. However, the terrorist discourse is not the only one where there are lurking contradictions, paradoxes and competitive, often conflictual representations, all these being characteristic of many 'convince at any cost' social discourses. At the textual level, we can find references to swords, horses, and lions, all imbued with highly positive meaning and suggesting nostalgia for a kind of cultural primitivism, in opposition to Western guns and bombs, and Western innovation, seen as a major flaw:

The Prophet ﷺ said: Paradise is under the shade of swords.

U8

Mentalité moyen-âgeuse, je n'adhère pas au moeurs de votre époque.

U9

Advanced technology cannot beat the *Mujahideen*. Do not underestimate the soldiers of Allah.

U10

What is specific to this imagistic side is the lack of photos of actual ISIS fighters, in preference to digitally modified images. The explanation is obvious: ISIS does not possess real medieval outfits, nor do they hang out with lions. These images tend to be very gloomy; the *mujahid* is portrayed wearing armour, holding in his hands the black flag of ISIS, riding a horse, alone or in the company of other *mujahideen*. In one image, the land on which they walk is full of green grass, while only the surroundings are marked by the signs of war and civilisation (high concrete buildings etc.), suggesting the discrepancy between the Islamic State, the Caliphate, perceived as a return to nature that they announce and fight for, and the rest of the world. In another digitally altered photo portraying the ISIS *mujahideen* (circulated across several Twitter accounts) there is the following statement: 'We are people that don't depend on weapons and numbers to win our wars, but depends on Faith'. The *mujahid* is still the hero who inflicts death, as portrayed in the Hollywood-like imagery, but, when adding the medieval dimension, the medieval *mujahid* is forced to bow before the superior weaponry of the West, acknowledging the increased likelihood of his own death. The text and images nevertheless convey that this personal proximity to death of any individual *mujahid*, raises no doubt whatsoever that the final victory will belong to ISIS.

Third, the most salient imagery is that of the beautiful death. And it may be even more socially important because it makes the narrative of the brave *mujahid* more dangerous as a tool of propaganda by advocating that death has greater value than life. I've identified two major types of representation

engendered by the beautiful death imagery: (1) The representation of dead ISIS soldiers, always seen as having sacrificed themselves for ISIS; (2) The representation of death as a desirable feature/realm. Only the first type of these representations will be discussed here, as the second is more relevant to the construction of the other powerful ISIS narrative – the (pre)figuration of the caliphate.

Accounts of ISIS militants abound in representations of dead Islamic State soldiers. They announce when martyrdom operations take place and they pray that Allah grants them paradise. Those who die are perceived as beautiful by those who remain. Death immediately embellishes all:

> My beautiful brother 'Ikrimah, what a marvelous smile may Allah accept you in Jannat al-firdaous, amīn!
>
> U11

But much more striking are the images that follow the text. Although ISIS militants use photos from the battlefield, it is believed that they manipulate the corpses before taking photos; making the ISIS soldiers look, amongst other things, as if they were smiling.

One of the ISIS strategies of visually constructing the beautiful death of a *mujahid* is by comparing his death with that of the enemy, thus making a macabre kind of competition for who has the best death. If the first is beautiful and good, the second is ugly and painful. The *mujahid*, with a smile on his face, enters paradise, while the disfigured and deformed enemy goes straight to hell. Even if the *mujahid* is killed by the enemy, his beautiful death enables him, as ISIS images and texts suggest, to symbolically defeat his still living enemy, anticipating the future victory of the ISIS:

> How can we[5] defeat them when their death is this beautiful?
>
> U12

Another strategy employed to visually construct the beautiful death of the *mujahid* is the use of two visual narrative patterns for a martyrdom operation. The martyrdom operation is, in ISIS conception displayed on Twitter, the deliberative military operation planned, often announced and conducted by a *mujahid* who knows that most probably he will find his own death. When ISIS fighters blow themselves up and there is no body left, the visual narrative pattern usually consists of three photos representing essentials moments of carrying out the attack. First, the smiling and presumably relaxed *mujahid* posing with his index finger pointing up, a gesture that besides being the already classical ISIS salute, represents the Islamic creed of *shahada* ('There is no God but Allah, and Muhammad is his Prophet'). The second photo displays the future martyr together with his military equipment (a car with explosive devices), again, relaxed and smiling. The third photo shows the aftermath of the suicide, namely the dense smoke of the explosion. When

the body does not disappear, the visual pattern consists of two photos. The first, with the beautiful and vivid *mujahid*, but not necessarily smiling, and the second exposing his corpse, smiling and often with the eyes wide opened. As for the smile, the Islamic State militants place great emphasis on this:

UN MUSULMAN RÉPOND PAR LE SOURIRE LÀ OU TOUT LE MONDE ATTENDRAIT SA COLÈRE.

U13

The fundamental difference between us and the Americans is simple. They live with smiles on their faces and we die with smiles on our faces.
Jihadi John @islamujahideen, February 27, 2015

May Allah grant victory to the *mujahideen* from All fronts and unite them! O how I envy your smiles and the musk emanating from your blood!

U14

LE FRÈRE ABOU WALIYA ALFARANCI: juste avant son mrtyr il m a tué avec son sourire et son regard.

U15

The smile in general is seen as a means of communication within the Muslim brotherhood and a symbol for the Muslim conception of the world, based on the strong belief in immortality and on obedience, as opposed to a Western hedonistic and individualistic conception. In fact, the opposite symbol of the smile is the RAGE. 'Die in your rage, Kuffar', being a frequent expression in ISIS accounts, as previously mentioned. The ISIS representations of the smile are built up on a thanatic foundation, in the sense that the smile expresses serenity and self-control engendered by the acceptance of death as a possibility at any moment, the smile of a dead martyr indicating the revelation of Paradise/*Jannah*.

The (pre)figuration of the terrestrial paradise of 'Khilafah'

The imagery of the beautiful death is responsible not only for the representations of dead ISIS soldiers, but also for the textual representation of death as a desirable feature/realm. The reason for which I choose to discuss this here is that it has more relevance to the figuration of the terrestrial paradise of the caliphate, as understood by ISIS than to the narrative of the brave *mujahid*. And we will see how this is possible.

Grafted onto the Islamic belief in the continued existence of a soul (Cassis 1997:48–66), it is a privileged, almost commonplace idea in ISIS Twitter discourse, that ISIS followers, whether soldiers or just supporters, love (it is exactly this word that they use) death more than Western citizens love life. The ISIS approach on this matter emphasizes, again, the same competitive

dimension. The Western world is seen as obsessed with a quality of life defined mostly by the acquisition of wealth and lacking any spiritual meaning. ISIS opposes this obsession, deeming it to be shallow and politically manipulated, in favour of the obsession for death. Many account owners manifest their longing for death, a very common expression being: 'may Allah grant us martyrdom'. A good death becomes the object of desire for ISIS supporters, just as a good life already is for the Westerners. There is a vague erotic vocabulary that alludes to a thanatic romanticism,[6] eliciting positive emotions, but there is also a vocabulary suggesting that within the ISIS discourse, death suffers, ironically, a paradoxical process of commodification. It becomes a tradable item, on a hungry death market. Death seems in this way to be set against a Western-style background. There is an entire pedagogy of the good death in the ISIS discourse on Twitter. The reason for such an approach to death is their religiously inspired certainty that death is only the door through which one enters paradise. By this conception, the suicide/martyrdom is a shortcut to a literal, absolute immortality and, thus it can only be beautiful and correct (a death for Allah, as some tweets emphasise), while trying to live at any cost, and even enjoying life, is seen as sinful and a sure way to throw away the chance of a literal immortality:

> We love DEATH as much you love and enjoy this LIFE. That its one of the differences between us, Kuffar.
>
> U16

> Don't be sad my mama. Your son is rushing to Allah. Ya Allah, one bullet away from you!
>
> U17

> For every journey there is a short cut, and the short cut to *Jannah* (paradise)
>
> U18

> J'éspère en Allah que je vais mourir.
>
> U19

> Tout être humains va à la mort pour passer à la vie sauf les moujahidines ils passent par la mort pour aller à la vie.
>
> U19

> Allah is our objective Quran is our constitution Prophet ﷺ is our leader Death for sake of Allah is highest of our aspirations.
>
> U20

This apparently strong belief in a literal immortality nurtured by ISIS militants has divided those interested in ISIS and terrorist phenomena. There are voices that contend that what drives them to commit crimes and martyrdoms are political agendas, economic issues or a sense of male camaraderie, and thus they defy the idea crossing all ISIS tweets, of a genuine belief in immortality

(Al-Gharbi 2017). Others see in it a religious expression articulated by millenarianism (Harris and Wood 2015). Both parties may be right if we take into account that their political and economic agendas are also marked by the need for immortality, only this time a different, non-literal version.

The literal immortality that ISIS discusses with great pleasure in their texts, without, however, portraying it in images (visual representations of Allah are forbidden according to Islamic tradition, and thus also the afterlife seems resistant to visual representation), cannot be fully comprehended in the absence of another significant narrative which gives birth to representations of a terrestrial paradise, namely the utopic 'Khilafah'/the Caliphate. This narrative – according to which ISIS will succeed, in the near future (expanding the territories they already control) to create a heaven on earth where all Muslims will live together in peace, according to their law and tradition, forming a perfect *Ummah* – functions as a facilitator for the acceptance and consent to die by the *mujahideen* and ISIS supporters. Scholars agree that one of the most powerful tools that ISIS use to convince people to join their army is the promise of a very material (as opposed to symbolic) territory regulated by *Sharia*, with a very consistent political and economic system (Napoleoni 2014; Weiss and Hassan 2015) and that this promise must remain attainable, otherwise ISIS will lose its legitimacy (Clarke and Amarasingam 2017). In fact, as it was observed, the self-declared caliphate already revealed undeniable organisational skills: for example, ISIS comprises both civil forces and military armies and has divided its occupied territories from Syria and Iraq into provinces (Aisch et al. 2014). Furthermore, as Shadi Hamid (2014) puts it, the promise of a caliphate has a significant potential for persuasion since it is something held dear by all Muslims who may not agree with ISIS's interpretation of the caliphate, but the notion of a caliphate – the historical political entity governed by Islamic law and tradition – is a powerful one, even among more secular-minded Muslims.

Aside from the idea of building a terrestrial and extendable paradise, the imagery of the Islamic State displays also the need for a symbolic immortality – a much more palpable immortality – not just an absolute, corporeal immortality. The symbolic immortality, coined by Robert Jay Lifton (1968, 1979; see also Lifton and Olson 1974), refers to the universal human need to experience a feeling of continuity and transcendence when confronting the unavoidable reality of personal death. It is a feeling, as the name underlines, attained through such symbolic means as, for example, children, nature, work, art etc. In ISIS perspective noticeable on Twitter, this world (*Akhira*) lacks depth, being, in fact, weaker, ontologically speaking, than the afterlife/*Jannah*, because it drives people far from Allah.

Don't let this dunya take you away from the akhirah.

U21

The caliphate is seen as a middle realm between the world as such and the afterlife. It will restore, according to ISIS suggestions, a certain ontological

force of the world by injecting faith into it and by encouraging moral behaviours. Symbolic immortality would mean, in such a context, that the soldiers of ISIS can think of the caliphate as being a result of their work (fighting, changing their lifestyle in order to strictly respect the Sharia, accidentally or purposely dying), ensuring the symbolic extension beyond their own limited life. As an ISIS supporter militating for the liberation of Kashmir says:

> Kashmir will be free Insha'Allah! It is our belief, the land that absorbs blood of martyrs can never remain occupied. (Indian Occupied Kashmir).
>
> U20

Also, this symbolic immortality is always projected through Others, through the *Ummah*. From the *mujahid* perspective, there are brothers that die and will die very soon with him, but the majority of the brothers will survive a very few deaths:

> When the ranks of the true martyrdom seekers increase, Victory will be around the corner – SHEIKH USAMA (R).
>
> U21

Here's how ISIS spokesman, Abu Muhammad al-Adnani, described the great advantage of ISIS, with a clear representation of symbolic immortality: 'Being killed . . . is a victory . . . You fight a people who can never be defeated. They either gain victory or are killed' (Hamid 2014). In addition, *Sharia* is perceived, as numerous tweets prove, as the law of the Prophet, divine in nature, standing against the changes of time, cultures and civilisations, so that it helps ISIS discourse in reaffirming the symbolic immortality:

> I am a Muslim who believes the divine shari'ah (law) of Islam is superior to any man-made law in the east or west.
>
> U22

> We'll carry on our Jihad and we don't care to barking dogs. Either death or victory until the law of ALLAH prevails globe. #Islamic_State.
>
> U23

Scholars observe that normally symbolic immortality functions both for the benefit of the individual, appeasing anxiety and feelings of closure, and, very importantly, for society and culture, helping them to follow an interest greater that just themselves.[7] Symbolic immortality accepts death, while keeping its disruptive power at bay – something that does not happen with ISIS, who seem to draw a much more devastating, thanatic power from their consent to symbolic immortality. Death becomes stronger than both symbolic and literal immortality – either of which should had have the force to tame the irruptions and manifestations of death. A good example in this sense is the desire of female ISIS supporters not only to marry a fighter who will soon lose his

life, but to give life to *mujahideen*. Thus, where parents usually nurture the hope to be outlived by their children, ISIS women accept and even proclaim their desire to deliver into the world sons that will die before them. This can also be correlated with the general role believed to be assigned to (even very young) children within the ISIS army, to be trained for war, instructed to shoot and to perform beheadings (Stern and Berger 2015). In fact, ISIS accounts also contain photos of children and even toddlers dressed in black and either holding guns or being surrounded by them:

> How I wish 2 be a wife of Mujahid Can give birth, can raise of a future Mujahids, a mother of Mujahid so I can share wid dem what I've learnt.
> U24

> In Shaa Allah hopefully I could raise a future mujahid on my own:-)
> Allahu A'lam bissawaab.
> U25

A possible explanation for the thirst for death and the mental and cultural construction of an immortality, which not even in its symbolical instances is able to control the relationship between man and death (the death drive, the anxiety, etc.) is their apocalyptic orientation. As the end of time as we know it is soon approaching, they feel entitled to act radically, committing crimes in order to achieve their goal. Moreover, the aforementioned (meta-)narrative of ISIS taking over the world is enriched with a moral justification: ISIS has to do this as a response to what they believe to be the contemporary tentacular crusade of the West against Muslims all over the world. Concerning this idea of a crusade, Graeme Wood insists that ISIS holds the hope to re-establish a seventh century-like civilisation (Wood 2015) and then prepare for the Apocalypse (see also McCants 2015). Drawing on the 'good versus evil' story, they pre-empt negative emotions such as the feeling of guilt. Moreover, reversing the Western narrative and perception on them, many Twitter accounts refer to the West and other Muslims as terrorists:

> When was the last time that #USA was not at war with someone? What a violent nation!
> U20

> You're either with the #Muslims OR You're with the #terrorists.
> U22

Until now we have discussed mainly the prefiguration of Khilafah. However, there are ISIS militants who try to offer instances of what Khilafah, despite not being fully established, looks like. ISIS, as the name suggests, is positioning itself as a state governed by justice (on a moral level) and by Sharia (on a legal level):

O America, like it or not the Islamic State is a fully functioning state now.
Get ready for your decline when even non-Muslims want to go.

<div style="text-align: right;">U26</div>

But these are only the rudiments. Under the hashtag 'Land of Khilafah' or similar names, such as 'the Land of Truthful', they put photos with colourful flowers, trees, green meadows, very blue waters of the sea, spectacular cliffs and clouds, and other parts of nature. Some of them look genuine, especially those portraying flowers in details, while other seems to have been digitally altered. There are militants who pose in the grass, surrounded by flowers and even animals (horses, cows, etc.), with the ISIS black flag fluttering in the air. All is natural, except for the moral principles of the ISIS soldiers, portrayed as distributing goods to populations in need from the occupied territories. There is no visual reference to the fact that Khilafah is actually a battlefield, where young men are both killing and dying. In the narrative of the terrestrial paradise of Khilafah, death is symbolically and consciously eliminated from the visual figurations of the caliphate. Still, this happens only when the ISIS Twitter users want to deliver this image of perfection, because otherwise images with mutilated people (and especially, demonstratively, children) by explosions and the chemical weapons used by Syrian president Bashar al-Assad, as well as the grisly images of dead *kuffars* abound *ad nauseam*.

Conclusions

Before summarising the content of this chapter, let us draw some methodological conclusions. I must acknowledge that collecting data for this chapter was not easy at all. I had to deal with three types of difficulty. First of all, practical, material difficulties: in August 2014, Twitter banned all official ISIS accounts. Still, long after that date, during the first months of 2015, there were many pro-ISIS accounts sharing violent content through the network. Twitter waged war and suspended these accounts, which obstinately kept returning in similar form, so that the ex-followers could recognize the owners. Unfortunately for me, suspension meant that all of the tweets from the suspended account were lost. Therefore, collecting information from ISIS accounts was always a race against time. Secondly, working on such a topic raised the issue of expertise. I started this research with the idea of anchoring it in the field of death studies. However, from the beginning I was aware that I needed to know more about other connected fields, namely counter-terrorism studies and Islam studies. I had to read books and articles in order to gain some specific knowledge. Thirdly, I encountered some emotional difficulties. I was haunted by the grisly, all pervading, images. I dreamed of dead people, beheadings and martyrdoms. I often experienced nausea. And, what was surprising for me is that despite being determined not to take sides (although, as Howard S. Becker stated in 1967, 'we cannot avoid taking sides'),[8] in some

moments I even experienced not the hatred I would have expected, but some sort of compassion towards the ISIS fighters, finding myself almost sympathetic towards their political issues.

Perhaps some of these difficulties were due to my inexperience and poor research abilities in the studies of terrorism and counter-terrorism, which affected the main thanatological/death studies approach. However, I am inclined to believe that what happened was that I was emotionally manipulated by the narratives of death, dying and immortality as they unfolded in the ISIS discourse on Twitter. It seems that propaganda is trickier to counteract when it takes the form of personal opinion, very praised in Western popular culture and when it is distributed via such an otherwise friendly social media channel as Twitter. And when the personal opinion manifests in the context of proximity to death, which implies consenting to die and not only to inflict death upon the enemy (a clear sign that propaganda becomes part of those who distribute it) – especially for those that had joined the ISIS troops in Syria, Iraq or Libya, but also for the others who dream about getting there – the reader/the public can become even more susceptible to manipulation. As I already mentioned in the introduction, the personal level of discourse does not automatically entail authenticity. When death forms a significant part of this discourse, the risk of associating authenticity with subjectivity increases, at least for the Western world where the conception of death is tributary to Martin Heidegger's (1962) conception of authenticity as acceptance of one's own mortality. And what is conveyed through the messages spread on Twitter is always a total acceptance of death, both as crime and potential suicide. On the other hand, delivering the illusion of authenticity is a phenomenon that cannot be ridiculed, because it is partially a phenomenon where ISIS militants are, beyond authenticity/non-authenticity, sincere. As Sam Harris emphasizes in his dialogue with Graeme Wood: 'the people who are devoting their lives to waging jihad really believe what they say they believe, however those ideas got into their heads' (Harris and Wood 2015). Or, as Wood underlines:

Its members aren't brainless brutes who cannot think – that's the Orientalist view, and ironically, it's the view that a lot of people who would call themselves anti-Orientalists take when reading the piece. ISIS members are often highly sophisticated people, just as capable of intelligent critical thought as anyone else.

Harris and Wood 2015

In various forms, it appears that death is the core concept of ISIS discourse on Twitter. It shapes the languages at a morphological and stylistic level, and it creates two important narratives, one of the brave *mujahid* willing to die for the advent of a utopian caliphate, and the second of the (pre)figuration of this caliphate as a terrestrial heaven. Perhaps if we want to do something in order to stop the ISIS propaganda – and potentially any propaganda employing death as significant semantic instrument – then a solution would be to render

visible the fact that death and immortality, as reflected by their tweets, are merely a misleading construction meant to seduce people by triggering strong emotions and by offering symbolic compensations for an inherently and circumstantially precarious existence and do not stand for the much more complex reality of war, life and death as such. A caveat should be kept in mind: although the ISIS vision of death is definitely simplistic, especially in relation to the ways they conceive the death of the Other, we cannot oversimplify the whole matter by saying that everything that ISIS's discourse reflects is stupid or insane. In fact, a number of counter-terrorist experts have argued that the chief trait of terrorists is their baffling normality (Hudson 1999) – which is actually much more difficult to accept. But beyond the matters of extremism and terrorism, I believe that the great lesson of ISIS propaganda on Twitter is that death remains a fashionable, redoubtable theme which can find a proper soil in the thanatic propensity of contemporary popular culture and which can be used in order to define and implement various political and social agendas. The power of death in popular culture has, and it is a circular relationship, a lot to do with the power of popular culture to shape death. Additionally, another lesson is that in a Western society that rediscovers the power of stories (Barusch 2012) but cannot always cope with their ambivalence (Gottschall 2012), social media is never a neutral actor or instrument.

Notes

1 In February 2015, I found the alleged account of the dubbed Jihadi John, the British executioner of several American and British ISIS prisoners (David Haines, James Foley and Alan Henning), an account that lasted for no more than two days.
2 I decided to keep, for the sake of authenticity, the grammar and spelling errors present in ISIS tweets. On the other hand, these errors may be indicators of the fact that ISIS militants are pressured (by time, by their superiors) to produce content on Twitter, or, another explanation, of the fact that they are not native English or French speakers, which suggests that these languages are used for propaganda.
 The names of Twitter accounts of the ISIS militants were anonymised to respect their privacy (U1, U2…, etc., from the word 'user', were employed instead). Only the name of Jihadi John, already a public figure, was kept.
3 I would have very much liked to present some revealing examples of the imagistic level, not only for the Hollywood-like hero, but also for the other two categories, the medieval knight and the beautiful death; I know it would have been more convincing. Unfortunately, although I had collected many photos portraying ISIS *mujahideen* in ways which make evident the existence of the three intertwined imageries, due to copyright issues I could not provide any. Moreover, I could not provide links to Twitter accounts because the majority, if not all the investigated accounts had been suspended (see Yadron 2016).
4 This Hollywood-like, glamourized dimension of representing the *mujahid* might be very convincing and manipulative especially for young people, including adolescents, who feel compelled to transcend their limits, while having little knowledge about the many faces and consequences of death. The fact that the majority of ISIS fighters and supporters are young and very young people has been emphasized by scholars and journalists (see Mullen 2015).
5 To be noticed that 'we' is a false one. The author of the tweet fakes his position (as if he was part of the enemies), in order to obtain a stronger effect.
6 Other scholars interested in ISIS phenomenon have spoken about a pornography of death and violence, especially in relation to the tendentious display of the dead *mujahideen* with

their big smile, but also when referring to the images of extremely violence: beheadings, crucifixions etc. This is another indicator of the fact that the ways in which ISIS approaches death are meant to always elicit an emotional response (see Bourrie 2016).

7 As Roy F. Baumeister (1991) puts it, the goal of the individual is to prolong his/her life, while society wants fresh new people to ensure its dynamics. In this sense, symbolic immortality functions like a compromise between the two.

8 Howard S. Becker (1967:239–247) argues that we inherently always take sides. The problem that we have, as researchers, is to make sure that we acknowledge and tame, as much as possible, our biases, so that our research meets the standards of good scientific work. Otherwise, hard to avoid sympathies do not render null our results.

References

Aisch, Gregor et al. (2014): 'How ISIS Works'. *New York Times*, September 6. Available online at: www.nytimes.com/interactive/2014/09/16/world/middleeast/how-isis-works.html.

Alfred, Charlotte (2015): 'Who's Behind the Islamic State's Propaganda on Twitter?'. *Huffpost*, March 6.

Al-Gharbi, Musa (2017): 'Don't Think of the "Islamic State" in Religious Terms'. *Middle East Policy Council*. Available online at: www.mepc.org/commentary/dont-think-islamic-state-religious-terms.

Alvanou, Maria C. (2015): 'Contemporary Extremist Violence: Interview with Prof. Marco Lombardi'. *Pemptousia*, August 3. Available online at: http://pemptousia.com/2015/08/contemporary-extremist-violence-an-interview-with-prof-marco-lombardi/.

Bandura, Albert (2015): *Moral Disengagement: How People Do Harm and Live with Themselves*. New York: Worth Publishers.

Barusch, Amanda (2012): 'Refining the Narrative Turn: When Does Story-Telling Become Research?'. *Gerontological Society of American*, November 16.

Baumeister, Roy F. (1991): *Meanings of Life*. New York: Guilford Press.

Becker, Howard S. (1967): 'Whose Side Are We On?'. *Social Problems*, 14 (3):239–247.

Berger, J. M. (2014): 'How ISIS Games Twitter'. *The Atlantic*, June 16. Available online at: www.theatlantic.com/international/archive/2014/06/isis-iraq-twitter-social-media-strategy/372856/.

Berger, J. M. and Jonathon Morgan (2015): 'The ISIS Twitter Census: Defining and Describing the Population of ISIS Supporters on Twitter'. *The Brooking Project on U.S. Relations with Islamic World*, No. 20, March.

Berger, Peter L. and Thomas Luckmann (1966): *The Social Construction of Reality: A Treatise in the Sociology of Knowledge*. New York: Doubleday.

Bourrie, Mark (2016): *The Killing Game: Martyrdom, Murder and the Lure of ISIS*. Montreal: Patrick Crean Editions.

Cassis, Hanna (1997): 'Islam'. In Harold Coward (ed.): *Life After Death in World Religions*. Maryknoll, NY: Orbis Books, pp. 48–66.

Clarke, Colin P. and Amarnath Amarasingam (2017): 'Where Do ISIS Fighters Go When the Caliphate Falls?'. *The Atlantic*, March 6. Available online at: www.theatlantic.com/international/archive/2017/03/isis-foreign-fighter-jihad-syria-iraq/518313/.

Cockburn, Patrick (2014): *The Rise of Islamic State ISIS and the New Sunni Revolution*. New York: Verso Books.

Coen, Sharon (2016): 'Six Ways Twitter Has Changed the World'. *The Conversation*, March 18. Available online at: http://theconversation.com/six-ways-twitter-has-changed-the-world-56234.

Cottee, Simon (2015): 'Terrorism with a Human Face: Mohammad Emwazi Didn't Look Like the Killer Who Became Jihadi John: Why Is That So Surprising?'. *The Atlantic*, March 8. Available online at: www.theatlantic.com/international/archive/2015/03/terrorism-with-a-human-face/387163/.

Cross, Mary (2012): *Blogeratti: Twitterati: How Blogs and Twitter Are Transforming Popular Culture*. Santa Barbara, CA: Praeger.

Cuthbertson, Anthony (2015): 'Anonymous Lists 9,200 Twitter Accounts Linked to Islamic State after Hacktivist Collaboration'. *International Business Time*, March 16.

Gaudin, Sharon (2012): 'In 6 Years, Twitter Becomes Major Social, Political Player'. *Computerworld*, March 22. Available online at: www.computerworld.com/article/2503093/in-6-years – twitter-becomes-major-social-political-player.html.

Gilsinan, Kathy (2015): 'Could ISIS Exist without Islam?'. *The Atlantic*, July 3. Available online at: www.theatlantic.com/international/archive/2015/07/isis-islam/397661/.

Gottschall, Jonathan (2012): *The Storytelling Animal: How Stories Makes Us Human*. New York: Mariner Books.

Hall, John (2015): 'ISIS Controls as Many as 90,000 Twitter Accounts Which It Uses to Spread Sick Propaganda and Radicalise Westerners, Terror Experts Reveal'. *Mail Online*, March 6. Available online at: www.dailymail.co.uk/news/article-2982673/ISIS-controls-90-000-Twitter-accounts-uses-spread-sick-propaganda-radicalise-Westerners-terror-experts-reveal.html.

Hamid, Shadi (2014): 'The Roots of the Islamic State's Appeal: ISIS's Rise Is Related to Islam: The Question Is: How?'. *The Atlantic*, October 31. Available online at: www.theatlantic. com/international/archive/2014/10/the-roots-of-the-islamic-states-appeal/382175/.

Harris, Sam and Graeme Wood (2015): 'The True Believers: Sam Harris and Graeme Wood Discuss the Islamic State'. *Sam Harris Blog*, March 4. Available online at: www.samharris. org/blog/item/the-true-believers.

Heidegger, Martin (1962): *Being and Time*. Oxford: Blackwell Publishing.

Hudson, Rex A. (1999): *The Sociology and Psychology of Terrorism: Who Becomes a Terrorist and Why? A Report Prepared under an Interagency Agreement by the Federal Research Division*. Washington, DC: Library of Congress.

Irshaid, Faisal (2014): 'How Isis Is Spreading Its Message Online'. *BBC News*, June 19. Available online at: www.bbc.com/news/world-middle-east-27912569.

Krol, Charlotte (2015): 'Mohammed Emwazi Is "Extremely Gentle", Says British Advocacy Group Cage Director'. *The Telegraph*, February 26. Available online at: www.telegraph. co.uk/news/worldnews/islamic-state/11437579/Mohammed-Emwazi-is-extremely-gentle-says-British-advocacy-group-Cage-director.html.

Lifton, Robert Jay (1968): *Death in Life: Survivors of Hiroshima*. New York: Random House.

Lifton, Robert Jay (1979): *The Broken Connection: On Death and the Continuity of Life*. New York: Simon & Schuster.

Lifton, Robert Jay and Eric Olson (1974): *Living and Dying*. London: Wildwood House.

McCants, William (2015): *The ISIS Apocalypse: The History, Strategy, and Doomsday Vision of the Islamic State*. New York: Martin's Press.

Moghul, Haroon (2015): 'The Atlantic's Big Islam Lie: What Muslims Really Believe about ISIS'. *Salon*, February 20. Available online at: www.salon.com/2015/02/19/the_atlantics_big_islam_lie_what_muslims_really_believe_about_isis/.

Mullen, Jethro (2015): 'What Is ISIS' Appeal for Young People?'. *CNN*, February 25. Available online at: http://edition.cnn.com/2015/02/25/middleeast/isis-kids-propaganda/index. html.

Napoleoni, Loretta (2014): *The Islamist Phoenix: The Islamic State and the Redrawing of the Middle East*. New York: Seven Stories Press.

'Nearly 50,000 Pro-Islamic State Twitter Accounts' (2015): *BBC News*, July 23. Available online at: www.bbc.com/news/world-us-canada-31760126.

Patalay, Ajesh (2009): 'Life Is Tweet: How the Twitter Family Infiltrated Our Cultural World'. *The Observer*, February 15.

Ruthven, Malise (2012): *Islam: A Very Short Introduction*. Oxford: Oxford University Press.

Selby, Jenn (2015): 'Russell Brand Argues Nick Clegg Could Join ISIS Because He's Alienated, Lost His Ideology and Has "Made More Corrupt Political Alliances"'. *The Independent*, March 4. Available online at: www.independent.co.uk/news/people/russell-brand-reasons-nick-clegg-could-join-isis-because-hes-alienated-lost-his-ideology-and-has-10084980.html.

Stanley, Tim (2015): 'Britain Didn't Create Jihadi John: Mohammed Emwazi Did'. *The Telegraph*, February 28. Available online at: www.telegraph.co.uk/news/worldnews/islamic-state/11441805/Britain-didnt-create-Jihadi-John.-Mohammed-Emwazi-did.html.

Stern, Jessica and J. M. Berger (2015): '"Raising Tomorrow's Mujahideen": The Horrific World of ISIS's Child Soldiers'. *The Guardian*, March 10. Available online at: www.theguardian.com/world/2015/mar/10/horror-of-isis-child-soldiers-state-of-terror.

Stern, Jessica and J. M. Berger (2016): *ISIS: The State of Terror*. New York: Ecco/Harper Collins Publishers.

Trianni, Francesca and Andrew Katz (2014): 'Why Westerners Are Fighting for ISIS'. *Time*, September 5.

Varghese, Johnlee (2015): 'ISIS Has Over 45.000 Twitter Accounts to Spread Its "Terror" Propaganda: Report'. *International Business Time*, January 28.

Vollum, Scott and Dennis R. Longmire (2009): 'Giving Voice to the Dead: Last Statements of the Condemned'. *Contemporary Justice Review*, 12 (1):5–26.

Weiss, Michael and Hassan Hassan (2015): *ISIS: Inside the Army of Terror*. New York: Regan Arts.

Wood, Graeme (2015): 'What ISIS Really Wants'. *The Atlantic*, March. Available online at: www.theatlantic.com/features/archive/2015/02/what-isis-really-wants/384980/.

Yadron, Danny (2016): 'Twitter Deletes 125,000 ISIS Accounts and Expands Anti-Terror Teams'. *The Guardian*, February 5.

Zimbardo, Philip (2008): *The Lucifer Effect: Understanding How Good People Turn Evil*. New York: Random House.

Index

Note: page numbers in *italics* indicate figures; page numbers in **bold** indicate tables.

Printed in Great Britain
by Amazon

40052688R00150